# VORTICISM

# and the English Avant-Garde

**WILLIAM C. WEES**

# VORTICISM and th

UNIVERSITY OF TORONTO PRESS

# nglish Avant-Garde

©University of Toronto Press 1972
Toronto and Buffalo
Printed in Canada
ISBN 0-8020-1763-0
Microfiche ISBN 0-8020-0098-3
LC 73-185744

UK and Commonwealth except Canada
Manchester University Press
316-24 Oxford Road
Manchester M13 9NR England
ISBN 0-7190-0504-3

FOR SYLVIA

# CONTENTS

# PLATES

# PREFACE AND ACKNOWLEDGMENTS

This book had its origin some twelve years ago, when I first saw *Blast, The Review of the Great English Vortex.* Curiosity about that huge 'little magazine' published over fifty years ago led me to the writings and visual art of its editor, Wyndham Lewis, and to certain works of Ezra Pound (a major contributor to *Blast*) which I had not read earlier – notably his 'memoir' of Henri Gaudier-Brzeska (another contributor to the magazine). From there the circles widened to include the sculpture and drawings of Gaudier-Brzeska and the works of other artists who assumed, or had attached to them, the label Vorticist. Soon Ford Madox Ford came into the picture, and Roger Fry, and T.E. Hulme, and F.T. Marinetti and his fellow Futurists, and finally a welter of people and places and events in the life and art of London between 1910 and 1915.

By the time I had finished my research (which included two extended stays in London and the accumulation of information through interviews, correspondence, and examination of unpublished material) I could see that to treat *Blast* or Vorticism in isolation, as phenomena of art history or literary history, obscured the uniqueness as well as the representativeness of the movement and its magazine. The best approach, I decided, was to reverse the order of my own discoveries, and move from milieu to individuals to *Blast*, from the most diffuse to the most succinct levels of inquiry. Less damage would be done to the whole picture that way. Distinctions between imitation and originality, the general and the personal, art and propaganda, intention and accident would be less strict and less restricting. Circumstances conducive to the growth of a movement would not seem to be simply this man's influence or that man's ambition.

Because of this approach, readers may also notice parallels between the Vorticists' times and our own, and a number of ways in which *Blast* and Vorticism are relevant to contemporary movements in art and letters. On these matters each reader will

have to make up his own mind. I have not tried to press the issue.

Nor have I tried to catalogue or even to refer to all the works of Vorticist art still in existence. To 'document' the movement has not been my intention. Much of that work has been done, in fact, by William C. Lipke in his unpublished doctoral dissertation, 'A History and Analysis of Vorticism' (University of Wisconsin 1966), by Anthony d'Offay in his exhibition catalogue, *Abstract Art in England 1913-1915*, and by Walter Michel in *Wyndham Lewis: Paintings and Drawings*, which makes an extremely important contribution to our knowledge of all phases of Lewis's visual art. My book has benefited from the work of all three men, and I want to record my special indebtedness to Walter Michel for his help and encouragement.

My chief concern has been to try to make *Blast* and Vorticism understandable in the context of their times. That endeavour would have been impossible without the help of many people whose contributions did not always take forms readily acknowledged in notes to the text. My deepest thanks go to Miss Sheelah Hynes for the interest she has taken in my project as well as for the kindness she has shown me and my family. I am also grateful for the help of Mrs Dorothy Pound, Miss Winifred Gill, Mr Ronald Alley, the late Alvin Langdon Coburn, the late Professor W.K. Rose, Miss Kate Lechmere, Mrs Spencer Gore, the late Helen Rowe, Mr R.H.M. Ody, Mr Douglas Cleverdon, Mr Anthony d'Offay, Mr Raymond Drey, Professor Joshua Taylor, Dame Rebecca West, Mr Herbert Wellington, Mr George Milman, Mr Carol Hogben, Corrinne and Arthur Cantrill, Mr C.J. Fox, Professor Bruce Spiegelberg, Mr Alan Munton, Mr R.J. Wheelwright, Professor Wallace W. Douglas, and Professor Richard Ellmann.

Considerable assistance has been given me by the staffs of the British Museum Reading Room and the Newspaper Library at Colindale, the Houghton and Widener libraries at Harvard University, Deering Library at Northwestern University, the Department of Rare Books at the Cornell University Library, Miller Library at Colby College, and McLennan Library at McGill University.

For permission to quote unpublished material, I wish to thank Mrs Anne Wyndham Lewis (letters of Wyndham Lewis), Mrs Dorothy Pound, committee for Ezra Pound (letters of Ezra Pound), Mrs Barbara von Bethmann-Hollweg (letters of Edward Wadsworth), Mr R.H.M. Ody (letters of Jessie Dismorr), King's College Library, Cambridge University (letter of George Bernard Shaw), Mrs Helen Peppin (letter of Helen Saunders), Mrs Kathleen Nevinson (letters of C.R.W. Nevinson), Miss Winifred Gill (letters written by her), Dame Rebecca West

(letter written by her), the Library Board of Cornell University (letters to and from Wyndham Lewis).

I am indebted to New Directions Publishing Corporation, New York, and to Faber and Faber Ltd, London, for permission to reprint passages from Ezra Pound, *The Cantos*© 1948 by Ezra Pound, and *Personae*© 1926 by Ezra Pound, and to New Directions Publishing Corporation for Dorothy Pound, Committee for Ezra Pound, for permission to quote from 'Pax Saturni' *Poetry* II (April 1913), 'Revolt Against the Crepuscular Spirit in Modern Poetry' *Personae* (1909), and 'Et Faim Sallir Le Loup Des Boys' *Blast* No. 2 (July 1915). For permission to use other material I wish to thank the Macmillan Company, publishers of *Tree of Heaven* by May Sinclair; W.W. Norton and Co., Inc. and Curtis Brown, Ltd, publishers of *The Edwardians* by Charles Petrie; Dodd, Mead and Co., McClelland and Stewart, and Ernest Benn Ltd, publishers of *The Collected Poems of Robert Service*; Douglas Cleverdon and British Broadcasting Corporation, producers of 'Vortex Gaudier-Brzeska'; George Allen and Unwin Ltd, publishers of *Catholic Anthology* in which appears 'No Prey am I' by Orrick Johns.

Parts of this book have appeared in different form in *Western Humanities Review* XXI (Spring 1967) and *Contemporary Literature* VI (Winter–Spring 1965) and VII (Summer 1966)© the Regents of the University of Wisconsin; my thanks go to the editors of both journals for permission to use that material here.

Permission to reproduce photographs of paintings, drawings, and sculpture has been kindly granted by Mrs Anne Wyndham Lewis, Mrs Barbara von Bethmann-Hollweg, Mr William Roberts, Mrs Lilian Bomberg, Mrs Celia Clayton, Mr Gratton Freyer, Mr David Drey, Mr John Brodzky, the Victoria and Albert Museum, and the Tate Gallery; vortographs by Alvin Langdon Coburn are reprinted by permission of George Eastman House.

I want to thank Professor E. Parker Johnson and the Committee on Research, Travel and Sabbaticals of Colby College, for providing financial assistance and granting me a sabbatical leave during which my research was completed and the writing begun. This book is published with the assistance of a grant in aid from the Humanities Research Council using funds supplied by the Canada Council. Much of the credit for the book's final form should go to Miss Prudence Tracy and Mr Allan Fleming of the University of Toronto Press. There would have been no book at all without the help of my wife, to whom this book is dedicated.

<div align="right">

W.C.W.

Montreal, July 1971

</div>

# VORTICISM

# and the English Avant-Garde

Lewis' *Composition* of 1913 makes the contrast with Bomberg even stronger. Instead of a brightly coloured criss-cross mosaic like *In the Hold*, we see a brown, gray, black, and white abstract design in which arcs, lines, rectangles, and sharply pointed wedges and splinters of light and dark cut over, under, and across each other, until the whole design seems locked into an endless internal struggle of conflicting geometrical forms. *In the Hold* keeps the eye moving over its surface; *Composition* draws the eye into the internal workings, the abstract structure of the work. Lewis' two other pictures follow the same strategy, and, with less intensity, so do the pictures by Wadsworth, Hamilton, and Atkinson. In every case, lines, planes, angles, geometrical figures overlap and intersect. Colours are subdued and, with the exception of Wadsworth's *Abstract Composition*, seem to be afterthoughts, rather than integral, basic elements of design. There is little sensuousness or decorativeness. Austere and cold, these designs seem to have no sources in nature, but to derive entirely from the artists' sense of abstract form.

For compromises between the bright mosaics on one wall and the low-keyed abstract diagrams on the other, the visitor can look at the sculpture in the room – at Jacob Epstein's fierce icon of mechanized man, *Rock Drill* (1915) (plate 17), and Henri Gaudier-Brzeska's cubist-primitive *Red Stone Dancer* (*c* 1913) (plate 20) and Brancusi-like *Bird Swallowing Fish* (1913-14) – or the paintings on the wall behind *Rock Drill*: William Roberts' *The Diners* (1919) and *The Cinema* (*c* 1920), and C.R.W. Nevinson's *The Arrival* (*c* 1913-14) (plate 7).

The works by Nevinson, Roberts, Gaudier-Brzeska, Epstein, Atkinson, Hamilton, Wadsworth, Lewis, and Bomberg constitute the Tate's Vorticist section. As a group, they provide a condensed impression of what was happening in the most advanced ranks of London's avant-garde artists around 1914. They show the context in which Vorticism lived out its brief life, but, without extensive explanations, qualifications, and a few exclusions, they cannot be taken to represent Vorticism. The variation in styles is too great and the period of time from which they are drawn is too long to give an accurate impression of what Vorticism was.

Furthermore, Vorticism was not simply a visual style. It was a group movement, and to be understood should be approached in the spirit of Ford Madox Ford's exclamation, 'Movements make for friendships, enthusiasms, self-sacrifice, mutual aid – all fine things! And movements are things of youth.'[9] Vorticism was that sort of movement, and it also illustrated Ezra Pound's definitions of a 'school' and an 'art movement.' 'A school exists,' Pound wrote in 1913, 'when two or three young men agree,

more or less, to call certain things good ...'[10] Years later, he wrote, 'The term "art movement" usually refers to something immobile. It refers to a point or an intersection or a declaration of conclusions arrived at.'[11] For several artists, Vorticism was a 'point' or 'intersection' of the sort Pound describes, and the Vorticists' magazine *Blast* was the 'declaration of conclusions arrived at,' as well as an illustration of just what sort of art – both literary and visual – those conclusions produced.

Vorticism offered, in Pound's phrase, a 'common ground of the arts.' In his memoir of Gaudier-Brzeska, Pound wrote, 'We wished a designation that would be equally applicable to a certain basis for all the arts. Obviously you cannot have "cubist" poetry or "imagist" painting.'[12] You could have Vorticist poetry and Vorticist painting: 'What I have said for one Vorticist art can be transposed to another Vorticist art,' Pound wrote in 1914.[13] Wyndham Lewis agreed that Vorticism 'affected equally the images which issued from its visual inspiration, and likewise the rather less evident literary sources of its ebullience.'[14] The movement epitomized a tendency of the times noted by the self-styled doyen of the Vorticists, Ford Madox Ford. 'For a moment in the just-before-the-war days,' said Ford, 'the Fine, the Plastic and the Literary Arts touched hands with an unusual intimacy and what is called oneness of purpose.'[15]

As a visual style, Vorticism can be pinned down to a particular way of juxtaposing abstract, geometrical shapes, pursued in 1913-14-15 by Wyndham Lewis, Edward Wadsworth, Cuthbert Hamilton, Lawrence Atkinson, Jessie Dismorr, Helen Saunders, and Henri Gaudier-Brzeska. The Vorticist visual style may be more broadly defined to cover more artists, more years, and a greater variety of styles,* but the present study tries to hold to the narrower definition – for reasons that should become clear by the time the reader has finished this book.

As a movement, in the senses suggested by Ford and Pound, Vorticism was part of the lives and the milieu of nearly a dozen young avant-garde artists and writers who made London their home in that 'little narrow segment of time, on the far side of world war i,' as Wyndham Lewis once put it. As a movement in a still broader sense, Vorticism mirrored its times, and the times – England between 1910 and 1914 – saw politics, social rela-

6

---

* Lipke, in his unpublished dissertation, 'A History and Analysis of Vorticism,' and in 'Ezra Pound and Vorticism: A Polite Blast,' makes Vorticism stand for three distinct styles produced by a large number of artists during more than a decade. On the other hand, the Vorticist visual style, as defined in the present study, coincides closely with the limits and criteria set forth by Walter Michel in 'Vorticism and the Early Wyndham Lewis' 6.

tionships, and the arts faced with radical challenges to their traditional values and accepted ways of doing things.

Chapters one through eight primarily concern themselves with the movement as a reflection of the times. They operate on the assumption that movements should be approached ecologically, that is to say, in terms of their living relationships with their environment. Chapters nine through twelve take up the movement's specific accomplishments as they appeared in painting and sculpture and, most significantly, in *Blast*. Together, the twelve chapters attempt a definition of Vorticism broad enough to show the movement's debt to its times, and narrow enough to isolate those things about Vorticism that not only made it unique in its time, but make it worth knowing about today.

# 1
# The New Spirit

*'To the rebels of either sex all the world over who in any way are fighting for freedom of any kind, I dedicate this study of their painter comrades.'*

*Revolution in Art*, a pamphlet written in defence of Post-Impressionism by the art critic Frank Rutter, opened with that sweeping dedication.[1] The date was November 1910, and the occasion, the first Post-Impressionist exhibition at London's Grafton Galleries. Extravagant as that dedication may sound to us today, it nonetheless caught the emerging spirit of the times, and with uncanny accuracy linked the sexual, social, political, and artistic rebellions that were to intensify tremendously in the following four years.

Those four post-Edwardian years were to be markedly different from the years immediately preceding. To the rebels of 1910-14, Edwardian England seemed like a reflective pause between late Victorianism, which had faded into 'Celtic twilight,' 'decadence,' and 'aestheticism,' and Modernism, which would be born in the flamboyant world of the pre-war rebel artists. The Edwardian scene called up metaphors of sleep: 'sleepy mellowness' characterized the arts, said Wyndham Lewis in a lecture in 1944,[2] and elsewhere he noted, 'England was in an unusually somnolent condition.'[3] 'Art in England was dormant,' writes Sir Herbert Read.[4] Ezra Pound characteristically hardened the metaphor and diagnosed the condition as 'petrifaction of the mind.'[5] Certainly, in comparison with the stormy years immediately to follow, the Edwardian intellectual climate seemed mild.

As Dorothy Baisch points out in her study of London's literary circles, the colourful coteries of the 1890s had given way, in the first decade of the twentieth century, to groups of writers and artists that seemed more solidly conventional: 'The country house replaced the café.'[6] Social responsibility, not rebellion, building, not blasting, suited the temper of the times, in which the major literary talents were James, Yeats, Hardy, Conrad,

the Garnetts, Wells, Galsworthy, Bennett, and Shaw. Edgar Jepson said the period's 'greatest achievement' in the novel was Wells' *Tono Bungay*, and its leading art critic was C. Lewis Hind.[7] To Lascelles Abercrombie, the quintessential Edwardian poetry was to be found in Hardy's *The Dynasts* and Doughty's *The Dawn in Britain*. As examples of 'development' and 'innovation' in the novel, Abercrombie listed *The Way of All Flesh, Kipps, Lord Jim*, and *The Old Wives' Tale*; in poetry he found the experimenters to be de la Mare, Masefield, Gibson, and Davidson. In every case, Abercrombie insisted, the innovations 'are not effected by breaking off the tradition and starting afresh; they are not revolutionary.'[8]

10   The only important Edwardian figure who would take an active part in the revolutionary movements to come, Ford Madox Ford, then seemed solidly fixed in the world of country-house friendships. It was a world the new rebel artists neither desired nor respected. 'Remember who were still alive in those years,' Ezra Pound wrote later, 'the respectable and middle generation, illustrious punks and messers, fakes like Shaw, stews like Wells, nickel cash-register Bennett. All degrading the values. Chesterton meaning also slosh at least then and to me. Belloc pathetic in that he had *meant* to do the fine thing ...'[9]

Far more immersed in mediocrity than the literary world was the art world, dominated by the Royal Academy of Art. As early as 1893, George Moore had called the Academy an 'incubus' that must be destroyed before new, vital art could develop in England.[10] In 1900 Roger Fry complained, 'The Academy becomes every year a more and more colossal joke played with inimitable gravity on a public which is too much the creature of habit to show that it is no longer taken in.'[11] Nevertheless, 'before 1911,' as David Bomberg said, Academy art 'was still the public conception of What Art Should Be In England.'[12]

The efforts of the New English Art Club (founded in 1886) to make English art contemporary with French art had pushed things forward only as far as the Impressionism of Walter Sickert and a few others. 'I doubt if any unprejudiced student of modern painting will deny that the New English Art Club at the present day sets the standard of painting in England,' Sickert wrote in 1910.[13] By the end of that year his assertion was no longer true; for while the N.E.A.C. had shown younger artists ways of liberalizing their conservative, academic training, it had not made the radical break with tradition that the times demanded. The best one could say of the English art scene up to 1910 was said very well by Sir Herbert Read:

It was a world in which the sprightly academicism of Augustus John could excite the cognoscenti. Ricketts and Shannon, Conder and the Rothensteins – these were the shimmering stars in a twilight through which the sinister figures of Oscar Wilde and Aubrey Beardsley still seemed to slouch. Walter Sickert was the closest link with reality – the reality of Degas and Manet, but Sickert was not then taken so seriously as of late.[14]

All this changed after 1910. The Academy, the N.E.A.C., John, and Sickert, as well as Shaw, Wells, Galsworthy, and Bennett, were swept aside by a flood of new interests and energies.

From every side comes testimony to this new spirit in the arts. Pre-war London was in a 'fever of rebelliousness,' says Frank Swinnerton.[15] 'Everything in art was a turmoil – everything was bursting,' C.R.W. Nevinson told a New York *Times* reporter.[16] In his autobiography, Sir Osbert Sitwell writes, 'A ferment such as I have never since felt in this country prevailed in the world of art. It seemed as if at last we were on the verge of a great movement.'[17] To introduce and justify his first volume of Georgian poetry in 1912, Edward Marsh wrote, 'This volume is issued in the belief that English poetry is now once again putting on a new strength and beauty ... We are at the beginning of another "Georgian Period" which may rank in due time with the several great poetic ages of the past.'[18] Analyzing the decade for the *New Age* (a magazine whose name – if not always its content – represented the spirit of the times), Ezra Pound wrote, 'These new masses of unexplored arts and facts are pouring into the vortex of London. They cannot help bringing about changes as great as the Renaissance changes ...'[19] *The New Renaissance* was to be Clive Bell's title for a book he began to write in 1910 when he became aware of, as he put it, the 'excitement in the air' and the 'sense of things coming right.'[20] 'The present,' said Lascelles Abercrombie in 1912, 'is a time fermenting with tremendous change; the most tremendous of all changes, a change in the idealistic interpretation of the universe.'[21] Wyndham Lewis believed, 'Europe was full of titanic stirrings and snortings – a new art coming to flower to celebrate or to announce a "new age." '[22] For Ford Madox Ford, 'it was – truly – like an opening world.'[23]

These grand hopes for the present brought with them an intolerant rejection of the past and the past's relics – as they seemed to the young rebels – cluttering up the present. Declaring his 'belief' in Swinburne, Browning, Tennyson, Wordsworth, Keats, Shelley, and Milton, but not in their 'imitators,' a character in a novel of the period goes on to announce, 'You can't destroy their imitators unless you destroy them. They breed the

11

disgusting parasites. Their memories harbour them like a stink-
ing suit of old clothes. They must be scrapped and burned if
we're to get rid of the stink. Art has got to be made young and
new and clean.'[24] Ezra Pound, who was particularly active in
promoting the 'youth racket,' as Wyndham Lewis called it,
announced in the pages of the *Egoist*, 'To the present condition
of things we have nothing to say but *merde* ... We artists who
have been so long the despised are about to take over control.'[25]
Taking control meant curing England of what Lewis called
'aestheticism, crass snobbery and langours of distinguished
phlegm,'[26] and what C.R.W. Nevinson – echoing and expanding
a Futurist declaration – diagnosed as England's 'canker of pro-
fessors, connoisseurs, archaeologists, cicerones, antiquaries,
effeminacy, old fogyism and snobbery.'[27]*

12

Pound's, Lewis', and Nevinson's gleeful rhetoric of contempt,
their 'youthfully contemptuous attitude toward the living dead'
(to borrow a phrase from G.S. Fraser), seems especially charac-
teristic of 1910-14, a period that saw the rise of the most youth-
fully contemptuous movement of them all, Futurism. The
Futurists, who provided a motto for the period with their proud
declaration, 'We are young and our art is violently revolution-
ary,'[28] formalized into manifestos the new generation's attacks
on the past and passéisme. Their intention, as they announced
in one of their manifestos, was,

1 To destroy the cult of the past, the obsession with the antique,
  pedantism, and academic formalism.

2 To scorn profoundly every form of imitation.

3 To exalt every form of originality, even if reckless, even if violent.[29]

'WE DECLARE,' began another manifesto, 'THAT ALL FORMS
OF IMITATION MUST BE DESPISED, ALL FORMS OF ORIGINALITY
GLORIFIED ... THAT ALL SUBJECTS PREVIOUSLY USED MUST BE
SWEPT ASIDE IN ORDER TO EXPRESS OUR WHIRLING LIFE OF
STEEL, OF PRIDE, OF FEVER AND OF SPEED.'[30]

These diatribes seem unnecessarily violent, but they came at a
time when the literary-art world felt strongly the need to pro-
mote the present and the new against the past and the passéiste
perpetuation of the old. Moreover, they reflect the marked
tendency toward violence in word and deed that accompanied
the various rebellions invoked by Frank Rutter's dedication to
*Revolution in Art*. In this, the artists merely followed the tend-
ency of the times: 'Such was the state of English nerves in those
days,' writes George Dangerfield, 'that violence made a stronger

---

* In 'Manifesto del Futurismo,' Marinetti had written, 'Voliamo liberare
  questo paese dalla sua fetida cancrena di professori, d'archeologhi, di
  ciceroni e d'antiquarii.' (*Archivi del Futurismo* I p17)

appeal to the public than any other form of speech and action.'[31]

1910-14 are the years in question, the years of the 'Vortex.' Ezra Pound used that image in December 1913 to characterize the frenetic life of artistic and literary London. 'You may get something slogging away by yourself that you would miss in the Vortex,' he wrote William Carlos Williams in America.[32] What 'Vortex' implied at the time can be guessed from May Sinclair's novel, *The Tree of Heaven*, published in 1917. Part II of her chronicle of a wealthy London family begins in the autumn of 1910, ends in the summer of 1914, and carries the title, 'Vortex.' 'These people,' she writes of the advanced artists and intellectuals depicted in part II, 'lived in a moral Vortex; they whirled round and round with each other; they were powerless to resist the swirl. Not one of them had any other care than to love and to make love after the manner of the Vortex. This was their honour, not to be left out of it, not to be left out of the Vortex, but to be carried away, to be sucked in, and whirl round and round with each other and the rest.' From that Dantesque metaphor of the liberated sex life, the Vortex expands to include 'the Vortex of the fighting Suffrage woman' and 'the Vortex of revolutionary art.' In May Sinclair's view, everything seemed caught up in 'the immense Vortex of the young century.' The reason for that was, simply, 'If you had youth and life in you, you were in revolt.'[33]

These years that Pound and May Sinclair symbolized in the Vortex, and that Miss Sinclair, along with Frank Rutter and the Futurists, equated with youth and revolution, were also the years J. Isaacs labelled the 'adolescence and intellectual turmoil' of contemporary literature,[34] and George Dangerfield, in *The Strange Death of Liberal England*, called 'four of the most immoderate years in English history.'[35] A history of these years proves there was more than Bloomsbury whimsy lying behind Virginia Woolf's famous assertion that, 'On or about December 1910 human character changed.'[36]

Virginia Woolf offered some evidence to support – or at least illustrate – her argument. She pointed to *The Way of All Flesh*, the plays of Shaw, and 'the character of one's cook.' In contrast to the Victorian cook, 'a formidable, silent, obscure, inscrutable' creature, the Georgian cook 'is a creature of sunshine and fresh air; in and out of the drawing room now to borrow the *Daily Herald*, now to ask advice about a hat.' The change in human character can also be noted, she insisted, in one's sympathy for Clytemnestra and Mrs Carlyle, and not – as would have been the case in the Victorian era – with their husbands. 'All human relationships have shifted – those between masters and servants,

husbands and wives, parents and children. And when human relationships change,' she concluded, 'there is at the same time a change in religion, conduct, politics, and literature.'[37]

Looked at in this broad context, the artistic revolution becomes one advancing flank of a general attack on established points of view and ways of doing things. Frank Rutter put the case too mildly when he wrote that the revolution in art 'indirectly, may be not altogether unconnected with the present unrest in politics and economics ...'[38] People inside and outside the rebel movements, as well as for and against them, felt that the violence done to nature by cubist painters was linked to the violence done to the body politic by political rebels like the militant suffragettes. 'Anarchy' came glibly to the tongues of art critics and MP's alike, for reasons more compelling to those living at the time than they may appear to us today.

For, the conditions Frank Rutter referred to as 'the present unrest,' and May Sinclair called 'the immense Vortex of the young century,' often expressed themselves more violently than Virginia Woolf's wry examples suggest. The passage of the Parliament act of 1911, after two years of the bitterest political rancour and class strife, the emergence of a fanatically militant women's suffrage movement, the sinister blustering of Sir Edward Carson and the Orangemen of Ulster and their open preparations for civil war with England, the tremendously intensified labour strife which could have led to a syndicalist-style general strike in September 1914 had war not broken out in August – these 'symptoms of national ill-health'[39] were as much consequences of changed human relationships as was the transfer of sympathy from Thomas to Jane Welsh Carlyle, and they led another student of that pre-war period, Sir Charles Petrie, to write that, 'The year 1910 ... does seem to associate itself with an unwelcome change in the country's state of mind.'[40]

Whether England's changed state of mind was welcome or unwelcome depends on the individual observer and what he chooses to observe, but change there was, and 1910 was the pivotal year. In April 1910 the Italian Futurists' leader, F.T. Marinetti, appeared in London for the first time to preach his doctrine of rebellion and violence. In November 1910 Roger Fry presented the new art of Europe in his Post-Impressionist exhibition, an event that led Sir Herbert Read to assert later, 'The modern period in British art may be said to date from the year 1910 ...'[41] On the social-political scene, serious labour unrest began in January 1910. The fanatical Unionist leader, Sir Edward Carson became a member of parliament for Ulster in February 1910. The militant suffragettes turned to civil disobedience and violence only after November 1910. The con-

14

sequences of these events were not always noticed by the public until two or three years later, but, like profoundly subterranean earthquakes, their advent in 1910 sent detectable shudders through the whole of English life and made many people feel that, as Dangerfield said, 'the old order, the old bland order, was dying fast ...'⁴²

The death of the old order not only was rapid; it was violent, and its violence struck a number of levels of society simultaneously. Sir Charles Petrie has summed up the situation admirably:

From such beginnings as serious strikes unauthorized by the Trade Union leaders, the early demonstrations of the new movement for women's suffrage, and the platform extravagances of the 1909 Budget campaign, [England's changed state of mind] grew until a temper of sheer fighting seemed to invade every aspect of the affairs, working up to the verge of civil war in 1914 ... In art ... violence of expression was an essential component. In social life the old steady penetration of the world of fashion by the world of wealth, only too pleased to maintain the old barriers once it was safely inside them, was giving place to a feverish, contemptuous construction of a new world of fashionable idleness, well attuned to a world of lurid art. Industry more and more took on the aspect of two massed opposed forces, and between them compromise became even more precarious. The result was that the period between the King's death and the outbreak of the First World War were very militant years.⁴³

Extremism, both revolutionary and reactionary, grew rapidly in these years, and, as H.A.L. Fisher has said, 'A spirit of fanaticism invaded a luxurious world which no longer felt itself secure.'⁴⁴

The sensitive antennae of avant-garde artists quickly picked up the temper of the times. As early as 1912, said Nevinson, artists were 'at war.' 'They were turning their attention to boxing and fighting of various sorts. They were in love with the glory of violence.'⁴⁵ Futurism had a lot to do with that: 'We shall extoll aggressive movement, feverish insomnia, the double quick step, the somersault, the box on the ear,' Marinetti proclaimed in the first Futurist manifesto. 'We wish to glorify War – the only health giver of the world.' Therefore, 'Art can be nought but violence, cruelty and injustice.'⁴⁶ True to the spirit of the times, a young poet in *The Tree of Heaven* declaimed,

O Violenza, sorgi, balena in questo cielo
Sanguigno, stupra le albe,
irrompi come incendio nei vesperi,
fa di tutto il sereno una tempesta,
fa di tutta la vita una bataglia,
fa con tutte le anime un odio solo!

[O Violence, burst forth, lightning in this sky
Bloody, rape the dawns,
Irrupt like the fires of evenings,
Turn all serenity into a tempest
Turn all of life into a battle
Turn all souls into hatred alone!][47]

'There was dynamism in the air,' said John Cournos, 'fraught with the sense of dire things to come. A strident note, as of hysteria, crept into life.'[48] 'The season of 1914,' Douglas Goldring recalled, 'was a positive frenzy of gaiety. Long before there was any shadow of war, I remember feeling that it couldn't go on, that something *had* to happen.'[49] Ford Madox Ford observed the same phenomena: 'The world, I think, was mad then. I don't know if you remember the season of 1914, in London and the world over. It comes back to me as a period of out-cries, smashing, the noise of broken glass falling to the ground and physical violence. An accursed year! The whole tone of personal contacts was strained, tense – mad!'[50]

The 'very militant years' of 1910-14 were the germinating period of Vorticism, and the last summer produced the movement in full bloom. Declaring, 'The artist of the modern movement is a savage,'[51] the Vorticists appeared at exactly the right moment. They epitomized the times in the cover of their magazine: a huge black 'BLAST' on an electric, pinkish purple background. Because of the violence and the noise, few people noticed at the time that the Vorticist movement also gave to the times an aesthetic and a body of painting, sculpture, and writing that transformed violence into art.

# 2
# Suffragettes Ulsterites and Post-Impressionists

On 18 November 1910 several hundred suffragettes led by Emmeline Pankhurst gathered in Parliament Square to protest the government's failure to pass a women's suffrage bill. When they tried to push through a police cordon they were pushed back, and when they persisted they were roughly repulsed and manhandled by angry police officers and unruly spectators. After a six-hour battle on what became known in the movement as 'Black Friday,' the militant suffragettes began a program of increasingly violent attacks on persons and objects representing established, male-dominated, society. Thousands of windows were smashed, golf greens were damaged, paintings slashed, uninhabited buildings burnt. On two occasions home-made bombs exploded in Westminster Abbey. Members of parliament and cabinet ministers were verbally and physically assaulted.

When arrested, the women went on hunger strikes. When the government retaliated with forcible feeding, the women resisted so courageously that some of them nearly died, and the government had to release them for fear of creating martyrs to the suffrage cause. When the women responded to their release with more acts of violence, more hunger strikes, and more near martyrdoms, parliament passed the 'Cat and Mouse' bill, which permitted the release of prisoners in danger of death from hunger strikes (or the effects of forcible feeding), but provided for their rearrest upon their return to health. Often the sign of their restored health was a new act of violence. This implacable determination left the government helpless. Since it would not, as several MP's suggested, let the women die in prison, nor would it, as the Labour leader Keir Hardie urged, give them the vote, it convulsively fluctuated between violence and clemency – neither of which did any good – and ended in virtual paralysis.

Meanwhile, the violence increased, mounting to a peak in May-June 1914. On 4 May, a middle-aged suffragette, Mrs Mary Wood, slashed Sargent's portrait of Henry James at the Royal Academy. On the same day a wooden pavilion belonging

to the Cavehill Bowling and Lawn Tennis Club in Belfast burned to the ground and suffragette literature was found at the scene, and an unexploded bomb, with the fuse burned out, was discovered under the valve house at one of the Dewsbury reservoirs. Suffragette literature had been left there as well. On 13 May, a portrait of the Duke of Wellington by Sir Hubert von Herkommen was hacked by Miss Gertrude May Ansell, another middle-aged suffragette. On 21 May, police stopped a march organized by militants to present a petition to the king at Buckingham Palace. Harassed by hostile bystanders as well as police, the women fought back, and sixty, including Mrs Pankhurst, were arrested. The next day, the women disrupted the court hearings by shouting and making speeches. One threw her shoe at the magistrate. On the same day one painting at the Royal Academy and five at the National Gallery were hacked by suffragettes. On the first of June a sixteenth-century church at Wargrave burned to the ground. Near the smoldering ruins police found messages from militant suffragettes, one of which, addressed 'To the Government Hirelings and Women Torturers,' boldly proclaimed, 'A retort to brutality and torture. Let the Church follow its own precepts before it is too late. No surrender. A sample of the Government's boasted suppression of militancy – defiance!!!' On 11 June, a bomb exploded near the Coronation Chair in Westminster Abbey, and three days later another exploded at a fashionable West End church, St George's Church, Hanover Square.

And so it went: the militant suffragettes assaulted society as a whole. Finding the Liberal government unwilling to give them the vote, and having no means of changing the government, they rejected any pretense of playing according to the established, parliamentary rules, which were the only rules the political system could tolerate. In this sense, they presented a truly radical challenge to the social system; for they would no more accept a Liberal compromise than a flat rejection by the Conservatives. Their response to either alternative was inevitably, more violence.

Violence, for the suffragettes, was not a theory or an unspecified threat. It was a premeditated act performed by individuals whose names and deeds became staple items in the popular press. Two names among many that aroused popular wrath and ridicule were those of Miss Lillian Lenton and Miss Freda Graham. In the early morning of 20 February 1913, the tea pavilion at Kew Gardens was destroyed by fire. Lillian Lenton was arrested, charged with arson, and placed in Holloway Gaol. Immediately, she went on a hunger strike, and three days later was discharged from Holloway in imminent danger of death

18

from pleurisy caused by a piece of food that had lodged in her lung during an attempted forcible feeding. She recovered, however, and on 8 May 1914, was in court again for attempting to break into a house. She delivered a speech throughout her trial, was sentenced to twelve months in jail, and a few days later was released under the 'Cat and Mouse' bill. On 27 May, shortly after Lillian Lenton's release, Freda Graham, who had slashed the five pictures at the National Gallery, was sentenced to six months imprisonment.

A little more than a month after that, the rebel artists of the Vorticist movement publicly established their kinship with the militant suffragettes by 'blessing' 'Lillie Lenton' and 'Frieder Graham' in the first issue of *Blast*. They went on to devote more than a page to announcing their approval of the suffragettes, whom they addressed as 'brave comrades,' asking only that they wield their hatchets with care, lest they destroy a *good* painting someday. (The Vorticists had some cause for worry. On 4 June 1914, a hatchet-bearing suffragette had destroyed two drawings at the Doré Gallery where several of the Vorticists exhibited their own work.) Still, the Vorticists were magnanimous: 'We admire your energy,' they wrote. 'You and Artists are the only things (you don't mind being called things?) left in England with a little life in them.'

Although the Vorticists did not resort to physical violence to advance their cause, they willingly acknowledged the bond of radical opposition to the Establishment, which they shared with their 'brave comrades' in the suffrage movement. They shared the same bond with the Orangemen of Ulster who, unlike the suffragettes, elicited widespread sympathy among Englishmen of Conservative sentiment. On 21 February 1910, Sir Edward Carson, a Protestant Irishman who practiced law in London, was elected MP for Ulster. An intense, humourless man, Carson had first won fame as the relentless prosecutor in the trial of Oscar Wilde, but his true calling came when Asquith's Liberal government, as a result of a coalition with the Irish nationalists, prepared a home rule bill for Ireland. Carson became a fanatical Unionist and the leader of Ulster's resistance to any form of home rule that would unite Catholic and Protestant Ireland under a single Irish government.

On 23 September 1911, Carson addressed a large body of Orangemen on the lawns of Captain James Craig's mansion in Belfast. There Carson declared that the Home Rule bill was 'the most nefarious conspiracy that has ever been hatched against a free people,'[1] and he advised his listeners to prepare to set up a separate, independent government if home rule became a fact. From this point on, while Carson continued making public

pronouncements that sounded treasonable to his opponents, his Ulster supporters were privately arming, drilling, and preparing for war against England, or Catholic Ireland, or both. Government muddling, Tory meddling, certain army officers' refusal to fight against Ulster, and the general political turmoil of the times, combined to make it appear just possible for Carson to turn his threats into fact.

Again, the self-righteous assertion of will without regard for parliamentary processes, constitutional principles, or even royal prerogatives, left the Liberal government without an acceptable course of action, and made Carson the heroic – or demonic – embodiment of the uncompromising, violent spirit of the times.

20 Sir Edward was ably assisted during this dangerous time by Captain James Craig, at whose house he had made his first rebellious call for Ulster independence. *Blast*'s list of the 'blessed' included the names 'Carson' and 'Capt. Craig.'

Lillie Lenton and Freda Graham, Carson and Craig, suffragettes and Orangemen – in no sense allies or sympathetic to each other's cause – exhibited the same absolute refusal to give way, compromise, or let 'the democratic process' decide the issues. By blessing them the Vorticists did not necessarily indicate Unionist sentiments or approval of votes for women. What they did indicate was admiration for, and a desire to share in, the 'temper of sheer fighting,' the new, violent mood of post-Edwardian England.

Sir Charles Petrie notes that, after 1910, 'The traditional Englishman, with his love of compromise, had become a relic of the past.'[2] What was true in politics and mores was also true in the arts. Neither old, established 'conservatives' (the Royal Academy) nor newly established 'liberals' (the New English Art Club and its allies at the Slade School of Art) could sufficiently free themselves from the past to satisfy England's new rebel artists. For them, the equivalent to Suffragette and Ulsterite intransigence was Post-Impressionism.

Roger Fry's exhibition, 'Manet and the Post-Impressionists,' which opened to the public on 8 November 1910, might not seem to be like the Suffragettes' 'Black Friday' or Carson's opening attacks on Home Rule. As it turned out, however, a Van Gogh, a Gauguin, or a Matisse aroused as violent a public reaction as a Lillie Lenton or a Sir Edward Carson. Between 1910 and 1914, labour strife, the Parliament act, screaming suffragettes, and artists' 'maltreatment of the human form divine' seemed, to many people, to be parts of a conspiracy to undermine traditional order and decency.

The shock created by Post-Impressionism would not have been so great had England not been so oblivious to the currents of change in continental art from the 1860s on. Even Impressionism had not won its battle for acceptance in England, in spite of the fact that, as Sir John Rothenstein said, 'England was offered unique and continuous opportunities of understanding impressionism from early in the history of the movement. Far from availing itself of such opportunities, English critical opinion actually hardened against it.' The consequence, Sir John notes, was that, 'after thirty-five years' exposure to impressionism ... the English public dismissed it as an extremist craze.'[3] That being the case, the few pre-1910 incursions of Post-Impressionist art could hardly have made a dent in England's indifference to newer art forms. Cézanne's work, for instance, had appeared in a big Impressionist exhibition in London in 1905 (an exhibition virtually ignored by the critics and public), and in the International Society exhibitions of 1906 and 1908. The latter exhibition also showed work by Monet, Gauguin, and Matisse. Kandinsky was included in the Allied Artists' exhibition in 1909; and, in June 1910 at Brighton, the English public was offered a full-scale exhibition of modern French art. Robert Dell, the Paris correspondent for the *Burlington Magazine*, and a group of Parisian dealers brought 262 items to Brighton, including work by Cézanne, Matisse, Bonnard, Vuillard, Signac, Vlaminck, Derain, and Rouault.

Not only had the work of some of the Post-Impressionists appeared in England before November 1910, but there had also been published a very important study of their work. *Modern Art*, a two-volume study by the German art historian Julius Meier-Graefe, had appeared in translation in 1908, and in it English readers could have found the aesthetic bases of the more recent movements and even the rationale for the particular emphasis Fry gave his exhibition. Meier-Graefe made Manet the starting point for the new movement, and emphasized Manet's 'recognition of painting as flat decoration; [his] ruthless suppression of all those elements used by the old masters to seduce the eye by plastic illusion; and [his] deliberate insistence on all the pictorial elements in their stead.'[4] The major followers of Manet, in Meier-Graefe's view, were Cézanne, Gauguin, and Van Gogh. If the Brighton exhibition was the curtain-raiser for Fry's exhibition, Meier-Graefe's *Modern Art* virtually provided the script for the show at the Grafton Galleries, in which Manet (represented by nine works) was used as the *point de repère* for a survey of modern art that gave major emphasis to Cézanne (21 works), Van Gogh (22 works), and Gauguin (36 works).

Fry's contribution was to link the major Post-Impressionists with younger and less well-known artists such as Redon, Denis, Serusier, Vallotton, Vlaminck, and Rouault, who were presented as outstanding in the younger generation. Picasso, Matisse, Friesz, and Derain, though included, were not treated as major figures, and, as Douglas Cooper has pointed out, 'there was scarcely a hint of the great achievements of the Fauve and Cubist movements which were then causing excitement in Paris.'[5] This thinness in the ranks of the most advanced of the avant-garde painters was noted at the time by Lewis Hind, who informed the readers of the *Daily Chronicle* (7 November 1910) that 'the extremist, serious, living representatives [of Post-Impressionism] are Henri Matisse and Picasso, represented meagrely at the Grafton Galleries (the committee were a little afraid of them) ...'

Few people in England complained of the committee's timidity; practically every one was provoked by its audacious temerity, and very few could have been sufficiently sensitive to the current Paris art scene to have realized that Matisse and Picasso deserved more important places in the exhibition. To most people, the exhibition committee (Fry, Desmond MacCarthy, Clive Bell, Lionel Cust, C.J. Holmes, Lady Ottoline Morrell, Lord Henry Bentinck, Robert Dell, and Dr Meyer-Riefstahl) appeared to have abandoned all standards of taste, decency, and public responsibility.

The first to say so were painters whose traditional styles now faced the direct challenge of Post-Impressionism. In a letter to the *Nation*, John Singer Sargent wrote of the work at the Grafton Galleries, 'I am absolutely sceptical as to their having any claim whatever to being works of art ...'[6] Sir Philip Burne-Jones wrote to the *Morning Post* (17 November 1910) denouncing 'the cult of ugliness and the anarchy and degradation of art exemplified to-day by the "Post-Impressionists." ' Sir William Richmond loaded his letter to the same newspaper (16 November 1910) with phrases like 'this rotten egotism,' 'these morbid excrescences,' 'these incompetents [who] neither could nor can draw, paint, or design.' Robert Morely, in a letter to the *Nation* (3 December 1910) found it 'impossible to take them seriously,' but contradictingly insisted that the exhibition must cease, 'for disease and pestilence are apt to spread.'

E. Wake Cook sent his sweeping condemnation to the *Pall Mall Gazette* (10 November 1910): 'The whole of the works exhibited in London, except the Manets, showed real or assumed incompetence; and the endeavour is to make the collection look like the output of a lunatic asylum.' To the suggestion by the *Morning Post*'s art critic, Robert Ross, that the paintings,

22

like 'the source of the plague,' should be burnt, Charles Ricketts replied (*Morning Post*, 9 November 1910) that the pictures should be preserved, since they might be of interest to 'the doctors of the body and the students of the sickness of the soul,' but the catalogue, with the 'curious sophistries' of its introduction, should be burnt. 'Why talk of the sincerity of all this rubbish?' said Ricketts.[7]

Many critics, like Robert Ross, were no less closed-minded than the painters. D.S. MacColl, artist and critic, found only 'appalling taste' and 'bad drawing' at the exhibition.[8] The *Connoisseur* said that the Grafton's walls 'are hung with works which are like the crude efforts of children, garishly discordant in colour, formless and destitute of tone.'[9] Ross, expressing sadness over the fact that 'distinguished critics [ie, the exhibition's committee] whose profound knowledge and connoisseurship are beyond question should be found to welcome pretension and imposture,' rejected out of hand the argument that these paintings deserved attention because they expressed the artists' emotions: 'The emotions of these painters (one of whom, Van Gogh, was a lunatic) are of no interest except to the student of pathology and the specialist in abnormality.' He declared that Cézanne 'is neither coherent nor architectural'; Van Gogh produced 'visualized ravings of an adult maniac'; Matisse is 'childish'; Denis, Signac, Cross, and Seurat produced work that 'any one sufficiently idle and mindless could reproduce' – which is the companion cliché to Robert Morely's 'any child of tender years ...' etc., etc.[10]

The public condemnation by critics and painters had its private counterpart in the minds of many, probably most, of the people who saw the exhibition. Wilfred Scawen Blunt's diary entry for 15 November 1910 no doubt speaks for many more people than just its author:

The exhibition is either an extremely bad joke or a swindle. I am inclined to think the latter, for there is no trace of humour in it. Still less is there a trace of sense or skill or taste, good or bad, or art or cleverness. Nothing but that gross puerility which scrawls indecencies on the walls of a privy. The drawing is on the level of that of an untaught child of seven or eight years old, the sense of colour that of a tea-tray painter, the method that of a schoolboy who wipes his fingers on a slate after spitting on them ... Apart from the frames, the whole collection should not be worth £5, and then only for the pleasure of making a bonfire of them ... These are not works of art at all, unless throwing a handful of mud against a wall may be called one. They are the works of idleness and impotent stupidity, a pornographic show.[11]

Blunt was not, on the whole, an intolerant or insensitive man.

Why should art that was taken seriously, as Arnold Bennett

pointed out, by 'hundreds of the most cultivated minds in Europe'[12] drive sensible, intelligent men to make any sort of wild charge, rather than consider the possibility that the Post-Impressionists were hard-working, serious artists devoted to presenting the fullest expression of their imagination and skill? Why must the exhibition be explained away by Blunt as 'an extremely bad joke or a swindle'; by Burne-Jones as 'a huge practical joke organized in Paris at the expense of our country-men'; by Morely as a reflection of 'the debasement of the lives of the painters in the Gay City'; or by Sickert as merely an effort 'to *épater*' and by the *Athenaeum* as 'deliberately intended to outrage?' Why must incompetence, perverse humour, char-latanry, or immorality be the only motivation behind an exhi-bition that the *Connoisseur* called 'a moment of misplaced effort'? The exhibition could not be accepted on its own merits, because most people did not know – and refused to learn – what its merits could be.

24

Something more complicated than some strange-looking pic-tures was involved. Otherwise, why should the exhibition's de-tractors revert to language nearly bursting with disgust and repressed fears? Why should Blunt resort to infantile and excre-mental imagery (privy walls, smeared spit, mud-throwing), or call an exhibition 'pornographic' because it presented 'maltreat-ment of the human form divine'? Why should Sir William Richmond treat the show as if it were an attack on young artists' virility?[13] Why references to 'plague,' 'disease and pesti-lence,' 'excrescences,' and 'degradation'?

Whatever else may be said, at least it is clear that these terms do not describe the works at the Grafton Galleries. Their authors were over-reacting to private impulses stirred up by the Post-Impressionists' art. By their reversion to images of violence and various forms of mental, physical, and sexual degradation, these cultured people exposed their own inability to cope with the implications of this new art. The art they likened to the scrawls of children and 'savages,' drove them to infantile and primitive levels of response. Such responses could be valid, even salutary, but in the context of the times – before the merits of children's and 'savages' ' art (not to mention the insights of Freud) had been widely recognized – most people simply could not appre-ciate their validity. And so people laughed or berated the artists and their works. In language latent with their own fantasies and dreams, they attacked 'nightmare art.'

Desmond MacCarthy who, as secretary of the exhibition, spent most of this time at the Grafton Galleries, offered one explana-tion for the public's violent reaction. 'Now, anything new in art,' MacCarthy wrote, 'is apt to provoke the same kind of indigna-

tion as immoral conduct, and vice is detected in perfectly innocent pictures. Perhaps any mental shock is apt to remind people of moral shocks they have received, and the sensation being similar, they attribute this to the same cause.'[14] Roger Fry, on the other hand, based his explanation on the exhibition's threat to the cultural snobbism of art patrons and connoisseurs.

These people [he wrote in 1920] felt instinctively that their special culture was one of their social assets. That to be able to speak glibly of Tang and Ming, of Amico di Sandro and Baldovinetti, gave them a social standing and a distinctive cachet ... It was felt that one could only appreciate Amico di Sandro when one had acquired a certain considerable mass of erudition and given a great deal of time and attention, but to admire a Matisse required only a certain sensibility. One could feel fairly sure that one's maid could not rival one in the former case, but might by a mere haphazard gift of Providence surpass one in the second.[15]

Their daily confrontations with irate gallery-goers showed Fry and MacCarthy the public's most immediate and personal reactions. Because they were immersed in the controversy, perhaps they saw less clearly how the reactions to Post-Impressionism fit into broader patterns of reaction that were beginning to appear in England around 1910.

When C. Lewis Hind asked himself, 'Why should a mere picture exhibition stir phlegmatic art England,' and even stir 'people who are not particularly interested in art?' he concluded, rather grandly, that, 'Behind the [Post-Impressionist] movement there is a purpose, an idea partaking more of the spiritual than the material. Mere picture-making was lifted into a larger region.'[16] In that 'larger region' Post-Impressionism joined women's suffrage, home rule, socialism, and all the other challenges to what had been the accepted ideas about man and his place in society.

Revolutionary art – to shift to social-political analogies appropriate to the times – threatened to bring down the whole art Establishment, its liberal as well as its conservative wings, its Sickerts as well as its Sir William Richmonds. It could do this simply by ignoring the 'rules' sanctified by tradition and the academies. Post-Impressionism, said the *Times*, rejects "all that civilization has done'; it 'throws away all that the long-developed skill of the past artists had acquired and perpetuated.'[17] It is, said Burne-Jones, 'a mockery of all human effort in the past – a paralysis of all hope of progress in the future.'[18] The assumption that art depended on an evolutionary 'progress' had its counterpart in the political liberalism of the time, and in both worlds its adherents were incapable of dealing intelligently or effectively with a radical challenge, whether from Post-Impressionism or from suffragettes and Carsonites. They knew no way to come to

terms with movements that unashamedly ignored and defied
traditional assumptions and procedures.

To choose to paint, as it seemed, without regard for the Greco-
Roman and Renaissance tradition, or even for its progressive
modifications, such as Impressionism, could only be regarded
as incompetence, a very bad joke, madness, perverse self-ad-
vertisement, charlatanry, or, worst of all, anarchy. 'To revert in
the name of "novelty" to the aims of the savage and the child ...'
Charles Ricketts wrote, 'is to act as the anarchist, who would
destroy where he cannot change.'[19] Roger Fry discovered that,
'The accusation of anarchism was constantly made,' by be-
wildered and outraged visitors to the Grafton Galleries, and that
the whole Post-Impressionist movement was generally regarded
as 'madly revolutionary.'[20] Apparently, any radical departure
seemed anarchical to even the most liberal Establishment. Frank
Rutter fully recognized these radical connotations when he
called his defence of Post-Impressionism *Revolution in Art*, and
so did Wake Cook when he attacked this revolutionary art in
his letter to the *Pall Mall Gazette* two days after the Post-
Impressionist exhibition opened.

Cook's remarks show to what extent Post-Impressionism
seemed, in 1910, to be part of those violent tendencies threaten-
ing to shatter English society. 'The later decadent movements
[ie, Post-Impressionism] are the exact analogue to the Anarchist
movements in the political world,' Cook wrote. 'These experi-
menters on the innocence of the public are such insensate
revolutionists that they would rebel against freedom, force an
open door with dynamite, and having nothing else to revolt
against, they fight the demand for good work, competent crafts-
manship.' Cook then elaborated upon his analogies of political
stability and 'competent craftsmanship' by arguing that the art
academies act as 'Senates in politics, or as Unionism offering a
barrier against the reckless haste of Socialism in a hurry and
against the criminal Anarchism which accompanies Socialism
like its shadow.'

In 1910, Cook's readers undoubtedly interpreted 'Senates' to
mean 'House of Lords,' which was then the beleaguered bastion
of Toryism, soon to have its traditional powers drastically
diminished by the Parliament act. The reference to 'Unionism'
made Post-Impressionism akin to Irish home rule and other
Tory anathemas, and so, again, geared the artistic response to
the political one. The fact that 'Unionism' as represented by
Carson and the Orangemen of Ulster threatened to contravene
all traditional, parliamentary procedures and throw Britain into
something very like anarchy, was not, presumably, Cook's
point. Emotional ties to Unionism and Academism were

26

stronger than the demands of logic, and now traditional art forms appeared to be as violently under attack as the House of Lords and the principles of Unionism. It was almost as if Cook had uncovered at the Grafton Galleries, not paintings and sculpture, but a cache of anarchist pamphlets and bombs.*

As might be expected, charges of immorality and anarchy made the exhibition all the more popular. Desmond MacCarthy had overheard reporters at the press viewing tossing out remarks like 'pure pornography' and 'admirably indecent,' and the public was quick to pick up suggestions of something risqué at the Grafton Galleries. 'Every day the exhibition of the Post-Impressionists is crowded,' the *Daily Graphic* (12 November 1910) reported, and shortly after the exhibition closed the *Art Journal* (February 1911, p 60) stiffly commented, 'Cordial dislike for the efforts of this band of artists has been expressed by many people who have visited the Grafton Galleries, and not a few have used words of absolute condemnation. Nightmare art, as it has been called, is good as a sensation, however, and the show has been well attended.' Attendance at the exhibition set a record for the Grafton Galleries, and, 'The sales,' said Clive Bell, 'were more than satisfactory.' Beyond that, Bell wrote, 'From all over the country came requests for reproductions, lectures and books about modern painting ... Galleries and museums in which were to be found collections of the primitive and exotic were frequented; and directors of ethnographical departments were perplexed by an influx of lively and inquisitive visitors ...' From the point of view of its defenders, the exhibition was, as Bell put it, 'a prodigious success.'[21]

While it is no doubt true, as the *Art Journal* claimed, that 'the public treated the show as a jest,' many young artists and art students took it much more seriously. They discovered Frank Rutter was right when he insisted that 'art in Paris had entered upon a stage practically unknown to us in Britain,' and that much of the work in the Paris Autumn Salon of 1910 was 'like nothing ever seen in a British Art Gallery.'[22] But now it *had* been seen at the Grafton Galleries, and the impact was sudden and strong, especially among the students at the Slade, where

* Cook's political analogies, as applied to Post-Impressionism, were repeated in a letter to the *Morning Post* (19 November 1910), and echoed by Sir Philip Burne-Jones in his letter quoted above, and by the *Athenaeum* 4333 (12 November 1910) 598. Noting that the press viewing fell on Guy Fawkes' Day, Robert Ross compared the paintings at the Grafton to gunpowder in the basement of the House of Commons, and he called the exhibition part of 'a wide-spread plot to destroy the whole fabric of European painting.' (*Morning Post* 7 November 1910)

the consequences of the confrontation of liberal tradition and 'radical' departure were most evident.

The Slade was no den of black reaction. In fact, then at the height of its vitality, it attracted many of the most talented art students in England, including a number of the artists who became leading figures in the avant-garde between 1910 and 1914. Wyndham Lewis studied at the Slade from 1898 to 1901, Cuthbert Hamilton from 1899 to 1903, Helen Saunders from 1906 to 1907. At the Slade in 1910 were Edward Wadsworth (1908-12), C.R.W. Nevinson (1908-12), William Roberts (1910-13), and David Bomberg (1910-13). The 1915 Vorticist exhibition embraced all of these artists – though Nevinson and Bomberg did not exhibit as 'official' Vorticists. Also at the Slade in 1910 were Mark Gertler, Paul Nash, and Ben Nicholson, who did not, however, figure as prominently in the pre-war avant-garde as the Vorticists, Nevinson, and Bomberg.

Nor were the teachers at the Slade backward-looking academic artists. Frederick Brown, Henry Tonks (who succeeded Brown to the Slade professorship in 1917), and Wilson Steer were open to new developments in art – until Cézanne came along. Tonks set the tone ('Tonks was the Slade and the Slade was Tonks,' said Paul Nash),[23] and although he approved of and practiced Impressionist devices in painting, his strong emphasis was on drawing, structure, form, and modelling. While this emphasis on formal qualities could lead to exploration of something like 'pure form,' it was not intended to lead students away from realism. 'Realism,' writes Andrew Forge in his history of the Slade, 'or rather what MacColl calls "a belief in a logic of beauty coherent with natural effect," was the general conviction of [Frederick] Brown's generation. Nothing could replace the precious individuality of the "thing there"; it was from the artist's study of the natural world that all expression was to devolve.'[24] The draughtsmanship of Augustus John and the painterly effects of Walter Sickert pretty well set the limits for the Slade's brand of modernity.

After working within those limitations, the Slade students found Fry's exhibition to be a revelation. Almost overnight Fry rechannelled the main flow of dynamic art in England. Professor Tonks called Post-Impressionism a 'contamination' and urged his students to stay away from the exhibition, but soon the school was 'seething under [its] influence,' recalls Paul Nash, who was a Slade student at the time.[25] Symbolic of the impact of Post-Impressionism is a scene in Gilbert Cannan's novel *Mendel*, in which the artist-hero, a Slade student and strong draughtsman in the Tonks tradition, comes home from the Post-Impressionist exhibition and dashes off 'a savage mother with a

green face thrusting a straw-coloured breast into the gaping red lips of a child.'[26]

Cannan captured in a symbolic and vividly pictorial scene what the apologists for Post-Impressionism tried to explain more discursively. 'Canons and standards based on technical grounds alone,' wrote Frank Rutter, '... continually fail in application because they do not allow for, or underestimate the vital importance of the eye-opening capacity of an artist ... It is the weakness and cause of decay in academies that they place over-much importance on what are really superficial qualities, qualities which are arid and barren without a vivifying influence underneath.'[27] Discarding 'canons and standards' brought on several drastic changes. One was a trend toward greater simplicity. The artist now 'begins to try to unload, to simplify the drawing and painting, by which natural objects are evoked ...' said Desmond MacCarthy in his unsigned introduction to the exhibition catalogue. Another member of the committee, the painter and director of the National Portrait Gallery, C.J. Holmes, made the same point. One of the outstanding Post-Impressionist qualities, Holmes wrote in his *Notes On the Post-Impressionist Painters*, was 'rigid simplification ... in which the means of expression are reduced to line and colour, unbroken (or practically so) by shadows or by attempts at surface modelling'[28] – which is the same point Meier-Graefe had made about Manet's 'recognition of painting as flat decoration.' Simplifying the work inevitably led to more emphasis on decorative qualities, or what MacCarthy's introduction to Post-Impressionism called 'synthesis in design; that is to say, [the artist] is prepared to subordinate consciously his power of representing the parts of his picture as plausibly as possible to the expressiveness of his whole design.'

The danger in simplifying is that it could lead to 'baldness, emptiness or childishness,' as Holmes put it. But the equation with children's art, and with 'savages' ' or primitive art, which the opponents of Post-Impressionism never tired of making, was repeated as praise by the movement's supporters. 'Primitive art, like the art of children,' wrote MacCarthy, 'consists not so much in an attempt to represent what the eye perceives, as to put a line round a mental conception of the object.' That happy phrase seemed to justify any deviation from 'the thing seen,' since it placed the source of the picture not in nature, but in the individual thought and feeling of the artist. This effectively cancelled any reference to nature as a necessary criterion for evaluating art. Instead, design, synthesis, decorativeness, and such undefinable qualities as 'rhythm' and 'harmony' took the place of 'realism' in the artist's conception of his work. In a lecture given

at the closing of the Post-Impressionist exhibition, Roger Fry said, 'Particular rhythms of line and particular harmonies of colour have their spiritual correspondences, and tend to arouse now one set of feelings, now another. The artist plays upon us by the rhythm of line, by colour, by abstract form, and by the quality of the matter he employs.' The artist may, of course, employ recognizable images, Fry admitted, but he must not break the picture's 'rhythm,' which is 'the fundamental and vital quality of painting, as of all the arts.'[29]

Many of the arguments presented by Fry, Rutter, MacCarthy, and Holmes did not originate with them, but were extensions and revisions of arguments already advanced in England by Pater, Whistler, the defenders of Impressionism, and the New English Art Club, and even by the Slade, where required reading for the students was John Fothergill's essay on drawing in the *Encyclopaedia Britannica*. There Fothergill attacked 'literary content' as a determining criterion for a work of art, and took, instead, a more formalist approach by emphasizing 'beauty of form' as the goal of drawing.[30]

But, unlike their predecessors, who could write about the School of Giorgione, or a Whistler 'nocturne,' or an Impressionist treatment of everyday life by Sickert, the apologists for Post-Impressionism had to talk about Cézanne, Gauguin, Van Gogh, Seurat, Matisse. To talk about 'rhythm' and 'harmony' in a Renaissance masterpiece was one thing, to apply the same criteria to a Gauguin Tahitian scene was another, and called for new twists in the critical vocabulary inherited from the post-Ruskin critics. Fry, Rutter, and the others did not always present their case very convincingly, and often their writings, not the pictures, served to advance the arguments of critics hostile to Post-Impressionism. At the same time, however, their proselytizing (which enraged staunch opponents like Professor Tonks) undoubtedly helped the younger artists get their bearings on this new art movement. However clouded the critical controversy became, the pictures, themselves, existed in their own right. That fact, with or without theoretical garnishing, gave heart to the young artists who were ready to rebel against academic standards, and even against the liberal standards of the Slade.

The Slade's commitment to 'the thing there' was not calculated to make the most of 'rigid simplification,' 'synthesis in design,' or putting 'a line round a mental conception of the object.' And Tonks would make no compromises: 'I cannot teach what I don't believe in,' he told George Moore. 'I shall resign if this talk about Cubism doesn't cease; it is killing me.'[31] He did not resign, however, and the man who admitted, 'I don't believe I

30

really like any modern development,' became, as Andrew Forge called him, 'the Slade's implacable super-ego.'[32] A chasm now separated the Slade teachers and their liveliest students. The 'liberal' position of the Slade became irrelevant in the face of the 'radical' art brought to London by Roger Fry, and it only remained for the Vorticists to make the schism final by putting Tonks' name at the end of a patronizing list of amusing and passéiste products of English culture:

> SO MUCH VAST MACHINERY TO PRODUCE
>> THE CURATE of "Eltham"
>> BRITANNIC AESTHETE
>> WILD NATURE CRANK
>> DOMESTICATED POLICEMAN
>> LONDON COLISEUM SOCIALIST-PLAYWRIGHT
>> DALY'S MUSICAL COMEDY
>> GAIETY CHORUS GIRL
>> TONKS[33]

'Radical' or 'revolutionary' seem the only adequate description for the new attitudes encouraged among young English artists by Post-Impressionism. One correspondent to the *Nation*, Michael Sadler, put his finger directly on the problem. Augustus John, he said, had simplified his art and achieved the fresh vision of the primitives without, like the Post-Impressionists, going too far: 'He is a development, whereas Post-Impressionism is an open breach.'[34] Exactly: liberal 'development' confounded by radical 'breach.' When the radicals take over, the Slade joins the Academy in the revolutionary tumbrils. John and Sickert become, in one stroke, useless. For, the Slade's standards could no more accommodate a Gauguin or a Matisse, than Asquith's Liberal government could accommodate an Emmeline Pankhurst or a Sir Edward Carson. 'Canons and standards' collapsed.

They collapsed in spite of the *Art Journal*'s premature report that, 'The Post-Impressionists at the Grafton Gallery caused a commotion, but their cries did not decoy many from the path of safety: artists ... were not sympathetic and the public treated the show as a jest.'[35] They collapsed in spite of the convictions voiced by Sir William Richmond, and undoubtedly held by many: 'For a moment there came a fierce feeling of terror,' Sir William wrote of his visit to the Grafton Galleries, 'lest the youth of England, young promising fellows, might be contaminated here. On reflection, I was assured that the youth of England, being healthy, mind and body, is far too virile to be moved, save in resentment against the providers of this unmanly show.'[36] To which Lewis Hind replied, 'Sir William would be astonished at the number of British artists and others who have been stimu-

lated and regenerated by [the Post-Impressionist exhibition] ...
and in whom it has bred discontent with their own productions,
the first step in growth.'[37] A reporter for the *Daily Graphic* (10
December 1910) perceived in the crowds who continued to
come to the Grafton Galleries, a lessening of ridicule: now
more 'come to scoff and remain to think.'

Among a small group there was great enthusiasm for this new
art, a development that surprised even Roger Fry himself. Re-
porting on a lecture he delivered at the Leicester Gallery while
the Post-Impressionist exhibition was still open, Fry wrote, 'The
gallery packed, crowds standing all the time and an extraordin-
ary interest. It's really very odd and sometimes frightens me.'[38]

32  What was frightening, presumably, was not the interest, per se,
but the enthusiasm with which these crowds trampled 'develop-
ment' underfoot as they threw themselves into the 'breach' of
revolutionary art. Perhaps Fry was also frightened by intima-
tions, like Virginia Woolf's, that beneath this enthusiasm was
a profound change in human character.

In any case, soon it became clear that the Post-Impressionist
exhibition of 1910 was not a climax, but a beginning, an open-
ing in the walls of both academicism and popular indifference,
through which renewed and more violent shocks would soon
assault the English art world. As early as January 1912, D.S.
MacColl, who had once been in the vanguard as a defender of
Impressionism and the N.E.A.C., now complained that, 'Three
months [after the Post-Impressionist exhibition closed], I found
the new religion established, the old gods being bundled without
ceremony into the lumberroom, and the ardent weathercocks of
the Press pointing steadily for the moment into the paulo-post-
futurum.'[39] MacColl's bitter observation was cheerfully sup-
ported by Clive Bell, who wrote in October 1912, 'Happily,
there is no need to be defensive [about Post-Impressionism].
The battle is won. We agree, now, that any form in which an
artist can express himself is legitimate, and the more sensitive
perceive that there are things worth expressing that could never
have been expressed in traditional forms.'[40]

However, even Bell felt some disquiet when, a year later, he
looked at some of the fruits of Post-Impressionism's victory at
the 'Post-Impressionists and Futurists' exhibition at the Doré
Gallery. Some English artists, it now seemed to him, had ex-
changed academic for Cubist and Fauvist formulas, and the
result was 'certain simplifications, schematizations, and tricks
of drawing, not as means of expression and creation, but as ends
in themselves ... One is constantly confronted at the Doré Gal-
lery by a form or a colour that is doing no aesthetic work at all;

it is too busy making a profession of faith; it is shouting, "I am advanced – I am advanced." '41*

For many serious young artists – in spite of Bell's remarks – becoming 'advanced' was not an easy thing. C.R.W. Nevinson, for instance, recalled in his autobiography 'the worry, the doubts, which this form of technique [ie, Cubism] gave rise to. I felt the power of this first phase of Cubism and there was a desire in me to reach that dignity which can be conveyed pictorially by the abstract rather than the particular.'42 Young artists, sensitive to the collapse of 'canons and standards' in art, could not resist the powerful current of new art channeled into England by Fry's Post-Impressionist exhibition. 'It cannot be denied,' Nevinson added, 'that the whole of this movement was opening out a new direction of aesthetic intention.' William Roberts agreed: 'We must remember, too, that this was an age of Impacts, and English artists were experiencing the combined impact of Cézanne, Van Gogh, Gauguin, Picasso, and the rest of the French Cubists, besides the Italian Futurists with their manifestos.'43 It is hardly surprising, or reprehensible, to find young, developing artists, who had been denied the opportunity to watch the evolution of Post-Impressionism, and so came upon it at its dazzling height, suddenly begin to reproduce the effects of a Gauguin, a Picasso, or a Matisse in their own work. 'The younger generation hastened to make up for lost time,' Frank Rutter wrote later, 'and in a year or two London had painters as "wild" as any in Paris.'44

By 1912, when Fry organized his second Post-Impressionist exhibition for the Grafton Galleries, it was possible to discover an 'English group' comparable in intention, if not execution, to Cézanne, Rousseau, Matisse, Picasso, Braque, Derain, and others of the most recent Paris schools who appeared in the exhibition. That English group consisted of Bernard Adeney, Vanessa Bell, Frederick Etchells, Jessie Etchells, Roger Fry, Eric Gill, Spencer Gore, Duncan Grant, Cuthbert Hamilton, Henry Lamb, Wyndham Lewis, Stanley Spencer, and Edward Wadsworth. 'Simplification and plastic design' characterized the work of these artists, Clive Bell wrote in the exhibition catalogue, and he noted that, while Wyndham Lewis produced the most abstract work, none of the group depended on anecdote or

---

* The fact that the exhibition's organizer, Frank Rutter, was not in the Fry-Bell circle, and that he was, to some extent, an ally of Wyndham Lewis and other defectors from Fry's Omega Workshops, may have led Bell to criticize more harshly the same artists who had appeared with Bell's approbation in Fry's exhibition the year before.

literary association for his effects. Two years earlier, Fry would have searched in vain for a representative group of English artists who showed they were learning the lessons of Post-Impressionism. Now Bell could proclaim, 'The battle is won,' and Virginia Woolf observe that Post-Impressionism had become 'all the rage' among the sophisticated.[45]

The ranks of the English avant-garde continued to swell and, as they did, the label 'Post-Impressionism' became less and less useful to describe the many manifestations of the new spirit in the arts. Hence Frank Rutter's title 'Post-Impressionists and Futurists' for the large show he organized for the Doré Gallery in the fall of 1913. In that exhibition, along with the Old Masters of Post-Impressionism and younger continental artists, Rutter included some of the previous year's 'English group' – Gore, Hamilton, Lewis, and Wadsworth – and added Jacob Epstein, Charles Ginner, Harold Gilman, C.R.W. Nevinson, Walter Sickert, and Alfred Wolmark. Although John Cournos complained that 'there is a little genius and much insolence' in the exhibition, and echoed Clive Bell's feeling that some artists had simply learned formulas for 'cubes,'[46] the fact remained that within three years a new generation of English artists had emerged and advanced far beyond the John-Sickert boundaries.

Like Unionist meetings and suffragette outrages, the public displays of avant-garde art became more and more numerous as the general temper of rebellion mounted in the months before war broke out in 1914. December 1913 saw Lewis, Nevinson, Etchells, Hamilton, Wadsworth, Epstein, Roberts, and Bomberg exhibiting together in the 'Cubist Room' of an exhibition at Brighton. The first London group exhibition in March 1914 included virtually every avant-garde artist in England, and many of them – especially the 'Cubists' – appeared as well in the 'Twentieth Century Art' exhibition at the Whitechapel Gallery in May, and at the Allied Artists' 'Independents' exhibition in June. In July David Bomberg presented a one-man show at the Chenil Gallery, with an almost totally abstract painting, *The Mud Bath*, hanging like a banner of victory outside the gallery door. (plate 9) By then, *Blast* had appeared with reproductions of what now became known as 'Vorticist' art, and with manifestos and literary counterparts of the painting and sculpture.

Less than four years after 'Manet and the Post-Impressionists,' the English art world had absorbed the violent, uncompromising temper of the times, and taken on nearly all the attributes of a revolutionary social movement: theorists and activists, swelling ranks of adherents, heavily attended public demonstrations in the form of lectures and exhibitions, plentiful publicity – good and bad – and an opposition associated with the status quo

and Establishment reaction. Separate, mutually suspicious groups had begun to form, and all that remained was for one group to attempt to seize the banner, issue a manifesto, and proclaim itself the true embodiment of the revolution. In July 1914, with the publication of *Blast*, the Vorticists made that attempt, but only after a number of other developments had brought that particular manifestation of the revolution in art to the forefront.

# London's New Bohemians

*She was a Philistine spick and span;*
*He was a bold Bohemian.*
*She had the* mode, *and the last at that;*
*He had a cape and a brigand hat.*
*She was so* riant *and* chic *and trim;*
*He was so shaggy, unkempt and grim ...*
*She was a triumph at Tango teas*
*At Vorticist suppers he sought to please.*

Although Robert Service had Paris in mind for his ballad, 'The Philistine and the Bohemian,'[1] London could have served as well. As London's avant-garde artists made their appearance after 1910, they brought with them the life style of their Parisian contemporaries. The café became an increasingly important locus of artistic and intellectual activity, and, at the same time, there was a shift toward something like the 1890s preference for coteries. 'Bohemianism' revived with the cafés and coteries, and, at the outset, good humour and bonhomie prevailed.

Richard Aldington remembered the period as 'an epoch comparatively free from fanaticisms, so that I had the experience of meeting human individuals and not merely embodied opinions.'[2] This was the genial world evoked by Ford Madox Ford, where 'friendships, enthusiasm, self-sacrifice, mutual aid' followed from the comradeship of avant-garde movements,[3] and where salons, studios, and cafés were as essential to an artist's life as ideas, pictures, sculptures, and books. In William Roberts' memory, '*la cuisine Française* and Vorticism are indissolubly linked,' and Roberts notes, quite correctly, that the opening pages of *Blast* 'have the gusto of a tavern song.'[4]

The bohemian, café life of London lightened the tone of personal relationships, undercut solemnities, opened new possibilities, and let fresh currents of art and ideas flow through the Vortex of London life. Vorticism would have been quite dif-

ferent if it had not absorbed and reproduced in its own way the life of pre-war London's bohemians.

The stereotype assiduously perpetuated by journalists and fiction writers is perfectly familiar today: 'The artists are as quaint as their pictures. They look a cross between the last word in "knuts" [the 1914 slang for ultra-fashionable young men-about-town] and the first word in the students of the Quartier Latin of a quarter century ago. They rejoice in being impossible, inconsequent, and incoherent ...';[5] 'a crowd of dirtyish, bearded, slouch-hatted individuals, like conspirators ...';[6] 'white-faced, longish-haired, dyspeptic-looking men' and 'eccentric ladies with long bare necks, false curls, enamelled faces, restless eyes, provocative hats, and sensational frocks.'[7]

38

Here were London's new bohemians. Some came from the Slade: the girls in long, loose dresses, wearing their hair in 'top knots,' and occasionally adding outlandish touches, such as one red and one blue shoe (as Nina Hamnet remembered a friend of Mark Gertler doing),[8] the men in capes and wide-brimmed 'Latin Quarter' hats, and some, like the 'Slade coster gang' recalled by C.R.W. Nevinson, dressed in 'black jerseys, scarlet mufflers and black caps or hats.'[9] In reaction against the Romantic capes and sombreros, a few artists, like the Italian Futurists on their periodic invasions of England, dressed in dark business suits – a mode Wyndham Lewis adopted in 1914, and tried to impose on the artists regularly in attendance at the Rebel Art Centre. He could do nothing with Ezra Pound, however, who might appear in 'trousers made of green billiard cloth, a pink coat, a blue shirt, a tie painted by a Japanese friend, an immense sombrero, a flashing beard cut to a point, and a single, large blue earring.'[10] Poverty made a few, like Henri Gaudier-Brzeska, bathe seldom and dress like the poorest labourers.

Although often they seemed to flaunt their pennilessness – at the Café Royal those who couldn't pay for their drinks were likely to act particularly arrogant toward those who could – many of the young artists were, in fact, very poor, and there was no dole to help them out. According to H.S. Ede, Gaudier-Brzeska earned £47.19s between October 1913 and March 1914, which left him, after costs for stone, tools, studio, and exhibitions were paid, less than £5 a month to support himself and Sophie Brzeska.[11] Ezra Pound and his wife lived on £40. 10s from October 1914 to October 1915.[12] One way or another, however, the artists survived, and for most of them *la vie bohémienne* was good.

It also made good copy for newspapers. 'The leaders of the

new movement, be it painting or music or literature, are para-
graphed daily, their eccentricities detailed, and their photo-
graphs scattered broadcast ...' John Rodker told the readers of
the *Dial Monthly* in 1914.[13] 'The painter could really become a
"star" ...' Wyndham Lewis said. 'Pictures, I mean oil-paintings,
were "news." Exhibitions were reviewed in column after col-
umn. And no illustrated paper worth its salt but carried a photo-
graph of some picture of mine or of my "school" ... or one of
myself, smiling insinuatingly from its pages.'[14] Not only Lewis
and his 'school,' but Nevinson (whose Futurist paintings were
particularly popular subjects for reproduction in newspapers),
Bomberg, Epstein, Roger Fry, Ezra Pound, and others were
interviewed and given good coverage in newspapers and popular
magazines. Readers of the popular press came to expect head-
lines like the following.

FREAK PICTURES

FUTURISTIC PUZZLES

ART THAT ALARMS

THE CONFETTI SCHOOL OF PAINTING
Everybody's Family Portraits on
One Canvas

THE LATEST OUTBREAK
Alleged That Business Men Are
Buying These Things

REBEL ART

MR. BOMBERG'S FUTURIST BOMBSHELL

SHOCKING ART
Pictures Designed
To Jolt the Senses

Such headlines, accompanied by facetious descriptions of paint-
ings and, occasionally, clumsy attempts at parodies of the new
art, became standard fare in the popular press. While the pub-
licity undoubtedly made the new artists better known, it created
a charged atmosphere in which the search for the 'latest thing'
led popular attention right past aesthetic considerations and on
toward bigger and better 'shocks' and 'bombshells.'

This sort of publicity did not, as some critics charged, produce
a multitude of insincere, notoriety seeking, fake avant-gardeists.
(There is no reason to believe that artists who experimented
with new styles of expression were any less sincere than artists
who stuck to the old ones. Certainly the latter, at least in 1910-
14, were more likely to earn a good living.) What the headlines,
reports, photographs, and interviews did, however, was to pro-
mote a certain inescapable feeling – shared by artists and public

alike – that avant-garde movements must catch the public eye quickly and effectively, because they are essentially as ephemeral as today's headlines.

The journalistic approach not only emphasized ephemerality and art's 'shock value,' it also imposed a conventional shape on movements: there had to be leaders and followers, rivalries, defections, and then new leaders and followers. The metaphorical implications of 'avant-garde' turned art movements into battles, advances and retreats, victories and defeats. Suddenly artists became old veterans or new recruits, and they were expected to 'fight for' some ism that could be reduced to a simple common denominator like the 'cube' or the 'Vortex.'

40      While the popular press helped create the public image of the avant-garde movement as we know it today (no such image existed until there *was* a popular press), the avant-garde, in effect, endorsed the headline approach by producing leaders and followers, schisms, dogmas, and common denominators that suited the journalistic formulae. The Futurists, who were most adept at exploiting the mass media of the day, paved the way for the Vorticists, who got instant publicity by publicly attacking Futurism. Under headlines like 'FUTURIST SQUABBLES,' 'THE FUTURIST SPLIT,' 'REBELS IN ART,' and, simply, 'VORTICISM,' the Vorticists' emergence on the avant-garde scene was suitably announced to the public.

Then, going the press one better, the Vorticists offered, in place of figurative 'bombshells,' a literal *Blast*, with its own headlines bigger and bolder than the newspapers dared print:

BLAST FIRST (from politeness) ENGLAND

OH BLAST FRANCE

CURSE

WITH EXPLETIVE OF WHIRLWIND

THE BRITANNIC AESTHETE

THE MELODRAMA OF MODERNITY

THE GOD OF SPORT AND BLOOD

What started as journalistic exploitation of the avant-garde ended as just the reverse. In paying the compliment of imitation, the Vorticists beat the press at its own game. But in a larger sense they won no victory. By committing their movement to a journalistic stereotype, the Vorticists suffered from its inevitable ephemerality. Once they had become 'the latest thing' and 'all the rage,' they could only suffer the fate of every fad, and fade away with yesterday's news.

The faddishness of the avant-garde gave the new artists more leg room than they might otherwise have had. Their attitude, said the London *Star*, could be summed up as ' "We are the fad

of the moment. The newspapers may ridicule us, but Society is falling at our feet ..." ' Society was, indeed, beginning to take notice of the new movements and their leaders. 'In a few houses,' Osbert Sitwell recalled, 'the discovery had been made that life could be more enjoyable if you surrounded yourself with intelligent people, or at least admitted one or two to panic the assembled herds.'[15] Clive Bell observed the same social phenomenon: 'To be open-minded became modish; people with interesting, subversive things to say were encouraged to talk – always provided they talked with an air of not taking quite seriously what they said ... One or two fine ladies had made open-mindedness and a taste for ideas fashionable: *snobisme* was doing the rest.'[16]

C.R.W. Nevinson happily records in his autobiography that during his 'rebel artist' period he dined at the homes of Lady Cunard, Lady Lavery, and Lady Constance Hatch.[17] When *Blast* appeared, its serio-mocking pronouncements became the subject of conversation in the most fashionable homes of Belgravia, and its editor lunched with Prime Minister Asquith, whose wife might have been one of the 'fine ladies' Clive Bell had in mind.[18]

Not only avant-garde artists, but their art, began to find welcome in the homes of the well-to-do. The *Daily News* (7 April 1914) noted that, 'The Cubist spirit is penetrating society, even to the extent of Cubist patterns in the gowns of the coming summer.' Roger Fry encouraged and capitalized on society's interest in the new art movement by opening the Omega Workshops in July 1913 to sell items designed and decorated by avant-garde artists. To own an Omega chair, table, rug or bowl became fashionable among people whose taste ran ahead of the times, and the Omega artists found themselves providing all manner of home furnishings, clothing, and trinkets for very important people.

The Omega counted among its supporters the Duchess of Rutland, Lady Diana and Lady Margery Manners, Lady Tree, Madame Vandervelde, wife of the Belgian ambassador, Lady Ottoline Morell, Lady Desborough, Lady Cunard, Countess Drogheda, and Princess Lichnowsky, wife of the German ambassador. On the Omega's special 'Art Circle' evenings, its show rooms became a gathering place for wealthy patrons of the arts. They paid ten shillings to mingle with artists, hear recitals by guest musicians, watch puppet shows designed and presented by Omega artists, and consume tea, coffee, lemonade, petits fours, and sandwiches made of Gentleman's Relish, and served by members of the Workshop.[19]

Omega interior decoration schemes appeared in several im-

portant houses, and the renegade Omega artist, Wyndham
Lewis, achieved some fame by decorating the dining room of
Countess Drogheda's house at 40 Wilton Crescent, in the heart
of Belgravia. Lewis painted a frieze, a chevron-pattern border
around a mantelpiece, and a panel over a doorway, all in austere
abstract designs lightened by the addition of vermillion, red,
green, and other vivid hues. The effect was usually called Fu-
turist or Cubist, because the term Vorticist had not been in-
vented yet.

The press reported the event. Four photographs of the decora-
tions appeared in the *Sketch* (4 March 1914) under the heading
'Lady Drogheda's Futurist Dining-Room.' Printed invitations to
a private viewing read, 'You are invited to view the Dining
Room at the above address, by kind permission of the Earl and
Countess of Drogheda, to see the Frieze Painting and a small
collection of Drawings by Mr. Wyndham Lewis, Thursday, Feb.
26th, Hours, 3 to 7.' A good many people came, according to a
typed press release, which began, 'The Countess of Drogheda
threw open her house at 40 Wilton Crescent to-day for viewing
of the Cubist Room just completed by Mr. Wyndham Lewis,'
and went on to provide a long list of notables who appeared,
including the Greek minister, the Chilian minister, and the wife
of the American ambassador.[20]

Mixing avant-garde art and high society did not necessarily
create enlightenment, or promote better art. Ezra Pound's 'Lady
Valentine' (in the 'Hugh Selwyn Mauberley' sequence) epito-
mized the society woman who used modern art to blend social
strata and 'catch the Lady Jane's attention.' Pound bitterly re-
sented the snobbishness that embraced *Blast* but would not
reward, or even find work for, the poverty-stricken Gaudier-
Brzeska. 'When Gaudier was too poor to buy stone,' Pound
wrote in 1920, 'he would gladly have made door-heads and
capitals, and no man offered him a stone door-post.'[21] And
Wyndham Lewis knew that saying 'subversive things' was per-
fectly safe in the sheltered gentility of pre-war London: ' "Kill
John Bull With Art!" I shouted. And John and Mrs. Bull leapt
for joy, in a cynical convulsion. For they felt as safe as houses.
So did I.'[22]

Like publicity in the press, this sanctioned rebelliousness en-
couraged the rebel artists to go further. If John and Mrs Bull
wanted to be shocked, the avant-garde would try harder to be
shocking. When the Vorticists got their chance, they shouted
'damn' and 'blast' in public, ridiculed everything their elders
took seriously, and made a virtue of perversity by blasting the
Bishop of London and blessing the Pope; blasting Sidney Webb

42

and Annie Besant, and blessing Sir Edward Carson and Lillie Lenton; blasting the Post Office, Beecham's Pills, and the British Academy, and blessing the Salvation Army, castor oil, and all ABC tea shops. They joyfully played *enfants terribles* for the benefit of a shocked and pleased press and public.

More useful to the new spirit than the great houses and the columns of the press were the regular gatherings, the salons, soirées, 'at homes,' 'evenings,' and 'afternoons' that brought together avant-garde artists and their less advanced contemporaries and elders. In a studio at 19 Fitzroy Street, the Camden Town group helped establish the pattern with Saturday afternoon gatherings regularly attended by Walter Sickert, Spencer Gore, Lucien Pissaro, Augustus John, Harold Gilman, and other painters who showed their latest work there and entertained their friends. That tradition of Saturday afternoon showings and friendly gatherings continued – with different participants – at the Rebel Art Centre during its brief life in 1914, and at Wyndham Lewis's Fitzroy Street studio, where William Roberts remembered assembling with other rebel artists 'on Saturday afternoons, usually about tea time.'[23] Lewis, who was not noted for his gregariousness, complained to a friend, 'The Saturdays are becoming so popular that I soon shall have to extend my premises. People come to drop cigarettes and shuffle their feet all over my carpet.'[24]

One of these sessions produced the long list of persons and things blasted and blessed in the Vorticist manifesto. According to Douglas Goldring, who was there, those present included Lewis, Ezra Pound, C.R.W. Nevinson, William Roberts (who wore a black hat and 'endeavoured to look "tough" '), and 'the oddest collection of *rapins* in black hats, girls from the Slade, poets and journalists.'[25] Everyone contributed names, and, when *Blast* appeared, its list of suffragettes, Ulsterites, boxers, aviators, actresses, actors, philosophers, music hall entertainers, writers, painters, critics, clergymen, and all manner of public figures and private friends, provided as complete a catalogue as could be found anywhere, of what occupied the avant-garde minds of pre-war London. (See pages 167-72 and appendix B)

Pound held his own 'evenings' in his small flat at 10 Church Walk, Kensington, where his Imagist associates, Richard Aldington, H.D. (Hilda Doolittle), and F.S. Flint were among the most frequent guests. At one of Pound's 'evenings,' Florence Farr read from proof sheets of Tagore's first volume to appear in England. Less exotic fare drew the avant-garde to two of the most popular gathering places of the pre-war years: South Lodge, the Kensington villa of Violet Hunt and Ford Madox

Ford, and 67 Frith Street, a seventeenth century house in Soho Square containing the apartments of Mrs Ethel Kibblewhite, whose Tuesday evening salon was presided over by T.E. Hulme.

At South Lodge, an abstract decoration by Wyndham Lewis over the mantelpiece in Ford's study, and a large white marble hieratic head of Pound by Gaudier-Brzeska in the garden, symbolized Ford's special affinity with the Vorticists. Pound presided at South Lodge tennis parties, and his presence, as well as Ford's invitations, attracted such rising stars of the avant-garde as Aldington, H.D., Epstein, Rebecca West, W.L. George, D.H. Lawrence, Gaudier-Brzeska, and Wyndham Lewis. *Les jeunes* (as Ford liked to call them) often found themselves in the company of older and more famous figures like Yeats, Lady Gregory, H.G. Wells, and R.B. Cunninghame-Graham, and occasionally Violet Hunt's invitations would bring in Lady St Helier or Lady Mond or other leaders of society who, as Ford's biographer, Frank MacShane, put it, 'could be counted on to make a new movement fashionable.'[26] At South Lodge parties, Ford told Lewis, there were 'generally some of the swell and wealthy, together with literary gents and picture buyers and people who help on MOVEMENTS.'[27] These practical advantages as well as the mutually stimulating company brought *les jeunes* to South Lodge and transformed it from an Edwardian enclave in Georgian London to a centre for the avant-garde.

Hulme's Tuesday 'evenings' were at least as lively as the South Lodge parties. If anything, they were more widely attended, and offered the same opportunities for young writers and artists to meet 'literary gents and picture buyers.' Imagists, Georgian poets, avant-garde painters and sculptors, editors, and critics mixed freely with, to quote C.R.W. Nevinson, 'politicians of all sorts, from Conservatives to *New Age* Socialists, Fabians, Irish yaps, American bums, and labour leaders such as Cook and Larkin.'[28] The conversation often followed Hulmean lines of interest: Bergson, Sorel, modern art, and particularly the experimental work of Epstein and other 'Cubists' in England. Much of what Hulme wrote on art for the *New Age* got its first airing at the Tuesday salon.

More bohemian soirées took place in Stuart Gray's big house on Ormonde Terrace at the bottom of Primrose Hill, Hampstead. Gray, a solicitor who had given up the law to devote his time to socialism and the arts, later helped organize and lead the 1932 Hunger March from Manchester to London. In 1914 artists, anarchists, and anyone else badly in need of a bed could find free lodging at Gray's house. David Bomberg and William Roberts, among others, stayed there for a time. A drawing by Roberts, *The Toe Dancer* (1914), shows Gray's wife dancing

at one of the Ormond Terrace soirées. (plate 3) In the rigidly stylized picture, a motley group of bohemians sit around three sides of a bare room, some watching and some ignoring, a bare-footed, half-dressed female figure performing a strange, primitive dance. In spite of a rather cold, satirical treatment, the picture conveys the sense of a secret world of avant-garde doings, upon which the public's imagination drew for its stereotype of the bohemian artist.

If soirées and salons were amusing and sometimes instructive to the avant-garde, cafés were essential. Everybody went out to dinner; everything had to stop for that. Cafés not only provided food but offered companionship and talk. South Lodge, 67 Frith Street, 19 Fitzroy Street, 10 Church Walk, and Ormonde Terrace were places to meet and talk, as well, but they had the disadvantage of not being public, and therefore not completely free from host-guest protocol. Cafés, since they were open to everyone, offered equal opportunity for privacy, intimate tête-à-tête, and general camaraderie.

Studios, the natural counterpart of cafés, were essential too, and good places to talk, but the pressure of unfinished work sometimes interfered, and friends' studios could be scattered about London – from Gaudier-Brzeska's studio under a railway arch in Putney, to the rows of identical Georgian buildings in Charlotte and Fitzroy Streets near the British Museum, to Cumberland Market (an old hay market with cobblestone streets and small houses with balconies, between Regent's Park and Euston), to Hampstead and Camden Town, to the long Caledonian Road and Brecknock Road stretching beyond Kentish Town. From all of these sections, the life of the studios crossed over and merged with the life of the cafés, the soirées, the salons, the parties in Mayfair. All of them influenced the style of avant-garde life in London. But most important were the cafés.

While a group from Mrs Kibblewhite's ate with Hulme at the Sceptre, Ford and friends from South Lodge might be at Lebers in Holland Park Road. Pound liked to introduce newcomers to Belloti's in Soho – 'the cheapest clean restaurant with a cook' in all London, Pound told Iris Barry;[29] while Lewis was partial to the Eiffel Tower in Percy Street off Tottenham Court Road, where the Viennese owner, Rudolf Stulik, welcomed all artists, but especially Lewis. 'I vould do anyting for Mr. Lewis,' he often told William Roberts.[30] Besides extending Lewis unlimited credit, Stulik let Lewis, assisted by fellow rebel artists, decorate a small upstairs dining room with Vorticist designs. Roberts also painted decorative panels for the Eiffel Tower, and used the

restaurant as the scene for his painting of the Vorticists celebrating the publication of *Blast*. (plate 6)

The Dieudonné, in Ryder Street, another café popular with the avant-garde, appears in Pound's Canto LXXVII nostalgically linked with two great Parisian cafes: 'Well, Compari is gone since that day. With Dieudonné and with Voisin ...' Ford Madox Ford less nostalgically described it in *No Enemy* as 'an underground haunt of prewar smartness ... with nasty foreign waiters and bad, very expensive champagne.'[31] A Vorticist dinner and an Imagist dinner occurred within two days of each other at the Dieudonné in July 1914.

46   Many of the same people came to both dinners, including the cigar-smoking, rotund American poetess Amy Lowell, who seems to have had a particularly hard time of it. John Cournos remembered the Imagist dinner (which was paid for entirely by Amy Lowell) as 'an uncomfortable affair' with, he felt, 'an undercurrent of hostility among the diners, and if not hostility, then condescension, toward the hostess.' Allen Upward gave a witty after-dinner speech based on an Amy Lowell poem about the poet bathing by moonlight, 'and he did it in such a way as to perturb and vex her puritanic soul,' said Cournos. 'The speech was long and throughout amusing, so that everyone at the table was shaking with laughter.'[32] At the Vorticist dinner Miss Lowell found herself subjected to the close scrutiny of Gaudier-Brzeska ('Gaudier's eye on the telluric mass of Miss Lowell,' Pound wrote in Canto LXXVII), and drawn into a heated argument with Ford Madox Ford. Nevertheless, 'The feast was a great success,' Pound reported, 'everyone talked a good deal.'[33] To James Joyce, Pound wrote, 'We have been having Vorticist and Imagist dinners, haciendo politicos etc. God save all poor sailors from la vie litteraire.'[34]

The strenuous life of the avant-garde went on elsewhere as well: at the Florence, in Rupert Street on the edge of Soho, where some of the rebel artists sponsored a dinner for Marinetti; the Dieppe, with its little tables and arbours decorated with flowers and cages of singing birds, some real and some mechanical; the Crabtree Club started by Augustus John and others in 1913; and less colourful places like Miss Ella Annette Abbott's tea shop in Holland Street near Pound's lodgings, and an ABC in Chancery Lane off Fleet Street, where Orage and a group of *New Age* staff met to read proof, discuss business, politics, and the arts. Hulme was often there, along with Aldington, Middleton Murray, Katherine Mansfield, J.C. Squire, Michael Arlen, Herbert Read, and Ezra Pound, who wrote music and art criticism for the *New Age* under the pseudonyms of William Atheling and B.H. Dias. The lively, often heated,

discussions that arose at these meetings helped give Orage's paper, as Alun Jones points out, 'its characteristic tone of lively and intelligent conversation.'[35]

The conversation could be equally brilliant at the Vienna Café in Oxford Street, the only 'continental café' in London, other than the Café Royal, said Wyndham Lewis.[36] Laurence Binyon and other members of the British Museum staff congregated at the Vienna, and it was there that Lewis first caught sight of Ezra Pound, an event preserved by Lewis in *Blasting and Bombardiering* and by Pound in Canto LXXX. Lewis planned to 'bless' the Vienna in the second issue of *Blast*, but, before that issue appeared, the café had closed, a victim of wartime anti-German sentiment. Lewis continued to go there until the end, defying that sentiment, and a friend who accompanied Lewis one evening remembered their being the only two customers in the place.[37] The café closed, to be replaced by a bank – it 'died into banking,' as Ezra Pound put it in Canto LXXX. Its passing is lamented in Canto LXXVII:

> in those days (pre 1914)
>> the loss of a café
>>> meant the end of a B.M. era
>>>> (British Museum era)

The British Museum, itself, was a centre and meeting place for artists and writers who had spent a few hours in the great domed reading room, or among the fragments of Grecian, Egyptian, Assyrian, Chinese, Oceanic, African, and other ancient and modern cultures of east and west. Artists were known to secretly check on each other's movements in the ethnographic rooms, like prospectors jealously guarding their 'finds.' It was said that the inspiration for Epstein's pair of white marble doves, one mounted on the back of the other, could be traced to a display of primitive carvings at the museum in which one bird had been set on another because of over-crowding in the display case. Some of the most vivid examples in Gaudier-Brzeska's Vorticist history of sculpture in *Blast* (the fetishes and love charms, the 'man-headed bulls in horizontal flight-walk,' 'The centuple spherical frog presided over the inverted cone that is the bronze war drum') can still be seen, where Gaudier saw them, in the British Museum.

The Museum was a centre in another sense. With the exception of outposts of activity in Chelsea, Hampstead, Kensington, Camden Town, and a few other parts of London, most of the avant-garde's gathering places were clustered in an area that could be defined as 'within reasonable walking distance of the British Museum': toward the west across Tottenham Court Road to the Eiffel Tower Restaurant in Percy Street; north up

Tottenham Court Road to Charlotte and Fitzroy streets and into Fitzroy Square, the site of the Omega Workshops; northeast to Russell Square and Woburn Place, where Yeats had rooms in the Woburn Buildings; east across Southampton Row, through the narrow Cosmo Place, past the Church of St George the Martyr into Great Ormonde Street, where the Rebel Art Centre was an avant-garde headquarters in the spring of 1914, and farther down Southampton Row to Theobald's Road where the Georgian poets and others gathered at the Poetry Book Shop opened by Harold Monro in January 1913; southeast through Bloomsbury Square to the Vienna in New Oxford Street; south down Charing Cross Road to Dan Ryder's Book Shop in St Martin's Court, where Gaudier-Brzeska's drawings were on sale and Frank Harris held court in a curtained-off section at the back; and southwest to Mrs Kibblewhite's and Soho cafés, the Dieppe, Belloti's, the Swiss, the Sceptre, and beyond, to Regent Street and the Café Royal at 68 Regent Street and the Cave of the Golden Calf, just off Regent Street in Heddon Street.

From theatres, music halls, salons, studios, and other cafés, people came to the Café Royal. Amid Edwardian splendour of mirrors, cut-glass chandeliers, gilded caryatids, painted ceilings, marble-topped tables, and red plush benches, the famous and obscure, the artists, 'knuts,' and unaccompanied women smoking cigarettes in public and dressed in 'freakishly sensational' costumes, all felt equally at home. Surveying the cafe at the beginning of the war, M.J. Woddis found it 'more startlingly Bohemian' than ever, and the 'spirit of camaraderie ... very strong.'[38] Douglas Goldring noticed that, 'If a "new Movement" was started on the Continent, the Café Royal was always the first place to hear of it and to "produce" it in England.' People came to regard the Café Royal as a 'spot from which new movements in art really sprang,' said Goldring, 'whereas in point of fact, it was only a centre from which they were exploited.'[39] Goldring insists on too sharp a distinction between originating and exploiting new movements. The new spirit was in the air, and the Café Royal helped bring it to earth. If that spirit had wafted across the channel, instead of springing up within the British Isles, there was no reason to imply that the English adaptations were artificial or unimportant.

For all its startling Bohemianism, the Café Royal, like a faded *grande dame*, had too much 'past.' The red plush and cut-glass were too reminiscent of Whistler, Oscar Wilde, Beardsley, and other luminaries of the recent past, and perhaps more suited to the bohemianism of Augustus John than of Wyndham Lewis. For a café conceived more in the spirit of *Blast* than of the

*Yellow Book*, London had the Cave of the Golden Calf, a large,
crowded basement at 9 Heddon Street, where continental cuis-
ine, gypsy music, ragtime, avant-garde art, and all the latest
'rages' mixed under the ministrations of August Strindberg's
second wife, Madame Frida Uhl Strindberg. Like practically
everything else connected with avant-garde movements, Ma-
dame Strindberg's Cave of the Golden Calf was well-publicized,
erratically run, torn by feuds, intensely active, and short-lived.

The frenetic avant-garde atmosphere of the Cave of the Golden
Calf could not be separated from the personality of Madame
Strindberg.[40] A tall, nervous, fiftyish woman dressed in black,
her haggard face disconcertingly decorated with a smear of
bright red lipstick never on straight, and dank, dark curls
pressed flat against her forehead, she was 'sinister but delightful,'
said Violet Hunt.[41] She seemed never to sleep, and indefatigably
edited a German-language newspaper and ran the Cave at the
same time. Her favourite expression, according to Wyndham
Lewis, was 'Je suis au bout de forces!'[42] Given to intense en-
thusiasms and histrionics, she seemed formidable or slightly
absurd to those on whom she turned her engulfing attention. 'I
admit,' wrote Augustus John in his autobiography, 'that the
sight of Mme. Strindberg bearing down on me in an open taxi-
cab, a glad smile of greeting on her face, shaded with a hat
turned up behind and bearing a luxuriant outcrop of sweetpeas
– this sight, I confess, unnerved me, even if I stood my ground.'[43]
Her effect on Wyndham Lewis, who generally did his best to
stay out of her way, can be guessed by the fact that on one
occasion he kicked her down a flight of stairs.[44] During the time
she tried to run the Cave of the Golden Calf, Lewis' physical
brutality was the least of her worries.

The Cave included a Cabaret Theatre Club, a kind of intel-
lectual alter ego to the earthy, nightclub frivolity of the Cave.
To announce its opening in the spring of 1912, Madame Strind-
berg sent out an elaborate eight-page brochure decorated with
drawings by Lewis (plate 4), and announcements were distri-
buted to the press by Austin Harrison, Spencer Gore, and Leon
Daviel as members of the Cabaret's executive committee. Gore
directed the decorations by 'leading young British artists,' as the
brochure put it, and Madame Strindberg brought in entertain-
ment from all fields of art.

Immediately, the Cave of the Golden Calf and the Cabaret
Theatre Club became a focal point for avant-garde activity.
Lewis designed a poster for it, and rented his large oil, 'Ker-
messe,' to Madame Strindberg to be hung on the stairway lead-
ing down from the street.[45] Lewis, Gore, and Charles Ginner

painted decorations on large canvasses attached to the walls to look like murals.* Epstein carved two white plaster caryatids, and Eric Gill made a golden calf. Cuthbert Hamilton and Lewis prepared a shadow play for presentation at the Cabaret Theatre Club. Lillian Shelley, one of the best known and most beautiful models of the day – 'a Botticelli-looking person, with strangely cut black hair, which is adorned with a golden-embroidered head-band, a perfect model of an Egyptian goddess'[46] – sang there and took Madame Strindberg's monkeys to the Savoy Hotel for 10:30 supper. Marinetti appeared and 'declaimed some peculiarly blood-thirsty concoctions with great dramatic force,' Lewis reported to a friend.[47]

50     Madame Strindberg ensured further participation from the avant-garde by reducing the annual membership subscription from five guineas to one guinea for 'fifty members of the arts.' Consequently, the Cave was, said Ezra Pound, 'the only night-club poor artists could get into.'[48] Here the Café Royal crowd, the 'moneyed revellers and less moneyed artists of various categories' freely mixed.[49] Hired gypsies and Negro jazz bands played, music hall girls sang, and everyone danced the Turkey Trot and the Bunny Hug.

'The first English Artists' Cabaret' combined revelry, art, cuisine, and culture – in the brochure's words, 'a gaiety stimulating thought, rather than crushing it,' and a congenial, continental environment in which members could expect to 'laugh freely, and to sit up after nursery hours.' As evidence of its high standards, the Cabaret listed 'some of the authors and composers under whose banners we range ourselves: Abercrombie, Villiers de l'Isle Adam, John Davidson, Walter Delamare, Arthur Machen, T. Sturge Moore, Ezra Pound, August Strindberg, Frank Wedekind, Yeats; Granville Bantock, Delius, Holbrooke, Raoul Lapare, Ernest Moret, Florence Schmitt, Dalhousie Young' – in 1912, a fairly 'advanced' roster.

The Cabaret performances were followed by supper and, to quote the brochure again, 'the picturesque dances of the South, its fervid melodies, Parisian wit, [and] English Humour ...' These, the brochure contended, 'will create a surrounding which, if it has no other merit, will at least endeavour to limit emigration.' Here was an odd presaging of the Vorticists' faith in the value of mixing Englishness with continental urbanity,

---

* Most people thought the paintings were murals but, according to Frederick Etchells, detachable canvasses were used. (Lipke 'A History and Analysis of Vorticism' p88) This would seem to be confirmed by the remark in Lewis' obituary of Gore in *Blast* No. 1, in which Lewis suggests that Gore's paintings done for the Cave should be included in a memorial exhibition.

but there would be no place for the 'picturesque,' or for the 'fervid melodies' of the south, in the Vorticists' commitment to a hard, northern, intellectual humour.

Although the Cave and Cabaret seemed to be thriving, behind the scenes problems arose. Madame Strindberg, distressed over what she called libellous remarks made about the Cabaret Club by Lilian Shelley, Epstein, and the show-business newspaper, the *Era*, and suspecting intrigues against the club, hired a private detective as her 'unofficial assistant.' The police, who kept a constant watch on the place, raided the club – not because it was rumoured to be 'an outpost of espionage,' as Pound claimed,[50] but because non-members were being asked to pay for food and drink in violation of the rules governing the opera- tion of private clubs.

Money problems plagued Madame Strindberg from the start. The first victims were the artists hired to provide decorations. None of them were paid, but only Lewis, who complained to Hamilton that the 'beastly Cabaret ... has been the cause of many ridiculous vexations to me,'[51] did anything about it. One Sunday, when Madame Strindberg was away, Lewis took over the till and stayed there until enough money had been paid in to cover the amount agreed upon for his work. He then pocketed what was due him and left.[52]* Less justifiable pilfering went on among the waiters who juggled the bills unscrupulously and held back large sums for themselves. The enterprise foundered in debts. On 13 February 1914, less than two years after the Cave opened, the liquidation sale took place. The furniture went for £ 90, the 'good will' for £ 10.

During its brief existence, the Cave of the Golden Calf made a sufficiently strong impact on the avant-garde life of the day for it to appear, not only in practically every reminiscence of the period, but in fiction as well: as 'The Merlins' Cave' in Gilbert Cannan's *Mendel* and 'The Night Club' in Ford's *The Marsden Case*. Its blend of revelry and rebel art became associated in people's minds with Vorticism, and with the hectic avant-garde world in general. Edgar Jepson, only half-facetiously, calls the Bunny Hug and Turkey Trot danced there 'Vorticist dances,'[53] and Sir Osbert Sitwell is not facetious at all in calling the Cave 'a super-heated vorticist garden of gesticulating figures, dancing and talking, while the rhythm of the primitive forms of ragtime throbbed through the wide room.'[54] The revelry of the West End, recalled Paul Selver, 'had its artistic counterparts in cubism, vorticism, futurism, the recitals of Marinetti, the publication of

* In *Rude Assignment* Lewis says he got £ 60 for his work at the Cave, but he does not say how he collected the money.

*Blast* ... [and] the Cave of the Golden Calf in Heddon Street.'[55]

The tensions and dangerous conflicts of the political world coincided with an increasingly frenetic tone in the life of the cafés. 'The artists at the Café Royal were unusually vociferous,' John Cournos remembered, and, recalling excited groups of artists arguing loudly at Mrs Kibblewhite's on a warm spring evening in 1914, he speculated, 'The civilized world was bored; unconsciously perhaps it responded to the idea of war as it might have to any idea which promised an outlet for banked-up repressions, which promised relief.'[56] The Cabaret's 'gaiety stimulating to thought' was turning into what Douglas Goldring observed as 'a positive frenzy of gaiety' during the season of 1914.[57] More and more, 'There was talk of wild young people in London,' writes George Dangerfield, 'more wild and less witty than you would ever guess from the novels of Saki; of night-clubs; of negroid dances.'[58] The Cave of the Golden Calf epitomized that wild world – as the Vorticists implicitly recognized by including Madame Strindberg among the 'blessed' in *Blast*. But everywhere the fervid melodies, ragtime, and vociferous arguments were breaking up the easy camaraderie and drowning out the long talks in the studios, salons, and cafés of the avant-garde.

# 4
# Coteries

If the studio-salon-café life became less open and less friendly as mid-summer 1914 drew nearer, a major contributing factor must have been the marked increase in the importance of coteries. After 1910 'groups' became increasingly characteristic features of the intellectual-artistic landscape: the Camden Town group, the Fitzroy Street group, the Cumberland Market group, the Grafton group, the London group, the Slade group, the Fry group, the Lewis group, the John group, the *English Review* group, the *New Age* group, the *Egoist* group, the Georgian group, the Imagist group, the Vorticist group – at various times and in various ways, these and other groups caught the public eye. No map could chart all the groups that rose like Pacific atolls above the sea: bunched but not contiguous, not very large, occasionally volcanic; some seemingly indistinguishable from those nearby, but revealing distinct, individualizing characteristics the closer one looked, others appearing quite distinct and then suddenly merging with a neighbouring island; some changing names and shapes and positions continuously, others sinking beneath the sea as mysteriously and suddenly as they had risen from it.

This shifting, unstable world was quite different from the Edwardian scene of a few years before. That comparatively stable, relaxed period of country house friendships disappeared amid groups 'more numerous and more impenetrable; farther separated from society and less kindly disposed towards it; more obscure in literary expression and less concerned about an audience,' wrote Dorothy Baisch in her study of the literary groups of the day.[1] Exactly the same generalizations apply to the art groups. Literary and art coteries showed the same signs of intolerance, willfulness, refusal to compromise and inclination to violence that infected the political life of England after 1910.

When the American, Arthur Jerome Eddy, published his

*Cubists and Post-Impressionists* in 1914, he put London's avant-garde artists under the single heading, 'Fauves,' and listed the outstanding figures exactly as follows: 'Fergusson, Peploe, Lewis, Wyndhover Lewis, Duncan Grant, Mrs. Bell, Frederick Etchells, Miss Etchells, Eric Gill, Spencer F. Gore, and a man who has done heroic service for the new movement, Roger Fry.'[2] If that sounds more like an evening's worth of half-caught introductions at the Café Royal than an informed report on London's avant-garde, Eddy is not entirely to blame. Since he could not observe the scene first-hand, he had to depend on catalogues, reviews, and other second- and third-hand sources of information. Eddy's failure was primarily not a matter of getting the names straight, but of making proper distinctions.

People much closer to the scene than Eddy had the same problem. As the titles of several major exhibitions suggest, the various factions within the modern movement were not easy to distinguish. 'Manet and the Post-Impressionists' neatly blended the art historian's penchant for continuity and categories with the publicist's aptitude for meaningful-sounding, ambiguous labels, but it did not make the new tendencies in art easier to sort out and identify. Roger Fry recognized the failings of the term he had invented, but he and others continued to use it. Fry's 'Second Post-Impressionist Exhibition' appeared two years after the first, and a year after that came Frank Rutter's 'Post-Impressionists and Futurists' exhibition. Rutter, too, questioned the value of the term he insisted on preserving. 'Movements so contrary and so numerous cannot be swallowed whole, however they are labelled,' Rutter wrote in the exhibition catalogue, 'and the work of each individual artist must be studied and analysed if justice is to be done to the various groups and fusions of groups concealed under the general term of "Post-Impressionism." '

In an attempt to make distinctions between 'groups and fusions of groups' a little finer, the Brighton Public Art Galleries called its exhibition of December-January 1913-14 'The Camden Town Group and Others; Exhibition of the Work of English Post-Impressionists, Cubists and Others.' The Whitechapel Gallery, backing away from such cumbersome attempts to clarify the avant-garde situation, called its exhibition of May-June 1914 'Twentieth Century Art: A Review of Modern Movements.' Even *Blast* was originally advertised as offering a discussion of 'Cubism, Futurism, Imagisme and all Vital Forms of Modern Art,' as if the magazine were to be a conglomeration of recent tendencies in art, instead of a concerted effort to stake out the territory of a particular, definable movement within the broad boundaries of Post-Impressionism.

General terms like Post-Impressionism, Cubism, Futurism, and Fauvism belied the actual tendency of the avant-garde to break up into smaller groups that sometimes had no particular visual style in common, but other times, as in the case of the Vorticists, not only shared an identifiable style, but had all the other trappings of an ism as well. Since the group and the coterie had become unavoidable facts of avant-garde life in pre-war London, the problem for participants and observers alike was to know for certain who belonged where.

By studiously observing the habitués of the Café Royal, a writer for the magazine *Colour* devised a seven-part division of the café's avant-garde. Essentially, he arrived at the following identifications.

1  The John Group, with all the little 'Johnnies.'
2  The Jacob Epstein Group of modernist sculptors and painters.
3  The Wyndham Lewis Group of Futurists.
4  The Camden Town Group of Post-Impressionists.
5  The Wolmark 'Colourist' Group – a development of the former school.
6  The Literary Group under the able guidance of Mr Savage, the Editor of 'The Gypsy.'
7  The Waterists, a group of watercolour painters, and the eccentric 'Cubists.'[3]

Relations between such groups often remained amicable – but not always. At the Café Royal, said Augustus John, 'Roger Fry, at the head of the Bloomsbury coterie, might well be on his guard in the proximity of the conspiratorial Wyndham Lewis with his small band of blood-thirsty Vorticists.'[4] An avant-garde-ologist for the *New Statesman* noted that as of July 1914 the Fry-Grant group (Friday Club, Grafton Group, Omega Workshops) opposed the Lewis-Wadsworth-Nevinson group ('Cubist Room,' Rebel Art Centre), and that the latter group had now split, Lewis and Wadsworth becoming Vorticists and Nevinson becoming a Futurist.[5]

When the anonymous author of the introduction to the catalogue for the Whitechapel Gallery's exhibition, 'Twentieth Century Art,' addressed himself to the same problem of distinguishing between various wings of the English avant-garde, he found four separate groups. The first 'treats common or sordid scenes in a sprightly manner and excels in a luminous treatment of landscape,' and included Walter Sickert, Lucien Pissaro, J.B. Manson, Harold Squire, Sylvia Gosse, Robert Bevan, Harold Gilman, Spencer Gore, and Malcolm Drummond. The second, under 'the influence of Puvis de Chavannes, Alphonse Legro and Mr. Augustus John,' sacrificed 'the illusion of three-dimensional space' for the sake of 'imposing decorative design' and simplifications that are 'distinctly linear.' Henry Lamb, Stanley

Spencer, Darsie Japp, Derwent Lees, and some work of Duncan Grant fell into this category. The characteristic style of the third group derived from the influence of Cézanne. 'Simplification is noticeable in the work of this group also,' said the catalogue, 'but it is that of "designing in volumes." ' For examples viewers were directed to the work of Vanessa Bell, Roger Fry, Duncan Grant, and Bernard Adeney. The fourth group 'has abandoned representation almost entirely.' Its representatives at the Whitechapel were Helen Saunders, C.R.W. Nevinson, William Roberts, Edward Wadsworth, Frederick Etchells, and Wyndham Lewis.

56 The London art world had come a long way from the simple division into academic and non-academic painters upon which the New English Art Club thrived in the 1880s and 1890s. When that large, diverse group, with its Impressionist bias, seemed to block the way of newer non-academic styles, the Allied Artists Association came into being in 1908, under the guidance of Frank Rutter. By permitting any artist who paid an annual subscription of one guinea to hang three works at its annual exhibitions, the A.A.A. remained open to the most experimental members of the avant-garde. Responding to this open spirit, even the Vorticists continued to show with the A.A.A. through the beginning of the war. While the absolute tolerance of the A.A.A. was a welcome change from the selectiveness of the N.E.A.C., it did not satisfy the coterie-urge that seemed to become increasingly pressing after 1910.

A more exclusive kind of grouping among artists began genially enough in Sickert's Fitzroy Street studio, with Sickert himself, Harold Gilman, Charles Ginner, Robert Bevan, Spencer Gore, Augustus John, Lucien Pissaro, Wyndham Lewis, and a few others, who gathered there for informal Saturday afternoon showings. From these gatherings came the Camden Town group, which held its first full-scale exhibition at the Carfax Gallery in June 1911, and presented what one of its members, J.B. Manson, called 'a coherent homogeneous school of expression.'[6] The same could have been said of another, smaller group, the Friday Club, which appeared at about the same time, with Roger Fry, Vanessa Bell, and Duncan Grant as its chief figures and most of the future Vorticists as occasional participants in its exhibitions between 1911 and 1913.

Hardly had the Friday Club and the Camden Town group been formed, named, and recognized, when new efforts at other group alignments began. On 21 February 1912, Roger Fry sent a note to Wyndham Lewis – who was, in fact, the notable exception to the Camden Town group's homogeneity – inviting him to a meeting at Vanessa Bell's where Fry, Frederick Et-

chells, and Duncan Grant planned to discuss the formation of a new group of artists. In keeping with the exclusive sentiments of coteries, Fry assured Lewis that at the outset this group would be kept quite small.[7] The proposed meeting produced no new coterie immediately, but it may have started the transformation of the Friday Club into the Grafton group and helped prepare the way for the Omega Workshops, both of which appeared in 1913.

By autumn 1913, the restless search for new alignments and new coteries that had turned the Friday Club into the Grafton group, invaded the Camden Town group as well. A meeting was scheduled for the 19th of November at Sickert's studio to discuss the formation of a new group. To Wyndham Lewis' doubts about the value of joining another Sickert-centred group, Edward Wadsworth replied, '(1) No neo-new-english group would be complete without us [by which he meant not only himself and Lewis, but Nevinson, Hamilton, Etchells and others of the cubist-futurist contingent] and (2) we ought not to throw away any chance of exhibiting or perhaps selling.'[8] Wadsworth's practical advice heeded, Lewis and other avant-garde artists attended the meeting, at which Harold Gilman was elected president and Spencer Gore secretary of a group that brought together the Camden Town group and the more advanced painters like Lewis and Wadsworth. The first exhibition of this new coterie was the ambiguously titled 'Camden Town Group and Others' at Brighton. For its next exhibition, held in March 1914 at the Goupil Gallery, the group increased its membership from 16 to 32 and appeared under a new name, the London group. In that and the following London group exhibition in March 1915, almost all phases of avant-garde art in London were represented, but without the diluting effects of completely open membership, which were noticeable at the Allied Artists' exhibitions.

Within the London group, a distinct faction developed simultaneously with the formation of the group itself. Anticipating this new development, Wyndham Lewis had hesitated joining Sickert's proto-London group, and when that 'neo-new-english' venture resulted in the exhibition at Brighton, Lewis and a few others saw to it that they were presented in a separate 'Cubist Room,' for which Lewis wrote an introduction for the exhibition catalogue. Lewis used the opportunity to distinguish the 'Cubists' – himself, Nevinson, Etchells, Wadsworth, and Hamilton – from the 'Post-Impressionists' and 'Others' in the exhibition. In his introductory note – which was reprinted in the *Egoist* (1 January 1914) – Lewis wrote:

These painters are not accidentally associated here, but form a verti-

ginous but not exotic island, in the placid and respectable archipelago of English art. This formation is undeniably of volcanic matter, and even origin; for it appeared suddenly above the waves following certain seismic shakings beneath the surface. It is very closely-knit and admirably adapted to withstand the imperturbable Britannic breakers which roll pleasantly against its sides.

Lewis gave special, but separate, attention to Bomberg and Epstein, and thereby implicitly eliminated them from the vertiginous island inhabited by himself and his colleagues. In effect, he announced the presence of a new coterie, which was to become the nucleus of the Vorticist group.

Shortly after Lewis made this announcement, T.E. Hulme, in a Quest Society lecture at Kensington Town Hall on 21 January 1914, called attention to 'one element [of the English avantgarde] which seems to be gradually hardening out and separating itself from the others.'[9] A week before his lecture, in a review of the latest Grafton group show, Hulme made that same element conspicuous by noting its absence from the show: 'The departure of Mr. Wyndham Lewis, Mr. Etchells, Mr. Nevinson and several others has left concentrated in a purer form all the worked-out and dead elements of the [Post-Impressionist] movement.'[10] Reviewing the London group exhibition in March, Hulme reinforced the existence of this separate 'cubist' element by distinguishing its work from the Camden Town contingent, as well as from 'the faked stuff produced by Mr. Roger Fry and his friends.' He discussed individually the work of its members: Lewis, Wadsworth, Hamilton, Etchells, Nevinson, and Gaudier-Brzeska. Like Lewis in his 'Cubist Room' introduction, Hulme gave separate, respectful, attention to the work of Bomberg and Epstein.[11]

What Lewis had perceived by late 1913, and Hulme by early 1914, the Whitechapel Gallery recognized in May 1914, by isolating, as its fourth group within the modern movements, those artists who had 'abandoned representation almost entirely.' Within that select group, the gallery's catalogue isolated a still smaller coterie: 'Some members of this group have recently established a "Rebel Art Centre." '

The Rebel Art Centre transformed a coterie into a publicly recognized institution, and, had it been run properly the Centre might have successfully rivaled Roger Fry's Omega Workshops, and attracted to the Vorticists the same public notice that the Omega drew to the Grafton group coterie. In the spring of 1914, the Rebel Art Centre and the Omega looked like rivals for the avant-garde market, as well as rival coteries. But the Rebel Art Centre soon closed, leaving what spoils there were for the

Omega to gather, while the coterie spirit of its supporters found more successful expression in the publication of *Blast*. That event concluded a process of separating and regrouping that had begun some eight months earlier, when Nevinson, Wadsworth, Etchells, and Hamilton joined Lewis in breaking from Fry's Omega Workshops.

The defection came only three months after the Omega opened in July 1913. The Omega had grown out of Roger Fry's determination to bring the Post-Impressionist revolution into the everyday lives of people who, only a short time before, had sneered, raged, and laughed at Post-Impressionism in the Grafton Galleries. At the same time, he hoped to provide financial assistance to artists whose commitment to the modern movement reduced their opportunities to show and sell their work. The need for such help was driven home to Fry (whose own private income was sufficient for comfortable, if not grand, living) by a small incident involving Duncan Grant. Invited down to Durbins, Fry's house in Guildford, Surrey, to meet a potential sitter for a portrait, Grant failed to show up. He didn't have the necessary 2s 6d for a return ticket. The following day he found a half-crown tucked away somewhere and made the journey, but his difficult straits convinced Fry that some way must be found to ease the poverty of young artists like Grant and his contemporaries.[12]

In 1911 Fry had arranged to have the dining room of the Borough Polytechnic decorated with large Post-Impressionist murals by Duncan Grant, Frederick Etchells, Bernard Adeney, Albert Rothenstein (later Rutherston), Max Gill, and himself. The results were well publicized, and perhaps set Fry to thinking along the lines that led, a year and a half later, to the Omega Workshops. At the Omega artists were paid five shillings a half-day – up to a maximum of thirty shillings a week – to make designs for rugs, furniture, wall paper, draperies, clothes, screens, lamp shades, pottery, cushions, boxes, trays, wooden toys, and Christmas cards. They also carried out specially commissioned jobs like a stained glass window or mosaics and steps for an entrance hall. On a larger scale, the Omega provided the furnishings and decorations for the Cadena Café in Westbourne Grove and for a room in the house of Arthur Ruck at 4 Berkeley Street, Piccadilly, and publicly displayed its decorating abilities in a 'Post-Impressionist' room at the Ideal Home Show in October 1913, and an Omega Lounge at the Allied Artists' Association exhibition in June 1914.

Some artists came in only occasionally to earn a few shillings. Others worked more or less regularly at the Omega. Duncan Grant and Vanessa Bell, nominally listed as co-directors with

Fry, devoted a great deal of time to the Omega, and they were joined at various times by Etchells, Wadsworth, Hamilton, Lewis, Turnbull, Nina Hamnet, Gladys Hynes, Winifred Gill, and others. Much of the tedious work – such as stringing bead necklaces or copying rug designs onto graph paper for the weavers to follow – fell to the women (Vanessa Bell excepted). The contribution of the better-known artists often came in the form of designs added to a folio – a kind of design pool – from which patterns for rugs, wall paper, textiles, etc., could be copied when the need arose. This procedure suited the ideal of communal anonymity that Fry tried to maintain for Omega products.

60    The Omega artists generally limited themselves to designing and decorating, and left the manufacturing to professionals. Occasionally the Omega sold things neither designed nor made by Omega artists, such as cloth in pure bright colours and bold designs made by Manchester textile mills for the African market, or coarse muslin handkerchiefs from Turkey and pots from North Africa, which Fry brought back from his travels. He was no doubt pleased by the family resemblance these actual 'primitive' and 'peasant' works shared with the products of his Post-Impressionist artists.

If occasionally the Omega was a bit artsy-craftsy and careless (some of its pottery leaked, some bowls collected soup around the rim, and the wood inlays for some trays came unstuck), and if it struck the fastidious G.B. Shaw as retaining too much of 'the true Fitzroy Square squalor,'[13] its general tone, nevertheless, was serious and professional, its products tastefully designed, competently made, and pleasantly free from 'dead mechanical perfection,' as Fry put it in an article on 'The Artist as Decorator' in *Colour* (April 1917). For the artists, there was not only the money they made, but – in the words of an Omega brochure – the pleasure of 'working with the object of allowing free play to the delight in creation in the making of objects for common life.'

The Omega artists were, as another brochure said, 'by nature predisposed to the study of pure design' – 'pure design' being, of course, one of the touchstones of Post-Impressionist criticism. Their natural predisposition toward 'pure design' and their commitment to Post-Impressionism helped them to adapt primitive and folk art to the exigencies of copying and machine-reproduction. One of the Omega's most notable accomplishments was to balance the practical need for easily reproducible designs against the aesthetic inclination toward an art based on simplicity, abstract design, and strong colour.

More than anything else, brilliant colour characterized the

Omega's products. As well as the materials made for African
eyes, the Omega offered chairs with bands of yellow, green, and
blue; wallpaper with purple sky, yellow moon, and blue moun-
tains; curtains in semi-abstract designs of purple, blue, crimson,
and yellow; rugs in totally abstract designs of yellow, black,
orange, red, blue, and purple. One rug, now at the Victoria and
Albert, was called 'The Pool of Blood' because of its design of
roughly concentric rectangles that moved from grey on the
outside to plum, deep purple, orange, and red in the middle. At
the time, most clothing and interior decoration tended to be in
dark, subdued colours or pale, neutral hues with intricate, fussy,
designs. At the 1913 Ideal Home Show, for instance, a writer
for the *Journal of the Royal Society of Arts* noted a 'prevalence
of Chinese or old English designs upon black backgrounds.'[14]
In that context, the Omega's unabashed use of pure, intense
colour and simple design seemed revolutionary.

Under the headline, 'HOW MR. FRY IS TRYING TO BRING A
"SPIRIT OF FUN" INTO OUR SEDATE HOMES,' the *Daily News and
Leader* (7 August 1913) described the Omega's 'chairs that are
witty, hangings that are humorous and curtains that sing gaily.'
Asked to 'explain' some brilliant patches of colour stitched into
a wool-work cushion, Fry told the *Daily News* reporter that it
represented 'a cat lying on a cabbage, playing with a butterfly –
a radiant rose-winged creature,' and, commenting on a folding
screen decorated with circus figures in distorted shapes (prob-
ably done from the design by Wyndham Lewis now at the
Victoria and Albert), Fry said, 'But how much wit there is in
these figures ... Art is significant deformity.' That cavalier dis-
tortion of Clive Bell's famous dictum about art as 'significant
form,' may have been the reporter's attempt at wit, but more
likely it was Fry's way of countering the philistinism of his inter-
viewer, as well as putting into practice the advice he once wrote
to C.J. Holmes: 'Do let me warn you not to have a consistent
theory about art – it is very dangerous. It should be made up
from time to time to suit the circumstances.'[15] Such circum-
stances must have arisen often as Fry conducted reporters,
guests, and potential customers around the ground-floor show
rooms at Fitzroy Square. In any case, the Omega artists could
not have had a more sincere and eloquent defender of their
work than Fry.

Faced with this strong-willed, self-effacing, witty, and highly
persuasive man, some people liked, admired, and nearly revered
Fry; others distrusted and disliked him intensely. The first Post-
Impressionist exhibition made him the chief proponent of the
new art, but his own painting and that of his closest associates
in the Friday Club and Grafton group, aligned him with one,

particularly decorative, type of Post-Impressionism. His age, Cambridge education, experience as a museum director, editor, art critic, and connoisseur gave weight and respectability to his advanced and often unpopular opinions, but they also opened a gulf between him and many younger artists of the avant-garde, who were suspicious of his Cambridge sophistication, his Bloomsbury clannishness, and his Quakerish benevolence. Because of his distant family connection with the great chocolate manufacturer Fry (some of the younger artists called him 'Chocolate Fry' behind his back), they thought he was far wealthier than he was, and to them he seemed a rich amateur, a dilettante who played at art. At the Omega they were restive and rebellious under his strong – if velvet-gloved – guidance.

They thought Fry tried to take over things and run them his own way. Nevinson's remark about the Friday Club – 'a remarkable little clique which was eventually ruined by the amateurish dilettantism of Roger Fry'[16] – suggests the ill-will Fry generated in some quarters when his influence seemed too great. Jacob Epstein complained in his autobiography of the 'hostility' of Fry and his 'clique of artists who arrogated to themselves the sole possession of superior taste in matters of art.'[17] T.E. Hulme ridiculed 'the fake stuff produced by Mr. Roger Fry and his friends,' and called Fry 'a mere verbose sentimentalist.'[18]

Even his friends could not ignore a certain aggressive self-righteousness and a desire to dominate other people which were part of Fry's make-up. In 1913 Edward Marsh wrote of an artist acquaintance, 'I'm afraid he has come under the noxious influence of dear Roger Fry whom I love as a man but detest as a movement ...'[19] Clive Bell found Fry to be 'open-minded,' but added, 'he was not fair-minded.' Fry felt people took advantage of him, and in reaction, became suspicious and unjust. 'He could be as censorious as an ill-conditioned judge,' Bell wrote.[20] Leonard Woolf, who came to know Fry well while serving as secretary for the 'Second Post-Impressionist Exhibition' in 1912, admitted, 'I was more than once surprised by [Fry's] ruthlessness and what seemed to be almost unscrupulousness in business.' When inviting painters to submit work to the 1912 exhibition, Fry had, through a mistake of his own, promised them better terms on the sale of their pictures than he could afford to pay. He had not allowed enough for the exhibition's commission, but, Woolf reports, 'When the time came to pay artists their share of the purchase amounts of pictures sold, Roger insisted on deducting a higher commission without any explanation or apology.'[21] According to Woolf, one of the few artists to protest to Fry was Wyndham Lewis, and it seems likely that the

incident continued to rankle as Lewis found himself increasingly at odds with Fry.

Before the open break in October 1913, Lewis had complained of what he believed to be Fry's special ill-will toward him,[22] and after that date, until the day he died, Lewis believed unshakeably that Fry's influence had seriously and permanently damaged his career. He never significantly modified the bitter opinion he expressed in a letter to Clive Bell in October 1913: 'Fry is a bad egg ... and I for one wish no longer to remain in his neighbourhood. He has some vulgar nasty, mean crookedness in his nature, that has left a trail of particular unsavoriness in his life.'[23]

For Lewis, the unquestionable proof of Fry's iniquity came in October 1913, when the Omega was commissioned by the *Daily Mail* to furnish and decorate a model room at the Ideal Home Show, an annual exhibition at Olympia for exhibiting interior decoration schemes and products for domestic use. Lewis believed that Fry had, in effect, stolen the commission from Lewis and Spencer Gore. Fry maintained that he had not, that the commission was the Omega's pure and simple.[24] The facts seem to be these: a representative of the *Daily Mail* asked P.G. Konody, the art critic, to recommend an avant-garde artist to decorate a room at the forthcoming Ideal Home Show. At the suggestion of Madame Strindberg, Konody recommended Spencer Gore, who had directed and contributed to the decorations of the Cave of the Golden Calf. Konody, or someone else, must have mentioned Wyndham Lewis (who had also received publicity for his work at the Cave) and the Omega as well, for Gore appeared at the Omega one day in July to announce that he, Lewis, and the Omega had been asked to do the job jointly. Since neither Fry nor Lewis were at the Omega at the time, Gore left the message with Duncan Grant and departed.

From that point on, the Lewis version and the Fry version diverge. According to Fry, Gore's message did not get to him – at least not in its full details – and in the meantime he had arranged with the *Daily Mail* to have the Omega do a room for the Home Show. Like other Omega projects, the room was to be an anonymous effort of Omega artists, and in no case could an individual Omega artist, such as Lewis, be in charge or get separate recognition. The room was, in fact, done under those conditions, by the Omega. According to Lewis, Fry simply ignored the part of Gore's original message that included Gore and Lewis, and appropriated the whole thing for himself and the Omega. After his trip to the Omega in July, Gore apparently made no further efforts to see Fry, nor did he even tell Lewis he,

too, was involved. Shortly before the show opened, and only by accident, Lewis learned of the original scheme for making him one of the planners. Confronted by requests for an explanation, Fry told Lewis that Lewis' and Gore's names were not mentioned during his conversations with a *Daily Mail* representative, and he wrote Gore that the possibility of Lewis and Gore being involved as individual artists, rather than as members of the Omega, had never been discussed. In any case, Fry said, that would have been out of the question under any circumstances, since the Omega would not have accepted a commission that violated the Omega's principle of individual anonymity.[25]

Possibly the muddle was caused by two different agents of the Home Show approaching Gore and Fry separately. Duncan Grant's failure to convey Gore's message clearly was further complicated by Gore's failure to follow up the matter until early October. As for Fry, it is quite possible that the Omega had assumed so much importance in his own mind that even if Lewis' and Gore's names had been mentioned, he would promptly have forgotten them, in the way anyone deeply committed to a project is likely to regard everything in the light of its relevance to that project. In no way vicious or consciously self-seeking, Fry could have regarded Lewis' and Gore's presence simply as an encroachment on the rightful territory of the Omega. He could not have been insensible to the collective benefits the Omega would gain by fulfilling such an important commission so soon after its opening.

In choosing to look at the incident in the worst possible light, Lewis was also letting out all the resentments that had piled up inside him for some time. During the previous year, Fry had explicitly praised Lewis' work and seen to it that Lewis was included in the second Post-Impressionist exhibition and smaller exhibitions, and Fry's close associate, Clive Bell, had assured Lewis that Fry admired his work.[26] Lewis, nevertheless, complained on more than one occasion that he got less favourable treatment from Fry than did others in the Friday Club-Grafton group coterie.[27]

In an undated note that may have been written as late as September 1913, Lewis' unhappiness with Fry began to surface. Apparently Fry had sent off some paintings from the second Post-Impressionist exhibition to a show in Liverpool, without including anything by Lewis. Fry's explanation, 'I forgot to ask if you had anything to send,' hardly satisfied Lewis. Nevertheless, Lewis wrote Fry, 'I am animated by most cordial sentiments as regards yourself and your activities. But to continue in [an] atmosphere of special criticism and ill-will, if such exist, would have manifest disadvantages, as well as being distasteful,

64

to me.' Lewis closed with a gesture of reconciliation: 'I wish you could give me, quite roughly, my bearings; and perhaps there is some unguessable reason for the incident I am directly writing of, that would alter its significance somewhat?'[28] But it all sounds too gracious, and the sheer formality of phrasing ('I am animated by most cordial sentiments as regards ... etc.') suggests that Lewis was working very hard to keep his feelings under control. He was losing patience, however, and the Home Show affair brought things to a head.

Enlisting the support of Wadsworth, Etchells, and Hamilton, Lewis confronted Fry at the Omega, and announced he would never come back. Angry words were exchanged, and Fry was heard to exclaim, 'Ca c'est trop fort!' as Lewis and the others ran down the stairs and stormed out, slamming the door behind them.[29] The defectors then sent a form letter to influential people interested in the Omega, in which they presented Lewis' version of the Ideal Home Show muddle, charging Fry with having gotten the commission 'by a shabby trick.' They tried to strengthen their argument by telling about another confusing and inconclusive episode involving two letters sent by Frank Rutter to the Omega: one to Fry requesting Etchells' address so that Rutter could ask Etchells to submit work to Rutter's 'Post-Impressionists and Futurists' exhibition, the other, on the same subject, to Lewis. Letter one, the defectors claimed, was answered by Fry who said, incorrectly, that Etchells had nothing to send. Letter two was opened and read by Fry, who then took ten days to forward it to Lewis. The charges about letter one were never proven. As for letter two, the charge was correct, but Fry insisted he accidentally opened the letter, not realizing it was addressed to Lewis, and then unintentionally let it get away among the clutter of papers on his desk and did not recover it for ten days.[30] Again Lewis and his friends believed they had hit upon an example of Fry's deviousness and unwarranted interference in the affairs of others.

Finally, the open letter presented a sweeping attack on the Omega's 'tendencies in Art' and on Fry's capabilities and personality:

As to its tendencies in Art, they alone would be sufficient to make it very difficult for any vigorous art-instinct to long remain under that roof. The Idol is still Prettiness, with its mid-Victorian languish of the neck, and its skin is 'greenery-yallery,' despite the Post-What-Not fashionableness of its draperies. This family party of strayed and Dissenting Aesthetes, however, were compelled to call in as much modern talent as they could find, to do the rough and masculine work without which they knew their efforts would not rise above the level of a pleasant tea-party, or command more attention.

The reiterated assurances of generosity of dealing and care for art, cleverly used to stimulate outside interest, have then, we think, been conspicuously absent in the interior working of the Omega Workshops. This enterprise seemed to promise, in the opportunities afforded it by support from the most intellectual quarters, emancipation from the middle-man shark. But a new form of fish in the troubled waters of Art has been revealed in the meantime, the Pecksniff-shark, a timid but voracious journalistic monster, unscrupulous, smooth-tongued and, owing chiefly to its weakness, mischievous.

No longer willing to form part of this unfortunate institution, we the undersigned have given up our work there.

<div align="center">

(Sgd.) Frederick Etchells

C.J. Hamilton

Wyndham Lewis

E. Wadsworth[31]

</div>

Thus ended the letter that Sir John Rothenstein later guessed might 'one day find place in the anthologies of invective.'[32]

By making their attack public, the Omega defectors opened themselves to libel charges, especially after Vanessa Bell obtained from an official of the Home Show a written statement that, 'The commission to furnish and decorate a room at the Olympia was given by the *Daily Mail* to Mr. Roger Fry without any conditions as to the artists he would employ.'[33] But Fry, agreeing with Vanessa and Clive Bell and others on his side that the best policy was silence, decided to do nothing. Lowes Dickinson wrote Lewis from Cambridge objecting to the 'libellous letter' and rejecting all its charges,[34] and Clive Bell, more shocked by the ill-manners than the possible libel, had a long talk with Lewis, the gist of which can be guessed from the draft of a letter he planned to send Lewis: 'Whatever you think of [Fry] and his doing you ought not to bombard the town with pages of suburban rhetoric. The vulgarity of the thing! And the provincialism! That's what I mind. You don't belong to the suburbs, so what the devil are you doing there?'[35] Only a month after the conflict, Fry sent Lewis a typed notice headed, 'Re the Exhibition of the Grafton Group at the Alpine Club Gallery, January 1914,' in which he pointed out that members of the group must contribute £8 each toward the rental of the gallery, and, if the money was not forthcoming, it would be assumed that the individual no longer wished to be a member of the group.[36]

If Fry intended the note to be a magnanimous, if impersonal, peace gesture, he did not succeed. The defectors were not to be mollified, and they were encouraged by some covert support. Augustus John sent Lewis a note expressing his approval of the break, but warning against unduly aggressive attacks that would

alienate friends unnecessarily.[37] Jessie Dismorr, who would later
join the defectors at the Rebel Art Centre, wrote Lewis, 'I
wonder how you are getting on with the Fry campaign – I am
really with you in spite of my apparent want of sympathy.'[38]
Others may have felt the same way. Nevinson, for one, willingly
accepted Lewis' invitation to join 'the party against Fry and the
Omega Workshops,'[39] and Gaudier-Brzeska complained to a
friend that the Omega had 'sucked his brains' and 'swindled
him.'[40] Most people probably would have agreed with Edward
Marsh's judgment, 'Of course it must be a misunderstanding,
[Fry] has probably been very unbusinesslike, but he is certainly
quite honest,'[41] but those who were ready to believe the worst
about Fry made Lewis' feud with the Omega a focal point for
their own anti-Fry feelings.

The defectors kept the flames burning as long as they could. In
December, Wadsworth spotted a paragraph in a Yorkshire
paper describing Lewis and himself as 'disciples' of Fry and
members of 'the Omega Group.' He reported to Lewis that he
had immediately drafted a reply 'disowning Fry and so on,'[42]
and in February 1914 Wadsworth wrote Lewis that the pub-
lisher Constable had asked 'whether "Blast" had any connection
with the Omega, so I disillusioned them on that point and said
the Omega was *dead*.'[43] (In fact, the Omega stayed open until
1919.) In March Fry wrote Duncan Grant, 'The Lewis group
do nothing even now but abuse me. Brzeska who sees them says
he's never seen such a display of vindictive jealousy among
artists.'[44] By July, when *Blast* appeared with the passage,

BLAST the

AMATEUR

SCIOLAST

ART-PIMP

JOURNALIST

SELF MAN

NO-ORGAN MAN,

only a few insiders could have recognized that bloated com-
posite of an art world scoundrel as the self-demeaning Roger
Fry.

If the Omega schism grew out of confusions and misunder-
standings, it also provided another example of the intransigent
and combative spirit of the times. It illustrated, as well, the way
a coterie can grow from mutual antagonisms as well as mutual
interests. It became a particularly important step on the way to
Vorticism, for it drove Lewis, Wadsworth, Etchells, Hamilton,
and (temporarily) Nevinson, into a tighter and more voluble
coterie, and gave them their first taste of what it is like to 'bom-
bard the town with pages of suburban rhetoric.' Their break

from the Omega left them free to shape a workshop closer to their own taste, when that opportunity arose.

Kate Lechmere, a young English artist who had studied at La Palette in Paris, met Wyndham Lewis in 1911, and in 1912 or 1913 she suggested to Lewis that an avant-garde atelier in London might be a good thing. When Lewis agreed, Miss Lechmere found suitable quarters and put up the necessary money for rent and other beginning expenses. In the spring of 1914, Lewis suddenly found himself the manager and co-director of the Rebel Art Centre – or, as it was legally registered, The Cubist Art Centre, Ltd., 38, Great Ormond Street, w.c.[45]

68     Kate Lechmere expected Lewis to make contacts in London's art world and to draw other artists to the Centre. Naturally, Lewis brought in the anti-Fry coterie of Etchells, Wadsworth, Hamilton, and Nevinson. Perhaps in reaction against the numerous women Fry attracted to the Omega, Nevinson announced, 'I won't have any damn women in it!' – only to be informed that a woman was supplying the money.[46] Soon two more women, Jessie Dismorr and Helen Saunders, became regulars at the Rebel Art Centre. However, Lewis was not able to attract more than passing interest from other important avant-garde artists – with the exception of Ezra Pound, who had by this time become deeply involved in the new movements. Instead of being satisfied to aim for an informal and productive atelier in the French manner, as Kate Lechmere had envisioned, Lewis wanted to make the Centre a much grander enterprise. However, he succeeded in making it little more than a meeting place for the anti-Fry coterie, which soon became the anti-Futurist coterie, and then the nucleus of the Vorticist coterie.

The physical setting was an appropriately 'advanced' combination of Post-Impressionist colours and Cubist design. In the long room that was to be studio, gallery, and meeting room, the walls were yellow, the curtains gold, the doors pillar-box red; there was a blue rug on the floor and a divan painted red and covered with bright white, blue, and red Liberty material. Near the divan stood a Futurist screen painted by Nevinson. The long studio was divided from a smaller office-studio at the back for Lewis by a large curtain of nets sized and decorated with coloured inks by Hamilton. On a white background, Hamilton worked out a complex, jaggedly linear design in bright colours: 'Points of purple and cubes of green and yellow, intermingling with splashes of deep rose-red, formed themselves ... into fantastic human figures,' wrote a reporter for the *Daily News and Leader*, who visited the Centre to interview Lewis.[47] To brighten the stern Georgian exterior, Kate Lechmere, who lived above

the Centre, put window boxes on the first-floor window ledges, and decorated them in brightly coloured abstract designs.

On the walls hung Lewis' large oil *Plan of War* (reproduced in *Blast*) and a painting called *The School-mistress*, which Violet Hunt described as showing a 'lady, clad in dull universal brown, her contours like those of an umbrella turned inside out and seemingly sodden by rain ...'[48] Gaudier-Brzeska, Bomberg, and Atkinson showed their work there beside the Picabia-like *Dancers* and totemic *Religion* of William Roberts, and a Futurist painting by Nevinson in which real lace was used to represent a petticoat (a detail Lewis liked to offer as proof of Futurism's vulgarity). Wadsworth's sprightly abstraction *Caprice* was put over the mantlepiece in a ceremony photographed by the *Daily Mirror*: Wadsworth, perched atop a stepladder, holds one corner of the frame against the wall, Nevinson steadies the ladder, Lewis, wide-brimmed hat in hand, a lock of dark hair hanging over his left eye, rests his right elbow on the edge of the mantlepiece and rubs his underlip meditatively, and, almost cropped out of the picture, an unrecognizable man – probably Hamilton – gazes upon *Caprice*.[49] A photographer for the *Graphic* found *Caprice* – in an earlier stage or in a slightly different version – hanging above a doorway, and a large oil by Lewis over the mantlepiece.[50] Other paintings of the group were hung for Saturday afternoon showings, but the 'series of large mural paintings and friezes' promised in the Centre's prospectus, resulted only in a semi-abstract mural by Lewis that was never finished. Ezra Pound's contribution was a sign on the wall reading 'End of the Christian Era,' a phrase he also used in advertisements for *Blast*. <span style="float:right">69</span>

Like the Omega Workshops, the Rebel Art Centre planned to do business in a business-like way: with properly decorated premises, a solicitor (named Rayner, who appears with Kate Lechmere among the 'blessed' in *Blast*), stationery with a letterhead and abstract design by Lewis, and arrangements for the profits to go to the directors. In a document dated 25 March 1914, however, Lewis signed over to Kate Lechmere any dividends due him for the first six months of the Centre's existence. Of course, there never were any dividends. If the Centre had hoped, as William Roberts later said, to best the Omega in a rivalry 'for the profits of the English interior-decorating market,'[51] it was totally unsuccessful. The only evidence of a commission being offered the Rebel Art Centre artists is a note from Nevinson to Lewis concerning Lady Cunard's wish to have Nevinson, Lewis, Hamilton, and Wadsworth decorate some handkerchieves, scarves, candles, and fans to be used for favours at a party.[52]

Initially, the Centre had high aspirations. Its prospectus made the Rebel Art Centre sound like a mixture of the Omega, Kensington Town Hall, the Slade, Saturday afternoons at 19 Fitzroy Street, and the recently closed Cave of the Golden Calf. There were to be lectures by Marinetti, Pound, 'some great innovator in music, Schoenburg or Scrabine [sic],' and others. Some 'short plays or Ombres Chinoise,' dances, and other 'social entertainments' were promised, along with special exhibitions and 'Saturday afternoon meetings of artists from 4 to 6 p.m.' There was also to be 'a "Blast" evening, or meeting to celebrate the foundation and appearance of the Review of that name,' and at that event, said the prospectus, 'a manifesto of Rebel Art will be read and address given, to the sound of carefully chosen trumpets.' An ambitious art school was to open on 26 April 1914, offering not only drawing and painting, but 'instruction in various forms of applied art, such as painting of screens, fans, lampshades, scarves. Mr. Wyndham Lewis will visit the studio, as professor, five days a week.'[53]

A few of the promised activities took place. Marinetti appeared, Pound talked on Vorticism (and published a version of the talk in the *Fortnightly Review* in September 1914), and Ford Madox Ford lectured, only to have his peroration interrupted by Lewis' large *Plan of War*, which suddenly fell off the wall and on to Ford, knocking the canvas loose and trapping Ford inside the frame. Some 'workshop' items were made and displayed at the Allied Artists' exhibition in June 1914. But the Centre's major project, its art school, never materialized, and Lewis did not get to try out the role of professor of art. Only two applicants turned up, according to Kate Lechmere, 'a man who wished to improve the design of gas-brackets and a lady pornographer.'[54]

Lewis' intentions – or at least his reaction against conventional methods of art school instruction – can be guessed from the principles set forth in the art school prospectus. The 'starting point and alphabet of the teaching,' it said, will be 'the principles underlying the movements in Painting, known as Cubist, Futurist and Expressionist.' Pupils will not be forced to follow any 'particular artist's idiosyncracy' (this, perhaps, was a jab at Sickert and John, who conducted small, informal ateliers of their own); instead,

The principle object of this school will be to help any student to do what he wants to do. If he prefers to play the fiddle to drawing he can do that, so long as he does not annoy his neighbour.

The academic basis of drawing will not be neglected. But those who are evidently meant for a child's paradise will be left with their wit, skill and ingeniousness. Instruction will approach them on tip-toe.

If Lewis is slyly joking, he also seems to be giving his endorse-
ment to the sort of dabbling and amateurism that he professed
to hate when he found it, or thought he found it, at the Omega
Workshops.

For the sake of an essay in *Vogue* many years later, Lewis re-
considered that never-realized opportunity to be Professor
Lewis, and wrote that had he 'been teaching Vorticism,' he
'would have insisted upon creation of a language absolutely
distinct from what was handed us by nature ... and an alphabet
of as abstract as possible a kind.'

> In my class [Lewis continued] I should have had upon a table objects
> numbered, or marked by letters, and have excluded those resembling,
> say, a bottle, or a hand, or an animal, or a flower.

> Had I been able to start a workshop like the Omega Workshops, I
> would have had classes developing the above themes [the repudiation
> of nature through abstraction], and encouraged the shaping, in clay, or
> in wood, of objects conforming to those theories.[55]

Helen Saunders felt that, in comparison with the Omega, the
Rebel Art Centre put 'perhaps more emphasis on formal design
and "abstract" painting.'[56] If those tendencies had been devel-
oped, the results might have been as distinctly different from
the Omega as the Vorticists' art differed from that of the Grafton
group.

But the Rebel Art Centre's 'workshop' produced little beyond
a few fans (some decorated in ink by Lewis), boxes, scarves,
and a table exhibited in the Centre's booth at the Allied Artists'
exhibition. These few samples, however, led Gaudier-Brzeska,
in an article for the *Egoist* (15 June 1914), to compare the
Omega's lounge, where he found 'too much prettiness,' with the
Rebel Art Centre's booth which displayed 'vigorous forms of
decoration.' Echoing the nine-month-old anti-Fry campaign,
and recalling, perhaps, the implications in the defectors' claim
that they were the 'modern talent' originally called in by the
Omega 'to do the rough and masculine work,' Gaudier noted
that the Rebel Art Centre's contributions showed that 'the new
painting is capable of great strength and manliness of decora-
tion.'[57] By the time Gaudier's praise appeared in print, the
Centre was on the verge of closing.

The Rebel Art Centre opened officially in April. By mid-May
Kate Lechmere, who had put her hopes and her money into the
venture, felt deeply discouraged. She had no business sense, nor,
she discovered, did Lewis, who failed to advertise the Centre
sufficiently, and sent out advertisements for events without in-
cluding the dates. Just when the Centre demanded his full at-
tention, Lewis switched his energies to the preparation of *Blast*.
To Kate Lechmere, the Centre's habitués seemed to do little

more than sit on the red, white, and blue divan, talking and composing letters to the press. Meanwhile, expenses mounted. The rent came due. Kate Lechmere suggested, to no avail, that the artists exhibiting at the Centre might contribute £3 each toward the rent.[58] Nevinson thought the Centre should get a twenty-five per cent commission on sales, instead.[59] Lewis, who had signed over his non-existent dividends to Kate Lechmere and borrowed from her to help pay for the printing of *Blast*, was not ready to accept her suggestion that, since he was using a room at the Centre for a studio, he should help pay the rent.[60]

As if these money problems were not enough, Lewis' constant worry about retaining control of the Centre increased the strain on his relationship with Kate Lechmere. From the outset, Kate Lechmere realized that, in her words, 'Lewis was rather touchy and apprehensive about his position at the Rebel Art Centre, and thought that if I'd any friends – close friendship with some artist – I might bring him into it and rather oust Lewis' position. It was a bee in his bonnet ... a phobia of his.' He told her that other artists should not be allowed to become members, so that they 'could be pushed off at any moment.'[61] Lewis suspected that Hulme and Epstein wanted to take over the Rebel Art Centre, and after Kate Lechmere met Hulme, Lewis began to suspect that she had 'gone over to Hulme's camp.' Heated arguments followed. One day Kate Lechmere arrived at the Centre to find everything – paintings, curtain, screen, divan – gone, and Lewis and his cohorts gone with them. She did not pay the rent. The Rebel Art Centre closed.

Deserting Kate Lechmere and publicly attacking Fry and the Omega, however impolitic and unproductive those deeds were, brought the members of the Vorticist coterie closer together, and made them more conscious of the mutual benefits of operating as a group. The coterie spirit pervaded the times, and Lewis, in particular, seemed ready to exploit it. 'I assumed too,' he wrote later, 'that artists always formed militant groups. I suppose they had to do this, seeing how "bourgeois" all Publics were – or all Publics of which I had any experience.'[62] Not only the imperviousness of 'bourgeois Publics,' but rivalries among the artists themselves and the combative, uncompromising spirit of the times undoubtedly helped to shape Lewis' and the whole avant-garde's strong inclination to form militant groups. Under Lewis' leadership, the Vorticist group carried that inclination to its pre-war conclusion.

# 5
# Ford and Hulme

In contrast to Roger Fry, whose contributions to the revolution in art were immediately recognized by allies and enemies alike, Ford Madox Ford and T.E. Hulme worked less publicly and less dramatically to advance the cause of rebellion in the arts. As a writer – and an 'Edwardian writer' at that – Ford could hardly compete with the young rebels who so easily caught the public's attention with their 'immoral' and 'anarchical' art. Hulme faced a similar problem: how could a young, aspiring philosopher and highbrow journalist make himself heard amid the 'Art Shocks' and coterie feuds? Through their response to the contemporary spirit – not only the café-coterie side of it, but the motivating forces underneath – both men solved the problem of communicating with their times.

Ezra Pound once wrote, 'Hulme wasn't hated and loathed by the ole bastards, because they didn't know he was there. The man who did the *work* for English writing was Ford Madox Hueffer (now Ford).'[1] That was how Ford and Hulme were regarded at the time, but Hulme's importance has loomed larger as people have come to recognize the relevance of his ideas to the developments in modern art as well as modern literature. In the period between 1910 and 1914, however, Hulme could not have matched Ford's diverse literary connections and his large circle of acquaintances. Within larger or narrower circumferences of influence, Ford and Hulme worked to define, and thereby influence, the tendencies of the times. Though neither was a Vorticist, both contributed to the making of Vorticism.

Ford, said Ezra Pound, 'had nobody to play with until Wyndham Lewis and I and my generation came along.'[2] Odd playmates they made. Ford: large, paunchy, adenoidal, with a moist pink mouth hanging open beneath a nicotine-stained moustache, and with a manner Wyndham Lewis likened to that of a 'military sahib in Hindustan.'[3] Pound: wiry, athletic, highly voluble, aggressively American in accent, bohemian in dress, and cosmo-

politan in interests. Lewis: dark, broad-shouldered, silent, easily offended, secretive, protected by a wall of carefully calculated mannerisms.

Ford, who did not drop his family name, Hueffer, until 1919, was ten years older, an established novelist and essayist, an intimate of Conrad and friend of James, a compeer of Wells, Bennett, and others in the generation of 'punks and messers' despised by the avant-garde. Yet, the closest observer of life at South Lodge, Douglas Goldring, recorded that of *les jeunes*, 'the two with whom [Ford] became most intimate were Ezra Pound and Percy Wyndham Lewis.'[4] If he lacked their youth and revolutionary fervour, he at least shared their conviction that basic changes in art and literature were necessary and desirable. He also showed a flatteringly high regard for the accomplishments of rebel artists like Lewis and Pound.

In literature, Flaubert and Turgenev were his idols. He denounced moralizing, over-writing, and vagueness, and preached precision and the *mot juste*. He believed a writer should never engage in stylistic excesses that would divert the reader's attention from the writing to the personality of the writer. His goal was the exact rendering of contemporary experience – 'to register my times in terms of my own time,' as he put it.[5] Instead of telling a story in a sequence of incidents, the writer, said Ford, should force the reader to experience the story in moments of intense 'impressions.' Ford called this method Impressionism, not because of any connection with French Impressionist painting, but because it was designed to give the fullest possible impression of reality.

The Impressionist goal, as Ford described it, does not sound revolutionary. Yet, Ezra Pound wrote of Ford in 1914, 'I find him significant and revolutionary because of his insistence upon clarity and precision, upon the prose tradition; in brief, upon efficient writing – even in verse.'[6] Pound was not in the habit of calling people 'significant and revolutionary' unless they truly seemed so to him; therefore, his praise of Ford shows how strongly the rebel artists felt themselves surrounded by writing that failed the Impressionist test. It shows, too, how much they appreciated an older, more established writer, who spoke out, as they did, against writing that was verbose, self-indulgent, sentimental, or doggedly devoted to fact for fact's sake. In that context Ford seemed revolutionary.

With a surprising tolerance for youthful extravagance and an eager openness to change, Ford cheered on each new wave of the avant-garde. Friendship and encouragement were probably his greatest contribution to the avant-garde, and these took their

74

most concrete form in South Lodge parties and in his one-year term as editor of the *English Review*.

'The EVENT of 1909-1910 was the *English Review*,' said Pound in 1939[7] (retrospectively putting the date of the review's founding a year too close to that magnetic date of 1910). Begun in December 1908 with Ford in the editor's chair, the *English Review* opened with Hardy's 'A Sunday Morning Tragedy,' and, during the year of Ford's editorship, included contributions from Conrad, James, Meredith, Wells, Galsworthy, Chesterton, Belloc, W.H. Hudson, Granville-Barker, Watts-Dutton, and other Edwardian and late-Victorian lights, along with a few representatives of the new generation: F.S. Flint, D.H. Lawrence, Norman Douglas, Pound, and Lewis. What made the review an 'EVENT' was not so much the accumulation of important contributors – though that was significant too and a remarkable testimony to Ford's connections and editorial abilities – but the spirit in which Ford went about producing the review. 'We aimed at producing an *aube de siècle* Yellow Book,' Ford wrote later.[8] A dawn appropriate to the brightening new day of post-Edwardian literature and art, the review was to be, as Ford put it, a 'movement-producer.' Douglas Goldring, Ford's sub-editor, agreed: 'The Review was, above all, to start a Movement and to found, in the French sense, a "school." '[9] – with, presumably, Ford as its *cher maître*.

Something like that began to happen. May Sinclair brought in a young American named Ezra Pound, only recently arrived from Venice. Unsolicited poems arrived from a new Midlands poet, D.H. Lawrence. One day Ford was accosted on the stairway of the *English Review* office by an unknown man in black coat and cape, long dark hair, and an 'immense steeplecrowned hat,' who silently pressed upon Ford rolls of manuscript, and then left without a word spoken. 'I had the impression,' said Ford, summing up the experience, 'that ... he must be Guy Fawkes.'[10] Instead, he was Wyndham Lewis delivering his story 'The Pole,' which Ford published in the review in May 1909. In that comparatively quiet period, the staid *English Review* was earning its reputation as 'the rallying point of the revolutionaries.'[11]

With its earnest and respectable articles on contemporary problems ('Present Discontent in India,' 'The Persian Crisis: Rebirth or Death,' 'The Constitutional Crisis: A Liberal View,' 'Divorce Law Reform,' 'The Task of Realism,' 'Aspects of the Social Question,' etc., etc.), the *English Review* seemed an unlikely centre for revolution; but then Ford, who talked and wrote of Christina Rossetti and the Pre-Raphaelites, of Dowson,

Johnson, and their 'tragic generation,' of Conrad, James, and Stephen Crane, seemed an unlikely playmate for the rebel artists, and his theory of Impressionism an unlikely rationale for a literary revolution. In spite of these unlikelihoods, the fact remains that Ford's review and his theories helped set the stage for the more revolutionary efforts to come, and, sensing this, Ford threw in his lot with the new movements.

With resigned benevolence, he took off his Edwardian robes to play a more modern role: 'New Schools of Art,' he said, 'like new commercial enterprises, need both backers with purses, and backers of a certain solid personal appearance or weight in the world. And it is sometimes disagreeable, though it is always a duty, to be such an individual.'[12] As the self-styled doyen of *les jeunes*, he eventually became an 'honorary Vorticist'[13] and the movement's 'novelist *en titre*.'[14] In 1909 he published Lewis and Pound in the *English Review*, and in 1914 they published Ford: the opening section of his novel *The Good Soldier* appeared in *Blast* under its earlier title, 'The Saddest Story.' 'The Vorticists kindly serialized my novel,' Ford wrote later, '– my Great Auk's Egg, they called it. The Greak Auk lays one egg and bursts. That bird was no louder than a thrush in the pages of *Blast*.'[15] It is true that 'The Saddest Story' reads like some pages of the *English Review* accidently bound into a copy of *Blast*, but its presence there was not a mistake. It acknowledged Ford's help in bringing about a magazine and a movement far more revolutionary than the *English Review* and literary Impressionism.

Ford ruefully accepted his obsolescence. 'It didn't, my poor old Impressionist Movement, last such a Hell of a time,' he wrote later. 'The hounds of Youth were upon its track almost before it sat in the saddle. The control of the *English Review*, which I had started mainly with the idea of giving a shove to Impressionism in its literary form, was really snatched from my hands by Mr. Pound and his explosive-mouthed gang of scarce-breeched filibusterers.'[16] While they did not literally take over the *English Review*, figuratively the revolutionaries did something very like it, simply by relegating the review, Ford, and Impressionism to the past. Such are the risks of a 'movement-producer.'

In slightly different versions, in two different books, Ford recreated his rejection by the 'explosive-mouthed' Wyndham Lewis. Walking with Ford and Pound, Lewis suddenly grabbed Ford's arm and in a speech broken by the portentous pauses habitual to him when he wanted to 'impress,' Lewis announced, 'You and Mr. Conrad and Mr. James and all those old fellows

are done ... Exploded! ... *Fichus*! ... *Vieux jeu*! ... No good! ...
Finished! ... Look here! ... You old fellows are merely non-
sensical,' and more to the same effect.[17] But with characteristic
good will, Ford defended the rebel artists from the attacks of
hostile critics. In an article on *Blast* written in 1915, Ford wrote,
'I am in London of the nineteen tens, and I am content to en-
dure the rattles and bangs – and I hope to see them rendered.'
The Vorticists, he argued, were trying to render them as truly as
possible. Placidly Ford concluded, 'I am curious – I am even
avid – to see the method that shall make grass grow over my
own methods and I am content to be superseded.'[18]

Pound had called him 'revolutionary,' but Ford knew better.
His literary Impressionism, like the visual Impressionism of the
New English Art Club and the Slade, was a reform, not a revolu-
tion, and suffered the fate of other 'liberal' reforms. 'So the
Vorticists and the others proceeded on their clamorous ways,'
said Ford. 'They abolished not only the Illusion of the Subject,
but the Subject itself ... They gave you dashes and whirls of pure
colour; words pared down til they were just Mr. Pound's "Petals
on a wet black bough"!'[19] Dashes, whirls, and pure colour were
characteristics of Post-Impressionism and, by putting them in
this context, Ford implicitly admitted that his method did not
offer a literary equivalent to the revolution in art brought about
by Cézanne and his successors.

Nevertheless, his good-humoured openness to change, even
change that threatened to leave him behind, contributed to the
avant-garde spirit of the day, and helped to ease the tensions and
ill-will produced by violent changes and personal ambitions. For
that reason, his work appropriately appears in *Blast*, in spite of
the fact that in matters of art, temperament, and age, he be-
longed to an older generation. The man who did belong, accord-
ing to those criteria of age, art, and temperament – T.E. Hulme
– neither contributed to *Blast* nor is mentioned in its pages. If
the reasons for Ford's presence in *Blast* are mainly personal and
tied to his place in the avant-garde milieu, so, too, must be the
reasons for Hulme's absence, for his theories accorded nearly
completely with those of the Vorticists.

Compared to the genial, open-hearted Ford, Hulme seemed
hard, uncompromising, violent. He loved to argue, and in in-
tense discussions he had a habit of driving his arguments home
by pounding on his listener's arm. He was big, muscular, and
liked to act tough. Of a critic who failed to recognize Epstein's
genius, Hulme wrote, 'The most appropriate means of dealing
with him would be a little personal violence.'[20] Epstein reports

that when asked 'how long would he tolerate Ezra Pound ... Hulme thought for a moment and then said he already knew exactly when he would know to kick him downstairs.'[21] He carried a brass knuckleduster carved for him by Gaudier-Brzeska, the sinister significance of which is hardly mitigated by Kate Lechmere's assurance that he only carried it 'as a sex symbol, not for aggressive purposes.'[22] Hulme rushed to enlist after war broke out in August 1914, and he was in the trenches with the Honourable Artillery Company before his translation of Sorel's *Reflections on Violence* appeared in 1915.

Hulme was killed at the Front in September 1917, some nine months after Ford had begun convalescing from a mild gassing and other complications created by life in the trenches. Before the war changed everything, Ford represented the tolerance, camaraderie, and mutual aid of the times; Hulme stood for its aggressive and violent spirit.

Though aggressive, Hulme was not an intellectual tyrant. He knew how to make friends and influence his contemporaries. 'He had a most dominating personality,' recalled one of those contemporaries, 'by means of which, however, he used to draw out the opinions of his guests and stimulate debate rather than to impose his own views.'[23] He exercised that talent most often at Mrs Kibblewhite's salons, but not everyone found it – or the salons – attractive. Wyndham Lewis jibed at the 'hautise' of the gatherings, and wrote a friend, 'They are a pretty boring folk! Epstein is the only individual in that little set who does anything or has any personality.'[24] Pound complained that Hulme's evenings were 'diluted with crap like Bergson, and it became necessary to use another evening a week if one wanted to discuss our own experiments ...'[25]

It is true that, at first, Hulme's interests did not seem relevant to avant-gardists like Pound and Lewis. Hulme was writing extensively on Bergson and translating Bergson's *Introduction to Metaphysics*, which appeared in 1913. But after a trip to Berlin in the winter of 1912-13, where he heard Wilhelm Worringer lecture on art, Hulme let Bergson drift into the background, and Worringer take over the foreground of his interests. Aesthetics so completely supplanted metaphysics that, beginning with an essay on Epstein in December 1913, everything Hulme published for the next year was on some aspect of modern art. Now Hulme's interests coincided with the experiments of Pound, Lewis, Epstein, Gaudier-Brzeska, and other avant-garde artists. Hulme began to talk their language by becoming the medium for the theories of Worringer.

Those theories appeared in *Abstraktion und Einfühlung*, Wor-

ringer's doctoral dissertation completed in 1906 and published in 1908, the same year in which Meier-Graefe's *Modern Art* appeared and helped bring the first Post-Impressionist exhibition to fruition. Unlike Meier-Graefe's two-volume study, however, Worringer's monograph was not translated until many years later, and was not even written with twentieth century art in mind. 'At the time, without knowing it,' Worringer wrote in a foreword added to a later edition, 'I was the medium of the necessities of the period ... The compass of my instinct had pointed in a direction inexorably preordained by the dictates of the spirit of the age.'[26] Hulme was the first Englishman to recognize the contemporary relevance of Worringer's theories, and to apply them to the work of London's avant-garde painters and sculptors.

Worringer's key terms, 'abstraction' and 'empathy,' describe two kinds of art that derive from two kinds of cultures. The type of culture determines the type of art, and, conversely, the characteristics of the art reveal the nature of the culture that produced it. Empathetic art is 'organic' and permeated by the viewer's 'activity' and 'inner life,' and by his 'empathy' with the work of art. Abstract art is 'inorganic' and 'life-denying' and repels the viewer's attempt to merge his feelings with the work of art. Empathetic art appears in cultures where individualism is strong, where men feel confidence in themselves and do not fear the tyrannies of nature or the supernatural, and where the cultural frame of mind is reasonable and scientific. The art produced is man-centred, joyful, self-indulgent. Abstract art derives from cultures that either fear nature and feel 'an immense spiritual dread of space,' or radically distrust nature, and believe it to be an illusion. Whether from fear or distrust, the culture makes individualism and a 'confident surrender to the outer world impossible.' Instead, men seek transcendental certainties and some form of 'redemption.' Their approach to life is 'religious'; their art is 'a joyless impulse to self-preservation.'

To make his distinctions concrete, Worringer refers to particular historical periods and their characteristic styles of art. Empathetic art, a product of 'the pure imitation impulse, the playful delight in copying the natural model,'[27] found its glory in Greco-Roman sculpture and the painting and sculpture of the Renaissance. Abstract art, with little or no reference to nature and everyday reality, tends towards forms that are non-representational, highly stylized, often geometrical, and monumental. This art tries to eliminate a sense of engagement in space, by eschewing chiroscuro, modelling, foreshortening, perspective, and other three-dimensional effects. The guiding

purpose of this art is to fuse 'the natural model with the elements of the purest abstraction, namely geometrical-crystalline regularity, in order by this means to impress upon it the stamp of eternalization and wrest it from temporality and arbitrariness.'[28] For examples of abstraction Worringer refers his readers to African, Egyptian, Oceanic, Byzantine, and Oriental art.

In the museums of world art, Worringer wandered freely between archeological, ethnological, and fine arts galleries. He approached with equal respect the winged, man-headed bulls of Assyria and the 'Winged Victory' of Samothrace, the carved wooden ancestral figures of the Easter Islands and the portrait paintings of the High Renaissance, insisting that they all, equally

successfully, expressed the 'artistic volition' of their respective cultures. While he admired both kinds of art, Worringer criticized the prevalent western assumption that a work of art was beautiful to the degree that it fulfilled standards of beauty established by Classical Greece and Renaissance Italy. Without denigrating empathetic art, he insisted on the equal beauty of abstract art. Reflecting upon the change from 'unnaturalness' (abstraction) to 'naturalness' (empathy) at the Renaissance, Worringer wrote,

The Renaissance, the great period of bourgeois naturalness, commences. All unnaturalness – the hallmark of all artistic creation determined by the urge to abstraction – disappears ... Whoever has felt, in some degree, all that is contained in this unnaturalness, despite his joy at the new possibilities of felicity created by the Renaissance, will remain conscious, with deep regret, of all the great values hallowed by an immense tradition that were lost forever with this victory of the organic, of the natural.[29]

Worringer tried hard to remain objective in his description and analysis, and impartial in his appreciation of both abstract and empathetic art.

Hulme made no pretense at objectivity or impartiality when he explicated Worringer for his contemporaries. Worringer tried to categorize and analyze two broadly defined types of art and the cultural impulses that lay behind them. Hulme put Worringer's method to narrower and more polemic uses. Worringer wanted to make a contribution to the psychology of style. Hulme wanted to defend abstraction and attack empathy, as part of a campaign to promote certain avant-garde artists he admired, and, more generally, to attack Humanism, Romanticism, and other legacies of the Renaissance.

That broader purpose, lying behind such essays as 'Humanism and the Religious Attitude' and 'Romanticism and Classicism,' became the basis of Hulme's posthumous fame, but, at the time,

what gave him an important place in the avant-garde was his
involvement in the new art movements. As lecturer and essayist,
he explained and promoted the work of Epstein, Bomberg, and
the Vorticists, and it was from these artists, most of whom came
to 67 Frith Street, that he got much of his practical, working
knowledge of the new art forms. 'With artists he was humble
and always willing to learn,' said Epstein, who believed his own
sculpture had helped 'to start the train of [Hulme's] thought.'[30]
According to Hulme, it was, in fact, Epstein's sculpture that
first convinced him of the impending revival of geometric art.[31]
Wyndham Lewis' account of Hulme's relationship with the
avant-garde would have been accurate, had he substituted 'we'
for 'I' when he wrote, 'What [Hulme] said should be done, I *did*.
Or it would be more exact to say that I did it, and he said it.'[32]

Listening to these artists, looking at their work in studios and
at exhibitions, pondering the applicability of Worringer's theo-
ries to their work and to his own likes and dislikes in art, Hulme
learned how to explain the rebel artists' work much more effec-
tively than more eminent critics like Roger Fry and Clive Bell
were able to do. One of Hulme's major contributions was his
presentation of an alternative critical approach for the one
offered by the apologists for Post-Impressionism. Fry and Bell,
said David Bomberg, 'had not the remotest idea what we were
doing. Hulme had and wrote about it and in this way he became
the spokesman for the innovators in the first exhibition of the
London Group.'[33] Those 'innovators,' as a glance at Hulme's
review of the first London group exhibition will show, were
Bomberg, Nevinson, Epstein, Lewis, Wadsworth, Hamilton,
Etchells, and Gaudier-Brzeska, all of whom were in, or closely
related to, the Vorticist movement.

To be 'spokesman' is not necessarily to be an influence, how-
ever, as Bomberg pointed out: 'There is no evidence whatever
of [Hulme's] having any influence on visual art or artists.'
Hulme's 'philosophic ideas,' said William Roberts, 'certainly
played no part in the rise of the English cubist movement in
general. Hulme's role in the Press vis-à-vis his cubist friends was
that of an apologist, their Public Relations Officer as it were.'[34]

Hulme's 'public relations' efforts began with an attack on Ep-
stein's critics in the *New Age* (25 December 1913) and con-
tinued for a year, as he expounded his (ie, Worringer's)
aesthetics, defended artists who illustrated his thesis, and at-
tacked artists like Fry, Grant, and Vanessa Bell, who did not
illustrate his thesis. He openly admitted, however, that his
analysis of avant-garde art was only part of a grander program
designed 'to show the relation between this art and a certain

changed outlook' in modern society. That program was to culminate in a work entitled 'The Break-Up of the Renaissance.'[35] But his extra-artistic intention, to expound an anti-scientific, post-Humanist ethic, did not prevent him from presenting the most complete rationale for 'a new constructive geometric art' to be found outside the pages of *Blast*.

Hulme's most extensive and theoretical discussion of the new art took place on 22 January 1914, when he addressed the Quest Society at Kensington Town Hall on the topic 'Modern Art and its Philosophy.'[36] If his listeners found the lecture 'almost wholly unintelligible,' as Ezra Pound complained in the *Egoist* (16 February 1914), the reason lay partly in Hulme's head-down, inflectionless delivery, and partly in the audience's unfamiliarity with Worringer. For, the theoretical structure of Hulme's argument, as he readily admitted, was 'practically an abstract of Worringer's views.' Lacking any knowledge of Worringer, the audience could easily have found Hulme's argument abstruse, if not totally mystifying. But by the time *Blast* appeared a half-year later, many of Hulme's fundamental arguments had become part of the Vorticist aesthetic.

Drawing upon Cubism and Bergson, Hulme substituted 'geometric' for 'abstract,' and 'vital' for 'empathetic.' Geometric art, he said, is angular, lifeless, and presents the human body in 'stiff lines and cubical shapes.' It reflects an underlying sense of man's separateness from the world around him, and its finest expressions can be found in the art of Byzantium, India, and Egypt. Vital art, however, is soft, naturalistic, and offers an empathetic pleasure. It reflects an amiable relationship between man and his environment. Its fulfilment was the Renaissance, and western culture has remained under its influence ever since.

Hulme had already stated his attitude toward that influence. A month before his Quest Society lecture, he had written in the *New Age* (25 December 1913), 'As if it was not the business of every honest man at the present moment to clean the world of these sloppy dregs of the Renaissance.' Since the first Post-Impressionist exhibition, a contempt for the Renaissance and the classical tradition that lay behind it had become *de rigueur* among avant-garde artists. Gaudier-Brzeska's pronouncement in *Blast* was symptomatic, if not exactly typical: 'VORTEX IS ENERGY! and it gave forth SOLID EXCREMENTS in the quattro e cinquo cento, LIQUID until the seventeenth century, GASES whistle until the FALL OF IMPRESSIONISM.'[37] By getting people to look at primitive and exotic art with new eyes, Post-Impressionism had encouraged a reaction against the classical-Renaissance tradition held sacred by the academies. 'For a while we

were absurdly unjust to the Greeks and Italians,' Clive Bell admitted later.[38]

Hulme's chief contribution, then, was not his attack on the Renaissance tradition of 'vital' art but first, his Worringer-inspired point of view and critical vocabulary and, second, his realization that he should shift the anti-Renaissance base of attack from Africa, Polynesia, or Egypt to twentieth century England and its totem, the machine. By shifting his reference point to the machine and drawing upon terms that emphasized mechanicalness, Hulme distinguished his criticism from Fry's, Bell's, and others of the 'advanced' school of critics. He evaded the cul-de-sac of primitivism, and the entangling vagueness of terms like 'rhythm,' 'harmony,' and 'significant form.' Guided by Worringer and a feeling for the nature of machinery, he used words that not only said what the art really looked like, but, through analogies, directed people's attention toward the modern, machine world that was one of the direct inspirations for that art. Conventional terms of praise like 'graceful, beautiful, etc.,' have been replaced, Hulme explained, by 'epithets like austere, mechanical, clear cut and bare ...'[39]

Hulme used such terms as 'stiff lines and cubical shapes,' 'austerity and bareness,' and 'hard mechanical shapes' in his own discussions of modern art. In support of his own views, he pointed out that the sensibility of modern artists finds satisfaction in the 'hard clean surface of a piston rod,' and in the machine-like qualities of 'engineers' drawings, where the lines are clean, the curves all geometrical, and the colour, laid on to show the shape of a cylinder for example, gradated absolutely mechanically.'[40] The artistic volition of the present, Hulme concluded, must be expressed 'not so much in simple geometrical forms found in archaic art, but in the more complicated ones associated in our minds with the idea of machinery.'[41] In that phrase, 'the idea of machinery,' Hulme rejected the Futurists' practice of making machinery the subject of the picture. What interested him was art that showed 'the attempt to create ... structures whose organisation, such as it is, is very like that of machinery.'[42] The machine's impact on form, not content, was what Hulme tried to make his listeners and readers appreciate.

Hulme argued that the assimilation of machinery into art controlled, for instance, Wyndham Lewis' pictures, in which 'it is obvious that the artist's only interest in the human body was in a few abstract mechanical relations perceived in it, the arm as lever and so on. The interest in living flesh as such ... is entirely absent.'[43] In general, Hulme found the 'innovators' of the London Group producing pictures 'dominated by a composition

based on hard mechanical shapes in a way which previous art would have shrunk from.'[44] For the first time, said Hulme, artists can be inspired by 'the superb steel structures which form the skeletons of modern buildings ...'[45] For support he could have quoted Wyndham Lewis' remark in the catalogue for the 'Exhibition of the Camden Town Group and Others' (December-January 1913-14): 'All revolutionary painting to-day has in common the rigid reflection of steel and stone in the spirit of the artist ...'

By 1914, much of Lewis' own work had taken on the mechanical qualities Hulme praised; so had Bomberg's, Wadsworth's, Roberts', Gaudier-Brzeska's and several others, including Epstein's. His 'Rock Drill' (first exhibited in March 1915) perfectly fulfilled Hulme's criteria. Most of these works appeared to have been created in the spirit of Orick Johns' lines published in Pound's *Catholic Anthology* of 1915:

> For behold the muscles of man –
> They are piston-rods; they are cranes,
> hydraulic presses, powder magazines.

But Hulme sensed another, deeper, less obvious relationship between geometric art and the modern machine world. He believed he saw in 'the use of mechanical lines in the new art,' not only the reflection of the 'mechanical environment,' but, more important still, 'a change in sensibility which is, I think, the result of a change of attitude which will become increasingly obvious.'[46]

That change of attitude was to create a frame of mind T.S. Eliot called 'classical, reactionary and revolutionary,'[47] and Hulme's speculations on it drew him away from the specific artistic problems of the avant-garde and back toward the philosophical, political, and ethical concerns of his writings before 1914. But, during the time he devoted his attention to the new art, he developed a consistent and accurate approach to geometrical art, and supplied some of the arguments the Vorticists needed to distinguish themselves from the general Post-Impressionist-Futurist movements of the time. Certainly, many of the Vorticists' aesthetic principles can be found, free from the stylistic fireworks of *Blast*, in the essays of Hulme.

By all rights, Hulme should have been represented in *Blast*, and there is some evidence that he expected to write an essay on Epstein for the first issue.[48] But the essay was not written, and in the meantime Lewis had come to regard Hulme as an enemy. He resented Hulme's high regard for Epstein, and he believed Hulme had stolen Kate Lechmere from him. When Lewis first learned that Kate Lechmere was seeing Hulme, he rushed to Frith Street and attacked Hulme, who dragged Lewis out to the

street and hung him upside down by his trouser cuffs on the
railing of Soho Square.[49] Since Pound was not on good terms
with Hulme either (he had sided with Lewis in a quarrel with
Hulme's favourite, Epstein), there was little chance that Hulme
would appear as a supporter of the Vorticists. The Lewis-Pound
*versus* Hulme-Epstein feud was a good example of the way per-
sonalities and personal relationships among members of the
avant-garde shaped the course of movements like Vorticism.
There was no South Lodge spirit of reconciliation to patch
things up. So, *Blast* No. 1 appeared with eleven pages devoted
to Ford's novel, and not a single word by or about Hulme.

# 6
# 'England Has Need of These Foreign Auxiliaries' Futurism in England 1910-13

'We are all futurists to the extent of believing with Guillaume Apollinaire that "On ne peut pas porter *partout* avec soi le cadavre de son père," ' Ezra Pound announced in an essay on Vorticism in the *Fortnightly* (1 September 1914). Pound could not leave it at that, however; so he added the important qualification: 'But "futurism," when it gets into art, is, for the most part, a descendant of impressionism. It is a sort of accelerated impressionism.'[1] A few months earlier, Wyndham Lewis wrote in *Blast*, 'Of all the tags going, "Futurist," for general application, serves as well as any for the active painters of to-day.' But, Lewis added, 'Futurism, as preached by Marinetti, is largely Impressionism up-to-date. To this is added his Automobilism and Nietzsche stunt.'[2]

As the leading spokesmen for Vorticism, Pound and Lewis had to distinguish between Futurism as a revolutionary frame of mind, and Futurism as a visual style peculiar to a group of Italian painters, whose manifestoes and chief spokesman, F.T. Marinetti, had made their brand of Futurism one of the best publicized art movements in England and the continent. Pound and Lewis wanted Vorticism to be clearly associated with the first kind of Futurism, and just as clearly dissociated from the second. 'You might keep in mind that Vorticism is not Futurism, most emphatically NOT,' Pound wrote to H.L. Mencken in March 1915.[3]

The differences between Futurism and Vorticism were not always as clear to other people as they were to the Vorticists. Consequently, Futurism seemed an active threat to the Vorticists' independence, while other influences, like Ford's 'Impressionism' and Hulme's 'Classicism,' did not. The give-and-take that Ford and Hulme conducted with their milieu attracted little public notice, and, in 1914, only the most discerning and *au courant* observers could have detected their contribution to Vorticism. But Futurism attracted everyone's attention in England, and many people regarded Vorticism as nothing more than

Futurism in English dress. For the Vorticists, then, the last and most difficult step toward gaining recognition for their movement became the repudiation of Marinetti and his brand of Futurism.

The bombastic, audacious, irrepressible Marinetti had spent much of his life among the avant-garde artists of Paris, where he had absorbed their delight in violent and public displays of contempt for bourgeois values. He created the Futurist movement by inventing the term 'futurist' and its opposite, 'passéist,' and introducing them to the world in the first 'Manifesto of Futurism,' printed in *Le Figaro*, 20 February 1909. In the following years Futurist doctrine expanded to include pronouncements on painting, sculpture, architecture, cinema, clothing, war, women, drama, music, politics, and music halls. Futurist theories were stated and restated, spun out, and sophisticated in innumerable manifestoes, lectures, exhibition catalogues, books, and articles, but the initial manifesto remains the best single statement of the Futurists' attitudes toward the modern world.[4]

With youthful bravado – 'We shall sing the love of danger, the habit of energy and boldness' – Marinetti launched the Futurist attack on 'passéist' institutions: 'Come, then, the good incendiaries, with their charred fingers! ... Set fire to the shelves of the libraries! Deviate the course of canals to flood the cellars of the museums! Oh! may the glorious canvases drift helplessly! Seize pickaxes and hammers! Sap the foundations of the venerable cities!' This delight in destruction led inevitably to: 'We wish to glorify War – the only health giver of the world – militarism, patriotism, the destructive arm of the Anarchist, the beautiful Ideas that kill, the contempt for woman.' On the constructive side, Marinetti proclaimed,

We shall sing of the great crowds in the excitement of labour, pleasure and rebellion; of the multi-coloured and polyphonic surf of revolutions in modern capital cities; of the nocturnal vibration of arsenals and workshops beneath their violent electric moons; of the greedy stations swallowing smoking snakes; of factories suspended from the clouds by their strings of smoke; of bridges leaping like gymnasts over the diabolical cutlery of sun-bathed rivers; of adventurous liners scenting the horizon; of broad-chested locomotives prancing on the rails, like huge steel horses bridled with long tubes; and of the gliding flight of aeroplanes, the sound of whose screw is like the flapping of flags and the applause of an enthusiastic crowd.

For art, there was now 'the beauty of speed,' evoked by Marinetti's announcement that 'A racing motor-car ... is more beautiful than the *Victory of Samothrace*.' Here was the sensibility Lewis later contemptuously labeled 'Automobilism.'

Marinetti saw further into the nature of twentieth century life

than Lewis gave him credit for. Like the Futurist of fifty years later, Marshall McLuhan, Marinetti hoped to open people's eyes and ears to the industrial-urban mass culture that even in 1910 drew western man inside the boundaries of a 'global village.' That process stimulated a new 'world-consciousness,' as Marinetti put it in his manifesto, 'Wireless Imagination and Words at Liberty.' In that manifesto Marinetti said, 'The inhabitant of a mountain village can, every day, in a newspaper, follow with suspense the movements of the Chinese rebels, the English and American Suffragettes, Dr. Carrel and the heroic sledges of the Arctic explorers.' Under the influence of this new 'world-feeling,' said Marinetti, man's 'need of knowing what his ancestors *did* is mediocre; that of knowing what his contemporaries *are doing*, in all parts of the world, is incessant.' These insights, along with pronouncements on 'man multiplied by the machine,' on the 'acceleration of life,' and on modern society's 'love of speed, of abbreviation, of summary and synthesis,' could have appeared in *Explorations* in the late 1950s, rather than in Harold Monro's *Poetry and Drama*, where, in fact, they did appear in September 1913.

When it came to putting his theories into practice, however, Marinetti went in the opposite direction from McLuhan's 'cool' presentation. Marinetti's favourite medium, the public declamation or *conferenza*, was decidedly 'hot.' Because he liked to expound and berate and dramatize, Marinetti did not always convey the subtlety of his ideas. The same problem arose when he applied his 'wireless imagination' to poetry. His 'words at liberty' (*parole in libertà*) poems incorporated a number of stylistic innovations to produce a crude, telegraphic report of events and sensations. Syntax disappeared, along with punctuation and metre, to be replaced by a simplistic onomatopoeia, mathematical and musical notations, and other non-verbal effects. Fragmented impressions and transcribed sound effects were about as much as 'words at liberty' had to offer until they evolved into pictorial poetry similar to Apollinaire's 'Calligrammes.' Soffici's 'Al Buffet Dalla Stazione,' for instance, used the words of a poem about a man sitting at a table reading a newspaper to form the outline of a man sitting at a table reading a newspaper.[5]

Going one step further, some Futurist painters incorporated words into predominately visual designs. Unlike the restrained Cubist constructions with words or word fragments like 'jour' and 'fête' strategically placed for formal and decorative effect, the Futurists' word-pictures used onomatopoeic words and sound effects 'dynamically.' For example, Severini's *Danza Serpentina*, reproduced in *Lacerba* (1 July 1914), was a brush

drawing with curves and splinter-shapes mixed with words and sound-effects like 'tta tta tta' and 'sz sz sz sz,' the latter getting larger and larger to suggest increasing volume. Carrà's collage on cardboard, *Patriotic Celebration*, was a shattered pinwheel of colours, words, and word-fragments. Joshua Taylor, who reproduced the collage in his book, *Futurism*, nicely captures its Futurist verve in his description: 'Beginning in the center with EVVIVVAAA L'ESERCITO and EEVVIIIVAAA IL REEE (Long live the Army! Long live the King!), it spirals outward with the HUHUHUHUHUHUHU of a siren and loses itself in echoes, shouts, songs, and the noise of traffic – TRRRRR and traak tatatraaak.'[6]

These word-picture experiments only began to appear after – and as an off-shoot of – the adoption of general Futurist principles by five young Italian painters, Umberto Boccioni, Carlo Carrà, Luigi Russolo, Giacomo Balla, and Gino Severini, who responded to Marinetti's first call to arms. Inspired by Marinetti's attack on passéism and by his evocation of 'the beauty of speed,' they issued a 'Manifesto of Futurist Painting' in the Milanese journal *Poesia* in February 1910, and followed it with a more carefully worked out 'Technical Manifesto of Futurist Painting' in April. 'We declare,' they wrote in the April manifesto, 'that all subjects previously used must be swept aside in order to express our whirling life of steel, of pride, of fever and of speed.'

Art, they insisted, must express 'universal dynamism' – a phrase intended to call up a violent sort of Bergsonian flux: 'All things move, all things run, all things are rapidly changing.' To catch this feverish flux, the Futurists tried to get beyond – in Bergson's words – 'sharply cut crystals' and 'frozen surfaces' of life, to find and express the 'continuous flux' that is reality. 'The materiality of bodies,' said the technical manifesto, must be broken down and the boundaries between objects dissolved so that objects and their surroundings merge: 'Our bodies penetrate the sofas on which we sit, and the sofas penetrate our bodies. The motor-bus rushes into the house which it passes, and in their turn the houses throw themselves upon the motor-bus and are blended with it.'

On canvas, these theories found visual equivalents in intricate patterns of overlapping images, which were supposed to represent different simultaneous events or multiplied components of a single event. 'A running horse has not four legs, but twenty, and their movements are triangular,' said the Futurists,[7] and several of Carrà's studies of running horses present, literally, that image of a many-legged animal shaped to fit a triangle composition. The best-known exercise in this manner is Balla's *Dynamism of a Dog on a Leash*, showing the torso of a little

black dog with a flurry of blurred feet beneath, many wagging tails behind, and a shining chain leash filling the air with whirling patterns above.

Overlapping or interpenetrating and simultaneous facets of an event usually produced more complicated pictures, like Boccioni's *States of Mind: The Farewells,* in which a railroad engine – its number, 6943, clearly visible amid billows of smoke – is caught in wavering diagonals of steam, shadowy human forms, sharply outlined signal towers, bright lights, and less identifiable shapes, lines, and angles. Another Futurist expression of simultaneity was Severini's evocation of a noisy, brilliantly lit cabaret, *Dynamic Hieroglyphic of the Bal Tabarin,* in which the image of a dancer in a white, puce, and pink costume decorated with real sequins glued to the canvas, 'explodes' into bright, angular fragments interwoven with banners, words ('valse,' 'polka,' etc.), musical instruments, hats, and faces broken into 'Cubist' facets and angles.

Paintings like these and many other Futurist works depended on strong empathetic appeal. In fact, the Futurists had announced in their technical manifesto, 'We shall henceforward put the spectator in the centre of the picture.'[8] They tried to do this by painting 'force-lines,' angles, curves, and swirls intended to represent the energies and forces of life extended into the composition of the work. The painting of a riot scene, for instance, should 'encircle and involve the spectator,' they said, 'so that he will in a manner be forced to struggle himself with the persons in the picture.'[9]

Without sacrificing the 'dynamism' of the object or event, the Futurist painters began producing increasingly abstract designs, like Balla's studies of light and his 1913 series of drawings using the vortex as a dynamic image of centripetal and centrifugal forces. Balla, more than the other Futurists, seemed drawn to purely visual problems created by the relationship of colour, lines, and planes, but all the Futurists, to varying degrees, shared his interest in abstract design. The technical manifesto had pointed out that, 'One may remark, also, in our pictures spots, lines, zones of colour which do not correspond to any reality, but which, in accordance with a law of our interior mathematics, musically prepare and enhance the emotion of the spectator,'[10] and in the catalogue for his one-man show in London in 1913, Severini insisted that, 'It has been my aim while remaining within the domain of the plastic, to realize, in the paintings and drawings which I am exhibiting, forms which partake more and more of the nature of the abstract.'[11]

At one extreme the Futurists produced schematic (or cinematographic) analyses of movement, and at the other extreme,

abstract compositions with titles like *I Want to Synthesize the
Unique Form of Continuity in Space* (Boccioni), or *Spherical
Expansion of Light (Centrifugal)* (Severini). But as far as the
public was concerned, Futurist polemics and Futurist art went
hand in hand, and the term 'Futurist' brought to mind mani-
festos and public demonstrations as readily as paintings and
sculpture, and, still less, poetry, drama, music, architecture, etc.
In England, the major exhibitions of Futurist work, in March
1912, April 1913, and May-June 1914, probably made no
greater impact on the avant-garde or the public in general than
did the visits of Marinetti between 1910 and 1914.

92    Marinetti arrived in England for the first time in April 1910. He
came 'adorned with diamond rings, gold chains and hundreds
of flashing teeth,' wrote Douglas Goldring, who also reported
that, according to Wyndham Lewis, Marinetti's money came
from 'a chain of de luxe brothels in Egypt, controlled by Mari-
netti père.'[12] This short, balding, dapper man with well-tailored
suits, a dark moustache turned up at the ends, and a personality
as florid as his prose style, arrived at the right time to take ad-
vantage of the growing importance of England's avant-garde.
He found a popular press ready to report the latest 'art shocks'
and a general spirit primed for dynamic change and violence.
With unshakeable self-confidence and a certain naïve-exotic
charm, Marinetti set out to make Futurism the best-known
movement of the day. In the process, he gave invaluable lessons
to the future Vorticists in the principles and practice of art
propaganda.

Marinetti appeared at the Lyceum Club in London in April
1910 to present a 'Discours futuriste aux Anglais,' in which he
not only explained the 'violent and complicated Futurist ideo-
logy,'[13] but applied Futurist criteria to England itself. He found
much that pleased him:

What we like in you is your indomitable and bellicose patriotism [he
told his English audience]; we like your intelligent and generous indi-
vidualism which allows you to open your arms to the individualists of
all countries ... You have kept an unbridled passion for fighting in all its
forms, from boxing – simple, brutal and swift – to the roar from the
monstrous throats of the guns crouched in their revolving caves of steel
on the decks of your Dreadnoughts, when they smell in the distance
appetising squadrons.[14]

But, as Marinetti was to point out again and again, England was
a paradox: 'You adore the beautiful flying machines that skim
over earth, sea and clouds, and yet you jealously preserve the
least fragment of the past.'[15]

Although Marinetti praised England for its open-armed recep-

tion of individualists from all countries, he berated his audience for applauding him, and concluded his speech with characteristic belligerence: 'Oh, you who are among the many who disapprove of these Futurist convictions of ours, but who nevertheless force yourselves to applaud me because of the duty of hospitality, go ahead and brutally break the block of your beautiful English courtesy, and hoot lengthily at me, at your pleasure, freely.'[16]

In March 1912, Marinetti returned, as outspoken as ever, and brought Boccioni, Carrà, and Russolo with him. The Futurists accompanied their first international exhibition, which had opened in February at the Bernheim Gallery in Paris. From Paris the exhibition came to the Sackville Gallery in London, and from there went on to Berlin, Brussels, Amsterdam, and Munich, touring the continent like a grand circus. Besides its more than thirty paintings, the exhibition offered a thirty-six page catalogue containing Marinetti's initial Futurist manifesto, the Futurist painters' first manifesto, their further statement of principles called 'The Exhibitors to the Public,' and explanations of many of the individual works in the show. For the London exhibition, everything in the catalogue was translated into English, with the result that the catalogue raised nearly as much controversy as the paintings.

Arriving less than two years after the first Post-Impressionist exhibition, the Futurists' show got the response one would expect. 'Emotions, experience, noises, headaches, vertigo, absinthe, these are the things which the Futurists try to express in terms of paint. They do not as yet express them in terms of art,' said the *Graphic* (9 March 1912). The *Evening News* (2 March 1912) was pleased to announce that Futurism had 'fallen flat as a breathless pancake' now that its manifestos and theories had been translated into paintings that looked like 'the most imaginative linoleum [or] the cut-paper work of a Colney Hatch Kindergarten ...' According to Walter Sickert, the *Morning Post* refused to print Robert Ross' review 'on the plea that the Futurist Exhibition was in itself an immorality, and must not be chronicled.'[17]

After roundly condemning the Futurists in an interview with the *Pall Mall Gazette*, the academic painter Sir Philip Burne-Jones wrote to the same newspaper (5 March 1912) to point out that the 'authors of the ludicrous productions' at the Sackville Gallery were 'outside the pale of Art altogether, and are no way concerned with it.' When challenged in his judgments by Max Rothschild, the proprietor of the Sackville Gallery, Sir Philip reiterated his condemnation and neatly ended the argument by admitting that, 'I oughtn't to have been interviewed

about such a silly subject.'[18] P.G. Konody made the same point perhaps more subtly. 'To analyze these Futurist pictures is simply impossible,' he wrote in the *Pall Mall Gazette* (1 March 1912). 'The majority of them strike one as the pictorial rendering of confused nightmares, in which all objects are not only in motion, but in dissolution under the impulse of violent forces.' The result, Konody concluded, is 'chaos.'

One of the few Englishmen to speak well of the exhibition was Walter Sickert, who wrote, 'Austere, bracing, patriotic, nationalist, positive, anti-archaistic, anti-sentimental, anti-feminist, what Proudhon calls anti-parnocratic, the movement is one from which we in England have a good deal to learn.' But Sickert inserted an important qualification: 'The Futurist movement confesses to a literary origin; and the alliance of pen and brush has its dangers for both.'[19] Because of the importance given to the catalogue's manifestos and interpretations, Futurism seemed too dependent on exposition and special pleading. For those reasons, said Lewis Hind in the *Daily Chronicle* (4 March 1912), 'the movement fails.' P.G. Konody admitted that a careful study of the catalogue 'invests these pictures with new interest – the fascinating work of trying to reconcile the visible facts with the printed key,' but he insisted that the pictures 'are the outcome of a new and thoroughly objectionable literary tendency.'[20] The Futurists did, presumably, expect the catalogue to be an important part of the exhibition (according to Boccioni, 17,000 copies were printed for the Paris exhibition alone[21]) and, like Marinetti's *conferenze*, it spread the impact of Futurism far beyond the walls of the Sackville Galleries.

While the general English reaction fulfilled Lewis Hind's prediction that 'England, as a whole, will laugh at or loathe these works ...'[22] the Futurists were satisfied. Severini reported to Boccioni that the exhibition was spreading the fame of Futurism,[23] and Marinetti, with his usual enthusiasm, declared in a letter to a friend that the show was a 'colossal success,' that more than 350 articles had been written about it, and that sales had exceeded 11,000 francs.[24] Futurism had made its mark in England.

Not content to let the exhibition, the catalogue, Marinetti's lecture, and the many articles in the press force Futurism upon the English consciousness, Marinetti and Boccioni tried to bring Futurist violence directly into English life. Boccioni joined suffragette demonstrations, where, in spite of the Futurists' much publicized 'contempt for women,' he found himself fighting to protect the demonstrators from hostile crowds, and 'encouraging and cheering them when [he] saw them arrested,' he reported in a letter to his friend, Vico Baer.[25] Then, inspired by Italian patriotism, he and Marinetti 'went to insult' the English

94

journalist, Francis McCullagh, who had covered Italy's campaign against Turkey in 1911 and had written some uncomplimentary reports on Italian tactics at Tripoli.

In the quiet of a cottage in Surrey, McCullagh was writing his book on the Italian campaign, *Italy's War for a Desert*, when, to quote his account in the introduction to that book, he was interrupted by three gentlemen:

They were Signor F.T. Marinetti, who calls himself a 'poet,' and who said that he had just come from Tripoli and was staying at the Savoy Hotel; Signor Boccioni, who is, I believe, a 'futurist' painter; and another gentleman who did not give his name, but whom I suspected to be the London correspondent of the 'Giornale d'Italia.' The object of these men was to fight a duel with me ... I told them that I would communicate with them in due course; whereupon one of them threatened to attack me there and then ... Then the 'poet' got on his legs and began an oration which lasted a quarter of an hour ...

'All this was very amusing,' McCullagh concluded, 'and the manner in which my visitor strutted about the room like a hero in melodrama was more amusing still.'[26]

If the tone of McCullagh's account represents a characteristic English response to the Futurists – especially to their more self-dramatizing and jingoistic postures – then a report of the same incident written by Giullo Bucciolini for *La Nazione* (16 March 1912), epitomizes, equally well, the very qualities in Futurism that the English found so hard to take seriously.

Marinetti and Boccioni demanded that McCullagh, in Bucciolini's words, 'answer for the lies written about the atrocity supposedly committed by our soldiers in Libya.' McCullagh 'made no reply.' 'Therefore,' Bucciolini wrote, 'Marinetti, who doesn't mince his words [che non ha peli sulla lingua], called McCullagh a coward and accused him of selling out to the Turks.'

'To tell the truth,' Bucciolini continued, 'as he was already there, Marinetti would have liked to strike him, but recalling that he was in his adversary's home, he exerted amazing self-control, and did not do it. In spite of this, McCullagh did not open his mouth.' Marinetti and Boccioni remained in London another twenty-four hours, to give McCullagh time to make his reply. But, 'Although very much alive, he played dead ... silence.'

To Bucciolini, who treated the two Futurists as heroes throughout his account, the lesson they gave the Englishman was 'just' because inspired by 'patriotism and national awareness,' and the act commanded admiration because it was 'audacious' and 'cavalier.' It was symptomatic, he felt, of a new Italian spirit, which the world could no longer afford to ignore.

It proved that 'Italians can demand respect, if they wish to do so.' That fact had not been taken into account by McCullagh when he wrote his 'lies.' Now he had been faced down and made to appear not only a liar but a coward.

After his first encounter with English culture, Boccioni, like Marinetti, regarded England with considerable ambivalence: 'London, beautiful, monstrous, elegant, well-fed, well-dressed but with brains as heavy as steaks,' he wrote Vico Baer. 'Inside, the houses are magnificent: cleanliness, honesty, calm, order, but fundamentally these people are idiots or semi-idiots ... What does it matter if some day under the ruins of London raincoats will be excavated intact, and account books without ink spots?'[27]

Marinetti returned to the futurist-passéist duality of English culture in a lecture at Bechstein Hall on 19 March 1912. There, according to the *Daily Chronicle* (20 March 1912), he praised England for 'its brutality and arrogance,' but attacked it 'as a nation of sycophants and snobs, enslaved by old worm-eaten traditions, social conventions and romanticism.' Two weeks earlier, in an interview with the *Evening News* (4 March 1912), he enthused, 'Why, London itself is a Futurist city!' As evidence he listed its 'brilliant hued motor buses,' 'enormous glaring posters,' 'coloured electric lights that flash advertisements in the night,' and the Underground, where 'I got what I wanted,' said Marinetti, '– not enjoyment, but a totally new idea of motion, of speed.' Unfortunately, he concluded, English artists were not taking advantage of this Futurist raw material: 'The fact is that your painters live on a nostalgic feeling, longing for a past that is beyond recall, imagining they live in the pastoral age ...'

By this time Marinetti's views were becoming known – and shared – by many in London's avant-garde. Marinetti's Lyceum Club lecture in April 1910 had introduced Futurism to England. The August 1910 issue of the *Tramp*, Douglas Goldring's magazine for 'outdoor living,' had printed passages from the initial manifesto and a letter sent by Marinetti to *Poesia* telling how he, and other Futurists, had flung thousands of copies of an anti-Venice manifesto from the clock tower of the Piazza San Marco. Then Futurism came to London in full force in March 1912, and found an audience ready to go to the Sackville Gallery to look at Futurist art, and to Bechstein Hall to listen to Marinetti lecture and read his own poetry 'with such an impassioned torrent of words that some of his audience begged for mercy,' said the *Times* (19 March 1912). That newspaper concluded that, 'The anarchical extravagance of the Futurists must deprive the movement of the sympathy of all reasonable men.'

London's avant-garde, which probably did not fall into the *Times'* category of 'reasonable men,' enjoyed what it heard. 'The long-haired gentlemen in the stalls and the ladies with Rossetti eyes and lips' – as the *Daily Chronicle* (20 March 1912) called the avant-garde segment of Marinetti's audience – 'rewarded him with their laughter and applause.' Substantiating the *Chronicle*'s report, Harold Monro wrote in *Poetry and Drama* the following year, 'People will recollect the discourse, and the wonderful reading, of the little Marinetti (little of body as he seemed in a huge empty hall, but immense of spirit), at the time of the [Futurist] exhibition, to a handful of English, who, just as night after night they clap Shaw, wildly applauded his outspoken derision of all their cherished national characteristics and customs.'[28]

The Futurists returned in 1913. In April, Severini showed thirty works in a one-man show at Marlborough Galleries, and happily reported to a friend that the show had to be extended beyond its original closing date of 26 April in order to accommodate the large crowds.[29] Interviewed by the *Daily Express* (11 April 1913), Severini said that while traveling in England he was glad to get out of the countryside with its 'hideous prettiness of the panorama (the delight of landscape painters),' and into the city, with its 'violent affirmation of human activity.' 'London,' he said, 'is a city where movement and order reign.' These qualities, accompanied by England's 'essentially masculine spirit,' would help Englishmen appreciate Futurism, said Severini.

Certainly Futurism was making headway in England. In September 1913, Harold Monro devoted a large part of *Poetry and Drama* to discussing Futurism, reprinting Marinetti's new Futurist manifesto, 'Wireless Imagination and Words at Liberty,' and offering translations of poems by Marinetti, Buzzi, and Palazzeschi, including such characteristic passages as,

We race

We rise

We must sing a new song of our speed

We must chant a new hymn of ascent.

Soon we shall make ourselves lungs of the sponge of the spaces and

wings of the plumes of the clouds.

O mankind of yesterday

you may bury a spear in your bosom!

Born is the race that shall leave you behind

by a leap into heaven, the men

who tread you like ants, and crush.

(Paolo Buzzi, from *Versi Libri*)

Destroy! destroy! destroy!
For no beauty exits but alone in the sound of this terrible word,
This shattering word like a hammer of Cyclops
Destroy! destroy! destroy!
(F.T. Marinetti, from *Distruzione*)[30]

A review of the Italian *Book of the Futurist Poets* in the same issue of *Poetry and Drama* pointed out that poetry like this 'is composed recklessly for immediate and wide circulation and declamation in large assemblies, frequently for purposes of propaganda. It is verse rather for the ear than for any close and studious scrutiny by the eye.' As if in confirmation, Marinetti appeared in November to propagandize and declaim at the Cave of the Golden Calf's Cabaret Club, the Poet's Club, the Poetry Bookshop, Clifford Inn Hall, and the Doré Gallery.*

'I was sorry you did not come to the Cabaret Club last night,' Wyndham Lewis wrote Mrs Percy Harris, a patron of the arts and friend of Ford Madox Ford, 'as Marinetti declaimed some peculiarly blood-thirsty concoctions with great dramatic force.' Lewis urged her to hear Marinetti at the Doré Gallery. 'He will not, there, enter into direct rivalry with the Grand Guignol, I imagine,' said Lewis, 'but will no doubt be well worth hearing.'[31] Marinetti later called the Doré session, 'una conferenza triomfale.'[32]

If audiences were not as sanguine about his success as Marinetti was, neither were they indifferent or hostile. 'Those who have heard [Marinetti] in the last few days, know what vitality means,' said Henry W. Nevinson, the journalist father of C.R.W. Nevinson. 'He pours out life like ungrudging nature,' Nevinson continued. 'Like all true-hearted fanatics, he lives only for his cause and never counts the cost,' but when Marinetti recited 'with such passion of abandonment,' Nevinson continued, 'no one could escape the spell of listening.'[33] John Rodker found 'this quality of vigour and strength' to be 'the most amazing thing about Signor Marinetti,' and he described a *conferenza* at which Marinetti 'spoke for more than an hour with a passion and a fervour incredible, a perfect torrent of phrase and sound coming from his lips – sufficient, one would have thought, for ten movements.'[34]

At the Poetry Bookshop, Edward Marsh observed Marinetti's performance with interested amusement, and described the

98

* According to Marinetti's introduction to *Zang Tumb Tuuum Adrianopli Ottobre 1912*, these performances took place from 16 through 20 November. The same locations, without dates, are listed in 'The Origins of Futurism' *Poetry and Drama* I (December 1913) 389.

event in a letter to Rupert Brooke. Since the large upstairs meeting room at the Poetry Bookshop was 'illuminated by a single nightlight,'

Marinetti began his lecture [Marsh reported] by asking how he could possibly talk in a penumbra about Futurism, the chief characteristic of which was Light, Light, Light? He did very well all the same. He is beyond doubt an extraordinary man, full of force and fire, with a surprising gift of turgid lucidity, a full and roaring and foaming flood of indubitable half-truths ... As a piece of art, I thought [his reading] was about on the level of a very good farm-yard imitation – a supreme music-hall turn.[35]

Harold Monro shared Marsh's admiration-reservations. 'We admire his extraordinary inventiveness,' he wrote in *Poetry and Drama*, 'we were enthralled by his declamation; but we do not believe that his present compositions achieve anything more than an advanced form of verbal photography.'[36]

For the benefit of the readers of the *New Freewoman*, Richard Aldington reported, 'M. Marinetti has been reading his new poems to London. London is vaguely alarmed and wondering whether it ought to laugh or not ... It is amazing to a glum Anglo-Saxon to watch M. Marinetti's prodigious gestures ... It would be humorous if M. Marinetti were not so serious, and really an artist in his own fashion.' Whatever his extravagances, Marinetti seemed to Aldington to be a 'fearless experimenter' and 'a great deal better than the bourgeois men and women who grin at him when he reads.'[37]

To crown Marinetti's success among the avant-garde, a committee of rebel artists – Etchells, Hamilton, Wadsworth, Lewis, and Nevinson – organized a dinner in his honour. Between twenty and thirty people paid 3s 6d each to dine with Marinetti at the Florence Restaurant on 18 November,[38] and to hear him declaim his 'Siege of Adrianople,' a prose-poem profuse with thumping, onomatopoeic passages describing the bombardment. In Marinetti's rendition, siege guns rent the air in a 'harmony of ZZZZANG-TUMB-TUM,' shattered fragments of echoes reverberated with a 'tumb-tumb-tumb-tumb-tumb-tumb,' and the whole battle 'orchestra' interminably played its theme of 'tumbtumb-tumbtumbtumbtumbtumb.'* Nevinson remembers Marinetti

---

* The poem appears in varying versions in print. A characteristic passage, as printed in *Zang Tumb Tuuum* pp184-5, reads as follows: '... pazzi bastonare professori d'orchestra questi bastonatissimi suooooonare suooooooonare graaaaandi fragori non cancellare precisare rittttt-agliandoli rumori più piccoli minutisssssimi rottami di echi nel teatro ampiezza 300 chilometri quandrati ... 20000 granate protese strappare con schianti capigliature tenebre zang-tumb-zang-tuuum tuuumb.'

accompanying the declamation 'with various kinds of onama-topoeic noises and crashes, while all the time a band downstairs played "You made me love you, I didn't want to do it." '[39]

If the conjunction of declamation and band music described by Nevinson sounds too good to be true, symbolically it was true enough. Aldington's grudging admission that Marinetti was 'really an artist in his fashion' suggests the respect, if not love, Marinetti inspired among the avant-garde. In an article for the *New Weekly* (30 May 1914), Wyndham Lewis, too, admitted to admiring Marinetti's ability 'to instill into people the importance of the Present, the immense importance of Life.' Proclaiming Marinetti to be 'the intellectual Cromwell of our time,' Lewis insisted that 'England has need of these foreign auxilaries to put her energies to rights and restore order.'[40]

Lewis often inclined toward exaggeration for stylistic or propagandistic effect, but there is no reason to believe that he did not mean what he said about Marinetti. Like many in England's avant-garde, he found Marinetti interesting, amusing, and useful to the avant-garde cause. Marinetti made things lively, and, by example, encouraged a boisterous contempt for bourgeois attitudes. His approach appealed more immediately to the most outspoken branch of the avant-garde than did Roger Fry's earnest efforts to convert the philistines, or Ford's wry encouragement of *les jeunes*, or Hulme's self-assertive and dogmatic defence of the new geometrical art. When Aldington called Marinetti a 'great experimenter' and Lewis told Mrs Percy Harris that Marinetti 'will be well worth hearing,' they spoke for the avant-garde as a whole.

Later, when Marinetti's themes became too familiar and his extravagant personality more of a hindrance than a help to the English avant-garde, Lewis and others launched their attacks against him. Those attacks gave the false impression that the Vorticists and others in London's avant-garde had always held the views summed up in Lewis' later references to 'the café-philosopher, Marinetti, with his epileptic outpourings in praise of *speed* and *force*,' and 'that clown Marinetti (the "father of fascism") and his bellowings about "passéisme" ...'[41] In point of fact, Lewis, like most of the avant-garde, had welcomed Marinetti's efforts in behalf of new, experimental art forms.

Even in November 1913, however, the rebel artists' acceptance of Marinetti had limits. In a note sent to Lewis the day after the dinner in Marinetti's honour, Nevinson wrote, 'I had quite a great deal of difficulty in preventing Marinetti from again expounding and proposing his philanthropic desire to present us to Europe and be our continental guide, etc.'[42] Lewis presumably approved of Nevinson's efforts to restrain Marinetti,

100

and, when he wrote a panegyric on Marinetti in the *New Weekly*, he made it clear that while Marinetti's message was vital and necessary, it was also Italian and 'southern.' It could not satisfy England's need for an 'expression of the Northern character.' After all, Lewis argued, ' "Futurism" is largely Anglo-Saxon civilization. It should not rest with others to be the Artists of this revolution and new possibilities in life. As modern life is the invention of the English, they should have something profounder to say on it than anybody else.'[43] By the time these sentiments appeared in print, there could be no doubt that Lewis expected a profounder statement to come from the Rebel Art Centre/*Blast* group whom Marinetti had offered to promote and guide.

Lewis' *New Weekly* article, echoing the spirit of mutual admiration that prevailed in November 1913, appeared at the end of May 1914, when Marinetti was making his last and longest foray into the precincts of London's avant-garde. It gave no hint of the impending denunciation of Marinetti and his brand of Futurism that soon came loudly and publicly from a group of the English avant-garde led by Wyndham Lewis.

# 7
# 'Time for Definition' Futurism in England 1914

'While I like London very much because it is the most futurist city in Europe, it is not yet completely futurist ... The streets are still not sufficiently lighted, and the traffic is too slow. You should have more electric light, more noise, and the traffic must be much quicker. Light, noise, speed – you can never have too much of these,' said Marinetti upon his return to London in the spring of 1914.[1] In spite of his continued enthusiasm, Marinetti now succeeded only in alienating his former allies, and inadvertently contributing to the success of Vorticism, the movement that first drew attention to itself by publicly attacking Marinetti's efforts to link Futurism to all forms of 'vital English art.'

In May and June 1914, the Doré Gallery presented a new 'Exhibition of the Works of the Italian Futurist Painters and Sculptors.' Here Boccioni's 'Development of a Bottle in Space' and other Futurist sculptures appeared in England for the first time, along with paintings and drawings by Boccioni, Carrà, Balla, Severini, and Soffici, and two assemblages by Marinetti: 'Mlle. Flic-Flic Chap-Chap,' a ballerina made from a paper fan, a cigarette, cigarette holders, and a piece of lace, and 'Portrait of Marinetti by Himself,' a stick figure made from flat pieces of wood and a clothes brush, and suspended from a wire to give the impression of a man running at top speed through empty space. In these congenial surroundings, Marinetti gave a series of *conferenze* much like those he had presented the previous November.

He performed, as well, at the Rebel Art Centre, whose leading artists also sponsored one of his Doré lectures,[2] and at the Poetry Bookshop where, Harold Monro reported to Edward Marsh, Marinetti 'declaimed to Yeats and made the room shake.'[3] On another occasion, described by Richard Aldington, Marinetti came to Yeats' rooms in Woburn Buildings, and after listening to Yeats recite, 'sprang up and in a stentorian Milanese voice, began bawling:

"Automobile
Ivre d'espace,
Qui piétine d'angoisse," *etc.,*

until Yeats had to ask him to stop because neighbours were knocking in protest on the floor, ceiling, and party walls.'[4]

At one Doré *conferenza* Marinetti lectured on Futurist clothes, a topic Balla had developed in a four-page manifesto, 'Le Vête-ment masculine futuriste,' issued in May 1914. Balla included designs for loose-fitting, multicoloured, asymmetrical suits that looked like modernistic harlequin costumes, and he urged cloth-ing designers to use triangles, cones, ellipses, spirals, and circles for their basic patterns. Futurist clothes should wear out quickly, Balla said, so that people would have the pleasure of buying new things frequently. Above all, clothes should stimu-late 'dynamic joy' in the wearer.[5]

In response to that challenge, Marinetti announced at the Doré the invention of a brilliantly coloured one-piece suit with one 'dynamic button.' 'We want to abolish the heavy black dress that has the appearance of mourning, and with it must go all neutral, pale, and "pretty-pretty" colours,' he said. 'Colour we want, certainly. Man's dress should be, in fact, twinkling with colours; but they should be vivid and brilliant colours ... There must be no symmetry; no so-called good taste and harmony of tone; and no stripes or straight lines,' and echoing Balla he said, 'The designs must suggest energy, impetuousness and move-ment. Cones, triangles, spirals and circles may be employed.'[6] Although Balla wore clothes made according to these principles, Marinetti seems always to have appeared in dark, well-tailored suits.

At other *conferenze* Marinetti lectured on Futurist painting, sculpture, poetry, and music, but his *pièce de résistance* was his recitation of 'The Siege of Adrianople.' On 30 April, the night of his first *conferenza* at the Doré, Marinetti recited his poem as he marched through the hall and pounded on a piece of wood with a hammer to simulate machine-gun fire while, backstage, Nevinson beat a bass drum to give the effect of distant cannons. 'If a human being was ever quite happy and in his element,' wrote Wyndham Lewis in *Blast* No. 2 (p 263, 'it was Marinetti imitating the guns of Adrianople at the Doré with occasional answering bangs on a big drum manipulated by his faithful English disciple, Mr. Nevinson, behind the curtain in the pas-sage.' These special effects, remarked the *Times* (1 May 1914), were 'exhilarating for the audience, but must have been severe work for the performer.' At the conclusion, Marinetti rushed back to the platform and announced, 'This was a very imperfect

rendering. There should be no passive listeners. Everyone should take part and act the poem.'[7]

As Edward Marsh had intuited when he heard Marinetti at the Poetry Bookshop six months earlier, Marinetti desired the uninhibited atmosphere of the music hall, where performer and audience responded openly and directly to each other. The music hall, Marinetti had said during his previous stay in London, was a truly Futurist institution. It had 'no tradition, no masters, no dogma, and subsist[ed] on the moment.' Furthermore, it not only provided a 'meltingpot of all those elements which are combining to prepare our new sensibility,' but it let the audience 'participate noisily in the action, singing [and] beating time with the orchestra ...'[8] All that remained was for Marinetti to bring Futurism directly into the music halls – which he did in June 1914. At one of London's most popular music halls, the Coliseum, number 12 on the bill from 15 to 20 June was a presentation of Futurist music. First Marinetti lectured on 'The Art of Noises,' then his colleagues played a 'Grand Futurist Concert of Noises.' The 'turn' was succinctly advertised on the placards as 'Marinetti "Noises." '

The noises came from twenty-three *intonarumori* invented by Luigi Russolo and Ercole Piatti. Usually called 'noise-tuners' in England, these forerunners of some of the more sophisticated mechanical sound-makers of today were large boxes with funnel-shaped speakers and cranks that were turned to produce the noises.[9] The noise-tuners fell into nine classes: buzzers, exploders, thunderers, whistlers, murmurers, gurglers, rattlers, cracklers, and roarers.[10] At a rehearsal, Marinetti told a reporter from the *Pall Mall Gazette* (12 June 1914), 'We not only produce noises, but also a perfect scale of noises.' The result, said Marinetti, is 'an enlargement of music; it is post-music.' At the performances Marinetti introduced the noise-tuners; then, under the direction of Russolo, they produced two 'noise spirals' called 'Awakening of a Great City' and 'A Meeting of Motor-Cars and Aeroplanes.' To a *Times* reporter, the effect was like 'sounds heard in the rigging of a channel-steamer during a bad crossing.'[11] To Nevinson, who attended the first performance, it was like 'the faintest of buzzes.'[12] The gallery heckled Marinetti, and shouts of 'No more!' from the audience ended the performance.

'Terrible!' said the *Sketch*'s music hall reviewer, who, contrary to Marinetti's Futurist theories about music halls and audience participation, insisted that the noise-tuners did not serve the music hall's purpose of providing 'cheerily irresponsible entertainment [that] has a soothing effect on the tired brain of the

worker.'[13] 'The most sensational "turn" of the week,' as the *Daily Graphic* (17 June 1914) called Marinetti and the noise-tuners, finished out the week, and afterwards Marinetti, with his usual buoyant optimism, reported to Severini, 'After the first stormy evening [the noise-tuners] had twelve triumphant performances. Extremely lively artistic interest. Many musicians, composers, among whom was Stravinsky, enthusiastically interested in the noise-tuners.'[14] As for the general public, the *Daily Graphic* probably caught its mood accurately enough: 'The audience seem to be of the opinion that Futurist music had better be kept for the future. At all events they show an earnest desire to not have it present.'

106 But by 1914, Futurism was very much present. It was a fad, and 'futurist' became the favourite appellation for anything new in art. In *The Future of Futurism*, John Rodker not only applied 'futurist' to Marinetti and the Italian Futurists, but to 'Vorticist, Cubist, Symbolist, Vers Librist' as well.[15] Wyndham Lewis was designated 'one of the foremost Futurists' by *T.P.'s Weekly* (11 July 1914), in spite of Lewis' attacks on Futurism in the pages of *Blast*. In the United States, works in the 1913 Armory Show were often called 'futurist,' although not a single Italian Futurist exhibited there.

Of the English avant-garde painters, only C.R.W. Nevinson unmistakeably deserved the label 'Futurist.' According to P.J. Konody, who seemed to get his information directly from the artist, Nevinson was deeply impressed by Severin's *Pan Pan at the Monico* in the 1912 Sackville exhibition, and found himself 'at once overwhelmed ... with interest in the Futurist propaganda.' Nevinson met Severini, they became good friends, and they returned to Paris together.[16] There, Nevinson met more Futurists and such semi-legendary figures as Modigliani, Apollinaire, and Gertrude Stein. 'I was certainly in the milieu,' he wrote later.[17] He returned to London, a confirmed Futurist.

At Frank Rutter's 'Post-Impressionists and Futurists' exhibition in October 1913 he exhibited his first Futurist painting, *Le Train de Luxe*. The following March, at the Allied Artists' Association exhibition he showed *Portrait of a Motorist* with bits of glass in the paint to suggest goggles and actual buttons on the motorist's coat. Reviewing the exhibition for the *Observer* (8 March 1914), P.J. Konody found Nevinson more than ever 'an English disciple' of Futurism. 'He has,' said Konody, 'the true Futurist sensibility. He is obsessed with the idea of speed ...' Later in the spring, the Cardiff *Western Mail* (15 May 1914) published a photograph of Nevinson's large painting *Tum-Tiddly-Um-Tum-Pom-Pom*. With 'force lines,' real confetti, a grinning female face, and many fragmented

faces, 'The picture shows – at least the artist claims that it shows – the chaotic movement, noise and enthusiasm of the Bank Holiday crowd,' the caption explained.

Nevinson remained true to Futurism after the Vorticists had started their own movement, and at the London Group exhibition in March 1915 he showed *The Arrival* which now hangs in the 'Vorticist Section' at the Tate. (plate 7) The sharp prow of a steamer dominates the centre of the painting, but it is 'interpenetrated' by fragments of smoke stacks, gangways, railings, ropes, decks, parts of the wharf, and other fractured images that make up the 'simultaneity' of a ship's arrival in port. Nevinson's other contributions to the exhibition were war paintings. In the Vorticists' own exhibition in June 1915, Nevinson contributed three war paintings, and listed himself in the catalogue as 'Nevinson (Futurist).' By then he had fulfilled the prediction of the erudite Yorkshire *Observer*, which had said on 15 June 1914, 'When Signor Marinetti leaves us Mr. Nevinson will have the distinction of Abdiel – "Faithful among the faithless only he." '

Although Futurism made no converts in England except Nevinson, it provided a handy label for the new and unusual in other fields besides painting. When a young Russian-American pianist named Leo Ornstein appeared at Steinway Hall in the spring of 1914 to give two recitals of music composed in experimental harmonies with 'blocks of notes struck simultaneously and ... consisting of four semitones,'[18] the critics headed their reviews, 'Futurist Music.' Since Ornstein's music had nothing in common with *gl'intonarumori*, and no direct connection with Balilla Pratella's Futurist compositions or manifestos on music, it was 'Futurist' only because it departed from accepted musical criteria – 'Anything more unlike music, as we understand the term, it is difficult to imagine,' said the *Athenaeum*[19] – and produced effects the critics found unpleasant – 'We have never suffered from such insufferable hideousness expressed in terms of so-called music,' said the *Observer*.[20]

The term 'Futurist' found its way, with equal inexactitude, into more popular areas, such as clothing styles and interior decoration. In spite of the fairly exact specifications for Futurist clothes in Marinetti's Doré lecture and Balla's manifesto, 'Futurist' became a popular label for any clothing style that, like the Omega Workshop's dresses, used brilliant colours in unexpected ways. 'Futurists invade Buckingham Palace,' headed a story in *London Life* (4 April 1914) about the appearance of 'Futurist' dresses at Court, one of which the magazine described in detail: 'The skirt was a rich shade of apricot yellow satin edged with brown fur, with an underskirt of pale blue charmeuse

showing beneath; the tunic of deep mauve crepe was embroid-
ered in a fine tracery of sea-green beads, while a sash of vivid
satin finished with gold was tied at one side.' Bright, contrasting
colours in interior decorating provided the basis for an article
on 'Futurism in Furnishing' in *Colour* (May 1916). The author
described a London room 'whose floor is stained purple; whose
lemon yellow walls are half concealed by orange satin draperies;
whose quaint art nouveau furniture is smothered under a
plethora of sky-blue, sea-green, and daffodil gold cushions ...'

In men's fashions, a violet tie with a pattern in emerald and
mustard yellow became a Futurist tie, and women's bathing
costumes with a black satin underdress and a loose tunic of
brightly coloured stenciled patterns was a Futurist bathing suit.
Shirts, pajamas, purses, lampshades, hats, quilts, anything in
'gay strong colour effects, allied to a curiously childish outline
of design,'[21] was likely to be called Futurist. Scarlet, magenta,
and purple were particularly popular in Futurist colour schemes.
The bright puce cover of *Blast* was definitely Futurist.

The Albert Hall Picture Ball on 3 December 1913 included a
Futurist tableau, and Edward Marsh went to the ball 'as a
Futurist picture,' in a costume designed by Wyndham Lewis.[22]
The newspapers photographed revelers in Futurist costumes at
the Artists' Revels on 13 March 1914, and at the All Fool's Ball
on 2 April. The *Daily Mirror* (16 March 1914) reported that,
'M. Jules Manicave, the pioneer Futurist chef, has evolved a
series of amazing dishes from which this dinner might be served:
*Hors d' Oeuvres*, Tomatoes with Brandy; *Soup*, Cod Liver Oil;
*Fish*, Herrings mashed in raspberry jam ...' etc. Obviously,
Futurism provided a field day for the exploiters of fads.

Like a fad it came and went quickly. A regular feature in the
*English Review*, called 'Letters from a Town to a Country
Woman,' devoted much of its space in early 1914 to tracing
'the Futurist influence' in 'the bizarre effects, the vivid colour-
ing, and the crude designs' appearing in clothing and decoration,
and urging its readers to avoid 'freakish or outré extrava-
gances.'[23] In May, the *Graphic* (23 May 1914), moralized about
the prevailing Futurist influence 'among crowds of smart women
with feathers stuck at eccentric angles, with "slashed" dresses,
with bits of crude colours stuck about them.' By July the *English
Review*'s Town Woman reported that 'the hideous Futurist craze
for sensationalism is happily passing.'

But during the months when Vorticism grew from a temporary
alliance of a few defectors from the Omega Workshops to a full-
fledged avant-garde movement, Futurism seemed to be every-
where: in the galleries, music halls, dress shops, and fashion
notes in the press. Because Futurism dominated the public

consciousness and became the generic term for everything new in the popular and fine arts, England's avant-garde artists had to work especially hard to establish a separate identity for themselves. They had to overcome the generally held opinion, summed up by the art critic Edward Storer, that they were Marinetti's disciples: 'The history of that group in England,' Storer wrote in the *New Witness* (11 March 1915), 'will make an interesting chapter one day. It was a case of speedy conversion for the most part. St. Augustine could not have had such success with the rude Saxons as Marinetti achieved with Messrs. Lewis, Bomberg, Nevinson, Wadsworth, etc.'

There was just enough truth in that gross exaggeration to satisfy the public and thoroughly irritate the English artists who had, by mid-1914, evolved their own movement and found their own leaders and spokesmen. Much of their noisiness, posturing, and spotlight-seeking can be blamed on that ubiquitous Futurist label. By no other means could they free themselves from it, and make themselves heard above the Futurists' din.

Unintentionally, Marinetti and Nevinson gave them the chance they needed by issuing 'Vital English Art,' the first Futurist manifesto directed specifically to English art. Nevinson took copies of the manifesto into the galleries of theatres and showered them down on the audiences in the stalls and dress circle. Several newspapers reported on the manifesto and quoted passages from it, and on 7 June the *Observer* printed it in its entirety.[24] 'I am an Italian Futurist poet,' began Marinetti's preamble, 'and a passionate admirer of England. I wish, however, to cure English Art of that most grave of all maladies – passé-ism. I have the right to speak plainly and without compromise and together with my friend Nevinson, an English Futurist painter, to give the signal for battle.'

From there the two Futurists opened their attack on passéism in England. They condemned,

1. – The worship of tradition and the conservatism of Academics, the commercial acquiescence of English artists, the effeminacy of their art and their complete absorption towards a purely decorative sense.

2. – The pessimistic, sceptical and narrow views of the English public, who stupidly adore the pretty-pretty, the commonplace, the soft, sweet, and mediocre, the sickly revivals of mediaevalism, the Garden Cities with their curfews and artificial battlements, the Maypole Morris dances, Aestheticism, Oscar Wilde, the Pre-Raphaelites, Neo-primitives and Paris.

They condemned, as well, 'the perverted snob who ignores or despises all English daring, originality and invention, but welcomes all foreign originality and daring,' 'the sham revolutionaries of the New English Art Club,' the old-style bohemians –

'Post-Rossettis with long hair under the sombrero" – and the timid pioneers 'who say: "post-Impressionism is all right, but it must not go further than deliberate *naivete*." (Gauguin).' Last, and worst, was 'the mania for immortality' and 'the ancestors of our Italian Art' who counsel restraint: 'They sit there on grandfather chairs and for ever dominate our creative agonies with their marble frowns: "Take care, children. Mind the motors. Don't go too quick. Wrap yourselves up well. Mind the draughts. Be careful of the lightning." '

To those timid words of caution, Marinetti and Nevinson replied, 'Forward! HURRAH for motors! HURRAH for speed! HURRAH for draughts! HURRAH for lightning!' They called for 'an English Art that is strong, virile, and anti-sentimental,' and braced by 'a heroic instinct of discovery, a worship of strength and a physical and moral courage, all sturdy virtues of the English race.' They wanted 'to create a powerful advance guard, which alone can save English Art,' and they closed by naming names.

So we call upon the English public to support, defend, and glorify the genius of the great Futurist painters or pioneers and advance-forces of vital English Art – ATKINSON, BOMBERG, EPSTEIN, ETCHELLS, HAMILTON, NEVINSON, ROBERTS, WADSWORTH, WYNDHAM LEWIS.

> F.T. Marinetti
> Italian Futurist Movement (Milan)
> C.R.W. Nevinson
> Art Rebel Centre (London)

Most of the artists named by Marinetti and Nevinson responded by rejecting Futurism and embracing Vorticism.

They took advantage of one of Marinetti's *conferenze* at the Doré to dramatize their schism. On the evening of 12 June, Nevinson was scheduled to share the platform with Marinetti and, 'The Futurist Painters, Russolo and Piatti, Inventors and Constructors of Noise-Tuners' who, the tickets announced, would 'also be present and give explanations on the Art of Noises.'[25] The audience, many of whom came primarily to see and hear the noise-tuners, found in their midst 'a determined band of miscellaneous anti-Futurists,' as Wyndham Lewis put it in his account of the events. According to Lewis, the group included himself, Hulme, Epstein, Etchells, Gaudier-Brzeska, Wadsworth, and a cousin of Wadsworth 'who was very muscular and forcible.'[26] They went together to the Doré explicitly to heckle the speakers.

Judging by other accounts, a report published in the *New Age* under the title 'Futile-ism' captured the mood, if not the literal facts, of the evening (all ellipses are in the original):

(ENTER STUDENT. The hot room is full for the most part of elderly

(passées?) ladies, including such half-forgotten crimes as Messrs. Cunninghame-Graham and Nevinson père. Barely twenty minutes late the lecturers arrive – ironical applause from frivolous audience. Sig. Marinetti rises and introduces 'mon ami Nevinson,' and refers to 'les noise-tuners' whose performance is eagerly expected. Mr. Nev. rises.)

MR. NEV. (reading his speeach – (!). But he seems frequently to digress):
    Before I read the manifesto ... I will make some remarks ... England
    to-day is no more a decadent country in art than in commerce.

STUD. (sotto voce): Nor no less, neither.

MR. NEV.: ... Compare him unfavourably with a second-rate Parisian
    painter, and say how much finer the latter is.

AN ARTIST: So he is!

MR. NEV.: You're a Russian! (Commotion.) Doubtless ... snobs ... what
    was known as backternacher ... a vile thing sprung up in England ...
    namely, the Pre-Raphaelites ... the Neo-Primitives ... superficial and
    highly accomplished colour-photography ... The Futurists ... their art,
    so vital, so intense and so complex ... Vortickists ...

THE ARTIST: Vorticistes! (Commotion.)

Kate Lechmere, who attended the performance, said that Gaudier-Brzeska went expressly to correct Nevinson's pronunciation of 'Vortickist,' and kept shouting 'Vorti-ciste!' with a strong French accent.[27] It was Gaudier's heckling that Nevinson recalled most vividly in his own account of the affair in his autobiography.[28]

While Lewis, Hulme, and the others continued to heckle him, Nevinson read the 'Vital English Art' manifesto. According to the New Age account, when Nevinson reached the exuberant passage of 'HURRAH' 's an assistant set fire to 'a small piece of magnesium wire. Tremendous Futurartistic effect.' Marinetti followed Nevinson to the platform and held forth for some time. Then, to return to the New Age's account,

(MR. MARIO sits down, his collar unstarched with sweat; the audience,
too, is tired out with his prosiness and the heat. He pops up again.)

MR. MARIO: I am quite at the disposition of the audience. I'm not the
    least bit tired. (The hideous rumour spreads that, though the 'noise-
    tuners' are present, they have not got their instruments and will not
    perform after all. The disappointed audience begins to disperse. MR.
    MARIO busily explains to STUD. and others some of the angular mon-
    strosities that are shown as Futurist sculptures.)

MR. MARIO: The face isn't dented in nature, but it is in the plastic; the
    mouth isn't swollen in nature, but it is in the plastic. (As STUD. de-
    parts, two small persons shake him enthusiastically by the hand. They
    are 'les noise-tuners.'[29]

Although Lewis claimed, 'The Italian intruder was worsted,'[30] the New Age suggested just the opposite, and so did the Manchester Guardian (12 June 1914), which reported that, 'The

111

new seceders from the Marinetti group, Messrs. Wyndham Lewis, and Co., who now call themselves the Vorticists, who promised at the beginning to provide a belligerent opinion, dwindled into silence very early in the evening.'

The silence was temporary, however. Immediately following the appearance of 'Vital English Art' in the *Observer*, the anti-Futurists sent to various newspapers and magazines a letter repudiating Marinetti and Futurism. The *Daily Mail* reported the repudiation on 11 June, and the *Times* on the 13th. The rebel artists who 'have hitherto associated themselves with the advanced art movement founded and led by Signor Marinetti,' the *Times* reported, 'are now disavowing allegiance to the Italian school of Futurists. They purpose inventing a more characteristically English form of expression ...' The complete letter itself appeared in the *New Weekly* on the 13th, the *Observer* on the 14th, and the *Egoist* on the 15th.

Without resorting to the insults and bad temper of the anti-Fry letter, Lewis and his co-signers just as decisively disassociated themselves from Marinetti and Futurism.

Dear Sir,

To read or hear the praises of oneself or one's friends is always pleasant. There are form of praise, however, which are so compounded with innuendo as to be most embarrassing. One may find oneself, for instance, so praised as to make it appear that one's opinions coincide with those of the person who praises, in which case one finds oneself in the difficult position of disclaiming the laudation or of even slightly resenting it.

There are certain artists in England who do not belong to the Royal Academy nor to any of the passéist groups, and who do not on that account agree with the futurism of Sig. Marinetti.

An assumption of such agreement either by Sig. Marinetti or by his followers is an impertinence.

We, the undersigned, whose ideals were mentioned or implied, or who might by the opinion of others be implicated, beg to dissociate ourselves from the 'futurist' manifesto which appeared in the pages of the 'Observer' of Sunday, June 7th.

The 'undersigned' were Aldington, Bomberg, Etchells, Pound, Wadsworth, Atkinson, Gaudier-Brzeska, Hamilton, Roberts, and Lewis. Following the signatures, a postscript stated, 'The Direction of the Rebel Art Centre wish to state that the use of their address by Sig. Marinetti and Mr. Nevinson was unauthorized.'[31]

'FUTURIST SQUABBLES,' announced the *Daily Express* (11 June 1914), and went on to suggest reasons for the repudiation of the 'Vital English Art' manifesto. 'Some of the English Futurists may well have felt the sting of the manifesto's dig at the

"Post-Rossettis with long hair under the sombrero," ' the newspaper remarked. The only other motive the *Daily Express* could discover for such a sudden and violent rupture of what had seemed to be amiable and mutual admiration between Marinetti and the English avant-garde, was that, 'These rebel artists are Anarchists who resent any kind of leadership.'

In reality, it was not a question of 'any kind of leadership,' but of the particular leadership offered by Marinetti. Six months before, during Marinetti's previous visit to London, the English artists closest to Marinetti had politely refused his offer to become their international spokesman and guide. Now the refusal was less polite. They did not want the public recognition of their movement to depend on Marinetti's flamboyant personality and his melodramatic performances. They did not want to share the limelight with a foreign movement or a charismatic leader who occasionally appeared for a few frenetic days of declamations and interviews, and then disappeared, leaving a distinct sense of anti-climax behind him.

Not only was Marinetti's style not their style – as Lewis tried to show in his *New Weekly* article by contrasting the 'southern' quality of Marinetti's Futurism with the 'northern' nature of the proper art for England – but there were philosophical differences as well. They came out in such arguments as one between Marinetti and Lewis, described in Lewis' *Blasting and Bombardiering*. By pointing out that machines were no novelty in England, and therefore could not inspire him as they did the Italians, Lewis goaded Marinetti into extolling speed, the '*ivresse* of traveling a kilometre a minute.' When Lewis replied that he did not like things to go too quickly, that if they did they were not there, Marinetti answered that they are only there when they *are* going quickly. These arguments, said Lewis, always ended in a stand-off:

'I prefer *one* thing' [Lewis said].

'There is no such thing as one thing' [replied Marinetti].

'There is if I wish to have it so. And I wish to have it so.'

'You are a monist!' he said at this, with a contemptuous glance, curling his lip.

'All right, I am not a futurist, anyway. *Je hais le mouvement qui déplace les lignes*

At this quotation he broke into a hundred angry pieces.

'And you "never weep" – I know, I know. *Ah zut alors*! What a thing to be an Englishman!'[32]*

* The poetry Lewis and Marinetti quote at each other is from Baudelaire's 'La Beauté,' which includes the famous lines, 'Je hais le mouvement qui déplace les lignes, / Et jamais je ne pleure et jamais je ne ris.'

The argument, as Lewis recreates it, may be fictional, but the different points of view were real.

Nothing more clearly distinguished Futurists from Vorticists than their attitudes toward speed and machinery. The Vorticist conception of machinery had already appeared in Lewis' remarks on the 'Cubist Room' at Brighton. 'The work of this group of artists,' Lewis wrote in the exhibition catalogue, 'for the most part underlines [the] geometric bases and structure of life ... All revolutionary painting to-day has in common the rigid reflections of steel and stone in the spirit of the artist; that desire for stability as though a machine were being built to fly or kill with ...'[33] Only the phrases 'to fly or kill with' carried Futurist connotations. Otherwise, with his emphasis on the stable, solid, and rigid, Lewis sounded more like Hulme than Marinetti. Hulme's 'idea of machinery' excluded the Futurists' vision of roaring motors and blurring speed, and, like the Vorticists, he attacked Futurism for 'being the deification of the flux' and the 'exact opposite' of the geometric, non-vital art he expected to be the art of modern, mechanized civilization. Futurist and Vorticist sensibilities divided according to their preference for an aesthetic based on Boccioni's 'in-and-out of a piston in a cylinder,' or Hulme's 'hard clean surface of a piston rod.'[34]

Although Hulme's ideas probably helped shape the Vorticists' attitude toward machines and art, it was Lewis rather than Hulme who led the attack on the Futurists. Less than three weeks after he wrote 'Man of the Week: Marinetti' for the *New Weekly*, Lewis used the same magazine to announce his intention 'to make Marinetti give up Automobilism.' 'Automobilism,' the title of his article, he defined as a peculiar failing of Futurism stemming from the 'extra-ordinary childishness of the Latins over mechanical inventions, aeroplanes, machinery etc ...' Lewis insisted that, 'For everything that is rubbishly puerile in the Latin temperament machinery has come as an immense toy.' The English, on the other hand, take machinery for granted. Besides, said Lewis, H.G. Wells 'has out-Marinettied our automobilist friend in his Melodrama of Modernity.' As a clincher, Lewis noted that many Futurist painters had moved away from romanticizing machinery and toward the painting of pure abstractions. He expected Marinetti, too, would 'very shortly follow Balla and others to a purer region of art ...'[35]

To that argument, which Lewis repeated in *T.P.'s Weekly* the following month,[36] Nevinson replied in a letter to Lewis, 'As a Futurist and not a Vorticist I have no doubt I shall change and evolve what ideas I possess. I know this may be a great source of trouble to you as I notice a continuous complaint in your articles on "automobilism" that the Futurists are not doing

exactly what they were two years ago.'[37] Nevinson, however,
did not follow Balla into the 'purer region' of abstraction, and
so Lewis' remarks about his 'automobilism,' however unfair
they may have been, suited Nevinson's work and confirmed the
difference that Nevinson had insisted on by calling himself 'a
Futurist and not a Vorticist.'

Still, if Lewis' argument was correct, then most of the Futurists
had already come over to his side, and he no longer needed to
attack 'automobilism.' But with his 'love of labeling,' as Nevin-
son called it,[38] and his zest for the game of art politics, Lewis
turned attacking 'automobilism' into a useful ploy for advancing
Vorticism at the expense of Futurism.

In *Blast* the Vorticists cleverly exploited the general Futurist
ideology while repudiating 'automobilism.' Like the Futurists,
they launched anti-passéist attacks on the 'years 1837 to 1900'
and the 'Victorian Vampire' that 'feeds upon modern London';
they praised the industrial 'Will' that 'reared up steel trees where
the green ones were lacking'; they blessed aviators, prize-
fighters, and music hall entertainers; they patterned the opening,
blasting-blessing section of *Blast* on a Futurist manifesto pub-
lished by Apollinaire in *Lacerba* (15 September 1913); they
wrapped their magazine in a cover of 'Futurist' purplish pink.

But they left no doubt about their repudiation of Marinetti's
brand of Futurism. 'We do not want to make people wear
Futurish patches, or fuss men to take to pink and sky-blue
trousers,' they announced in the preface to their manifesto
(p 7). In one of his contributions, Lewis wrote, 'The Futurist
statue will move, then it will live a little, but any idiot can do
better than that with his good wife, round the corner' (p 135).
Futurism, said Pound in his 'Vortex' essay in *Blast*, is the
'dispersal' or 'disgorging spray' of a Vortex (p 153).

While *Blast* was filled with scornful allusions to the Futurists'
'gush over machines,' its illustrations and text showed that Vor-
ticism was committed to exploring the potentialities of the
'forms of machinery.' Instead of multiple images, and blurred,
merging forms, however, the Vorticists' machine aesthetic pro-
duced static, rigidly geometrical, and nearly or completely
abstract designs. Nothing could have been further from the
perfectly stable cone-Vortex in *Blast* than Balla's 'vortices'
whirling through a series of interpenetrating positions like a
cartoonist's version of a wildly spinning top.

Although Futurist and Vorticist aesthetics differed sufficiently
to make a break between the two movements inevitable, the
actual schism began as a matter of art politics and conflicting
personalities, and concluded in much the same way. After the
Doré incident of 12 June and the repudiation in the press of the

'Vital English Art' manifesto, Lewis and Nevinson continued sniping at each other in print. In his 'Automobilism' article for the *New Weekly*, Lewis wrote, 'Futurism as a generic name for all new art is all right. But if a man comes along with a patent in the mere name "Futurism," if his innocent disciple enthusiastically commandeers the address of a place in no way automobilist, to put at the bottom of a stupid polemic, it is time for definition.'

Nevinson, in the same issue, deplored 'the petty and personal polemics [and] ridiculous technical differences that the directors of the Rebel Art Centre seem so much to enjoy.' He pointed out that he and Marinetti had the perfect right to praise or criticize any artist at any time, and that his and Marinetti's statement had not called other artists 'Futurists' or claimed their allegiance to Futurist principles. As for using the Rebel Art Centre for an address, Nevinson said he used it 'simply as a member uses the address of his club.' 'I had no idea how very strongly the directors [of the Rebel Art Centre] felt against Futurism,' he added. 'I even understand they professed to teach it, and I know that in a prospectus they mention it as a vital form of art.'[39]

That was perfectly true, and Nevinson could have quoted from the Centre's prospectus for its art school to support his point. 'Cubist, Futurist and Expressionist' principles were to be the 'starting point and alphabet' of the teaching, the prospectus said, adding that, 'All art with any vitality to-day can be placed in one of these categories.' Nevinson could have pointed to the first advertisement for *Blast*, as well. That advertisement, which appeared in the *Egoist* on 1 April 1914, said *Blast* would provide a 'Discussion of Cubism, Futurism, Imagisme, and all Vital Forms of Modern Art.'

But the *Egoist* advertisement and the Rebel Art Centre prospectus were written before Marinetti and Futurism were regarded as direct threats to the independence of the *Blast*-Rebel Art Centre coterie. As a Futurist, Nevinson had nothing to lose and much to gain if Futurism – as an aggressively publicized movement and a commercially successful fad – trod on the toes of less publicized and less faddish movements. He could not – or would not – see how easily the more famous movement, Futurism, could easily engulf and destroy the just emerging and less famous movement, Vorticism.

Continuing his argument in a letter to Lewis written the day after the Doré affair, Nevinson touched upon issues more closely tied to the personalities and inner workings of the avant-garde itself. Why, Nevinson wondered, did Aldington, Gaudier-

Brzeska, and Pound, none of whom was mentioned in 'Vital
English Art,' sign the repudiation? Was it because they resented
*not* being mentioned?[40] The answer, as Nevinson should have
known, was that all the names attached to the repudiation of
Futurism (with the exception of Bomberg's), would also appear
at the end of the Vorticist manifesto in *Blast*. The 'Vital English
Art' pronouncement, in other words, threatened to steal the
limelight just as the Vorticists prepared to make their own
entrance on the avant-garde stage, to the accompaniment of a
resounding *Blast*. Issuing 'Vital English Art' just before *Blast*
appeared must have looked like betrayal to the artists who were
counting on their magazine to make their own English, non-
Futurist, movement, known to the world.

In the same letter, Nevinson assured Lewis that no intrigue
was intended. If there seemed to be, he said, that was only
'delusions of your highly suspicious, NEURESTHENIC mind.'
While that side of Lewis – what many people who knew him
called his 'persecution mania' – must be taken into account, it
seems much less involved in Lewis' argument with Marinetti
and Nevinson than it had been in his attack on Fry and the
Omega, or in his mismanagement of the Rebel Art Centre.
Lewis' manoeuvres, like Marinetti's and Nevinson's, can best be
understood as plays and counter-plays in the game of art
politics.

After *Blast* appeared, the game petered out, but not before
Lewis used an article entitled 'Futurism and the Flesh' in *T.P.'s
Weekly* (11 July 1914) to label Nevinson 'the only authentic
Automobilist left in Europe, except Marinetti.' Nevinson, in
turn, took advantage of the *Observer*'s correspondence column
(12 July 1914) to profess his amusement at seeing 'these ex-
Futurist professors [ie, the Vorticists] performing intellectual
contortions "within the stationary centre of a whirlpool!" that
the strong and swift-flowing stream of Futurism was bound to
cause and has left behind.'

In the meantime, someone who signed himself 'Marionetti
Bombelewis' of 'The Only Art Centre' sent a letter to the *Ob-
server* (5 July 1914) announcing the formation of a new move-
ment, 'Infinitism.' 'Where other ists grovel in the mundane,
rejoicing in motors, whirlpools, vortices and such like inanities,'
wrote 'Bombelewis,' '*We* lift our eyes to the vaulted heavens,
and piercing the empyrean with our eagle-eyes roam through
space, ignoring time.' Exclaiming, 'Hurrah! then for the void;
Hurrah! for the Comet; Hurrah! for the Star dust, Gee-whiz-
bang! Hurrah! for Infinitism!' the writer closed by announcing
the forthcoming publication of a new journal, 'The Dam,' and

pointing out that he refrained from mentioning his followers
names, 'for the fear that should I do so – they would turn and
rend me.'

Ignoring the feuds sprung up about him, Marinetti pronounced
his London foray a success: 'Crowds. Prolonged and tumul-
tuous applause,' he wrote in a letter to Severini.[41] Although he
would not have been happy to see the headline in *Il Picolo della
Sera* announcing, 'VORTICISTS SURPASS FUTURISTS IN AUDA-
CITY,'[42] he was willing to leave the English avant-garde to take
care of itself. He soon turned to the grander project of bringing
Italy into the war against Austria and Germany. On 15 Sep-
tember, Marinetti stood in a box at the Teatro Dal Verme in
Milan waving the Italian tri-colour, while, in another box,
Boccioni tore the Austrian flag to shreds. For this and other
pro-war demonstrations, Marinetti, Boccioni, Carrà, Russolo,
and Piatti were sent to jail. From their cells they released a
manifesto called 'The Futurist Synthesis of War.'

Nevinson, who joined the Red Cross Ambulance Corps shortly
after the war began, also spoke of the war with true Futurist
zest. 'I am firmly convinced,' he told the *Daily Graphic* (11
March 1915), 'that all artists should enlist and go to the Front,
no matter how little they owe to England for her contempt of
modern art, but to strengthen their art by a fearless desire for
adventure, risk and daring ...' To the *Daily Express* (25 Feb-
ruary 1915) he explained, 'This war will be a violent incentive
to Futurism, for we believe there is no beauty except in strife,
no masterpiece without aggressiveness.' In fact, however, Nev-
inson departed more and more from Futurist techniques, and
shortly after the war ended he announced, 'I have now given up
Futurism ...'[43]

By then, there was no reason to insist on being a Futurist. For,
although a few of Nevinson's former colleagues and antagonists
still painted in a Vorticist style, they no longer operated as a
combative, propagandizing movement. No one felt the need any
longer to assert, 'I am a Futurist, not a Vorticist,' or vice versa.
That phase of art politics in England ended with the war. The
new phase of the 1920s had a different tone, and such things as
noise-tuners at the Coliseum, Marinetti declaiming at the Doré,
Nevinson flinging manifestos from theatre galleries, or Vorti-
cists making headlines with anti-Futurist attacks seemed
definitely pre-war.

118

# 8
# 'Our Little Gang'

At the 1913 Allied Artists' exhibition, Ezra Pound made the rounds, looking for promising new work. Impressed by 'a figure with bunchy muscles done in clay painted green' and an accompanying marble group, Pound looked up the sculptor's name in the catalogue, and for the amusement of a friend who was with him, began producing ridiculous pronunciations of the sculptor's last name 'Brzxjk – ... Burrzisskzk – ... Burdidis – ...' Suddenly a dark, slender young man darted from behind a pedestal.

'Cela s'appelle tout simplement Jaersh-ka,' he said. 'C'est moi qui les ai sculptés.' Without another word he disappeared – 'like a Greek god in a vision,' said Pound.[1]

A short time later, after Pound's fellow-American, John Cournos, formally introduced the poet to the sculptor, Pound bought a small marble torso and the marble group he had admired at the Allied Artists' exhibition. He paid 'what would have been a ridiculous figure,' said Pound (it was £15, according to H.S. Ede[2]), 'had it not been that he had next to no market and that I have next to no income.' In December 1913, Pound reported the purchase to his friend, William Carlos Williams. 'Have just bought two statuettes from *the* coming sculptor, Gaudier-Brzeska. I like him very much,' Pound continued. 'He is the only person with whom I can really be "Altaforte." '[3]

Pound read his dramatic monologue, 'Sestina: Altaforte,' to Gaudier, hoping that its aggressively virile celebration of war would appeal to the young sculptor and convince him of its author's worthiness to be sculpted. To reinforce that stratagem, Pound bought a four-foot block of white marble, the largest piece of stone Gaudier had ever carved, and Gaudier set to work on what became known as the 'Hieratic Head of Ezra Pound.'

In the spring of 1914, Pound went often to Gaudier's studio under a railway arch in Putney. As he sat on a wooden chair,

talking, listening, and watching Gaudier work, a friendship between the two men flourished. 'He was certainly the best company in the world,' Pound said, 'and some of my best days, the happiest and most interesting, were spent in his uncomfortable mud-floored studio when he was doing my bust.'

'You understand it will not look like you,' Gaudier told Pound as the bust gradually emerged from the stone. 'It *will ... not ... look ... like* you. It will be the expression of certain emotions which I get from your character.' The result was a monumental, phallic, geometrically simplified head with the imperturbable gaze of a sphinx. It was a monument, not only to a friendship, but to a view of life and art that Gaudier would sum up in an essay in *Blast*. The friendship with Pound helped to bring Gaudier into the Vorticist group; the view of life and art, as well as much of the work he produced in 1913-14, proved he belonged there.

120

Pound and Wyndham Lewis first met in 1909 or 1910, in circumstances even less promising than the first meeting between Pound and Gaudier. Laurence Binyon had invited Pound to the Vienna Café, where the British Museum set, of whom Binyon was a leading figure, regularly lunched. Lewis, then under the wing of Sturge Moore, another Vienna regular, lunched there as well. Before Pound arrived, according to Lewis' account, someone informed the group that Pound was a Jew. Thus, when Pound appeared, Lewis was 'mildly surprised to see an unmistakeable "nordic blond," with fierce blue eyes and a reddishly hirsute jaw, thrust out with a thoroughly Aryan determination.' Lewis felt no interest in 'this cowboy songster,' and he ' "sensed" that there was little enthusiasm' for Pound among the group. 'And when I rose to go back to the museum,' Lewis says, 'he had whirled off – bitterness in his heart, if I know my Ezra.'[4]

Pound's bitterness – if it existed – had mellowed considerably by the time he recalled in Canto LXXX that he, as Binyon's 'bulldog,' had been brought in to face Moore's 'bulldog':

So it is to Mr. Binyon that I owe, initially,
Mr. Lewis, Mr. P. Wyndham Lewis ...[5]

Subsequently, it was to Jacob Epstein that Pound owed his appreciation of Lewis' work. When, around 1912 or 13, Pound remarked to Epstein that he found sculpture much more interesting than painting, Epstein replied, 'But Lewis' drawing has the qualities of sculpture.' That, says Pound, 'set me off looking at Lewis.'[6]

He was not immediately converted. As late as March 1915, Pound wrote John Quinn, 'Out of much that I do not care for [in Lewis' work] there are now and again designs or pictures

which I greatly admire.'[7] To the readers of the *Egoist* (15 June
1915), however, he proclaimed Lewis to be 'one of the greatest
masters of design yet born in the occident' and the 'most articu-
late voice' of the new age.[8] By March 1916, his private opinion
coincided with his public one: 'The vitality, the fullness of the
man!' he wrote to Quinn. 'Lewis has got Blake scotched to a
finish. He's got so much more *in him* than Gaudier ... It is not
merely knowledge of technique, or skill, it is intelligence and
knowledge of life ...'[9]

Lewis never spoke as highly of Pound as Pound had of him.
Nevertheless, once his initial indifference to 'the cowboy song-
ster' had passed, he, as he said, 'enjoyed the acquaintanceship
immoderately.' 'I found him to be "one of the best," ' Lewis
wrote in *Blasting and Bombardiering*, 'I still regard him as one
of the best, even one of the best poets.'[10]

Lewis had less to say of Gaudier-Brzeska. Although both men
spent some time at the Omega Workshops, mixed in the Ford
and Hulme coteries, enjoyed reputations as notable 'bohemians'
and avant-garde artists, and joined the attack on Marinetti and
Nevinson at the Doré Gallery, they never became close friends.
While Gaudier called Lewis' abstractions 'the start of a new
evolution in painting,'[11] Lewis thought Gaudier 'a little too
naturalistic and not starkly xx century enough.'[12] At the same
time, Lewis admired Gaudier's vitality and spoke of Gaudier's
death at the Front in 1915 as a turning point in his own attitude
toward governments and their wars. 'This little figure was so
preternaturally *alive*,' Lewis wrote, 'that I began my lesson then:
a lesson of hatred for this soul-less machine, of big-wig money-
government, and these masses of half-dead people, for whom
personal extinction is such a tiny step, out of half-living into
non-living, so what does it matter?'[13]

Gaudier's sculpture, unlike his personality, did not excite
Lewis. He called Gaudier 'a good man on the soft side, essen-
tially a man of tradition – not "one of Us" ...'[14] Nor, for that
matter, did Lewis regard Pound as 'one of Us,' as a peer in the
artistic revolution. Pound's poems in *Blast* he thought of as
'compromising' work that 'let down ... the radical purism of the
visual contents.'[15]

In the spring of 1914, however, Pound's admiration and liking
for both Gaudier and Lewis was strong enough to link the three
– the twenty-two year old Frenchman, the twenty-eight year old
American, and the thirty-one year old Englishman – into a
temporary triumvirate. 'As an active and informal association
it might be said that Lewis supplied the volcanic force, Brzeska
the animal energy, and perhaps that I contributed a certain
Confucian calm and reserve,' Pound wrote in a letter to *Reedy's*

*Mirror* in 1916.[16] Fifty years later, he described the three-way relationship more concisely: 'Gaudier for sculpture, E.P. for poetry, and W.L., the main mover, set down their personal requirements.'[17]

Briefly and restively, Pound, Gaudier, and Lewis formed an alliance with a few like-minded artists, all of whom found reasons to unite (the joint attack on Fry and the Omega, the Rebel Art Centre venture, the anti-Futurist campaign, the publication of *Blast*) stronger than individual inclinations to remain divided. As Pound readily admitted, unity was not the Vorticists' strong point. 'The Vorticist movement,' he wrote in the *Egoist* (15 August 1914), 'is a movement of individuals, for individuals, for the protection of individuality.' The Vorticists' opening statement in *Blast* concludes, '*Blast* presents an art of individuals.'

That would not seem to be a very promising basis for a group movement. But Pound in the *Egoist*, and the Vorticists in *Blast*, wanted to make it clear that no one in the group had to sacrifice individual expression to the demands of some co-operative aesthetic. At the same time, Pound believed firmly – and with good reason – that the individuals in the group shared similar intentions and that nothing was more appropriate in that day of groups and isms, than for them to operate under a common label. As he put it at the time, 'It cannot be made too clear that the work of the vorticists and the "feeling of inner need" existed before the general noise about Vorticism. We worked separately, we found an underlying agreement, we decided to stand together.'[18]

Of the three major Vorticists, Pound most actively promoted the idea of 'an informal association' of artists willing 'to stand together.' He felt that his years in London had come to fruition only when, in December 1913, he could write William Carlos Williams, 'We are getting our little gang after five years of waiting.'[19]

The five years following Pound's arrival in 1908 had provided several opportunities for getting a gang together. There had been Hulme's post-Poet's Club group of 1909, the *English Review* and South Lodge coteries, the *Egoist*-Imagist crowd, but none had finally suited Pound's growing rebelliousness and his increasing interest in the visual and plastic arts. Whatever truth there may have been in Lewis' harsh analysis of Pound's motives – that Pound merely attached himself to avant-garde groups in order to enjoy 'the dust and glitter of *action* kicked up by the more natively "active" men'[20] – the fact remains that Pound's

pre-war years in London only seemed fulfilled when he found himself 'at last *inter pares*,' to use his words,[21] as a member of the Vorticist group.

Pound arrived in London in the autumn of 1908, already on the lookout for an appropriate group to join. In February 1909, he wrote Williams, 'Am by way of falling into the crowd that does things here.'[22] The 'crowd' Pound had in mind included late-Victorians and Edwardians like Selwyn Image, Lawrence Binyon, Victor Plarr, and others he met through Elkin Mathews, Pound's first publisher in England. That 'crowd' was a far cry from the 'gang' Pound would tell Williams about in 1913, but it brought Pound into London's literary circles and introduced him to the pleasures of being in a group. It also helped to make London aware of Ezra Pound.

Before long, an anonymously composed 'Virgin's Prayer' circulated among the avant-garde:

> Ezra Pound
> And Augustus John
> Bless the bed
> That I lie on.[23]*

Later, *Punch* made facetious reference to 'Mr. Ezekial Ton,'[24] and the *London Opinion* printed some *vers libre* parodies entitled 'Paregoric' written by 'Hosea Tuppence.'[25] In the *Egoist* (1 August 1914), John Felton printed a set of 'Contemporary Caricatures,' one of which described 'Mr. E*** P****':

His mind is a patch-work of derivations

Agitated by the wind of Transatlantic snobbery.

At times really illuminating

He is too lost in the bog of personal vanity

To be anything more than the Roosevelt of Letters.

He adds a Nonconformist conscience

To the peculiar methods of the Salvation Army –

Hence his right to be called the Master of Artistic Cant.

Self-consciousness hides his three amiable qualities from the unobservant –

Yet he dearly loves to impress strangers.

He knows a little of almost everything, but nothing well.

He has the average American's respect for the latest novelty.

Impossible to know if he ever thought of anything himself.

If he had a real conviction he might achieve.

---

* In a letter to Lewis (13 January 1918), Pound quotes the verse, and says that he first heard it in 1909, and that he definitely was not the author of it. (*Letters of Ezra Pound* p129)

Appearance – a whitened golliwog on a cleft carrot.
Style – Flashy, blustering and often vulgar.
Destiny – The admiration of the colonies.

Pound made no effort to trim his personality to fit patterns approved by people like John Felton. If anything, he did just the opposite. He often exaggerated his American accent and played the role of a wheeler-dealer, free-swinging son of the frontier. At the same time, he dressed like a decadent poet of the 1890s, glibly quoted Provençal poetry, and believed himself to be 'at the heights of Whistler and the refinements of Debussy.'[26] This frontiersman-aesthete ('born in a half savage country,' yet 'bent resolutely on wringing lilies from the acorn,' as he put it in 'Hugh Selwyn Mauberley') refused to hide his considerable education, or to temper his opinions, or to disguise his enthusiasms.

It is not surprising that people who met him in those London years often felt he personified the stereotyped American cultural parvenu. 'His enthusiasm was only equalled by his vitality,' said Edgar Jepson, 'and little less than both was his touching ingenuousness of God's Own Countrymen, which caused the New, if it was formless and sufficiently grotesque, to impress him so deeply.'[27] To Wyndham Lewis, Pound represented 'the raw solemnity of the classic Middle West.'[28]

When Brigit Patmore first encountered Pound at a South Lodge party, she was struck by the fact that the 'long, slim young man leaning back in a low chair, withdrawn into his clothes,' actually smiled at her. 'The very un-Englishness of this pleased me,' she wrote later.[29] Without that un-Englishness, Pound might have had a much harder time among London's artists and writers. If Pound's friendliness at first embarrassed people, eventually it broke down their resistence.

While he never missed an opportunity of 'pouring his stinging sarcasm on the smug complacency of successful mediocrity,' wrote a fellow-American, the photographer Alvin Langdon Coburn, he was 'a fine fellow ... a staunch friend.'[30] 'Ezra was kind to all,' said Bridget Patmore.[31] Not everyone could have said, as one contemporary did, 'I never met anybody who didn't like Pound,'[32] but it was true that Pound had the rare ability not to take arguments and even insults personally. Consequently, few people quarreled successfully with Pound, and many came to like and admire him. Even Lewis would preface an attack on Pound's taste and aesthetics with a tribute to Pound as a 'generous and graceful person,'[33] and write, without irony, of Pound's 'heart of gold.'[34] Friendship was one bond between Pound and the other Vorticists that no amount of argument over aesthetic values would break.

Pound's crinkly, thick, reddish-gold hair brushed straight back
from his forehead, his beards and moustaches that came and
went in rapid succession, his capes and canes, his casual Ameri-
can manners – these things rubbed some people the wrong way.
So did his habit of issuing what Paul Selver called 'Bland utter-
ances, for which the epithet "dogmatic" is preposterously
weak.'[35] Such utterances as Pound's proposition that 'Dante is
a great poet' because he presented the Image, 'Milton is a wind-
bag' because he did not,[36] made unsympathetic observers, like
the composer Cecil Gray, dismiss him with contemptuous refer-
ences to his 'bombastic, arrogant, perverse charlatanism.'[37]

Sympathetic observers blamed Pound's less endearing qualities
on what Douglas Goldring called the natural 'arrogance of a
revolutionary poet.'[38] They enjoyed the spectacle of a generous,
dogmatic, arrogant, friendly, erudite, smiling, hirsute, bohemian
American poet confronting London's cultural world. At a
literary tea, said Phyllis Bottome, Pound was 'an electric eel
flung into a mass of flaccid substance,'[39] and Richard Aldington
readily admitted that 'Ezra was great fun, a small but persistent
volcano in the dim levels of London literary society.'[40] It was
only a matter of time until the 'revolutionary poet' found his
proper place in the company of revolutionary painters and
sculptors.

At first, Pound's friendships were literary and predominately
with older men, such as the Elkin Mathews 'crowd,' Ford
Madox Ford, and W.B. Yeats. 'I made my life in London by
going to see Ford in the afternoon and Yeats in the evening,'
Pound said many years later.[41] He also got to know lesser lights
like T.E. Hulme, Florence Farr, Desmond Fitzgerald, F.S. Flint,
and Edward Storer, who discussed poetry and read their poems
to each other. This was the 'forgotten school of 1909,' as Pound
called it a few years later, the school that laid the ground work
for the Imagist movement.[42] It gave Pound his first chance to
join contemporaries, rather than respected elders, in a search
for new and distinctly modern approaches to writing poetry.

Discussions among this group encouraged Pound's thoughts
along lines he had already laid out for himself. In a letter to
William Carlos Williams, written shortly after he got to London,
Pound outlined his idea of the 'ultimate attainments' for a poet:

1  To paint the thing as I see it.
2  Beauty
3  Freedom from didacticism
4  It is only good manners if you repeat a few other men to at least do
   it better or more briefly. Utter originality is of course out of the
   question.[43]

In this frame of mind, Pound eagerly joined Hulme, Flint,

Storer, and the others in their discussion of foreign literatures, *vers libre*, and the Image.

Those discussions, reinforced by Ford Madox Ford's pronouncements on effective prose style, and by Pound's own poetic taste and practice, generated a 'Prolegomena' in *Poetry Review* in February 1912. That formulation of poetic principles considerably sharpened the focus of the list of 'attainments' written for the benefit of William Carlos Williams. Now Pound argued that poetry should display an 'absolute rhythm' corresponding to the exact shade of the poet's feelings. It should not contain symbols that interfere with clarity of statement; it should be 'fluid,' like a tree, and 'solid,' like water in a vase; it should be precise. In a passage one would have expected from Hulme, Pound predicted that the new poetry would be 'harder and saner.' 'It will be as much like granite as it can be,' he continued, 'its force will lie in its truth, its interpretive powers ... I mean it will not try to seem forcible by rhetorical din, and luxurious riot. We will have fewer painted adjectives impeding the shock and stroke of it. At least for myself,' Pound concluded, 'I want it so, austere, direct, free from emotional slither.'

Reworked and made more epigrammatic, these ideas reappeared a year later in F.S. Flint's short essay, 'Imagisme' and Pound's 'A Few Don'ts by an Imagiste,' both published in the March 1913 issue of *Poetry*. By that time the term 'Imagism' (more often spelled 'Imagisme' to give it a French look) had become known to English and American poetry readers. In November 1912, Pound's *Ripostes* came out with an appendix containing poems by Hulme and a brief comment by Pound, in which an enigmatic reference to 'Les Imagistes' appears. In the same month, *Poetry* identified a new contributor, Richard Aldington, as 'one of the "Imagistes," a group of Hellenists who are pursuing interesting experiments in *vers libre* ...' and, in its January 1913 issue, *Poetry* included some brief comments on Imagism by Pound, and three poems by Hilda Doolittle, who signed them 'H.D. Imagiste.'

Dora Marsden's magazine the *New Freewoman* and its successor the *Egoist* began publishing poems by Imagists (Pound and Aldington handled the literary department for the magazine), and in February 1914 the climax to the movement's year and a half build-up came with the publication of *Des Imagistes: An Anthology* containing poems by Aldington, H.D., Pound, Flint, Amy Lowell, William Carlos Williams, Skipwith Cannéll, Allen Upward, John Cournos, James Joyce, and Ford Madox Ford. But by then Pound's own interests were changing, and in the following months he broke the Imagist triumvirate of Aldington, H.D., and himself, to form a Vorticist triumvirate with

Lewis and Gaudier-Brzeska. Imagism, he said later, simply marked 'a point on the curve of my development ... I moved on.'[44]

Officially, he did not move on until mid-summer 1914, when Amy Lowell planned to back a new Imagist anthology and to use a committee for selecting poems to be included in it. Pound responded to this plan in a letter to Amy Lowell. 'Imagism stands, or I should like it to stand for hard light, clear edges,' he wrote. 'I cannot trust any democratic committee to maintain that standard.'[45] Since he could not force his standards on the group, and had no money to back an anthology of his own, Pound withdrew from the scheme and from Imagism. Amy Lowell's anthologies, *Some Imagist Poets* (1915, 1916, and 1917), appeared without contributions from Pound.

'As what H.D. termed the "Hippopoetess," Miss Lowell, was trying to break down the definition of Imagism by omitting the most vital proposition in the original definition,' Pound wrote many years later, 'it was appropriate to get another label for vitality in the arts.'[46] The new label was Vorticism, but before the label had been invented – in fact, before the publication of *Des Imagistes* and the appearance of Amy Lowell on the scene – Pound had begun to separate himself from the Imagist movement.

In early 1914, as Pound began to address himself to the social and cultural conditions of his day, he gave up the Imagists' cool, decorous tone. 'To the present condition of things we have nothing to say but "merde," ' Pound wrote in the *Egoist* in February 1914. In June he announced, 'We will sweep out the past century as surely as Attila swept across Europe,' and in the same essay: 'Damn the man in the street, once and for all, damn the man in the street who is only in the street because he hasn't intelligence enough to be let in anywhere else ...'[47] As he became more argumentative, Pound's tone and language became more violent, and his conception of the artist's role more militant. Instead of the craftsman of language, the careful observer who transforms what he sees into precise Images, the artist, Pound now wrote, is a 'savage' who 'must live by craft and violence. His gods are violent gods.'[48] The time's characteristic contempt for bourgeois values and its rhetoric of violence had found another voice.

'Ezra Pound has a desire personally to insult the world,' Yeats said in January 1914. 'He has a volume of manuscript at present in which his insults to the world are so deadly that it is rather a complicated publishing problem.'[49] The previous October, in a letter to Alice Corbin Henderson, Harriet Monroe's assistant at *Poetry*, Pound had written, 'I wonder if *Poetry* really dares to

devote a number to my *new* work. There'll be a *howl*. They won't like it. It's absolutely the *last* obsequies of the Victorian period ... BUTT they won't like it ... I guarantee you *one* thing. The reader will not be *bored*. He will say ahg, ahg, ahh, ahhh, but-bu-bu-but this isn't Poetry.'[50] In this frame of mind, Pound responded gladly to Wyndham Lewis' 'cheery invitation to provide ... "something nasty for *Blast*," ' as Pound put it later.[51]

A new Poundian persona – a combined *enfant terrible* and social satirist – appeared as early as April 1913, when Pound published a series of poems called 'Contemporania' in *Poetry*. Surrounding delicate Imagist pieces like 'In A Station of the Metro' and 'Dance Figure' were several poems in this new vein.
One was 'Salutation the Second' which concluded,

> Ruffle the skirts of prudes
>> Speak of their knees and ankles.
> But, above all, go to practical people –
>> go! jangle their door-bells!
> Say that you do no work
>> and that you will live forever.

Another was 'Pax Saturni,' in which Pound declared that those who

> Call this a time of peace,
> Speak well of amateur harlots,
> Speak well of distinguished procurers,
> Speak well of employers of women ...

are people who 'will not lack [their] reward[s].' In a third, 'Commission,' Pound sends his 'song' to 'the women in the suburbs,' 'the hideously wedded,' and 'those who have delicate lust.'

Pound had come a long way from 'Revolt against the Crepuscular Spirit in Modern Poetry' in *Personae* (1909), where he wrote such lines as,

I would shake off the lethargy of this our time, and give
For shadows – shapes of power
For dreams – men ...

and,

Great God, if we be dam'd to be not men but only dreams,
Then let us be such dreams the world shall tremble at
And know we be its rulers though but dreams!

By 1913 Pound was still in 'revolt,' but he had shed that melodramatic cloak and packed away the archaisms and sonorities. Without giving up his 'altaforte' spirit, he modernized his diction, rhythms, and line arrangements, and put them at the service of a satiric, as well as rebellious, view of society. Not dreams, but actual institutions and pressures of society concerned Pound, and he turned upon them with a furious delight,

commanding his 'songs' to 'Go like a blight upon the dullness of the world' ('Commission').

His 'new work,' Pound told Alice Corbin Henderson '[is] not futurism and it's not post-impressionism, but it's work contemporary with those schools and to my mind the most significant that I have yet brought off.'[52] It was not Imagism either, or presumably Pound would have called it that. It must have been the sort of 'ithyphallic satiric verse,' as he called it in a letter to Joyce,[53] that appeared in *Blast*. The prime example would be 'Fratres Minores' (which *Blast* printed with its first and last two lines cancelled out):

With minds still hovering above their testicles
Certain poets here and in France
Still sigh over established and natural fact
Long since fully discussed by Ovid.
They howl. They complain in delicate and exhausted meters
That the twitching of three abdominal nerves
Is incapable of producing a lasting Nirvana.

In *Blast*, Pound also published 'Salutation the Third' which went well beyond 'Salutation the Second' in its snarling, Juvenalian attack on society – specifically, on the social forces that obstruct artistic innovations.

Let us deride the smugness of 'The Times':
GUFFAW!
So much the gagged reviewers,
It will pay them when the worms are wriggling in their vitals;
These were they who objected to newness,
HERE are their TOMB-STONES.
They supported the gag and the ring:
A little black BOX contains them.
so shall you be also,
You slut-bellied obstructionist,
You sworn foe to free speech and good letters,
You fungus, you continuous gangrene.

Then followed a stanza attacking sycophants who live off art without changing or improving it.

Come, let us on with the new deal,
Let us be done with Jews and Jobbery,
Let us SPIT upon those who fawn on the JEWS for their money,
Let us out to the pastures.

(Since anti-philistinism, not anti-semitism motivated those lines, Pound had the sense and the decency to change the second and third lines when the poem was reprinted in the 1926 edition of *Personae*. The revised verse reads, 'Let us be done with panders and jobbery,/ Let us spit upon those who pat the big-bellies for profit.')[54] After proclaiming that he will not 'flatter' his enemies

with madness or an early death, Pound ended with a belligerent
flourish:

I have seen many who go about with supplications,
    Afraid to say how they hate you.
HERE is the taste of my BOOT,
    CARESS it, lick off the BLACKING.

Confronted by poems like these, Pound's fellow-Imagists either
drew back in disgust or pounced on them as proof of Pound's
weaknesses as a poet and as a person. 'One rather regrets some
of the work recently produced by Mr. Pound,' said Aldington
in the *Egoist* (1 May 1915), and in his review of *Blast*, Alding-
ton wrote, 'Mr. Pound is one of the gentlest, most modest, bash-
ful, kind creatures who ever walked this earth, so I cannot help
thinking that all this enormous arrogance and petulance and
fierceness are a pose.'[55] In a letter to Harriet Monroe, Amy
Lowell pronounced the poetry 'too indecent to be poetical,' and
added, ' "Blast" will give you a good idea of what Ezra has been
obliged to descend to in order to keep his name before the
public.'[56] To her mind, Vorticism was 'a most silly movement,'
and Pound's commitment to it proved that 'he has nothing more
to say.'[57] F.S. Flint wrote directly to Pound, 'You are entangled
in the charlantry of Vorticism, and, if the word Imagism con-
notes anything at all, it is the last word to apply to your propa-
ganda here or in America ... You had the energy, you had the
talents (obscured by a certain American mushiness), you might
have been generalissimo in a compact onslaught: and you
spoiled everything by some native incapacity for walking square
with your fellows; you have not been a good comrade, voilà!'[58]

In the heat of a quarrel that was, as Flint admitted to Harriet
Monroe, 'both a private and an artistic one,'[59] the Imagists' re-
actions to Pound's new interests and new direction of 'on-
slaught,' help to explain why he had to move on from Imagism.
He needed a movement less fastidious about personal and
artistic expression, and more fully committed to the rebellious
spirit of the times. A quiet and strictly literary revolution like
Imagism could not hold Pound when a noisier revolution in-
volving both literature and the visual arts called him into battle.

Furthermore, Imagism, itself, had encouraged Pound to feel a
common bond with the rebel artists of the Vorticism movement.
In a general way, Pound's emphasis on 'hard light, clear edges'
had its visual counterpart in the clean-cut, sharply defined
shapes that Wyndham Lewis, Gaudier-Brzeska, and the other
Vorticists began to produce around 1913. More specifically,
Pound, like Hulme, believed Imagist poetry shared basically
similar concerns with painting and sculpture. 'This new verse,'
Hulme said, 'resembles sculpture rather than music; it appeals

to the eye rather than to the ear.'[60] Pound called Imagism poetry 'where painting or sculpture seems as if it were "just coming over into speech," ' and in so far as a poem is Imagist, he said, it 'falls in with the new pictures and the new sculpture.'[61] As if acting directly upon the logic of that statement, Pound, personally, fell in with the artists producing the most revolutionary of the new pictures and sculpture.

His friendship with Gaudier and Lewis and other avant-garde artists was not the only way he joined London's art world. He frequented the galleries and exhibitions and wrote articles on the new art for the *Egoist* and the *New Age*. He attended Hulme's Tuesday evening salon, where talk of new painting and sculpture dominated the conversations, and where Hulme expounded many of the ideas on art he later printed in his *New Age* articles. As an enthusiastic member of London's café-salon bohemia, Pound joined in endless discussion of Cubism, Futurism, Expressionism, and the work of leading experimental artists of England and the Continent. He supported the Rebel Art Centre, and he signed the anti-Futurist pronouncement circulated by Lewis and the Rebel Art Centre group.

Pound declared his allegiance to the avant-garde artists in a poem called 'Et Faim Sallir Le Loup Des Boys' in *Blast* No. 2:

Say I believe in Lewis, spit out the later Rodin,

Say that Epstein can carve in stone,

That Brzeska can use the chisel,

Or Wadsworth paint ...

H.D., Aldington, and Imagism did not appear in Pound's list of allegiances. They had to be subordinated to the broader movement toward new forms in all the arts. To that movement, Pound contributed an Imagist's visual and sculptural poetry, a satirist's rough, ribald scorn for conventional society and its philistine taste, and a propagandist's unquenchable pleasure in promoting the cause of his chosen group.

Toward the end of 1910, at the age of nineteen, Henri Gaudier chose London for his temporary home. At that time his training and predilections led him to admire most highly the work of the Greeks, Michelangelo, and Rodin. During the next four years his thinking about art deepened, and his own work changed. His circle of acquaintances grew and took in more and more of London's most advanced rebel artists, so that by 1914 he became, by rights of friendship and common artistic outlook, an appropriate addition to the evolving Vorticist group.

Although he was French – born at St Jean de Braye, near Orléans – he had been in England twice before. In 1906 he spent two months in London as a student; in 1908 he studied at

University College, Bristol, and worked as a clerk for a firm of
coal contractors in Cardiff. In April 1909 he left Bristol for
Nuremberg, and from there he went to Munich, where, he later
told Pound, he helped make fake Rembrandts for a living. From
Munich, Gaudier went to Paris where he met Sophie Brzeska,
a Polish woman almost twenty years his senior. By this time
Gaudier had decided to devote his life to sculpture, and Sophie
wanted to be a writer. They went to live in London, and there
they presented themselves as brother and sister – Henri and
Sophie Gaudier-Brzeska. They played their brother-sister roles
so successfully that many people who knew them did not know
the truth until 1931 when H.S. Ede published *Savage Messiah*,
132   a biography of Gaudier-Brzeska.

Sophie's and Gaudier's intense, ambiguous, and ambivalent
life together was complicated by poverty. Once Sophie begged
in the streets to get money for food, and Gaudier went around
the local pubs drawing portraits of the customers at a penny a
head. They lived in a succession of shabby rooms like the one
John Middleton Murray described in recalling his first visit to
Gaudier and his 'sister.' The room, which was in a building in
Fulham Road, contained nothing but 'a bit of a bed ... a couple
of seedy deck chairs, and a scrap of matting on the floor.'[62]
Later, the dirt-floored studio under a railway bridge – Arch 15,
Winthrope Road, Putney – where Pound sat for his marble bust,
served as living quarters and studio.

A more affluent sculptor in the adjoining studio occasionally
gave Gaudier a small piece of stone left over from his own
work, and on at least one occasion Gaudier stole pieces of
marble from the yard of a near-by monument company. Ray-
mond Drey, an early friend, gave Gaudier a bundle of old
cotton-spinning spindles made of tempered steel. From these
Gaudier hammered out his chisels.

As romantically bohemian as their life may have seemed to
some, it was hard on Sophie's health and state of mind. Gaudier,
who took no interest in physical comfort, thrived on it. While
Sophie tended to stay in the background – she was often ill,
always nervous, and her self-consciousness made other people
uncomfortable in her presence – Gaudier found himself in the
swirl of London's café-studio night life. Writing to Sophie, who
was temporarily out of London, Gaudier provided a small slice
of the sort of life he lived. He described going to a Wagner
concert with his friend, the painter Alfred Wolmark, and 'a Jew
from Cracow,' to whom he sold a small alabaster Venus for
£3. 'Afterwards,' he told Sophie, 'they took me to a "*café à
putains*". We cleared out at once and ran into Epstein. He
praised [Madame] Strindberg's Cabaret [Theater Club].' The

day before, Gaudier reported, he had spent the afternoon at Epstein's studio; from there he had gone to Wolmark's for dinner, and then to the Café Royal, where he sat with 'Epstein, his wife, a French engraver called Norbel, and Augustus John, who looked as if he would burst. While we were drinking someone called me and I looked round to find [Edward] Marsh, with Mark Gertler – I talked to him and he invited me to dinner next week.'[63]

Around this same time, Gaudier's work began to appear in public exhibitions: first at the 1913 Allied Artists' exhibition, where Pound discovered it; then, in the following year, in the Grafton group's exhibition at the Alpine Club, in the Doré Gallery's 'International Exhibition of Modern Art,' in the Allied Artists' exhibition at Holland Park Hall (which Gaudier also reviewed for the *Egoist*), at the Whitechapel Gallery's exhibition of twentieth century art, and, in 1915, the Vorticists' exhibition at the Doré. Like Gaudier himself, his sculpture became part of the avant-garde scene. It would be seen, Ford Madox Ford recalled, in 'sitting rooms of untidy and eccentric poets with no particular merits, in appalling exhibitions, in nasty night clubs, in dirty restaurants ...'[64]

Gaudier had none of Ford's fastidiousness about nastiness and dirt. Horace Brodzky, upon first meeting Gaudier, thought he looked like 'a dirty little urchin standing at the door smiling.'[65] He was short and thin, and looked even smaller in his usual attire of baggy trousers, unironed workman's shirt, and bedraggled tie. His dark hair hung in long lank strands over his collar; a sparse beard and moustache gave a faintly Oriental look to his face. He seemed to cast a spell over those who met him, so that they saw, not a dirty, underfed, often ill-mannered, and easily excitable urchin, but some kind of sleek, untameable creature of the wilds. To Frank Harris, he was 'a sort of shy, wild faun-like creature all exclamations and interjections'; to Middleton Murray, 'a panther, crouching to the ground, almost one with the earth, sensuous, swift and strong'; to Pound, 'a well-made young wolf or some soft-moving bright-eyed wild thing.'[66] Winifred Gill, Roger Fry's quiet, observant young assistant at the Omega Workshops, remembered Gaudier from his brief visits to the Omega, and years later wrote,

His eyes were quick and bright as an animal's
That lives by its wits in a hedge, wide-set
In a sallow face, and of so dark a brown
Across these fifteen years they might be black,
Glancing out through the strayed wisps of his hair.
Tall? No, but powerful, his movements elastic –
Strength under control.

Further into her poem, Miss Gill recalled a characteristic incident:

'Look here,' he said, and fished out of his pocket
A carved bone and laid it upon my palm.
Image with image linked in a subtle curve
Stained brown as with age and use, the surfaces polished
To ivory. He watched me turn it. 'Well, tell me
What country that came from?' 'Nigeria?'
He laughed his satisfaction, took it and muttered,
'Made it myself to-day from a toothbrush handle.'[67]

By 1913-14, it was typical of Gaudier to feel complimented if someone mistook his sculpture for the work of a 'primitive.' Like Hulme and like Epstein (whom he called '*cher maître*'),[68] Gaudier found inspiration in the art of cultures outside the museum-approved, academy-perpetuated tradition of Phidias and Praxiteles, Donatello and Michelangelo, Rodin and Maillol – the 'Greco-Roman and Gothic' tradition, as Gaudier called it.

At first, when his own work showed the direct influence of Rodin and Maillol, Gaudier fully approved of Phidias, Michelangelo, and, especially, Rodin. 'We shall never see a greater sculptor than Rodin, who exhausted himself in efforts to outvie Phidias,' he wrote in 1910, 'and did outvie him in his Penseur ... Rodin is for France what Michelangelo was for Florence ...' In 1911, he wrote, 'I admire Michelangelo's "Slave" for its magnitude, because heroism, creative energy, astonishes me; the Samothrace "Victory" because its poetry pleases my senses.' Rodin's 'John the Baptist,' he says, 'could hold me for days.' However, in the same year he wrote, 'There are few things so detestable as the Venus of Milo – and exactly because she is no more than a line enjoyed by pigs – an enormous stomach if you like, without lumps, without holes, without hardness, without angles, without mystery, and without force – a flabby thing made of wool, which goes in if you lean against it, and what's worse, makes a fellow hot.'[69]

Rodin had said of that other famous Venus, the 'Venus di Medici,' 'You almost expect, when you touch this body, to find it warm,' and on another occasion remarked, 'Every masterpiece of the sculptor has the radiant appearance of living flesh.'[70] Repelled by this living-flesh, warm-body approach to sculpture, Gaudier finally rejected 'Greco-Roman and Gothic' sculpture, in favour of primitive, archaic, and exotic sculpture with the qualities those Venuses lacked: hardness, angles, mystery, and force.

Gaudier's early busts of Horace Brodzky, Frank Harris, and others among his early acquaintances in London, as well as early figures like *Wrestler* and *Fallen Workman*, were done in

134

clay or plaster with strongly modelled surfaces. But the Rodin-
esque style disappeared, as Gaudier began to make small,
deceptively simple carvings in stone – a fawn, a bas-relief cat
licking its paw, several torsos. These were what Ford Madox
Ford called Gaudier's 'caressable' sculptures that 'had the
tightened softness of the haunches of a fawn.'[71] At the same
time, Gaudier carved stiffer figures, formalized and abstract (in
Worringer's sense of the term), such as *Singer*, done in the
manner of archaic Greek statues; *Imp*, inspired, perhaps, by
bow holders from the east Congo;[72] *Caritas*, based on the large
bowls with caryatids used in Hawaii and the Cameroons;[73] and
*Red Stone Dancer*, whose compact form, in-turning rhythms,
and strange dance-gesture suggested a primitive idol as enig-
matic to 'civilized' eyes as a primitive altar piece. (plate 20)

Pound neatly summarized Gaudier's evolution from Rodin-
esque to Vorticist sculptor: 'The Rodin admixture he had purged
from his system when he quit doing representative busts ...
Maillol I think went next. Epstein reigned for a time in his
bosom; and then came the work I can only refer to himself, to
his own innovations, to his personal combinations of forms.'[74]
Gaudier's most personal expression produced what Pound called
'the squarish and bluntish period' of late 1913 and 1914. Dur-
ing this time Gaudier made the veined alabaster *Stags*, in which
the heads, antlers, eyes, and hoofs of two stags become simply
sharp-edged facets of an intricate abstract design. His *Birds
Erect*, in limestone, reduces the birds to a few interpenetrating
geometrical shapes, and goes farther than *Stags* toward com-
plete non-representation. The 'squarish and bluntish' qualities
were most apparent in some small 'toys' and a door-knocker he
showed at the Allied Artists' in 1914, all of which were cut
directly in brass. (plates 18 and 19) They probably came closer
than any of his other works to incorporating the Vorticist treat-
ment of arcs, triangles, and a few other simple, basic geo-
metrical shapes.

Like Brancusi, whom he met at the Allied Artists' exhibition
in 1913, Gaudier experimented with more and more simplified
forms, and at the time went further than Brancusi in what R.H.
Wilenski called 'geometrization.'[75] The same tendency appeared
in his drawings. Besides representational sketches and drawings
in which he vividly captured his subject in the barest minimum
of lines, Gaudier created stylized 'primitive' line drawings, 'calli-
graphic sketches' of animal forms, and a series of drawings
progressively reducing realistic forms to geometrical shapes and
interrelated planes and masses. He also made pastel drawings
of stylized machines or machine-like shapes. These, along with
his other highly stylized and abstract drawings and his geo-

metricized carvings, placed his work directly within the main tendencies of the Vorticist painters, especially as those tendencies were defined in Hulme's Worringer-inspired writings on art.

Hardness, not softness; sharp edges instead of smoothly rounded curves; sculptual surfaces like stone, not flesh (Fabruci, Gaudier's fellow-sculptor in the studio next to his in Putney, said Gaudier's work was 'not sculpture but stones')[76]; the thing itself, not the thing as something else; these became Gaudier's goals and the rationale for his continued exploration of abstract, geometrical forms and of methods of carving that emphasized the hardness of the material itself.

Like Pound, Gaudier had to face the criticism of admirers who liked his earlier work, and could not understand why he refused to continue working in that Romantic-Rodinesque manner. Those who believed, with Horace Brodzky, that Gaudier was basically a 'naturalist sculptor ... with a big dash of the romantic,' and that his last abstract works were 'not in any sense his real work [but were] experiments, works done to startle the public, or in emulation of work done by others,'[77] regarded Gaudier's Vorticist phase with regret and distaste.

In spite of Brodzky's suspicions that bad influences lay behind Gaudier's rejection of the naturalist-romantic tradition, he could not argue that Gaudier acted out of ignorance. 'As a student of his art,' said Ford Madox Ford, '[Gaudier] had an erudition and a turn of phrase that I have never known equalled.'[78] A more dispassionate observer, the *Athenaeum*'s art critic, Raymond Drey, exclaimed over Gaudier's 'amazing knowledge ... [his] tremendous knowledge about primitive sculpture in all countries.'[79] Syrian, Mesopotamian, Chinese, Archaic Greek, African sculpture, all were familiar to him and figured in the Vorticist history of sculpture he presented in *Blast*. These far-ranging interests pre-dated his involvement with Epstein and the Vorticists. Pound believed, in fact, that the germ of Gaudier's 'Vortex' essay in *Blast* could be found in one of his notebooks of 1911, where the sculptor begins to consider 'the dominant characteristics of the different periods of sculpture.'[80]

Furthermore, Gaudier's drawings and early sculpture proved his ability to do good work in the Rodin-Maillol style admired by Brodzky and others among his early friends in London. So, the fact that he chose to reject that style and the sculptural tradition it represented, suggests that his artistic convictions had changed. The changing attitudes of the times made Gaudier's turn toward abstraction, if not inevitable, at least valid and fully in accord with the artistic rebellion going on around him.

Gaudier first joined the public controversies over contempor-

136

ry sculpture in March 1914, when he published a letter in the *Egoist*. There he distinguished between 'barbaric' sculpture produced by 'a people to whom reason is secondary to instinct,' and 'civilized' or classic sculpture produced by 'a people to whom instinct is secondary to reason.' (Like Worringer and Hulme, Gaudier thought of sculpture as the product of 'a people' rather than of an individual sculptor.) Gaudier put the new sculpture in the first category. The modern artist 'works with instinct as his inspiring force,' Gaudier continued,

His work is emotional. The shape of a leg, or the curve of an eyebrow, etc., etc., have to him no significance whatsoever; light voluptuous modelling is to him insipid – what he feels he does so intensely and his work is nothing more nor less than the abstraction of this intense feeling ... That this sculpture has no relation to classic Greek, but that it is continuing the tradition of the barbaric peoples of the earth (for whom we have sympathy and admiration) I hope to have made clear.[81]

The point would be clearer after the appearance of his 'Vortex' in *Blast* No. 1.

But *Blast* would not appear for another three months. In the meantime, Gaudier got the chance to comment on modern sculpture and on contemporary English art in general, by writing a review of the spring Allied Artists' exhibition for the *Egoist* (15 June 1914). His opinions in that review clearly aligned him with the emerging Vorticist group. He attacked Futurism: 'It is impressionism using false weapons. The emotions are of a superficial character, merging on the vulgar in the "syncopation" – union jacks, lace stockings and other tommy rot.' As for Kandinsky: 'I have been told that he is a very great painter, that his lack of construction is a magnificent quality, that he has hit something very new. Alas I also know all his twaddle "of the spiritual in art" ... My temperament does not allow of formless, vague assertions.' He dismissed most of the sculpture shown: 'An agglomeration of Rodin-Maillol mixtures and valueless academism – with here and there someone trying to be naughty: curled nubilities and discreet slits.'

The only artists 'who are at all furthering their sculptural expression,' said Gaudier, are Epstein and Brancusi (neither of whom had work on display), Zadkin and Gaudier, himself. Of his brass door knocker in an abstract design, Gaudier wrote, '[Because] it is not cast but carved direct of solid brass, the forms gain in sharpness and rigidity.' Preferring 'sharpness and rigidity' to 'formless, vague assertions,' Gaudier found as few painters as sculptors whose work satisfied him. Wyndham Lewis and Edward Wadsworth were the only ones he praised unequivocally, though he mentioned two other Vorticists, Jessie Dismorr and Helen Saunders, as being 'well worth encouraging

in their endeavours towards the new light.' The hand-decorated objects exhibited by the Rebel Art Centre drew his praise for showing that 'the new painting is capable of great strength and manliness in decoration,' while many of the Omega's items irritated him with 'too much prettiness.' Although he commented on sixteen painters in all (among whom were Wolmark, Brodzky, Bevan, Gilman, and Ginner), he effectively drew the line of his interests after mentioning Dismorr and Saunders. His allegiance to the Rebel Art Centre group seemed clear. 'With them,' he said, 'stops the revolutionary spirit of the exhibition.'

Gaudier's faith in the 'revolutionary spirit,' like his preference for 'strength and manliness,' for 'barbarism,' for 'sharpness and rigidity,' for hardness, angles, mystery, and force, for sculpture free from the influence of 'those *damn* Greeks' – all coalesced in the 'Vortex' he would write for *Blast*. His sense of kinship with Epstein, Lewis, Wadsworth, and others in the Rebel Art Centre group put him in exactly the same group that Pound had pledged his allegiance to in 'Et Faim Sallir Le Loup Des Boys.' Joining that 'little gang' and contributing to *Blast* would be the last gestures Gaudier made in behalf of the 'revolutionary spirit,' before he went off to war.

The 'extreme avant gardist' of 1914, as Wyndham Lewis once called himself, began, like many English artists of his generation, dutifully drawing from plaster casts in the Antique Room of the Slade. That was in 1898, and by 1900 Lewis' drawing had won him a Slade scholarship and a reputation as one of the strongest draughtsmen to appear at the school. In 1901 Lewis left the Slade to study on the continent. He spent time in Spain, Holland, and Germany, and settled temporarily in Paris, where he read, wrote, painted, listened to Bergson at the Collège de France, observed with amusement the bohemian extravagances of his friend, Augustus John, and lived his own version of the Latin Quarter life. He returned to London in 1909, some six months after Pound had arrived there, and about six months before Gaudier-Brzeska came over from Paris.

Lewis brought back to London some short stories in manuscript, and, with the help of Sturge Moore, he hoped to land a job writing monthly articles for Ford's *English Review*. As it turned out, Lewis did not join the staff of the *English Review*, but Ford published three of his stories (in May, June, and August 1909), and Douglas Goldring published five others in *The Tramp: An Open Air Magazine* (in June, August, September, December 1910, and February 1911). Before the end of 1910, Lewis had completed a novel and submitted it to the well-known literary agent, J.B. Pinker. When Pinker declared

it 'unmarketable,' Lewis accepted the rejection philosophically
('It is a lesson showing the futility of pot-boiling for me ...' he
told Pinker),[82] but continued to write both prose and poetry.

At this point in his career, Lewis later said, he was '(a) osten-
sibly a painter, but (b) privately almost a writer.'[83] In a letter to
Augustus John in 1910, he reported working on 'a book of
verse,' and declared, 'I'm going to do nothing but poetry now
this novel's finished.'[84] That novel was probably an early version
of *Tarr*, which did not appear until 1916, when the *Egoist* pub-
lished it serially. Lewis did not publish a book of verse until
1933 when Faber and Faber brought out *One-Way Song*. The
stories in the *English Review* and *The Tramp* were his only
important published writings until *Blast* appeared in 1914.

In the intervening years, while Lewis the writer remained
private, Lewis the painter became increasingly well known. In
1911 Lewis showed two paintings in the Camden Town group's
exhibition in June, and three more in the group's second exhibi-
tion in December. But Lewis was out of place in a group
dominated by Sickert, and he separated from the Camden Town
group as he worked out his own visual idiom under the influence
of Post-Impressionism, Futurism, Cubism, and Expressionism.
Recognizable forms, such as faces and figures, became simpli-
fied, angular elements in pictures that emphasized abstract de-
sign rather than life-like representation. An Expressionist side
to Lewis' interests led him to produce strange and stark pictures
with powerful psychological undertones; a Futurist side en-
couraged him to shatter his subject matter into interpenetrating
fragments; a Cubist side played down sensuous line and colour,
and played up structure and formal, abstract design. During the
next four years, those three artistic urges continued to operate
in varying and unequal proportions, as Lewis worked on semi-
abstract and, finally, totally abstract paintings and drawings.

At the Allied Artists' exhibition in the summer of 1912, Lewis
left no doubts about his break from the predominant interests
of the Camden Town group. He exhibited a large, nearly ab-
stract oil painting called *Kermesse*, which one unsympathetic
critic said looked like 'boiled lobster legs, each two yards long.'[85]
Clive Bell commented more respectfully, and more usefully, in
his review for the *Athenaeum*:

Entering the arena, the visitor will probably first turn to the large picture
by Mr. Wyndham Lewis. To appreciate the work, he should take the
lift to the gallery, whence having shed all irrelevant prejudices in favour
of representation, he will be able to contemplate it as a piece of pure
design. He will be able to judge it as he would judge music – that is to
say, as pure formal expression.[86]

If Bell seemed unduly determined to impose his own theory of

'significant form' on Lewis' painting, he at least prepared viewers to expect something new and important from Lewis' experiments in abstraction. Frank Rutter realized that, 'Here for the first time London saw by an English artist a painting altogether in sympathy with the later developments in Paris.'[87]

That fall, at Fry's second Post-Impressionist exhibition, Lewis showed a series of drawings made to accompany the text of Shakespeare's *Timon of Athens* (the drawings, without the text, were published the following year by Max Goschen under the imprint of the Cube Press). These drawings integrated mask-like faces, stylized limbs, truncated bodies, arcs, lines, and wedges, with overlapping and intersecting black and white planes, to produce abstract designs with representational details. This style continued to hold Lewis' interest even after he started making totally abstract designs, and it served as a kind of bridge for him when his desire to express his war experience forced him back toward more representational work.

In 1912, however, Lewis was moving directly toward abstraction, and the Timon drawings, with their dependence on hard, angular, abstract shapes, definitely pointed in that direction. Already, Lewis had to be distinguished from his own contemporaries in the English avant-garde, as Clive Bell realized when he tried to write a brief introduction to the English section of the second Post-Impressionist exhibition. The dominant tone of that section was set by Vanessa Bell, Duncan Grant, Frederick Etchells, and Roger Fry. Bell felt at home among the work of these painters, who clearly showed the influence of Cézanne, Matisse, and other Post-Impressionists. Lewis' work did not seem to fit in. Faced with the *Timon* drawings and three other works by Lewis (*Creation, Amazons,* and *Mother and Child*), Bell wrote,

We shall notice that the art of Wyndham Lewis whatever else may be said of it, is certainly not descriptive. Hardly at all does it depend for its effect on association or suggestion. There is no reason why a mind sensitive to form and colour, though it inhabit another solar system, and a body altogether unlike our own, should fail to appreciate it. On the other hand, fully to appreciate some pictures by Mr. Fry or Mr. Duncan Grant it is necessary to be a human being, perhaps, even, an educated European of the twentieth century.

Lewis' indebtedness to twentieth century European sensitivity simply revealed itself differently, but the difference was sufficient to distinguish him from the Fry-Bell-Omega group. Another year would pass before Lewis could be placed among artists with intentions comparable to his own.

When Lewis showed a revised version of 'Kermesse' along with six other works at Frank Rutter's Post-Impressionist and Fu-

turist exhibition in the fall of 1913, he enjoyed the more con-
genial company of Wadsworth, Hamilton, Etchells, Nevinson,
and Epstein. Nevertheless, *Kermesse* was the only work by an
English artist that the *Times'* critic noticed, and, like Bell the
year before, he grasped at extraterrestrial references to make an
adequate response. 'An impressive design,' he wrote of *Ker-
messe*, 'and [it] looks as if it were an illustration of some new
romance by Mr. Wells about forms of life on another planet.'[88]

Although John Cournos sourly remarked that it was 'as la-
boured and uninspired' as an academy piece,[89] *Kermesse*
pleased Clive Bell, who found it 'greatly improved' from its
earlier version at the Allied Artists', in spite of what he felt to
be a sacrifice of form for the sake of 'drama and psychology.'[90]
In any case, it helped the Countess Drogheda discover 'the
great cleverness of futurism,' as she told Lewis, and inspired her
to invite Lewis to paint decorative friezes for her diningroom.[91]
Madame Strindberg rented it to hang at the Cave of the Golden
Calf, and John Quinn finally bought it in 1916. In *Kermesse* –
which Lewis regarded as still 'in its primitive state'[92] – and in
the *Timon* drawings, Lewis tentatively explored the possibilities
of what Bell liked to call 'purely formal expression.'

He took the final step in 1913 by eliminating representative
details entirely. In the 'Cubist Room' at Brighton (December
1913-January 1914), in the London group, Whitechapel, and
Doré exhibitions in the spring of 1914, and at the weekly Rebel
Art Centre viewings, Lewis showed totally abstract designs
using interlocked lines, arcs, triangles, rectangles, and other
geometrical shapes. If he used colours at all, they were generally
low-keyed hues: gray, ochre, rust, brown, dull blue. *Composi-
tion* (1913), now at the Tate (plate 10), and the large oils,
*Slow Attack* and *Plan of War* (both reproduced in *Blast* No. 1),
and a number of other drawings and paintings of 1913-14-15,
showed that Lewis had broken entirely from the Augustus
John/Slade School tradition in which he had started. He had
forged ahead of almost all his contemporaries in producing un-
compromisingly geometric and peculiarly expressive abstrac-
tions.

He had gone so far in that direction that the normally
sympathetic critic, P.J. Konody, was prompted to call Lewis'
work in the 1914 London group exhibition 'geometrical obfus-
cations,' and Lewis the 'most puzzling artist of the whole group.'
At the same time, Konody readily admitted that, 'About Mr.
Wyndham Lewis's sphere's and curves and straight lines there is
not only a fascinating air of powerful vitality, but a firmness and
sureness that suggest a very definite purpose.'[93] Clive Bell, how-
ever, sounded like Aldington writing on Pound or Brodzky on

Gaudier-Brzeska, when he commented on Lewis' most extreme work. 'It is particularly to be regretted,' he wrote in 1917, 'that Mr. Lewis should have lent his great powers to the canalizing ... of the new spirit in a little backwater called Vorticism.'[94]

Neither hostile viewers like Bell, nor puzzled ones like Konody, denied the expressive power of Lewis' drawing and composition. Intercutting planes of light and dark, sharply delineated by strong, unambiguous lines, gave Lewis' work a sense of conflicting forces locked in perpetual struggle. No English avant-gardist who produced pure abstractions came close to equalling Lewis' knack for conveying a visual effect of harnessed energy. The *Athenaeum* (7 March 1914) perceptively noted in work as

142 minor as Lewis' decorative friezes for Lady Drogheda's dining room, 'a sustained draughtsmanship which makes Mr. Lewis, in our opinion, the leader of the English Cubists.' Lewis was the only artist mentioned by name when the *Daily Mirror* (30 March 1914) printed three photographs of the Rebel Art Centre artists, and the *Daily News* (7 April 1914) devoted an article headed 'Rebel Art in Modern Life' entirely to Lewis' opinions on Cubism, Futurism, interior decoration, and modern life in general. Besides quoting Lewis extensively and printing a large photograph of him standing in front of his painting *The Laughing Woman,* the *Daily News* identified Lewis as 'the extremely able leader of the Cubist movement in England.'

By the spring of 1914, no artist in England better fulfilled the 'leader' role than Lewis. The reasons had to do only partially with his 'sustained draughtsmanship' and uncompromising abstractions. If aesthetic criteria were the only consideration, Epstein and Bomberg probably deserved the title as much as Lewis. But, as far as 'leadership' is concerned, other things counted as much as talent. In those things, Lewis excelled.

There was the 'shock' value of his art, for instance. Under the headline, 'Shocking Art,' the London *Star* quoted Lewis as saying, 'Our object is to bewilder. We want to shock the senses and get you into a condition of mind in which you'll grasp what our intentions are.'[95] Lewis succeeded in 'shocking' even when he did not create greater understanding of his intentions. That sufficed to attract the public's eye and provide journalists with lively material for their articles.

Lewis' own journalism, ostensibly written to help the public grasp the intentions of avant-garde artists, had the effect of casting him in the role of spokesman for the avant-garde. He appeared as the defender and explainer of English Cubist art in the introduction he wrote for the 'Cubist Room' of the 'Camden Town Group and Others' exhibition at Brighton. That introduction came out as a separate article in the *Egoist* in January

1914, and in the same month, Lewis gave a lecture on modern art – which Pound found 'unintelligible'[96] – at Kensington Town Hall. On 8 January, 12 February, and 2 April 1914, Lewis continued his crusade for English avant-garde in the form of letters published in the *New Age*, the primary purpose of which was to defend the art of Jacob Epstein. In the *New Weekly* (30 May 1914), he performed the same service for Marinetti and the Futurists, but two weeks later he used the same magazine to ridicule 'Automobilism' and to advance the cause of Vorticism. *Blast* appeared less than two weeks after that. As editor and chief contributor, Lewis could not help but give the impression of being the 'leader' of the group represented by *Blast*.

Newspaper and magazine reports on controversies and other 'newsworthy' events in the art world reinforced the 'leader' image. Although the 'round robin' letter attacking Fry and the Omega was talked about rather than written about, it marked Lewis as a spokesman for dissident artists. Accounts of the 'Vital English Art' controversy generally identified Lewis as the leader of the anti-Marinetti faction, and reports on the opening of the Rebel Art Centre and the impending appearance of *Blast* gave Lewis more publicity. Even the small fame won by his decorations for the Cave of the Golden Calf increased considerably with the public notice given to his 'Cubist' friezes for Lady Drogheda's diningroom.

'Of course, Wyndham Lewis is the most interesting painter going,' a 'distinguished novelist' told Richard Aldington, who happily quoted the remark in the *Egoist* (1 January 1914), along with the novelist's further comment, 'If I hadn't my wife to consider, I should have him in to decorate the house.' Whether it was his wife's taste or her virtue that seemed in danger, the unnamed novelist did not make clear. It might have been both, since Lewis' pictures fit the popular idea of 'shocking' and 'immoral' art, and Lewis, himself, was sufficiently bohemian to titillate bourgeois imaginations.

After eight years on the Continent – including a good deal of time spent in the company of Augustus John – Lewis looked the proper bohemian: wide-brimmed black hat and black cape, an unkempt moustache, and long dark hair hanging loosely over his neck and about his pale, slightly petulant face. This was the man Violet Hunt remembered: 'His deep, dark, Italian eyes looked out of a buzz of hair flanking on either side the upturned collar of an Inverness cape.'[97] Lewis, himself, said that at that time he was spiritually 'a character in some Russian novel.'[98] It was this Lewis who appeared before Ford Madox Ford at the *English Review* office: 'He seemed to be a Russian,' Ford wrote later. 'He was very dark in the shadows of the staircase. He wore

an immense steeple-crowned hat. Long black locks fell from it. His coat was one of those Russian-looking coats that have no revers. He had also an ample black cape of the type that villains in transpontine melodrama throw over their shoulders when they say "ha-ha!" ' After producing 'crumpled papers in rolls' (manuscripts of his short stories), and handing them to Ford, Lewis 'went slowly down the stairs' without uttering a word. 'I have never known anyone else whose silence was a positive rather than a negative quality,' Ford commented, and concluded his account by adding, 'I had the impression that he was not any more Russian. He must be Guy Fawkes.'[99]

For the caricaturist E.X. Kapp, Lewis personified London's version of the Latin Quarter type. In a drawing for the *New Weekly* (30 May 1914) (plate 1), he shows a shaggy-haired and dissolute Lewis sitting slumped at a café table with a cigarette dangling from his lower lip and an empty wine glass near at hand. Lewis served equally well for the literary caricaturist, John Felton:

Mr. W****** L****

His mind is a 100 h.p. racing automobile
Which back-fires twice in every ten seconds.
Hence the chaotic state of his personality.
Perhaps the most vigorous intelligence in Bloomsbury
He is blighted by the anaemia of abstractions.
His brilliance is that of prismatic petrol
Spilled on a damp asphalt road.
He is sinister, prodigiously vain,
Affectedly Sphynx-like, immobile, witty.

In painting resembles Picasso and Blake;
In literature Blake and Milton.

Appearance – a 'lapin' of antecedents disguised by a 'manner.'

Style – Incomprehensible, except in advertisements.

Destiny – Hanwell, the Order of Jesus, or Westminster Abbey.[100]

This sort of treatment, like newspaper pictures and articles, gave Lewis more fame than most of his fellow rebel artists enjoyed. With only mild exaggeration, Lewis could write later, 'At some time during the six months that preceded the declaration of war, suddenly, from a position of relative obscurity, I became extremely well-known ... By August 1914 no newspaper was complete without news about "vorticism" and its arch-exponent Mr. Lewis.'[101]

In his later writings, Lewis perpetuated the image of himself as what he called '*chef de bande*,' while others, notably William Roberts, attacked it. Roberts maintained that Lewis manipu-

lated his connections with Bomberg, Nevinson, Wadsworth, and other 'Slade Cubists,' and used his association with 'the ingenious word Vorticism, to establish a hegemony over the English abstract movement.'[102] If it is understood that 'leaders' are journalistic conceptions created by 'artistic power politics' (to use Augustus John's phrase), then the 'leader' legend promoted by Lewis is accurate enough.

The 'chef de bande' who stared composedly from the pages of the newspapers, who issued – and got others to sign – polemics and personal attacks, who produced paintings and drawings that challenged the tolerance of even his most sophisticated contemporaries, was the public image of a very private man who jealously guarded his individuality. 'Every man who can, remains independent of Society, however much he may use it,' Lewis wrote in 1915. 'He never uses its jargon, seeks support for its manners, or allows any doubt to subsist as to whether the words he utters came from him or from it.'[103] More bluntly, he wrote in Blast No. 2: 'There is Yourself: and there is the Exterior World, that fat mass you browse on' (p 91). Ironically, some of the traits that turned him into a public figure and contributed to his success in 'artistic power politics,' came from his attempt to remain independent of society. He evolved a personal-artistic credo that combined Ezra Pound's 'craft and violence' with Stephen Dedalus' 'silence, exile and cunning.' For people like John Felton, Lewis simply disappeared behind a 'manner.' Edward Marsh, upon meeting Lewis, wrote, 'He is magnificent to look at, but I don't think he liked me, and I suspect him of pose, so we shan't make friends.'[104] Many people had that reaction. Others regarded Lewis' 'manner' as less an escape or disguise, and more a carefully reconstructed character, an aggressively unsentimental role Lewis consciously chose to play.

Helen Rowe, an artists model who knew Lewis well in 1914, noticed that Lewis tried 'to do everything with great deliberation.'[105] He subjected the most commonplace actions to thorough scrutiny, and then chose a particular way to speak, laugh, gesture, sit, walk, eat, etc. He considered the American way of eating more organized than the English, so he copied it. When he spoke, he tended to break his sentences into stiff, formally pronounced phrases separated by impressive pauses. The silence would be filled by what Winifred Gill described as 'a portentuous intake of breath issuing in rich, deliberate speech.'[106] This deliberateness and the repression of spontaneity and naturalness that went with all his carefully chosen mannerisms put a great strain on Lewis, and on his relations with other people. Undoubtedly it also encouraged him to regard

everyone as being, like himself, a collection of carefully chosen and more-or-less smoothly articulated character-facets. His satire reflected that point of view, and so, to some extent, did his painting.

Perhaps the most disconcerting weapon in Lewis' arsenal of mannerisms was silence – an aggressive silence that Ford had called 'a positive rather than negative quality,' and Rebecca West described as 'patches of silence which meant something to him, apparently, for he was quite contented, but meant nothing to me.'[107] Besides preferring rudeness to small talk, Lewis must have known how impressive silence can be, especially silence garbed in sombrero and black cape. 'Affectedly Sphinx-like,' Felton called him, and so he was. But, by remaining silent, Lewis could also keep closer watch on himself and those around him.

Light talk and easy companionability went against the grain for Lewis. A solitary man with few admirers, fewer friends, and none of the near-adoration that men as different as Roger Fry and Augustus John attracted, Lewis, nevertheless, interested and amused those people who got past the barrier of his 'manner.' Even Rebecca West, in spite of Lewis' silences, acknowledged her fascination with what she called Lewis' 'curious unreasonable charm.' Richard Aldington found Lewis 'amusing and intelligent,'[108] and Kate Lechmere, who put up with a lot during the short life of the Rebel Art Centre, remembered Lewis as witty, brilliant, and 'a good friend.'[109] Pound, of course, enjoyed Lewis' company, while admitting that, 'Lewis can be very trying at times,'[110] and David Bomberg – himself a highly sensitive and temperamental man – talked with Lewis until dawn after their first meeting. 'I recognized in the conversation,' Bomberg said later, 'a man honouring the same pledge to which I was staking my life – namely, a partizan.'[111]

As a partizan, Lewis shunned artiness as firmly as he squelched small talk. Artiness and amateurism went hand-in-hand, Lewis felt, and he seemed instinctively to get his back up in the vicinity of 'amateurs' – a contemptuous term in Lewis' vocabulary for people not totally committed to art, not, in other words, 'partizans.' The worst were men and women who played at art to be 'bohemian' and joined the café-salon-studio life. The Omega Workshops seemed to Lewis a haven for such people. Hulme's weekly salon at Mrs Kibblewhite's was another. Nor did he like the gypsies and beautiful, lounging models ('art tarts,' he called them[112]) of John's bohemian milieu. When the Rebel Art Centre opened, Lewis cut his hair, dressed in tailored suits, and insisted on similar neatness from his associates. Kate Lechmere had to dress in simple white blouses and long dark skirts like a high-

class shop girl. By maintaining a professional tone at the Centre,
Lewis hoped to keep artiness and amateurism at bay.

In his everyday life, Lewis liked talking with shop keepers, ABC waitresses, professionals, and craftsmen, the men who sold paints and made canvasses and frames. The one friend with whom Lewis could be totally at ease was Captain Guy Baker, an ex-army officer, who was not an artist. Lewis enjoyed the company of people who, as Helen Rowe put it, 'didn't have theories on art.' He liked places that were not fancy, such as the ABC's, and people who went about their work without unnecessary fuss. Probably one of the reasons for 'blessing' prize fighters, music hall entertainers, and aviators in *Blast* was that they were not arty.

Rather than an Omega 'evening' for wealthy customers and patrons, Lewis would choose, unhesitatingly, an afternoon in a little flea-pit cinema at the bottom of Charlotte Street, where children went for tuppence to see, among other things, Charlie Chaplin one-reelers. This was before anyone talked about Chaplin, but Lewis discovered him there. 'Come and see a clown,' he said to Helen Rowe one day, and took her to sit among the children and marvel at an actor who understood that mannerisms not only disguise, but have the power to take on lives of their own. One of Lewis' favourite Chaplin characters was the artist, whose every movement was programmed according to the stereotype of the nineteenth century *artiste*. Real and fictional equivalents of that character became butts of Lewis' own satiric jokes.

The seeming contradiction of a long-haired bohemian acting like a no-nonsense professional can be resolved fairly easily by realizing that the former returned in 1909 from Paris, and gradually, under the cover of protective mannerisms, evolved into the latter by the time of the Rebel Art Centre and *Blast*. More puzzling is the contradiction between the Lewis whose intellectual independence and obviously great talent assured him of success as an artist and art politician, and the Lewis whose dealings with other people made him appear undependable, spiteful, defensive, conspiratorial, and nearly paranoic. Long before he became 'the Enemy' and the underground man whose address was a Pall Mall safe deposit box, Lewis revealed a disconcerting secretiveness and defensiveness that created the impression, nearly unanimously expressed by people who knew him, that he suffered from a 'persecution mania.'

Lewis did not like to be pinned down or to promise to do things, and when he did agree to do something he often put it off until the last minute, or just did not do it at all. On two occasions Lewis agreed to paint drop curtains for theatrical

performances (one at the Chelsea Arts Club, the other at the Cave of the Golden Calf), and brought them in, the paint still wet, just before curtain time, when it was too late for them to be properly mounted and hung.[113] He agreed to carve an over-mantle for the Omega's room at the Ideal Home Show, and then left for a holiday. The piece of wood showed only a few tentative knife-marks when Lewis had his row with Fry and left the Omega for good. His murals at the Rebel Art Centre remained unfinished, as did most of his other schemes for the Centre. When pressured to finish a job or keep a commitment, Lewis' characteristic reaction was either evasion or resentment that often turned into abuse of the person applying the pressure.

148

Lewis seemed unnaturally anxious to detect malice toward him in the actions of other people. The Ideal Home Show furore showed how quickly and violently Lewis turned mistakes and confusions into a conspiracy against him; in the end, it was Lewis who organized a conspiracy against Fry. The 'Vital English Art' manifesto produced a similar over-reaction, in which Lewis interpreted genuine praise from Marinetti and Nevinson as some sort of insidious belittling of his own talent, and he was the one who conspired to attack the Futurists. At the Rebel Art Centre Lewis believed his directorship to be threatened by a possible coup engineered by Hulme for the benefit of Jacob Epstein. When Kate Lechmere pointed out that Epstein showed no interest in the Centre's doings, Lewis slowly shook his finger at her and intoned, 'Hulme is Epstein ... and Epstein is Hulme.'[114]

That admonitory gesture was one of Lewis' mannerisms. He used it in mock solemnity when he lectured Helen Rowe on the morals to be derived from the cliff-hanger serials he took her to see at the cinema. He would use the plight of the heroine at the end of an instalment as the basis of some truism. 'Now, Helen, remember, the moral of *that* is ... "always kill your man cleanly," ' Lewis would say and slowly wave his finger at her as he spoke.[115] Possibly, in other instances as well, Lewis used the waving finger to signal a more detached and comic view of what he was saying than his listeners, such as Kate Lechmere, fully appreciated.

In the same vein, Lewis' 'persecution mania' may have been more put on than real. One day Lewis rushed into Spencer Gore's flat. Announcing that he was being followed by a man to whom he owed money, Lewis dived behind a sofa and stayed there, out of sight, until Gore assured him that the street below was deserted.[116] Apparently Gore did not think Lewis might be putting on an act; yet he had received, some time before, a letter from Lewis, which recounted at length the tragic effect of

an outdated two franc piece on Lewis' credit in Paris. Lewis had bought the two franc piece from Gore for a shilling, only to have it rejected as worthless when he tried to buy something with it. 'Now for the whole length of the Avenue d'Orleans,' Lewis wrote Gore,

I am a disreputable byword, as one hardened in the subtlest forms of deception ... Each sweep of my barber's razor grates with a grim reproach, – I feel sure he uses an old razor, employed upon no other chin, desecrate to me. When I order my modest luncheon, the mournful tones of the garçon's voice echoed dismally in a gloomy kitchen beyond, sounds as though the food were paid for with bad money in advance, as though at least the waiter's tip, and this being at my mercy, were never worth the lifting from its place. I'm sure that my photograph is in every police register in Paris, with some epithet for fallen folks beneath.[117]

If this were not so clearly written with tongue in cheek, it too might have been evidence of Lewis' 'persecution mania.'

If a man suffering from a 'persecution mania' can see the humour of it, then he controls it at least as much as it controls him. Lewis seemed to be in this position. But many people did not think so. They believed to be 'real' what was probably, at least in part, Lewis' consciously contrived 'manner.' They missed the once-removed satirist underneath, like people who miss Johnathan Swift's grin behind the bewildered frown of Lemuel Gulliver. If the 'manner' significantly misrepresented the man, perhaps that was Lewis' intention. In any case, it contributed to the mysterious, conspiratorial, elusive personality that Lewis showed to the world. While it made Lewis seem to play, in Augustus John's words, 'the part of incarnate Loki, bearing news and sowing discord with it,'[118] it also contributed to his success in 'artistic power politics,' and gave unusual interest to his image as 'leader.'

Whatever the psychological pressures may have been behind Lewis' various manœuvres, perhaps only an overly sensitive defensiveness and inclination to conspiracy and combat could have made Lewis a 'leader' among his fellow avant-garde artists, many of whom were also defensive, quarrelsome, unreliable, and as easily split by mutual antagonism as joined by coterie cohesiveness. Furthermore, others, besides Lewis, had pushed well beyond the advanced lines established by Fry and his Grafton group coterie, and by 1914 had entered the boundless realm of abstractionism. Working under similar external pressures and internal motivations, they found themselves joining Lewis, Gaudier-Brzeska, and Pound in the 'informal association' that produced *Blast* and Vorticism.

There was Edward Wadsworth, an engineering student turned

painter, who went from the Slade to the Omega Workshops, where he met Lewis, threw in his lot with the anti-Fry coterie, and became Lewis' most active lieutenant at the Rebel Art Centre. Wadsworth had already developed a characteristic style based largely on industrial-urban imagery – cogwheels, trestles, pipelines, factories, smokestacks, and the like – and, as a Vorticist, he simply went a step farther into abstract designs based on these motifs. (plate 15) That was probably in Pound's mind when he wrote in the *Egoist* (15 August 1914) that, whereas Lewis would have been a Vorticist in any case, Wadsworth was made a Vorticist by the times. William Roberts called Wadsworth the only *real* Vorticist, other than Lewis,[119] and Lewis said later that Wadsworth was 'the painter most closely associated with my Vorticist activities.'[120]

150

A few other artists worked closely with Lewis. One was Frederick Etchells, whom the Fry-Grant-Bell coterie had considered one of their own until he left the Omega with Lewis and signed the letter attacking Fry and his Workshop. Another was Cuthbert Hamilton, a Slade student from 1899 to 1903, a teacher at Clifton College from 1907 to 1910, a collaborator with Lewis in a shadow-play project for the Cave of the Golden Calf, and an ally of Lewis, Wadsworth, and Etchells in the attack on Fry and in the subsequent founding of the Rebel Art Centre. (plate 16) Two others were Jessie Dismorr – known first as an English 'Fauve' in the circle of Fergusson, Peploe, and other contributors to *Rhythm* and the *Blue Review* – and her friend, Helen Saunders, another Slade student (1906-7) and contributor to the Allied Artists' exhibitions of 1912 and 1913. (plate 13) Lewis probably had Wadsworth, Etchells, Hamilton, Dismorr, and Saunders in mind when he wrote later that, while he had hoped to give the impression that 'there was a kind of army beneath the banner of the Vortex,' there were, in fact, 'only a couple of women and one or two not very reliable men.'[121]

These five painters, along with Lewis, Gaudier, and Pound, constituted the centre circle of Vorticism. A few other artists were on the perimeter. William Roberts was one. (plates 3 and 6) Shy, silent, ruddy-cheeked and boyish, 'Bobbie' Roberts was only eighteen years old when he left the Slade in 1913. He arrived at the Omega just after Lewis and his fellow defectors had left. 'Following an invitation from their leader [Lewis], I went over to the Rebels,' Roberts wrote later.[122] Among the 'rebels,' said Pound, 'Bobbie was regarded as a whim of W.L.'s.'[123] But Roberts' Cubistic *Dancers* and his hieratic tangle of ecstatic worshippers in *Religion* – both of which hung at the Rebel Art Centre and were reproduced in *Blast* – showed

that Roberts shared the basically abstractionist intentions of the
Vorticists.

Another artist moving in the same direction as the Vorticists was the poet and self-taught painter and sculptor, Lawrence Atkinson. Twenty years older than Roberts and something of an outsider, Atkinson won recognition as one of the 'advanced forces of vital English art' in the Marinetti-Nevinson manifesto, and his name leads the list of signers of the Vorticist manifesto in *Blast*. (plate 14)

C.R.W. Nevinson just missed being a Vorticist. He joined Lewis' forces at the time of the anti-Fry campaign, and actively supported the Rebel Art Centre. Only his allegiance to Futurism prevented Nevinson from being one of the most active Vorti- cists, and, in fact, he helped plan *Blast*. But, after the anti-Futurist efforts of June 1914, he found himself outside the Vorticist circle and no longer an ally of the *Blast*-Rebel Art Centre group. (plate 7)

Still more peripheral to Vorticism, though central to the avant-garde movement in England, were David Bomberg and Jacob Epstein. The high-strung and fiercely independent Bomberg had embraced geometrical-abstract art by the time he left the Slade in 1913. Only a year later he showed his work in a one-man exhibition at the Chenil Gallery, and proclaimed in the catalogue his commitment to 'the construction of Pure Form.' But the brighter colours and more open, arabesque-like structure of his cubist designs distinguished his work from the somberly coloured and knotted or locked-together constructions of the characteristic Vorticist designs. (plates 8 and 9) For both personal and aesthetic reasons, he refused to identify himself with the Rebel Art Centre, and he showed his work at the 1915 Vorticist exhibition only as a non-Vorticist invited to show with the group.

Although Epstein contributed two drawings to *Blast* No. 1, he did not regard himself as a Vorticist. Nevertheless, he was an old veteran of avant-garde battles. From 1908, when his statues for the British Medical Association Building in the Strand created a scandal, he had pushed ahead with experiments in 'primitive,' extremely simplified, and monumental sculpture. Lewis insisted in 1913 that Epstein was 'the only great sculptor at present working in England,'[124] and T.E. Hulme used Epstein's fetish-like carvings in flenite as proof of that sculptor's ability 'to clear the world of the sloppy dregs of the Renaissance.'[125] Epstein and Gaudier seemed to divide the English world of avant-garde sculpture between them. Ford Madox Ford noted that in exhibitions, cafés, and salons one would see either 'a brutal chunk of rock that seemed to have lately fallen

unwanted from a slate quarry, or ... a little piece of marble that seemed to have the tightened softness of the haunches of a faun ... The brutalities would be the work of Mr. Epstein – the others Gaudier's.'[126]

Gaudier's last work was harsher and more abstract than Ford's comments would suggest, and Epstein's masterpiece of the period was not among his large, 'primitive' carvings in stone. It was *Rock Drill*, which made its first appearance in 1915. At that stage it was a complete, though extremely stylized, figure in plaster. Later, only its head, upper torso, and arms were cast in bronze to produce the enigmatic icon of mechanized man now on display in the Vorticist section of the Tate. (plate 17) For Epstein, the statue expressed his, as he put it, 'ardour for machines (short-lived),' and he even thought of connecting the full-figure statue to a working pneumatic drill, 'thus completing every potentiality of form and movement in a single work.' At the 1915 London group show, he exhibited the plaster figure perched on a non-working drill, but he quickly decided this 'was really child's play.'[127] In its final form, *Rock Drill* conveyed less of the Futurists' 'ardour for machines,' and more of Hulme's concept of inorganic, 'nonvital' art derived from the modern sensitivity to machine forms.

Epstein not only shared with Lewis, Gaudier, and the other Vorticists a Hulmean concept of geometrical, abstract form, he also objected to the Futurists and strongly disliked Fry and the Omega Workshops.[128] When, as he put it, 'Cubism was in the air, and abstraction an interesting experiment,'[129] he briefly joined step with the Vorticists, and by his proximity seemed to swell the ranks and importance of the movement. But Epstein was not a Vorticist; first and last, he was his own man. Moreover, he and Lewis had a falling out, and Epstein, like Bomberg, was just as happy to stay free of the group movement headquartered at the Rebel Art Centre and represented to the world by *Blast*.

Epstein could not isolate himself from the broader circle of London artists whom the public called extremist, anarchical, immoral, dishonest, and insane. Nor could Epstein, any less than Bomberg or Nevinson or Roberts or Lewis, work free from the revolutionizing influences of Post-Impressionism, Futurism, Expressionism, and Cubism, all of which contributed to what Roberts called 'the Art atmosphere of the period, which we all breathed.'[130]

The English artists who breathed that atmosphere most deeply were ignored, misunderstood, or attacked, except by a few sympathetic critics like P.J. Konody, Frank Rutter, and Clive

Bell. Even the sympathizers seldom granted their countrymen equal status with avant-garde artists on the Continent. The complaint of Frank Rutter in 1910, that 'three-fifths of the [Autumn Salon in Paris] are like nothing ever seen in a British Art Gallery,'[131] resounded through English critical opinion of the time. Reviewing *Blast* in August 1914, Richard Aldington bemoaned the fact that even American artists seemed better than English artists;[132] surveying the avant-garde contributions to the London group exhibition of March 1915, Frank Denver said the Vorticists were 'pioneers painting in the rear of Munich, Paris and New York ...'[133] and, as late as 1917, Clive Bell still felt that English artists had yet to join the 'international league of youth' whose headquarters was Paris. Vorticism, he regarded as a 'puddle of provincialism.'[134]

The revolutionary atmosphere of the Continent seemed all the more exhilarating to English artists who still found themselves caught in the insular traditions of British art, where Turner was regarded as a remarkable exception to the tradition of realistic depiction of nature and man, Whistler a near-revolutionary for conceiving of paintings as harmonies in colour instead of pictures of people and things, Pater an immoralist for appealing to the sensual pleasure of art as a value in its own right, and Roger Fry a madman-charlatan-anarchist for defending Cézanne and preaching a doctrine of 'significant form.' In such a climate, English Picassos, Matisses, or Brancusis were not likely to flourish. So, a Wyndham Lewis, a David Bomberg, a Jacob Epstein, were marvelous developments indeed.

Least likely to succeed was an abstract art that made no compromises at all with the public's expectations. The Fry-Grant-Bell school of English Post-Impressionists and the English Fauves somewhat mollified their viewers' hostility by using recognizable images and pleasant colour to produce the sort of work T.E. Hulme contemptuously dismissed as 'the usual Cézanne landscapes, the still lifes, the Eves in their gardens, and the botched Byzantines.' Their 'strong family resemblances,' said Hulme, revealed themselves through the almost uniformly 'pallid chalky blues, yellows and strawberry colours.'[135]

The artists Hulme admired – the small circle of Vorticists and fellow-Cubists like Bomberg and Epstein – challenged the contemporary audience's expectations at every point. To the gallery-goers' delight in colour, they offered predominately black, white, and muddy or dull metalic hues. To the general pleasure in sensuous line, they provided sharp, hard-edged shapes that looked as if they might have been made with triangle and t-square. To the penchant for literary or symbolic references in art, they gave purely visual design. To the assumption that art

should reflect 'life,' they either eschewed all reference to 'life,' or else abstracted, fragmented, and reduced it to nearly anonymous parts that were inseparably fitted together to make no reference beyond their own intricate design.

Granting all the exceptions – such as Gaudier's line drawings, Bomberg's bold colours, Epstein's refusal entirely to desert recognizable human and animal shapes, Lewis' tendency to give his pictures literary or symbolic titles – the fact remains that a discernable visual and sculptural style had emerged by 1914, a style definable in terms provided by Hulme's writings on abstract-geometrical art, and recognizable by a reasonably close adherence to the characteristics succinctly listed by Walter Michel: 'totally abstract, or near-abstract composition; jagged over-all forms; and small or narrow compositional elements sharply bounded by straight-lines or geometric arcs.'[136] Enough works fulfilling these criteria appeared to prove that a 'school' existed. Until June 1914, the best label for that school was 'English Cubists,' and from that group emerged the coterie of artists who discovered 'an underlying agreement,' and, as Pound said, 'decided to stand together.'

That 'underlying agreement' included the willingness to experiment with abstract form, and to create emotionally charged, highly expressive compositions. The most notable theoreticians of the group, Lewis, Gaudier, and Pound, tended to think about the essential qualities of their arts in similar terms. Lewis wrote some years afterwards that his abstract 'Planners' series of 1913-14 represented 'a mental-emotive impulse' or a 'subjective intellection ... let loose upon a lot of blocks and lines.'[137] That is not too far from Pound's definition of the Image in his article on Vorticism in the *Fortnightly* (1 September 1914): 'The image is an intellectual and emotional complex in an instant of time.'[138] Gaudier, in a letter of 28 October 1912, set down descriptions of three artistic emotions: 'linear emotion, produced by the rhythm of outlines and of strokes, sculptural emotion, rendered by the balance of masses ... pictorial emotion, produced by various coloured pigments.' These three emotions, said Gaudier, seemed to be united in 'a vast intellectual emotion.'[139]

Besides trying to convey their sense of an intense artistic expression through strikingly similar phrases – 'vast intellectual emotion,' 'intellectual and emotional complex,' 'mental emotive impulse' – these three artists sought out comparable images when they tried to characterize the kind of art they admired and wished to produce. 'Sharpness and rigidity' was Gaudier's way of putting it; 'rigid reflections of stone and steel' was Lewis'; 'hard light, clear edges' was Pound's. And all three, when they

tried to put these notions into practice, were given up as lost by many of their former supporters and admirers.

However unpopular, vague, and incomplete these aesthetic criteria were, they at least revealed similar sensitivities and a common set of feelings about what modern painting, sculpture, and poetry had to offer. That was enough, along with the various schisms, controversies, and coterie activities, to draw Lewis, Gaudier, and Pound into temporary alliance, and to bring into their circle a small band of artists with visual styles comparable to Lewis'. Pound's 'little gang' turned into an 'informal association' of individuals who called themselves Vorticists. Their group identity within the general avant-garde scene depended not only on their similar visual styles and aesthetic outlook, but on their willingness to accept that label. It also depended on Lewis' masterstroke in artistic power politics: the publication of *Blast*.

# 9
# 'Blast': Preparations

Late in 1913, the Countess of Drogheda invited two of London's leading avant-garde artists, Wyndham Lewis and C.R.W. Nevinson, to paint some 'futurist' decorations for her dining room. Nevinson, though interested, was recovering from a serious illness and preferred to let Lewis carry on alone. When Lady Muriel Paget needed some artists to make 'futurist' back-drops for *tableaux vivants* at the Albert Hall Picture Ball in December, she went to Nevinson, who, in turn, brought in Lewis, and the two worked on them together. During the same time, Lewis and Nevinson began meeting at Verrey's Restaurant to plan a new magazine, which they hoped would promote avant-garde art in England.[1]

The only other contemporary attempt to produce a magazine devoted to the new art in England resulted in an expensively printed monthly called *Colour*, whose first issue appeared in August 1914. Although its editor, T.M. Wood, claimed to present 'modern art in England in its characteristic phase of this moment,'[2] he decorated the cover with a picture by the popular Edwardian painter, Frank Brangwyn, and included among the magazine's illustrations a romanticized realistic painting, *Laughter*, by William Strang, a Beardsleyesque *Fantasy* by Elsa Moxter, an Impressionist *Pont des Arts, Paris* by K.M. Morrison, and several conventional magazine illustrations by Sinclair and others. Wood called Brangwyn 'a truly modern artist' and Strang, 'ultra-modern'; whereas, the Vorticists blasted Brangwyn in both issues of *Blast*, and ignored Strang entirely. The closest *Colour* came to offering the kind of modern art Lewis and Nevinson had in mind was in reproductions of a mild Post-Impressionist study by Fergusson, *The Yellow Hat*, and a woodcut, *Woman Bathing*, by Horace Brodzky.

Although later issues occasionally reproduced something by Augustus John, Gaudier-Brzeska, John Nash, Mark Gertler, Alfred Wolmark, Nina Hamnet, or Nevinson himself, its sub-scribers never saw an example of the work that Lewis and

Nevinson wanted to present and defend in 1913. They had in mind what the catalogue for 'The Exhibition of the Camden Town Group and Others' at Brighton, called 'the work of English Post-Impressionists, Cubists and others'; what Marinetti and Nevinson called 'vital English art'; and what the first advertisement for *Blast* called 'Cubism, Futurism, Imagisme and ALL Vital Forms of Modern Art.' *Colour* offered virtually none of this, in spite of its claims to being interested in the most 'modern' art in England. *Colour*'s failure proved the need for the sort of magazine Lewis and Nevinson wanted to bring out.

In October 1913, Lewis, Wadsworth, Etchells, and Hamilton had left the Omega Workshops, and by that act deprived themselves of the promotional assistance of England's leading exponent of avant-garde art. Then, in November, the same four artists, joined by Nevinson, sponsored the dinner for Marinetti at the Florence, and by *that* act signalled their allegiance to the iconoclastic and propagandizing spirit of Futurism, and to the notion that an avant-garde movement prospers when its members not only exhibit together under a common label, but issue manifestoes and control their own magazine. In December, Lewis, Nevinson, Etchells, Hamilton, and Wadsworth appeared with Bomberg and Epstein under the label 'English Cubists' in the exhibition at Brighton. The time seemed right for the 'English Cubists' to speak to the public through their own magazine, just as the Futurists were doing through *Lacerba*, and to issue their own manifestoes, as the Futurists had been doing – continuously, it seemed – since about 1910.

The problems facing Lewis and Nevinson were, first, how to get a magazine put together and published, and, second, how to make it represent an English revolution in art without simply imitating publications already produced by the continental avant-garde. In the process of solving these problems, a third arose. That was, how to invest the magazine with a singleness of purpose, so that instead of a miscellaneous collection of 'modern' opinions and works, it would appear as the unified expression of a particular group of modern artists.

Some timely help on the first problem came from Douglas Goldring. After Nevinson's father, the well-known journalist, H.W. Nevinson, had tried to use his connections in the publishing world to find a publisher for the new magazine, and T.E. Hulme had failed to interest the *New Statesman*'s publisher, Harold Latimer, in backing the venture, Goldring found a small firm, Leveridge and Co., willing to print the magazine.[3] John Lane, who had published the *Yellow Book*, and was known as 'a man for novelties,'[4] agreed to act as publisher. He had little to lose, since he provided only the machinery for advertising

and distribution. Lewis had to bear the printing costs, and he turned for help to the backer of the Rebel Art Centre, Kate Lechmere. Taking several of Lewis' paintings as collateral, Miss Lechmere lent Lewis £100 and gave him an order for fifty copies of the magazine.[5] The loan and order assured the magazine's being printed, and seemed, at the time, to be good business as well as an act of friendship. It turned out to be bad business and one of the things that brought Kate Lechmere's and Lewis' friendship to an end.

From the first, the problems of financing and publishing the magazine created so many problems that Nevinson became discouraged. In February 1914, he pronounced the project a failure, and dropped out.[6] Wadsworth and Pound, who had already joined in planning the magazine, filled the vacancy left by Nevinson's departure. With the one confirmed Futurist out of the way, Lewis could make the magazine more responsive to his own outlook and interests.

He could not, however, eliminate Nevinson's influence entirely; for it was the Futurist who named the magazine. In mid-November 1913, when the planning had hardly begun, Nevinson suggested calling the magazine *Blast*.[7] Lewis was not completely happy with the name, but Wadsworth liked it, and argued that it should not be rejected unless a better name came along.[8] None did, and even Lewis finally came around to defending it. While ignoring the Futurist connotations of the word, he insisted on its appropriateness for his magazine. ' "Blast" signifies something constructive and destructive,' he told a *Daily News* reporter. 'It means the blowing away of dead ideas and worn-out notions. It means (according to the Anglo-Saxon interpretation) a fire or flame.'[9] It was also an expletive like 'damn!' and sufficiently impolite, by English standards, to make Lewis and Wadsworth doubt that booksellers like W.H. Smith would be willing to carry a magazine with *Blast* for its title.[10] For better or worse, the name stuck, and in many ways it helped shape the magazine. Much of the characteristic tone and content of *Blast* seemed to come from its editor's attempt to live up to the violent connotations of his magazine's name.

The magazine was his, in the sense that he became sole editor upon the departure of Nevinson. It was not *only* his, however. Wadsworth and Pound actively assisted in its preparation. Some of the planning meetings were held at Wadsworth's flat,[11] and Wadsworth arranged with the publisher, Constable, to see the proofs of Kandinsky's *On the Spiritual in Art* before it was released, so that he could review it for *Blast*. He edited and lengthened the magazine's manifesto. He had photographs taken of the works to be reproduced in *Blast*, and drew up a list of

how many copies should be printed and where they should be distributed: 1000 for London, 500 for the United States, 100 each for Oxford and Cambridge, etc.[12]

Pound, who had been engaged as Yeats' secretary and was spending the winter at Yeats' retreat in Sussex, managed to keep in touch and make his own contributions. He wrote and sent off advertisements like the one that appeared on the back cover of the *Egoist* (1 April 1914).

<div align="center">

Discussion of Cubism, Futurism, Imagisme and ALL

Vital Forms of Modern Art

THE CUBE        THE PYRAMID

Putrefaction of Guffaws Slain by Appearance of

BLAST

NO Pornography      NO Old Pulp

END OF THE CHRISTIAN ERA

</div>

Besides applying the satiric spirit of 'Salutation the Third' to advertising prose, Pound patiently wrote out a list of seventy-five people who should receive publicity about *Blast* (among whom were James Joyce, D.H. Lawrence, Phyllis Bottome, Robert Bridges, Walter Lippmann, and Olivia Shakespear), and mailed the list to Lewis along with a request to send proofs for *Blast* to him in Sussex.[13]

Meanwhile, Lewis enlisted the help of Etchells, who was in Paris at the time, and of Alick Schepeler, a friend who worked for the *Illustrated London News*, to publicize *Blast* and get subscriptions. To fill out the literary content of the magazine, he went to Rebecca West, whose short story, 'Indissoluble Matrimony,' had been rejected by Austin Harrison at the *English Review*. Lewis liked the story and got it for *Blast*.[14] Ford Madox Ford gave Lewis the opening chapters of his new novel, which appeared in *Blast* with the title, 'The Saddest Story,' but came out a year later, in its complete form, as *The Good Soldier*. Gaudier-Brzeska contributed an essay, and Pound provided an essay and some poems. Lewis, himself, wrote a series of notes on modern art, and composed a hybrid drama-short story, 'Enemy of the Stars.'

While the material for *Blast* accumulated, Lewis and Pound held the meeting at which, as Douglas Goldring described it later, 'We solemnly compiled lists of persons who should be blasted and of others who should be blessed. I have often wondered what Pound and Lewis thought of their disciples. I know what I thought of them! The proceedings terminated with a quarrel between Lewis and C.R.W. Nevinson, I fancy on the subject of Futurism.'[15] *Blast*'s anti-Futurist bias went unnoticed by most people at the time, but those lists of the blasted and the blessed – perhaps because they came from the milieu, and not

simply from Lewis and Pound – attracted more attention than almost anything else in the magazine.

Lewis undoubtedly knew that Apollinaire had used a blasting-blessing format in a Futurist manifesto issued in June 1913.[16] In 'L'Antitradition Futuriste: Manifeste-Synthèse,' Apollinaire attacked and praised under two sets of headings, *Destruction-Construction* and *Merde Aux – Rose Aux*. His tone was Futurist; his bias, French. His awareness of the continental avant-garde movements made the manifesto a very different document from the Vorticists' English-centred pronouncement. Apollinaire's *Rose Aux* list now reads like a catalogue of major innovators in early twentieth century art: Marinetti, Picasso, Apollinaire, Matisse, Kandinsky, Leger, Duchamp, and Stravinsky appeared there. Roger Fry was the only Englishman included in that advanced and cosmopolitan company. The Vorticists copied Apollinaire's format, but with the substitute headings 'Blast' and 'Bless.' Like the lists themselves, those expletives gave a certain Englishness to *Blast*'s pronouncements, and helped the Vorticists to distinguish their movement and their magazine from the products of the continental avant-garde.

Another essential ingredient of *Blast* came, if not exactly from the English avant-garde milieu, then from one man's sense of that milieu. In December 1913, writing to William Carlos Williams, Pound had called the London literary-art scene 'The Vortex,' and, sometime between April and June 1914, Pound applied the image, metaphor, and symbol of the Vortex to the work of Lewis and the other 'English Cubists' in whose behalf Lewis and Nevinson had undertaken to bring out *Blast*. The idea of incorporating the Vortex into *Blast* must have come late in the magazine's preparation, however. The advertisement Pound sent to the *Egoist* did not mention the Vortex or Vorticism, nor did Pound mention Vorticism when, in March or April 1914, he told James Joyce that Lewis was starting 'a new Futurist, Cubist, Imagiste Quarterly.'[17] Only after that did Pound, Lewis, and others begin to talk about Vorticism and to associate *Blast* with a Vortex.

Describing the special qualities he perceived in Lewis' drawing, Pound wrote, '[It is] every kind of whirlwind of force and emotion. Vortex. That is the right word, if I did find it myself.'[18] Explaining the new movement to Violet Hunt, Lewis said, 'At the heart of the whirlpool is a great silent place where all the energy is concentrated. And there at the point of concentration, is the Vorticist.'[19] In *Blast*, Pound announced, 'The Vortex is the point of maximum energy.' And Lewis wrote, 'The Vorticist is at his maximum point of energy when stillest.' Pound said, 'All experience rushes into the vortex.' Lewis said, 'The new

vortex plunges to the heart of the Present.' At strategic points in the magazine, Lewis printed the Vorticists' Vortex.

The image seemed so right, suddenly, that drawing upon its literal, visual, and metaphorical meanings became the most efficient way of defining the quintessence of *Blast* and the movement it represented.

162    Once Pound had supplied the magazine and movement with a Vortex, then whirlpools, whirlwinds, vortices, and – more abstractly – cones spinning on vertical axes came quickly to mind. Pound and Gaudier could then call their essays for *Blast* 'Vortex,' and Lewis could call his essays 'Vortices and Notes,' and supplement the magazine's manifesto with statements specifically drawing upon the Vortex for its tone and imagery. The magazine that in April vaguely promised a 'Discussion of Cubism, Futurism, Imagisme and ALL Vital Forms of Modern Art,' could, in June, announce it would contain 'The Manifesto of the Vorticists. The English Parallel Movement to Cubism and Expressionism. Imagisme in Poetry. Death Blow to Impressionism and Futurism and all the Refuse of naif science,'[20] and the title page could now identify *Blast* as the 'Review of the Great English Vortex.' Now Vorticism and *Blast* would appear simultaneously.

First announced for April, then for 18 June, *Blast* carried the date 20 June 1914 on its title page, but was not officially released by John Lane until 2 July.[21] 'It is an awful business to get it out,' Lewis complained to Alick Shepeler. 'I am not a business man,' he admitted, and added that his 'undeniable political activity' had taken time away from his editorial work.[22] The Rebel Art Centre required some of his time, and so, of course, did his own writing and painting. His general indifference to deadlines and other commitments undoubtedly slowed things down. So did John Lane's decision to censor Pound's 'Fratres Minores.' The magazine could not be released until black bars had been printed across the three offending lines.

Furthermore, until late spring the magazine lacked a clear-cut identity, and there was no pressing need to get an identity established in the public eye. Pound, by coming up with the symbol of the Vortex, and Marinetti, by too zealously promoting Futurism and threatening to overshadow the 'English Cubists,' provided the needed stimuli for getting the magazine done, but they

also forced Lewis to delay its appearance until the Vortex and talk of Vorticism were added to the magazine. Lewis placed 'Review of the Great English Vortex' under the original title, *Blast*, and inserted a preliminary statement headed 'Long Live the Vortex!' immediately preceding the manifesto. To end his 'Vortices and Notes,' he included another proclamation in manifesto-prose called 'Our Vortex,' and concluded the magazine with Pound's and Gaudier's 'Vortex' statements, both of which seemed to have been written in direct response to the evocative power of that word. With these additions, Lewis could expect to distinguish *Blast* from Futurism and other -isms vying for public attention.*

An absurdly inadequate page of errata stuck in after the title page hardly prepared readers for *Blast*'s unusually numerous misprints and lapses into what the *Pall Mall Gazette* (1 July 1914) called 'indifferent grammar and bad spelling.' Lewis' last-minute additions to the magazine and his habitual negligence about details and deadlines must have created chaos at the printers, and deprived *Blast* of the careful proofreading it needed. In his own defence, Lewis could have pointed out, however, that nothing like *Blast* had appeared before. He had no precedents to follow and no one with sufficiently similar experience in editing to advise him. Some Futurist manifestoes and *parole in libertà* poems, and some pages of Marinetti's *Zang-tumb-tuuum* had demonstrated the expressive possibilities of typography and layout, but no one had tried to extend those possibilities to the production of an entire magazine whose contents came from different people expressing themselves in different literary forms and different arts.

Given Lewis' weaknesses as an editor, and given the size, scope, and originality of the magazine he edited, the wonder is that anything concrete ever came from those first tentative planning sessions at Verrey's in the late fall of 1913. But as the 'season' of 1914 proceeded, unaffected by the impending consequences of Sarajevo, *Blast* appeared, proclaiming, 'Long live the great art vortex sprung up the centre of this town!'

---

* Walter Michel has suggested to the author that substantial parts of *Blast* No. 1 may have been set up in type before the Vortex and Vorticism came on the scene. Some further evidence supporting this hypothesis is that, except for Lewis' essay, 'Our Vortex,' and the general title of his essays, 'Vortices and Notes,' all references to the Vortex appear in the first and last signatures of *Blast*. The first signature of eight pages (all others are sixteen pages) includes the title page, a page of errata, and a prefatory Vorticist statement. The next signature opens with the manifesto and contains no mention of the Vortex. The last signature contains Pound's and Gaudier's 'Vortex' essays.

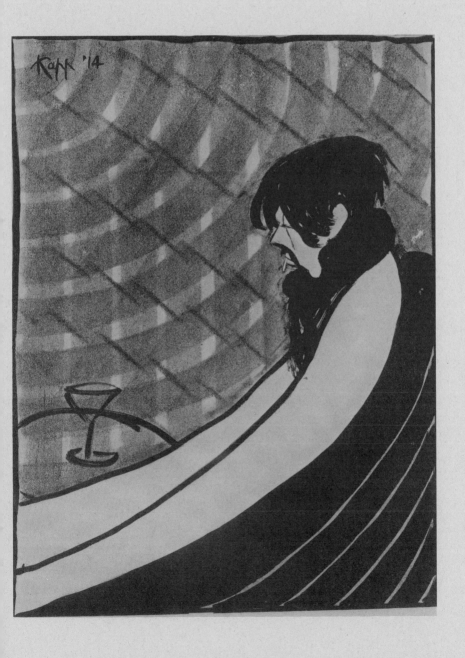

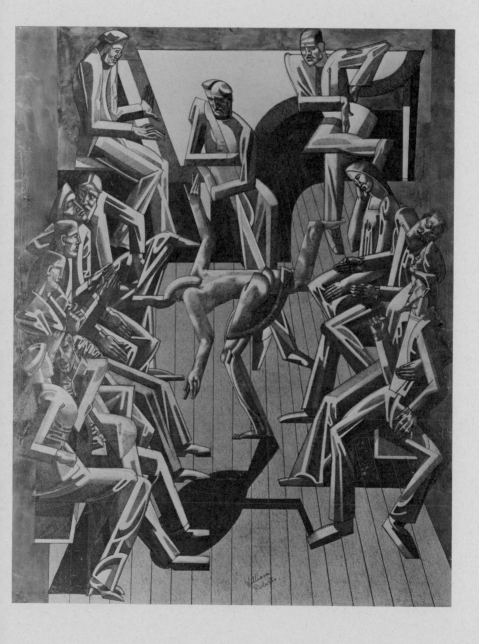

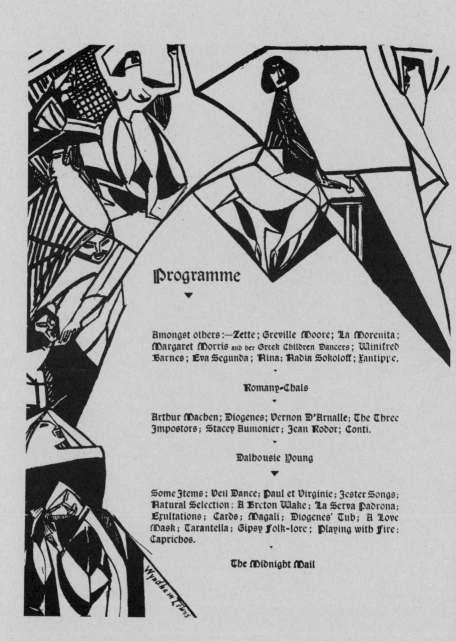

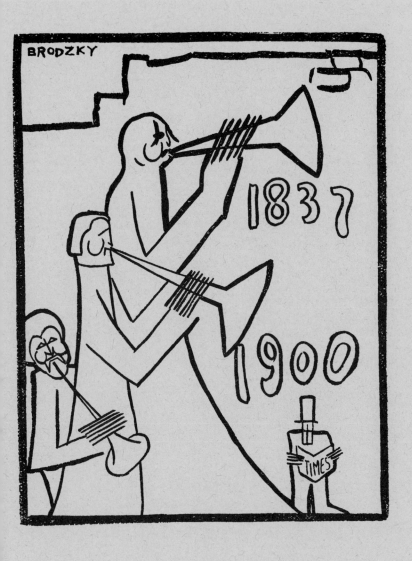

6 WILLIAM ROBERTS *The Vorticists a
the Restaurant de la Tour Eiffel: Spring 191
1961-
oil on canvas 72″ x 84
Tate Gallery, Londo*
According to Roberts the figures are as follows: *l to r, seated* Hamilton, Pound
Roberts, Lewis, Etchells, and Wadsworth; *standing* Dismorr, Saunders
the waiter Joe, and Rudolph Stuli

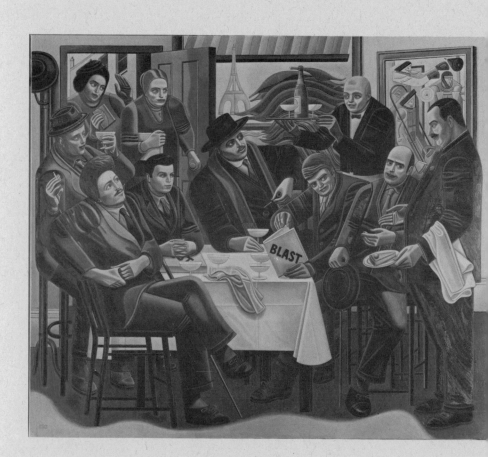

7 C.R.W. NEVINSON *The Arrival* c1913-14
oil on canvas  30″ x 25″
Tate Gallery, London

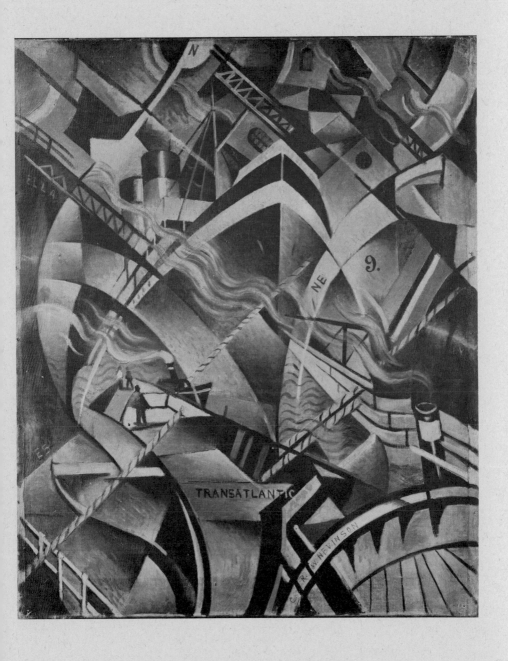

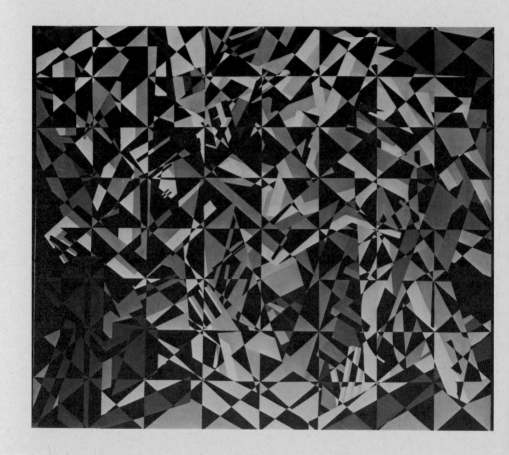

9 DAVID BOMBERG *Mud Bath* 1914
oil on canvas  60″ x 88¼″
Tate Gallery, London

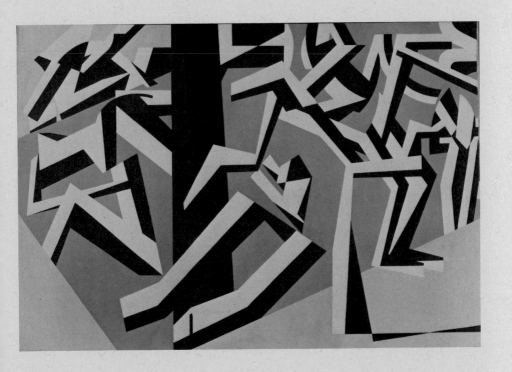

10 WYNDHAM LEWIS *Composition (Later Drawing of Timon Series)* 1913
pen and chalk 13½″ x 10½′
Tate Gallery, London

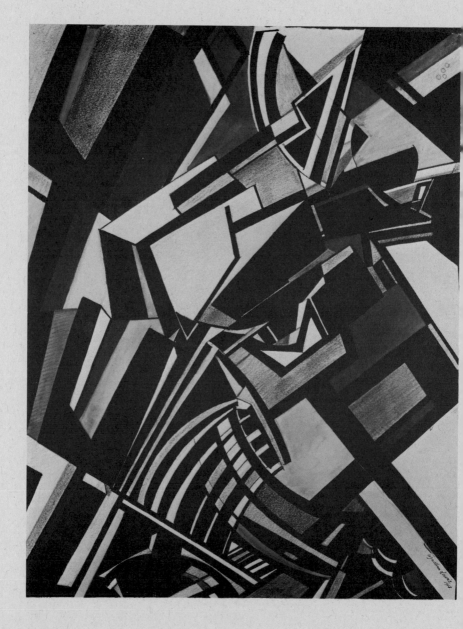

1 WYNDHAM LEWIS *Revolution (The Crowd)* c1915
oil on canvas 78″ x 60″
Tate Gallery, London

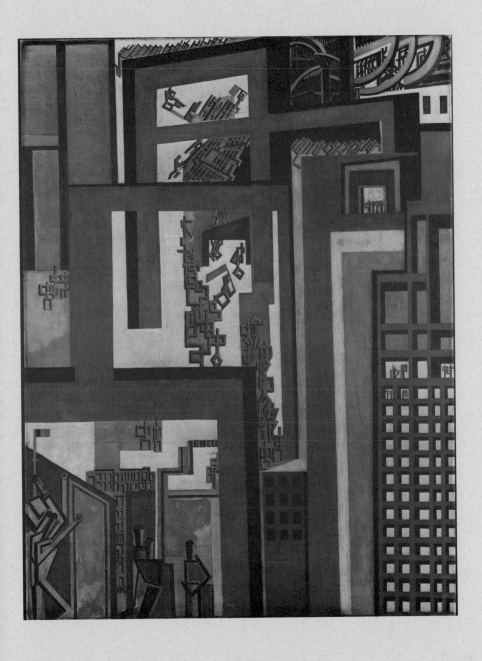

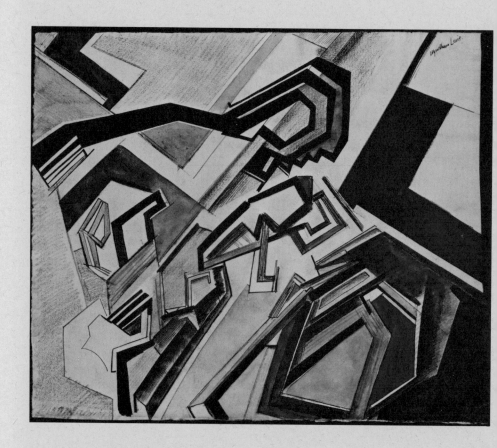

12 WYNDHAM LEWIS *Planners (Happy Day)* 1913
pen and chalk 12½ " x 15½ "
Tate Gallery, London

HELEN SAUNDERS *Composition in Blue and Yellow* c1914-15
pencil, chalk, wash, and collage 10⅞″ x 6¾″
Tate Gallery, London

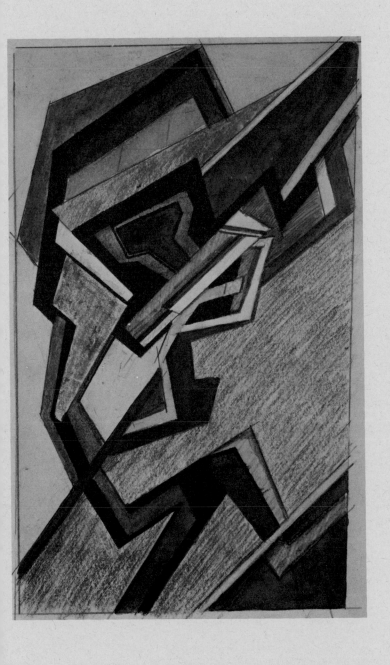

14 LAWRENCE ATKINSON *Composition* c1913
pencil and coloured crayons 13½ ″ x 21½ ″
private collection, London

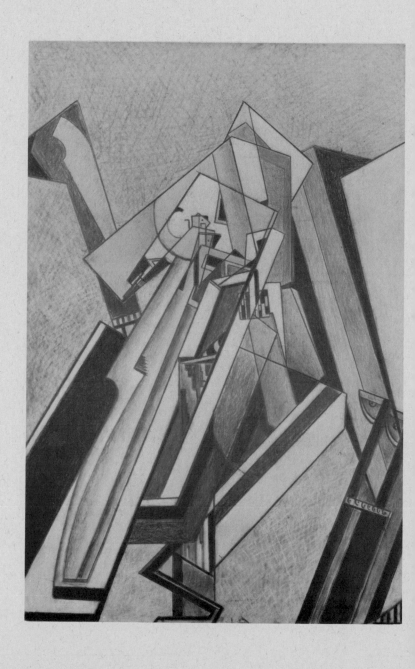

EDWARD WADSWORTH *Abstract Composition* 1915
gouache 16½ " x 13½ "
Tate Gallery, London

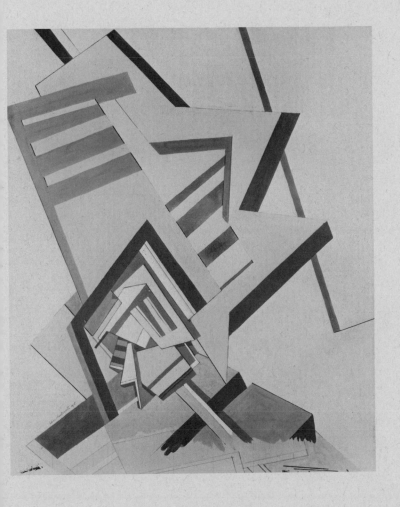

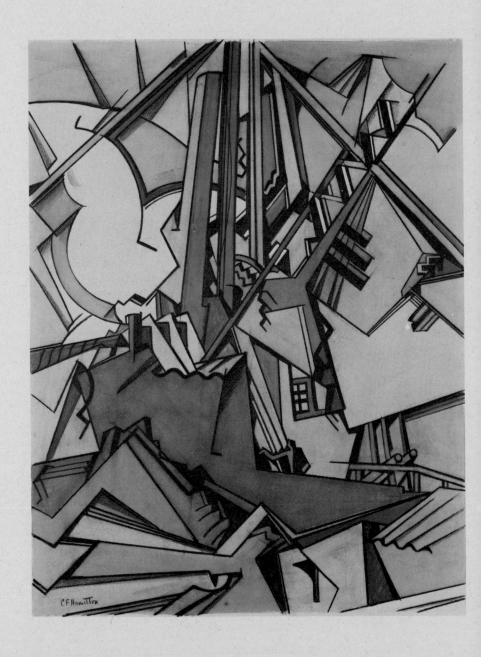

16 CUTHBERT HAMILTON *Reconstruction* c1919-20
black chalk and gouache 19¼″ x 15¼″
Tate Gallery, London

JACOB EPSTEIN *Rock Drill* 1913
bronze 27¼″ high
Tate Gallery, London

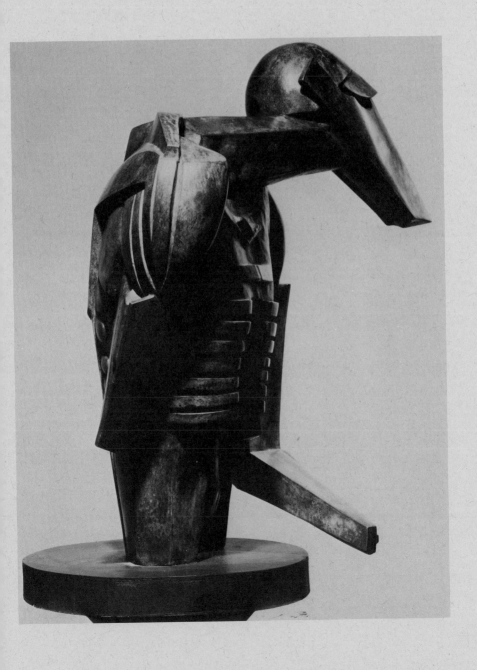

18 HENRI GAUDIER-BRZESKA
*Brass Fish* 1914
from the collection of the late Major
Dermot Freyer

19 HENRI GAUDIER-BRZESKA
*Brass Toy* 1914
Mrs Celia Clayton

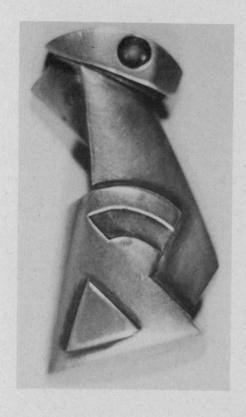

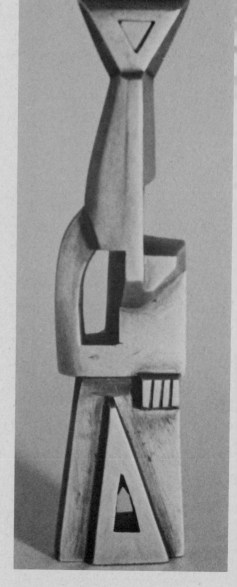

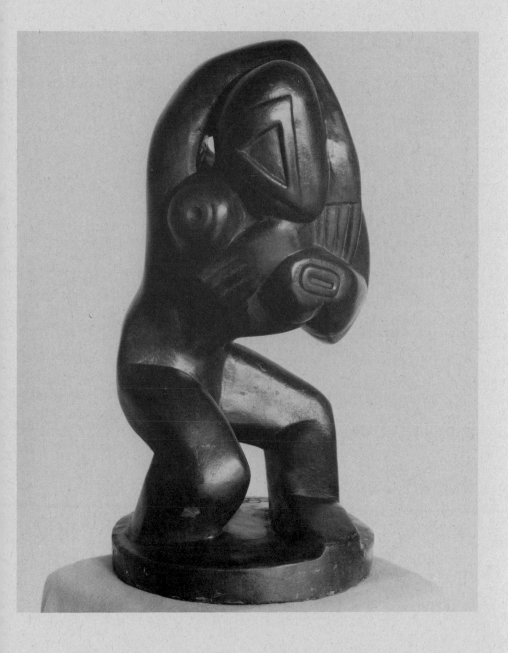

# CURSE

**the flabby sky that can manufacture no snow, but can only drop the sea on us in a drizzle like a poem by Mr. Robert Bridges.**

# CURSE

**the lazy air that cannot stiffen the back of the SERPENTINE, or put Aquatic steel half way down the MANCHESTER CANAL.**

**But ten years ago we saw distinctly both snow and ice here.**

**May some vulgarly inventive, but useful person, arise, and restore to us the necessary BLIZZARDS.**

# LET US ONCE MORE WEAR THE ERMINE OF THE NORTH.

# WE BELIEVE IN THE EXISTENCE OF THIS USEFUL LITTLE CHEMIST IN OUR MIDST!

## 2

# OH BLAST FRANCE

pig plagiarism
**BELLY**
**SLIPPERS**
**POODLE TEMPER**
**BAD MUSIC**

# SENTIMENTAL GALLIC GUSH
# SENSATIONALISM
# FUSSINESS.

**PARISIAN PAROCHIALISM.**

Complacent young man,
so much respect for Papa
and his son !—Oh !—Papa
is wonderful : but all papas
are !

# BLAST

APERITIFS (Pernots, Amers picon)
Bad change
Naively seductive Houri salon-
picture Cocottes
Slouching blue porters (can
carry a pantechnicon)
Stupidly rapacious people at
every step
Economy maniacs
Bouillon Kub (for being a bad
pun)

# BLESS ALL PORTS.

**PORTS, RESTLESS MACHINES** of | scooped out basins
heavy insect dredgers
monotonous cranes
stations
lighthouses, blazing
    through the frosty
    starlight, cutting the
    storm like a cake
beaks of infant boats,
    side by side,
heavy chaos of
    wharves,
steep walls of
    factories
womanly town

**BLESS** these **MACHINES** that work the little boats across
clean liquid space, in beelines.

**BLESS** the great **PORTS** | HULL
LIVERPOOL
LONDON
NEWCASTLE-ON-TYNE
BRISTOL
GLASGOW

# BLESS ENGLAND,
Industrial island machine, pyramidal

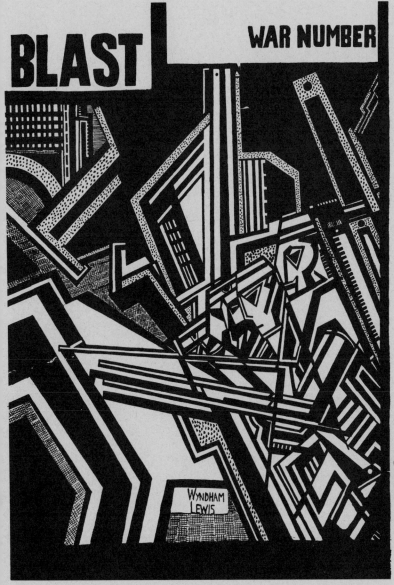

# 10
## 'Blast': The Manifesto

In keeping with the avant-garde spirit of the day, *Blast* intended to shock. Not only its name, but its cover, size, and typography worked to that end. Variously described as 'violent pink,' 'puce,' 'purple,' 'magenta,' 'bright cerise ... that makes one feel as if the outer cuticle had been removed,' and 'the color of an acute sick-headache,'[1] *Blast*'s cover was a broad expanse of pinkish purple crossed diagonally by the single word 'BLAST' in three-inch high block letters. The back cover repeated, like an echo, the diagonal 'BLAST' of the front. Between the covers were nineteen art reproductions on good-quality glossy paper, one woodcut, and 160 nearly folio-sized pages of unusually heavy paper on which Leveridge had used thick, blocky print.

Compared to other smaller, thinner, and more decorous avant-garde magazines of that time, such as *Rhythm* and *Blue Review* (with their conservative blue covers), *Poetry* (with even more conservative grey), and the *Little Review* (with muddy brown), *Blast* seemed exceedingly brash, if not gauche and in bad taste. At its best, however, *Blast* conveyed a dogged aggressiveness as it advanced upon its times like a modern barbarian destroying everything old and decadent in its path. In the spirit of Nietzsche's declaration, 'This universe is a monster of energy without beginning or end, a fixed and brazen quality of energy,'[2] *Blast* set about establishing a new, virile civilization based on hardness, violence, and the worship of energy. 'Will Energy some day reach Earth like violent civilization, smashing or hardening all?' Lewis asked in 'Enemy of the Stars.'

*Blast* looked like and sounded like a harbinger of that Energy. There was a certain barbaric aggressiveness, not only in the sheer bulk of the magazine, but also in Lewis' manipulation of the attention-grabbing devices of newspaper headlines and advertising posters. Oversized type and large areas of white space visually reinforced *Blast*'s extravagant mixture of jocular, evangelical, and irreverent pronouncements upon the times. Blasting, cursing, and damning, the Vorticists denounced and joked

outrageously as they went about their self-appointed task of, in Lewis' words, 'blowing way dead ideas and worn-out notions.'

Naturally, England came first and got the most attention. Its mild, wet climate symbolized what the Vorticists regarded as the soggy and unhealthy spirit of the average Englishman, and its fogs represented the influences of Victorianism still hovering over modern England. And so, the manifesto began,

## BLAST First (from politeness) ENGLAND

166

### CURSE ITS CLIMATE FOR ITS SINS AND INFECTIONS

DISMAL SYMBOL, SET round our bodies,
of effeminate lout within.
VICTORIAN VAMPIRE, the LONDON cloud sucks
the TOWN'S heart.

From cursing England's 'flabby sky,' 'lazy air,' and 'drizzle like a poem by Mr. Robert Bridges,' the manifesto went on to blast France for, among other things, its 'sentimental Gallic gush,' its petit bourgeois 'fussiness,' and its 'ubiquitous lines of silly little trees.' Then the Vorticists redirected their guns at England to blast a type Lewis would later satirize savagely in *The Apes of God*: 'CURSE with expletive of whirlwind THE BRITANNIC AESTHETE, Cream of the Snobbish Earth, Rose of Sharon of God-Prig of Simian Vanity ...'

After blasts at English humour ('Quack English drug for stupidity and sleepiness') and sport ('Humour's first cousin and accomplice'), the opening section of the manifesto finished with its longest and loudest blast at 'years 1837 to 1900.' For two and a half pages it castigated various manifestations of Victorianism, such as 'pasty shadow cast by gigantic Boehm' (the Victorian sculptor of innumerable public statues), 'Bourgeois Victorian Vistas,' 'weeping whiskers,' and, to quote a characteristic passage of Vorticist rhetoric:

## SENTIMENTAL HYGIENICS
## ROUSSEAUISMS (wild Nature cranks)
## FRATERNIZING WITH MONKEYS
## DIABOLICS—raptures and roses
of the erotic bookshelves

**culminating in**
# PURGATORY OF PUTNEY.
# CHAOS OF ENOCH ARDENS

| laughing Jennys
| Ladies with Pains
| good-for-nothing Guineveres.

# SNOBBISH BORROVIAN running after
# GIPSY KINGS and ESPADAS

bowing the knee to
wild Mother Nature,
her feminine contours,
Unimaginative insult to
# MAN.

In this choppy poster prose transformed into a new kind of expletive poetry, the Vorticists blamed the Victorian frame of mind for food fadists, nudism, Darwinism, hermetic cults, the eroticism and 'evil' of the 1890s, Rousseauist Romanticism, middle-class suburbs like Putney (where Swinburne ended his career in sheltered respectability at No. 2, The Pines), and various forms of sentimentality grafted on middle class materialism and hypocrisy, such as Tennyson's Enoch Arden, Rossetti's 'lazy laughing languid Jenny,' the coddled, delicate ladies of Victorian fiction and real life, the gypsies of George Borrow's extremely popular romances, and all other attempts, sophisticated or naive, to perpetuate Romance and revive the Picturesque.

The blasting culminated in the list produced at Lewis' and Pound's tea party, and undoubtedly added to by Lewis and the other Vorticists. (See appendix B) Anyone who took the time to read through the list probably wondered what these fifty-odd individuals and institutions had in common, besides their forced presence on the same page of *Blast*. However, people in tune with the Vorticists' milieu would have noticed soon enough that most of the names in the list stood for attitudes generally ridiculed by the avant-garde, and that they could be put into fairly specific categories.

Some names represented what would have been called, if the word had been in vogue then, the Establishment: the British Academy; the Bishop of London; A.C. Benson, son of the Archbishop of Canterbury, poet, novelist, author of three books in

the English Men of Letters series, and editor, with Viscount
Esher, of Queen Victoria's letters; Lionel Cust, director of the
National Portrait Gallery; Robertson Nicoll, editor of the *Book-
man*; William Archer, drama critic of the *Nation*; St.Loe
Strachey, editor of the *Spectator*; Lord Glenconner of Glen, the
Lord High Commissioner to the General Assembly of the
Church of Scotland; Frank Brangwyn, the Edwardian painter
who continued to cast a large shadow over the post-Edwardian
art world; Professor Patrick Geddes, biology professor at St
Andrews and co-author of a pamphlet, *Problems of Sex* (1912),
which attacked contemporary British society for slipping away
from strict moral standards; and the Reverend Frederick
Brotherton Meyer, who used his pulpit in Regent's Park Chapel
to denounce the luxuries of London's 'smart set,' the increase in
Sunday public amusements, and other liberalizing tendencies of
the time.

168

The fact that the Reverend Mr Meyer gained a certain fashion-
ableness by denouncing the fashionable suggests a second cate-
gory: blasts directed against people who represented fads and
sentimental appeals to popular taste or to snobbish needs to
catch onto 'the latest rage.' In this category were Father Bernard
Vaughan, SJ, who became a favourite with society women be-
cause of his fiery sermons against the self-indulgent leisured
classes; the Reverend R.J. Campbell, minister of the Congrega-
tional City Temple and a much-admired spokesman for the
'new theology' of the day; Annie Besant, who was giving five
lectures on mysticism at Queen's Hall during May and June
1914; Sir Abdul Baha Bahai ('that jolly and religious bour-
geoise Abdul Baha,' as Pound referred to him in 1913),[3] leader
of the universalist world religion, Bahaism; and Otto Weiniger,
the young German genius and suicide who wrote *Sex and
Character* (1903), a 'psychological analysis' of society that
leaned heavily on near-mystical evocations of the passive,
physical, childbearing woman who must, by nature, submit her-
self to the active, intellectual, world-running man. Though laced
with anti-semitism as well as anti-feminism, Weiniger's book
was in vogue in some 'liberated' intellectual circles around 1914.

Popular writers, especially those with an aura of religion hang-
ing about them, constituted a third category for blasting. One
was Marie Corelli, whose romances were consistently panned
by the critics and devoured by the public. Another was Rhabin-
dranath Tagore, whose fame in England rapidly spread from a
few literary circles to the general reading public and the popular
press, where he was regarded with nearly religious awe. A third
was the Catholic priest and novelist R.H. Benson, whose novel,
*Initiation*, came out in 1914. A fourth was 'Clan Meynell,' the

family of writers who had been the centre of a Catholic writers'
group in the 1880s and 1890s, and whose best-known member,
Alice Meynell, published her *Collected Poems* in 1913. A fifth,
'Clan Strachey,' did not so much represent widespread popu-
larity, as it did a literary clique's power to promote the careers
of those within its group and, as it seemed to some outsiders, to
obstruct the advancement of others of whom it did not approve.

Exceptional popularity, without evidence of exceptional
ability, were criteria for a fourth category, and led to blasts at
Ella Wheeler Wilcox, whose verse was widely read in popular
magazines and newspapers; the late-Romantic composer, Sir
Edward Elgar, who received the Order of Merit in 1911 for his
coronation march for George V, and was widely acclaimed for
a masque celebrating the king's visit to India, which was pre-
sented at the London Coliseum in March 1912; and Willie
Ferrero, an eight-year-old prodigy, much in the news in the
spring of 1914 for conducting symphony concerts before the
Czar of Russia (9 February 1914) and Queen Alexandra at
Albert Hall (2 May 1914).

A fifth category included – to use the sort of terms the Vorti-
cists would use – do-gooders, fuzzy-minded reformers, and
idealists: Norman Angel, author of *The Great Illusion* and out-
spoken peace agitator; Sidney Webb (and, by implication,
Fabian Socialism in general); the Reverend Percy Dearmer,
Vicar of St Mary the Virgin, Primrose Hill, a well-known
speaker and writer on social reforms; the Countess of Warwick,
Frances Evelyn, popularly called 'the Socialist Countess' be-
cause of her speeches in favour of Socialism and her efforts to
use her connections among the English nobility to raise money
for the Socialist cause; and John Galsworthy, whose reformist
spirit pervaded such widely praised plays as *Strife* (1909) and
*Justice* (1910).

In a sixth category were people who seemed to be blasted
simply because they were popular with the public, but not, for
one reason or another, with the Vorticists. In that list were the
famous cricketer, C.B. Fry, who also wrote on cricket and
started a sporting magazine, *Fry's Weekly*; the actor-managers
Charles Hawtrey and Martin Harvey; the actor-author Seymour
Hicks, who first won fame in Gaiety Theatre productions of the
1890s; the Gaiety Theatre's star actor and writer, George Gros-
smith, and the Gaiety's manager, George Edwardes (the famous
Gaiety chorus girls had already been included in the manifesto's
opening blast at England); and three 'Beechams': Sir Joseph
Beecham's Grand Season of Russian and English Opera and the
Russian Ballet, which was the major attraction of the 1914
'season' (and for that reason perhaps belongs in the second

category, along with other fads), Thomas Beecham, not yet
knighted, but already famous as a conductor, composer, and
operatic impressario, and Beecham's Pills, the widely advertised
'digestic tonic' that sold six million boxes a year by promising
to cure 'stomach and liver trouble' and 'all bilious and nervous
disorders.'

A seventh and final category would cover blasting just for the
fun of it – such as blasts at the Post Office and Cod Liver Oil –
or blasting that grew from special circumstances and private
reasons known only to insiders. There was a blast at 'Clan
Thesinger,' presumably because one of the Thesinger family –
Ernest Thesinger, a former Slade student who became a famous
actor – brought his mother, Lady Thesinger, to the Rebel Art
Centre, where both looked around and left without buying any-
thing or offering any form of patronage.[4] Frustrated hopes for
a commission may have had something to do with the blast at
Thomas Beecham, too; for, he was responsible for calling off
some sort of project that Nevinson, Wadsworth, and Lewis had
planned to do for him and Lady Cunard.[5] A blast at 'Rev.
Pennyfeather (Bells)' stemmed from Ezra Pound's personal
pique with the Reverend Prebendary Sommerset Edward Pen-
nefeather, Vicar of Kensington, whom Pound held personally
responsible for the frequent and prolonged ringing of the bells
in St Mary Abbots Church. In his Kensington digs, nearly
adjacent to St Mary Abbots, Pound heard many performances
of the Bellringers' Guild. For the coronation of George V, the
guild performed a work lasting three and one-half hours. 'It
appeared to me impossible that any clean form of teaching cd.
lead a man, or group, to cause that damnable and hideous noise
and inflict it on helpless humanity in the vicinage,' Pound wrote
years later, '... vigorous anti-clerical phase ensued.'[6]

From blasting, the manifesto turned immediately to blessing,
and not only followed the typographical style of the blasting
passages, but blessed some of the same things that had been
blasted. First, again, was England, blessed for its ships, sailors,
ports, and for its vast industrialization: 'BLESS ENGLAND, In-
dustrial island machine, pyramidal workshop, its apex at Shet-
land, discharging itself on the sea.' Even English humour ('great
barbarous weapon' and 'hysterical WALL built round the EGO'),
and 'cold, magnanimous, delicate, gauche, fanciful, stupid,
ENGLISHMEN' are blessed. After blessing hairdressers for 'at-
tack[ing] Mother Nature' and making 'systematic mercenary
war' on otherwise uncontrolled growths of hair and beard, the
manifesto counter-balanced its blast at France, with a blessing
on French 'vitality ... manners ... masterly pornography ... com-

bativeness, great human sceptics, depths of elegance, female qualities, females, ballads of its prehistoric apache ... great flood of life pouring out of wound of 1797. Also bitterer stream from 1870. Staying power like a cat.' Then, completing the symmetry, came a full page of names collectively blessed.

Some of the blessings, like most of the blasts, seemed designed to affront respectable public opinion. And so, the Vorticists blessed the militant suffragettes, Lillie Lenton and Freda Graham, and the truculent Ulsterites, Carson and Craig. Since they had blasted Fabian Socialists and Liberals, they now blessed the old Trade Unionist, Robert Applegarth, who had devoted his life to agitating for industrial unions and socialism. After blasting leaders of the Established Church, they blessed the Pope and the Salvation Army.

Virtually ignoring proper, approved art and culture, the Vorticists blessed working class entertainments such as boxing and music halls. Five professional fighters – Young Ahearn, Colin Bell, Dick Burge, Petty Officer Curran, and Bandsman Rice – appeared in the list, along with six music hall entertainers: Gaby Deslys, Shirley Kellog, Gertie Millar, George Mozart, George Robey, and Harry Weldon. The new sport of aviation, which was attracting the aristocracy as participants and the general public as spectators, received *Blast*'s approval in the form of blessings on the well-known pilots Grahame-White, Gustav Hamel, B.C. Hucks, and M. Salmet. Something of the Futurist sentiment that led to blessing pilots also lay behind blessings on John Barker, the famous London department store, and on Sir Joseph Lyons, founder of the ubiquitous gold and white Lyons Corner Houses, where the man on the street could have his cup of tea in clean, convenient, modern surroundings.

Only a few selected representatives of the fine arts were blessed. The best-known were Chaliapine (who had been a sensation that spring with the Russian Opera in London), Lydia Yavorska (the actress-producer, whose productions of modern continental plays were running that year at the Ambassador Theatre), Granville-Barker, R.B. Cunninghame Graham, Frank Harris, James Joyce (whose *Portrait of the Artist* was then running serially in the *Egoist*), Gilbert Cannan, and W.L. George, two outspoken critics of the status quo.

Finally, the Vorticists blessed people who had been good to them, or to the avant-garde in general. They blessed Frank Rutter and P.J. Konody, two art critics sympathetic to the new movements; Madame Strindberg, who had tried to make the Cave of the Golden Calf and Cabaret Theatre Club a centre of avant-garde activities; and Lord Howard de Walden, patron of the Poetic Drama Centre and Gordon Craig's School of the Art

of the Theatre, as well as president of the Contemporary Arts Society which was founded 'to acquire works by living artists of merit who are imperfectly, or not at all, represented in the national and municipal galleries, and to lend its acquisitions as a circulating collection or collections to public galleries.'[7] The Society bought Lewis' *Laughing Woman* in 1913, and that may be the reason for blessing its president. Gratitude also prompted the blessing of Kate Lechmere, the solicitor Rayner, who had assisted Lewis and Kate Lechmere at the Rebel Art Centre, and Leveridge, *Blast's* printer.

The blessing list differed from the blasting list chiefly in being longer (seventy-seven names in all), including fewer public figures and more friends (some of whom were mentioned by first name only), and, in general, being less political or ideological than the blasts. The combined blasting and blessing sections of the manifesto subjected *Blast's* readers to an intricate set of allegiances and antipathies, fads, antifads, and jokes – a condensed and often enigmatic projection of the Vorticists' state of mind in the spring of 1914.

Lewis designed the pages of the blast-bless manifesto to get the greatest possible impact from the union of form and content. Diction, syntax, typography, and layout united to produce Vorticist picture-poems, somewhat like Apollinaire's 'Calligrammes' or the Futurists' *parole in libertà*. Lewis, however, made his designs more formal and abstract, and less dependent upon onomatopoeia and words printed in representational shapes. Since he was working with a manifesto, rather than individual poems, Lewis unified the work by sticking to the same blocky typeface for all upper case letters, but he varied their size as he varied the spacing of words and the length of lines. He also composed pages, or parts of pages, according to a few simple abstract shapes.

Some pages gave the impression of walls or pyramids made from layers of type piled on top of each other. (see plates 21, 22, and 23) Other sections used an abstract design based on a vertical axis with balancing rectangles at the top and bottom of the axis line, like this:

or this:

The complete fourth blast was constructed that way:

**BLAST**

THE SPECIALIST
" PROFESSIONAL "
" GOOD WORKMAN "
" GROVE-MAN "
ONE ORGAN MAN

**BLAST** THE

AMATEUR

SCIOLAST
ART-PIMP
JOURNALIST
SELF MAN
NO-ORGAN MAN

Part of the blessing on Englishmen offered a variation on the same design:

**BLESS** | cold
magnanimous
delicate
gauche
fanciful
stupid

## ENGLISHMEN.

Another typographical design used two very different masses, a line or two of type played off against several shorter lines, which, abstracted, would look like this:

or this:

as in the following passages from the blasts at France and at humour.

**PARISIAN PAROCHIALISM.** Complacent young man, so much respect for Papa and his son !—Oh !—Papa is wonderful : but all papas are !

Quack ENGLISH drug for stupidity and sleepiness.
Arch enemy of REAL, conventionalizing like

gunshot, freezing supple
REAL in ferocious chemistry
of laughter.

174

As if to emphasize the abstract design, Lewis sometimes added an axis line, as in part of the first blast at England.

## SO MUCH VAST MACHINERY TO PRODUCE

THE CURATE of "Eltham"
BRITANNIC ÆSTHETE
WILD NATURE CRANK
DOMESTICATED
              POLICEMAN
LONDON COLISEUM
 SOCIALIST-PLAYWRIGHT
DALY'S MUSICAL COMEDY
GAIETY CHORUS GIRL
TONKS

The most satisfactory variation of this pattern came when the vertical elements ('axis' and vertical columns made from short lines) united with horizontal elements both above and below the vertical, as in the following examples.

## CHAOS OF ENOCH ARDENS

laughing Jennys
Ladies with Pains
good-for-nothing Guineveres.

## SNOBBISH BORROVIAN running after
## GIPSY KINGS and ESPADAS

# OH BLAST FRANCE

pig plagiarism
**BELLY**
**SLIPPERS**
**POODLE TEMPER**
**BAD MUSIC**

## SENTIMENTAL GALLIC GUSH
## SENSATIONALISM
## FUSSINESS.

175

**PORTS, RESTLESS MACHINES** of | scooped out basins
heavy insect dredgers
monotonous cranes
stations
lighthouses, blazing
through the frosty
starlight, cutting the
storm like a cake
beaks of infant boats,
side by side,
heavy chaos of
wharves,
steep walls of
factories
womanly town

**BLESS** these **MACHINES** that work the little boats across
clean liquid space, in beelines.

In each case, the unifying design comes from slight variations
on the same abstract relations of vertical and horizontal ele-
ments.

The blessing on ports comes closest to illustrating its subject in
the manner of a 'Calligramme.' The horizontal base supports
the pillar of type and the vertical axis, while the line at the top
not only braces the pillar but helps frame the empty space on
the left side of the axis. The whole composition makes an ab-

stract picture of the empty 'clean liquid space' of the harbour on the left, and the filled, cluttered, wharf-like area on the right.

The Vorticist prose-poem-picture blessing ports was probably the manifesto's most successful word design, but, throughout part I of the manifesto, Lewis subtly led the reader into combining a feeling for spatial relations with a comprehension of the literary sense of the lines. Perhaps the most alert readers also noticed that the magazine, itself, was an 'axis' for the huge letters of 'BLAST' balanced opposite each other on the front and back covers.

Part II of the manifesto looked more conventional, and depended on language to make its impact on the reader. Suggestions of compression and sudden, explosive, release of energy appeared on every page in phrases like 'violent structure of adolescent clearness,' 'violent boredom,' 'exploded in useful growths,' 'sudden pouring of culture into Barbary,' 'Chaos invading Concept and bursting it like nitrogen,' 'insidious and volcanic chaos.' 'We only want Tragedy,' the manifesto proclaimed, 'if it can clench its sidemuscles like hands on it's belly, and bring to the surface a laugh like a bomb.' In the manifesto's prose, even the oppressive weight of English philistinism could be charged with potentially explosive energy: 'A movement towards art and imagination could burst up here, from this lump of compressed life, with more force than anywhere else.'

The mood created by that cluster of words – 'violent,' 'exploded,' 'bursting,' 'burst up,' 'volcanic,' 'bomb' – reinforced Blast's aggressive vision of artists as fighters, mercenaries, savages, barbarians, and revolutionaries, whose violent energies suited the dynamic, potentially violent modern world. 'The Art-instinct is permanently primitive,' said the manifesto, 'the artist of the modern movement is a savage.' His world is appropriately jungle-like: 'Our industries, and the Will that determined, face to face with its needs, the direction of the modern world, has reared up steel trees where the green ones were lacking; has exploded in useful growths, and found wilder intricacies than those of Nature.'

England, in the Vorticists' eyes, offered the most concentrated expression of this industrial wilderness, and was its chief creator:

The Modern World is due almost entirely to Anglo-Saxon genius, – its appearance and its spirit.

Machinery, trains, steam-ships, all that distinguishes externally our time, came far more from here than anywhere else.

However civilizing and domesticating the impact of industrialism might seem to be, in fact, the manifesto argued, it opened

up a new kind of 'jungle' for artist-savages to exploit in their art:

It cannot be said that the complication of the Jungle, dramatic tropic
growths, the vastness of American trees, is not for us.

For, in the forms of machinery, Factories, new and vaster buildings,
bridges and works, we have all that, naturally, around us.

Therefore, according to the manifesto's logic, England should
produce the artists best equipped to bring 'the forms of ma-
chinery,' into art:

Once this consciousness towards the new possibilities of expression in
present life has come, however, it will be more the legitimate property
of Englishmen than of any other people in Europe.

It should also, as it is by origin theirs, inspire them more forcibly and
directly.

They are the inventors of this bareness and hardness, and should be the
great enemies of Romance.

By this line of argument, the Vorticists accomplished two things
at once. They found a way to establish what was unique and
English about their movement, and they allied their movement –
whether they intended to or not – with T.E. Hulme's crusade
against softness, empathy, and other expressions of the Ro-
mantic point of view. To think of 'the inventors of bareness and
hardness' as 'the great enemies of Romance,' and to link those
inventors with the modern artist's response to machinery, was
exactly what Hulme did in his defence of Epstein, Bomberg,
and other 'English Cubists.'

The Vorticists outdid Hulme in invoking the creative energies
of a great, primitive, barbaric will that could produce a 'bare-
ness and hardness' satisfying to a primitive 'Art-instinct' and
appropriate to a modern world of machine forms. The problem
was to restrain and shape that energy so that it would not
disperse and lose its force. One kind of solution appeared in the
unbroken outlines, hard, geometrical shapes, metallic surfaces,
and machine forms of Vorticist art. Another was the Vortex
image itself. Stable and self-contained, yet suggesting whirling
concentrations of energy, the Vortex in the pages of *Blast* sym-
bolized primordial force restrained by the shaping power of art.
At the same time, there was something disturbingly authori-
tarian about the Vortex. Spinning in space on an unshakeable
axis, it seemed to condense into the simplest abstract form the
most austere and inhuman possibilities inherent in 'the forms of
machinery.' That solid, stable, clean-cut, and domineering form
became more than a concocted symbol sewn on the rebel artists'
banner; it was, in itself, an expression of what Vorticism was all
about.

Once a reader sensed that the Vortex was more than a label,

and began to recognize its metaphoric implications, he could make more sense out of the diverse lines of attack and praise in the manifesto and elsewhere in *Blast*. He could see, for example, that the Vorticists tended to separate art into two categories essentially parallel to Hulme's and Worringer's 'abstraction' (of which the Vorticists approved) and 'empathy' (of which they did not). Anything that seemed clear-cut, hard, rigid, and uncompromising gained the Vorticists' approval; conversely, blurred lines, softness, flexibility, and compromise were rejected and ridiculed. *Blast* consistently attacked art that lacked hardness and sharpness, that depended more on chiaroscuro, modelling, and intricate interplay of varying hues, than on strong outlines, abstract design, and flat, unmixed colour.

178

Going beyond purely artistic matters, the Vorticists also attacked speed, mass education, democracy, sentimentality, and romanticism because they, too, seemed to blur lines of distinction and break down rigid demarcations. When Lewis quoted Baudelaire at Marinetti – 'Je hais le movement qui déplace les lignes' – he was not only reacting against the Futurists' unreasonable delight in speed or their naïve attempts to convey movement on canvas, he was also summing up a set of attitudes shared by Hulme, the Imagists, and the Vorticists.

Although a list of eleven 'signatures for manifesto' followed the manifesto proper, probably only five or six of the signers could have fully accepted – or, perhaps, even understood – the full implications of the Vortex. The names, as they appeared in *Blast*, were,

R. Aldington
Arbuthnot
L. Atkinson
Gaudier Brzeska
J. Dismorr
C. Hamilton
E. Pound
W. Roberts
H. Sanders
E. Wadsworth
Wyndham Lewis

Of these, Richard Aldington and Malcolm Arbuthnot (a fashionable professional photographer) were not in any sense active Vorticists. Atkinson had little to do with the group's activities and contributed nothing to *Blast*. Jessie Dismorr and Helen Saunders (the misspelling 'Sanders' was probably 'in deference to [her] conventional home background'),[8] while active in the group, had no work in the first issue of *Blast*. William Roberts, whose *Dancers* and *Religion* appeared in

*Blast*, later claimed that Lewis added his name to the list with-
out his permission.[9]

Of the manifesto's signers, perhaps only Lewis, Wadsworth, Hamilton, and Gaudier-Brzeska subscribed to all that the Vortex stood for. At least, only they contributed work to *Blast* that satisfied its uncompromising demands. That was hardly surprising, since their 'English Cubist' style had been the source of the term in the first place, and examples of that 1913-14 style provided the best illustrations of Vorticism in *Blast*. Wadsworth's *Cape of Good Hope* and *A Short Flight*, Hamilton's *Group*, and Lewis' *Plan of War*, *Timon of Athens*, and *Slow*
*Attack* were totally abstract designs composed of sharply defined separate geometrical elements – arcs, circles, ovoids, triangles, irregular rectangles, etc. – which overlapped, intersected, and generated larger geometrical patterns that unified the work as a whole without obscuring the separate parts that made it up. Other illustrations by Wadsworth and Lewis, and by Roberts, Etchells, Epstein, and Gaudier, less strictly followed the Vorticist aesthetic, but, by appearing together between the covers of *Blast* and in proximity to the manifesto, they made a convincing show of strength for the Vorticist movement. They only slightly diluted the unified impact Lewis hoped to create with *Blast*'s fusion of illustrations, manifesto, typography, and the colour, size, shape, and weight of the magazine.

# 11
# 'Blast':
# The Battering Ram
# as a Work of Art

Lewis once complained that his intention to make *Blast* 'a battering ram all of one metal' had been subverted by much of the magazine's literary content, which he regarded as 'soft and highly impure.'[1] *Blast*'s readers, moving on from the manifesto to Pound's poems could see immediately what was bothering Lewis. The poems only partially satisfied the uncompromising demands of the Vortex. The mild disrespect of 'The New Cake of Soap,'

Lo, how it gleams and glistens in the sun
Like the cheek of a Chesterton,

and the sophomoric ironies of 'Meditatio,'

When I carefully consider the curious habits of dogs,
I am compelled to admit
That man is the superior animal.
When I consider the curious habits of man,
I confess, my friend, I am puzzled,

echoed, but weakly, the manifesto's irreverent and sardonic comments on its times. Although Pound struck off a good, hard, Vorticist image in 'Come My Cantilations' – 'We speak of burnished lakes,/And of dry air, as clear as metal' – he was just as likely to paint with a Post-Impressionist palette:

The gew-gaws of false amber and false turquoise attract them.
Like to like nature! These agglutinous yellows!

('Women Before a Shop')

Green Arsenic smeared on an egg-white cloth.
Crushed strawberries! Come let us feast our eyes.

('L'Art') *

Even 'ithyphallic satiric verse,' like 'Fratres Minores' and the arrogant denunciations in 'Salutation the Third' paled beside

---

* By adding the date of the first Post-Impressionist exhibition to the title – 'L'art 1910' – as he did when the poem appeared in *Lustra* (London 1916), Pound left no doubt about the kind of art that inspired the poem. Before appearing in *Blast*, 'L'Art' had been included in *Canzoni* (London 1911).

the blasting section of the manifesto. They were much less shocking in the pages of *Blast* than Pound's earlier, less abusive satire had seemed in the pages of the *New Freewoman*, the *Egoist*, and *Poetry*.

For a literary equivalent of Vorticist art, *Blast* offered 'Enemy of the Stars,' Lewis' strange mixture of short story and closet drama. Lewis wrote it, he said, because his 'literary contemporaries' were 'not keeping pace with the visual revolution.'[2] In December 1910, at the beginning of that revolution in England, Arnold Bennett had foreseen the possible effect of the Post-Impressionist exhibition on English writers. 'I have permitted myself to suspect,' Bennett wrote in the *New Age*, 'that supposing some writer were to come along and do in words what these men have done in paint, I might conceivably be disgusted with nearly the whole of modern fiction, and I might have to begin again. This awkward experience will in all probability not happen to me, but it might happen to a writer younger than me. At any rate, it is a fine thought.'[3] Less than four years later, in 'Enemy of the Stars,' Lewis fulfilled Bennett's worst suspicions.

While Bennett might have been prepared by the Post-Impressionist exhibition for Pound's 'agglutinous yellows' and 'crushed strawberries,' he probably was not ready for the shifting, ambiguous imagery, the jagged syntax and harsh tone through which Lewis created a prose style equivalent to the Vorticist visual style. Instead of logical and syntactically ordered sentences and paragraphs, Lewis tended to use isolated sentences and sentence fragments, and to replace exposition with clusters of incongruous images and metaphors. Here is the introduction of the play's central character, Arghol.

Investment of red universe.

Each force attempts to shake him.

Central as stone. Poised magnet of subtle, vast selfish things.

He lies like Human strata of infernal biologies.
Walks like wary shifting of bodies in distant equipoise.
Sits like a God built by an architectural stream, fecunded by mad blasts [of] sunlight. (p61)

Action, like characterization, comes across in glimpses and fragments, rather than continuous, 'linear' narration. A fight between Arghol and his disciple, Hanp, appears as a discontinuous sequence of images which are nearly surrealistic in their incongruity:

Flushes on silk epiderm and fierce card-play of fists between: emptying of 'hand' on soft flesh-table.

Arms of grey windmills, grinding anger on stone of the new heart.

Messages from one to another, dropped down anywhere when nobody is looking, reaching brain by telegraph: most desolating and alarming messages possible.

The attacker rushed in drunk with blows. They rolled, swift jagged rut, into one corner of shed: large insect scuttling roughly to hiding.

Stopped astonished. (p75)

The prose style, itself, seemed, at times, like an exchange of blows.

Violence permeates the story. 'Volcanic light' illuminates Arghol's yard; the sky is 'the boiling starry cold' with 'stony clouds' and 'icefields' of stars; speech is 'hot words drummed on [the] ear'; a laugh 'snapped like a fiddle cord'; silence falls 'like a guillotine.' The two chief characters are described in the beginning as, 'Enormous youngsters, bursting everywhere through heavy tight clothes, laboured in by dull explosive muscles, full of fiery dust and sinewy energetic air, not sap.' (p55) The play's action suits the explosive nature of the characters. Arghol, a wheelwright and an intellectual, who is beaten nightly by a mysterious 'Uncle,' lectures his apprentice-disciple, Hanp, then defeats him in a vicious fight. When Arghol falls asleep, Hanp stabs him to death, and ends the action by drowning himself in a murky canal.

Lewis forced an odd kind of restraint upon the violence and melodrama of his story by breaking his sentences, clauses, and fragments into isolated, static pieces. He interrupted continuity and cause-effect relationships, so that events seemed not to come about, but simply to *be*. In place of the traditional story-teller's time-continuum, Lewis offered spatial fragments, and gave those fragments the same feeling of compressed energy that he produced through the interlocked facets of his Vorticist paintings and drawings.[4]

Intent on forcing literature to catch up with the visual revolution, Lewis not only applied this visual sense of form to the story's syntax, he also drew upon Vorticist art for his setting and characters. The predominate colours of the setting – black, white, and metallic 'red of stained copper' – were characteristic of his own colour schemes at the time. (His 'Sunset Among the Michelangelos,' with its grey-green monumental figures posed in a desolate landscape before a scarlet sky, could have been a stage designer's sketch for a production of 'Enemy of the Stars.') The characters, like many figures in the work of Epstein, Gaudier-Brzeska, and Lewis himself, had masks for faces. Hanp's was a 'mask of discontent, anxious to explode'; Arghol's

a 'great mask, venustic and veridic,' a 'head of black, eagerly carved, herculean Venus, of iron tribe, hyper barbarous and ascetic.' The characters moved like animations of Epstein's monumental figures or the strangely distorted half-machine, half-human figures in many of Lewis' drawings of 1912-14.

Furthermore, according to Lewis' 'stage arrangements,' the audience was supposed to see the scene 'as though it were a hut rolled half on its back, door upwards, characters giddily mounting in its opening.' The set was a Vortex: its outer edge, a circle of bleachers for the audience, and its centre a dark gangway along which the characters came and went, and from which a steady wind flapped the actors' clothes and 'blar[ed] up their voices.' In this Vortex, Arghol and Hanp acted out their violent allegory.

'Enemy of the Stars' was not only an exercise in converting diction and syntax to a prose equivalent of the interrelated geometric facets of Vorticist paintings and drawings. Nor was it simply a symbolic elaboration of the manifesto's vision of violence. It also reworked *Blast*'s theme of the artist as individualist and mercenary whose cause is no one's but his own, and whose personality, like Arghol's mask, is 'hyper barbarous and ascetic.' It dramatized the haughty egotism of the Vortex and, at the same time, gave voice to Lewis' own dogmatic individualism.

In an essay called 'The Physics of the Not-Self' appended to a revised version of 'Enemy of the Stars' published in 1932, Lewis gave a special meaning to 'self.' He meant by the word, not the individual ego, but just the opposite: the accumulated effects of the environment on the individual. The 'self' was the 'affliction got through indiscriminate rubbing against [one's] fellows: Social excrescence,' as Arghol puts it. Arghol says he had done all he could to rid himself of this 'self': 'I have smashed it against me,' he tells Hanp, 'but it still writhes, turbulent mess. I have shrunk it in frosty climates, but it has filtered inward through me, dispersed till my deepest solitude is impure.' (p71) In a dream sequence, Arghol relives his first attempt to purge himself of this impure 'self.' As a young art student he rejected his books, his 'art life,' and his café friendships, all 'companions of parasite Self,' in order to announce, ' "I am Arghol." He repeated his name – like sinister word invented to launch a new Soap in gigantic advertisement – toilet-necessity, he, to scrub the soul.' (p80)

Scrubbed clean, 'he had ventured into solitude,' where the 'Self' he thought he had destroyed returned – in the form of Hanp, whose persistent presence in Arghol's life forces him to admit that he cannot totally escape the 'parasite Self.' 'You are an unclean little beast, crept gloomily out of my ego,' he says to

184

Hanp. 'You are the world, brother, with its family objections to me.' (p73) The fight, the murder, and the suicide in 'Enemy of the Stars' drive home the moral: the ego and the 'Self' cannot be separated, nor live together in peace. If one dies, the other dies too. Man's fate is to embody that fatal conflict.

The battle between Arghol and Hanp might represent Worringer's 'Abstraction' versus 'Empathy' or Hulme's 'Classicism' versus 'Romanticism,' but in the story's dream sequence, Lewis left a clue to another possible source of conflicting polarities. Among the articles in the room Arghol recreates in his dream is a copy of Max Stirner's *Einzige und Sein Eigenthum*, which has been translated into English as *The Ego and His Own*. In his book, Stirner defines a radical form of egoism perpetually in conflict with everything around it. This ego creates itself and is a total entity unto itself. Anything – religion, nationalism, love – that threatens its absolute independence must be rejected or tyrannically subordinated to the ego's will. 'Where the world comes in my way – and it comes in my way everywhere – I consume it to quiet the hunger of my egoism,' Stirner wrote.[5] Only the ego matters: 'I am I,' and again, 'I am the Unique,' Stirner proclaimed in behalf of the ego.[6]

True selfishness, Stirner argued, frees the ego from all ulterior concerns, but, he added, 'My zeal need not on that account be slacker than the most fanatical, but at the same time I remain toward it frostily cold, unbelieving, and its most irreconcilable enemy; I remain its *judge*, because I am its owner.'[7] This 'frostily cold' zeal, like the manifesto's bleak northern 'humour,' suits Arghol's personality perfectly. Even Stirner's tone ('We will go along a bit of road together, till perhaps you too turn your back on me because I laugh in your face')[8] sounds like something from 'Enemy of the Stars' – or, for that matter, from the manifesto or from Lewis' other contributions to *Blast*.

In 'Vortices and Notes,' Lewis subsumed Hanp, the 'Self,' the 'World,' and 'Nature' under the single – and for him, contemptuous – term, 'Life':

'Life' is a hospital for the weak and incompetent.

'Life' is a retreat of the defeated.

It is very salubrious – The cooking is good –

Amusements are provided.

'In the same way,' Lewis continued, 'Nature is a blessed retreat, in art, for those artists whose imagination is mean and feeble, whose vocation and instinct are unrobust.' (p130) Lewis found the same fault in the conventional artist who paints landscapes

or nudes according to 'Life,' and the Futurist who tries to go even further by converting art into 'Life.' 'The Futurist statue will move: then it will live a little,' Lewis wrote, 'but any idiot can do better than that with his good wife, round the corner. Nature's definitely ahead of us in contrivances of that sort.' (p135)

In Stirnerian tones, Lewis proclaimed, 'The Vorticist does not suck up to Life. He lets Life know its place in a Vorticist Universe!' (p148) He uses life for his 'brothel,' said Lewis, so that he can keep himself 'pure for non-life, that is Art.' Art, then, becomes the contrasting force to 'Life,' as Arghol is to Hanp, and the ego to the 'world.' Even Time dissolves in the presence of Art: 'Life is the Past and the Future, the Present is Art.' In fact, Lewis insisted, 'There is no Present – there is Past and Future, and there is Art.' (p147)

For the sake of Art, said Lewis, artists must reject society; for, in society, men 'overlap' and 'intersect,' and 'promiscuity is normal.' Artists must undergo a 'course of egotistic hardening' before they can produce the hard 'outside art' Lewis admired. As an example of that kind of art, Lewis referred to a display of German woodcuts at the Twenty One Gallery. In the hard, clean-cut outlines and the elemental black and white forms of the woodcuts, Lewis found the sort of art Vorticism stood for. The woodcuts, Lewis wrote with admiration, are 'disciplined, blunt, thick and brutal.'

For similar reasons Lewis praised certain African carvings. Following Worringer and Hulme, he argued that primitive art reveals a personality contracted into itself from fear of 'disolv-[ing] in the vagueness of space.' Under such conditions, Lewis said, the personality becomes a 'bullet-like lump'; its emotions are 'clean, clear cut'; its art is hard, dense, packed with compressed energy. Implicitly, Lewis seemed to equate the primitive artist's isolating withdrawal from the 'vagueness of space,' with the Vorticist artist's 'egotistic hardening' and withdrawal from the diluting effects of 'Life.' As in the manifesto, primitivism and modernism, savagery and art, meet in the Vortex. In that frame of mind, Lewis concluded his rejection and belittling of 'Life' with an arrogant affirmation of the hardness, energy, and violence of the Vortex.

Our Vortex is fed up with your dispersals, reasonable chicken-men.

Our Vortex is proud of its polished sides.

Our Vortex will not hear of anything but its disastrous polished dance. (p149)

For Lewis, the Vortex was a whirling, arrogant, polished monster of energy; for Pound, it was a stable, strong source of

creative energy. For Lewis, it produced an art defined by a few, specific criteria and limited to a few, distinct cultures; for Pound, it inspired the great art of any age. For Lewis, it grew out of the revolution in the visual arts; for Pound it came from Imagism.

In Pound's two-page essay, 'Vortex' (pp153-4), the debt to Imagist aesthetics was obvious. Pound defined Vorticism by its freedom from the sins of style condemned by the Imagists. 'Vorticism,' he wrote, 'is art before it has spread itself into a state of flacidity, of elaboration, of secondary applications.' Like Lewis, he held to the notion that Vorticist art represented a compression and retention of energy. The Vortex was the 'point of maximum energy.' Futurism was a 'dispersal' and a 'disgorging spray.' Impressionism and other 'popular beliefs' were 'corpses of vortices.' In the same vein, Pound would later say that under the influence of Amy Lowell, Imagism 'went off into froth.'[9]

Pound called a work's concentration of energy its 'primary pigment.' 'The Vorticist relies on this alone,' he wrote, 'on the primary pigment of his art, nothing else.' Every concept or emotion calls forth an expression in 'some primary form,' said Pound. If the form is 'sound' then it belongs to music, 'if formed words, to literature; the image, to poetry; form, to design; colour in position, to painting; form or design in three planes, to sculpture; movement to the dance or to the rhythms of music or of verses.' If this principle is not followed, if the artist tries to express in one art what would be more appropriately expressed in another, then, Pound argued, he can not achieve 'the greatest efficiency' of his art. Energy is lost, the work becomes merely 'secondary application.'

Although Pound's argument seemed to presuppose absolute distinctions between the arts, it also brought the arts together under a single aesthetic principle, 'the primary pigment,' and a single expressive image, the Vortex. Moreover, he believed he saw origins of Vorticism in painting and sculpture, as well as poetry and aesthetic theory. To prove it, he summarized what he called the 'ancestry' of Vorticism.

'All arts approach the conditions of music.' – *Pater.*

'An Image is that which presents an intellectual and emotional complex in an instant of time.' – *Pound.*

'You are interested in a certain painting because it is an arrangement of lines and colours.' – *Whistler.*

Picasso, Kandinsky, father and mother, classicism and romanticism of the movement.

As an example of the 'primary pigment' at work in poetry, Pound then quoted H.D.'s 'Oread.'

Whirl up sea –
Whirl your pointed pines,
Splash your great pines
On our rocks,
Hurl your green over us,
Cover us with your pools of fir.

In Pound's mind, the common ground for H.D., Picasso, Kandinsky, Whistler, Pater, and himself seemed to be a sense of abstract form in art, and the recognition that an 'intellectual and emotional complex' depends upon the relation of the formal elements of an art, and not on reference to facts, ideas, 'truths,' or anything else that lies outside the formal limits of the art itself.

That was Pater's main point in his essay 'The School of Giorgione,' from which Pound misquoted the famous proposition, 'All art constantly aspires towards the condition of music.' Art, said Pater, is 'always striving to be independent of the mere intelligence, to become a matter of pure perception, to get rid of its responsibilities to its subject or material.'[10] Pound wanted to equate his notion of 'the primary pigment' with Pater's 'pure perception,' and use it as a way of measuring the degree to which a work of art contained or 'dispersed' its energy. Rather than make sharp outlines, hard surfaces, monumentality, and other Vorticist characteristics the evidence of a 'primary pigment' successfully employed (though, in fact, he tended to favour these characteristics just as Gaudier-Brzeska and Lewis did), Pound seemed satisfied to suggest frames of reference – Pater, Whistler, Cubism, Expressionism, Imagism – and let the reader's intuition take it from there. Because Pound's 'Vortex' ranged farther from *Blast*'s predominate 'English Cubist' aesthetic, it could be more tolerant and more catholic in its taste than the Vorticist manifesto or Lewis' 'Vortices and Notes.'

Gaudier-Brzeska's 'Vortex' (pp155-8) stuck closer to the manifesto's aesthetic criteria, but, like Pound's essay, it did not limit the application of the Vortex to modern times only. In fact, Gaudier tried to write a history of sculpture from a Vorticist point of view, and to make it, at the same time, what Pound called, 'the proclamation of a new birth out of the guttering and subsiding rubbish of 19th century stuffiness.'[11] It was Gaudier's Vorticist manifesto.

After an opening incantation,
Sculptural energy is the mountain.
Sculptural feeling is the appreciation of masses in relation
Sculptural ability is the defining of these masses in planes,
Gaudier presented a sculptor's vision of creative energy: 'THE PLASTIC SOUL IS INTENSITY OF LIFE BURSTING THE PLANE.' Not

only did Gaudier display the characteristic Vorticist predilection for words like 'intensity' and 'bursting,' but he found a way to make the Vortex represent the essential shaping force of a culture, to become, in effect, its 'artistic volition,' as Worringer would put it. For Gaudier, the creative energy of the Vortex begins with a sphere: 'The sphere is thrown through space, it is the soul and object of the vortex.' (Presumably Gaudier wanted a sphere to suggest the simplest three-dimensional form that would distinguish sculpture from the two-dimensional planes of painting and drawing.) The Vortex of various cultures then makes simple, abstract variations on the sphere; hence, the 'HAMITIC VORTEX' of Egypt 'RETAINED AS MUCH OF THE SPHERE AS COULD ROUND THE SHARPNESS OF THE PARALLELOGRAM.' The 'SEMITIC VORTEX,' driven by a 'lust of war ... elevated the sphere in a splendid squatness and created the ... man-headed bulls in horizontal flight-walk' and the 'howling lions: THE ELONGATED HORIZONTAL SPHERE BUTTRESSED ON FOUR COLUMNS.' In China, during the Shang and Chow dynasties, the Vortex produced 'convex bronze vases,' while the 'centuple spherical frog presided over the inverted truncated cone that is the bronze war drum.' In Oceana and Africa, 'They pulled the sphere lengthways and made the cylinder, this is the VORTEX OF FECUNDITY, and it has left us the masterpieces known as love charms.' In these same cultures the awesome forces of nature created a 'VORTEX OF FEAR, its mass is the pointed cone, its masterpiece the fetishes.'

In contrast to these compact and geometrical shapes, which Gaudier evoked with obvious admiration for their dehumanization and abstraction, the characteristic sculpture of the Greeks and the classical-Renaissance tradition moved Gaudier to scorn and derision. The Greek, he said, 'petrified his own semblance.' Nearly paraphrasing Pound's comments about art that has 'spread itself into a state of flacidity,' Gaudier wrote of the Greek, 'HIS SCULPTURE WAS DERIVATIVE, his feeling for form secondary.' As for Renaissance and post-Renaissance sculpture: 'VORTEX IS ENERGY! and it gave forth SOLID EXCREMENTS in the quattro é cinquo cento, LIQUID until the seventeenth century, GASES whistle till now.' Modern sculpture, however, had broken the hold of the Greeks and the Renaissance. Speaking of himself, Epstein, Brancusi, Archipenko, Dunikowski, and Modigliani, Gaudier wrote, 'We have crystalized the sphere into the cube, we have made a combination of all the possible shaped masses – concentrating them to express our abstract thoughts of conscious superiority. Will and consciousness are our VORTEX.' That was *Blast*'s concluding statement.

As for the other contributions to *Blast*: little of the Vorticist

spirit could be found in the chatty, Jamesian subtleties of Ford's 'The Saddest Story,' or in the ripe, mystical passages from Kandinsky that Wadsworth quoted at length in his review of *The Art of Spiritual Harmony*, or in the dignified and moving prose in which Lewis wrote an obituary for his close friend, Spencer Gore, who had died that spring from pneumonia. In spite of Lewis' claim that some of Gore's last works 'belonged rather to this present movement than to any other' (p150), nothing in the two paintings by Gore reproduced in *Blast* – 'Brighton Pier' and 'Richmond Houses' – indicated Vorticist leanings.

190

On the other hand, the Vorticists' exhortative address to militant suffragettes, offering their support, but cautioning against destroying works of art – 'YOU MIGHT SOME DAY DESTROY A GOOD PICTURE BY ACCIDENT' (p151) – returned to the manifesto's tone, sentiments, and over-sized type.* And Rebecca West's story, though far from 'Enemy of the Stars,' did not seem totally out of place in *Blast*. Its theme echoed the Vorticists' praise of violence – 'God is war, and his creatures are meant to fight' (p110) – and its action reaches a climax when a husband and wife fight and nearly drown in an actual Vortex, a whirlpool at the bottom of a waterfall. Although the prose of 'Indissoluble Matrimony' seemed tight and energetic in comparison to the relaxed narrative of 'The Saddest Story,' it did nothing to disprove Lewis' complaints about the failure of writers to catch up to the revolution in art. For literary counterparts to its revolutionary art, *Blast* had to depend on 'Enemy of the Stars,' part I of the manifesto, and Gaudier-Brzeska's 'Vortex.'

One effect of the non-Vorticist contributions to Blast was to reinforce the impression, fostered by the blast-bless lists, that Vorticism was not as divorced from the interests and personalities of the general avant-garde scene as its isolated, aloof Vortex implied. Another effect was to heighten, through contrast, the magazine's peculiarly Vorticist qualities, and to remind readers that *Blast* had taken general attitudes of the milieu, shaped and hardened them, and presented them to the world as Vorticist art and doctrine.

The anti-English sentiments of England's avant-garde artists and critics, mixed with their hopes for a new, revolutionary movement in England, came out in *Blast*'s ambivalent ethno-

* The Vorticists' apprehension may have arisen in part because of the young hatchet-wielding suffragette who destroyed two drawings at the Doré Gallery on 4 June 1914. The Vorticists and other avant-garde artists often showed their work at the Doré.

centrism. The magazine blasted England and things English, yet presented a vision of England as the prime mover of the modern, industrial world, and the proper source of a revolutionary art appropriate to the twentieth century.

*Blast* took up the milieu's anti-philistinism, and attacked not only the taste and habits of the 'abysmal inexcusable middle-class (also Aristocracy and Proletariat),' but expressed contempt for compromise, for democratic and collective decisions and actions, and even for mass education and other liberal reforms to which the majority of Englishmen had given their support by voting the Liberal party into power.

The avant-garde's belief in individualistic expression became, in *Blast*, a 'course in egotistic hardening while bohemian gregariousness and good humoured bonhomie disintegrated in the face of an aggressive and isolating 'humour' with its 'WALL built round the EGO.'

Primitivism, which even a sophisticated and gentle Quaker like Roger Fry prescribed for the ills of academy-plagued English art, turned into barbarism, the calculated violence of the mercenary, the 'bullet' soul of the savage, the 'disastrous polished dance' of the Vortex – and the Vorticists' deep fellow-feeling for art that is 'disciplined, blunt, thick and brutal.'

From the welter of modern life confronting avant-garde artists, *Blast* selected, for greatest admiration, the machine. 'Vorticism accepted the machine world,' Lewis said later. 'It sought out machine-forms'[12] – not the locomotives, automobiles, and airplanes romanticized by the Futurists, but more abstract and static 'machine forms,' such as girders, trestles, buildings, ships, wharves, and heavy machinery. The perfect Vorticist machine was the dynamo, whose work goes on out of sight, beneath a hard, implacable exterior. The Vorticists sought out 'machine forms' that, like the conical Vortex reproduced in the pages of *Blast*, combined internal energy and external calm.

From the milieu's various and contradictory aesthetics, *Blast* took up the only theory that seemed capable of coping with the impact of the machine on modern life. Following Worringer and Hulme, *Blast* rejected man-centred Greek and Renaissance art, and looked, instead, to the awesome, inhuman, and abstract art of primitive and non-western cultures, and to the equally anti-empathetic machine forms of its own culture. *Blast* wanted to expound on and express (in Lewis' words) 'the hard, the cold, the mechanical and the static.'[13] But, at the same time, it did not want to achieve those effects at the sacrifice of energy, dynamism, or other expressions of the contemporary fascination with action and violence.

In *Blast* the Vorticists tried to balance violence and repose, just as they tried to fuse form and content. The magazine's form – the magazine as medium for the Vorticists' message – made *Blast*'s content more than just destructive and constructive propaganda. Blast's size and the colour of its cover, its typography, layout, and illustrations, its pugnacious and arrogant tone, its doctrine and rhetoric, its manifestoes and personal pronouncements by Lewis, Gaudier, and (to a lesser extent) Pound, reinforced each other, and carried along with them the magazine's non-Vorticist contributions. Because form and content worked toward a single, unified impact, *Blast* was, in itself, a Vorticist work of art, and perhaps the most successful of all Vorticist works of art.

# 12
# Aftermath

No one knew exactly what to make of *Blast*. Its colour affronted the reader's good taste; its layout and typography shouted at him like penny press headlines and advertising posters; its tone veered unpredictably between joking and exhortation, destructive satire and aesthetic high seriousness. 'The chill flannelette pink cover recalls the catalogue of some cheap East-end draper,' said one reviewer,[1] inadvertently revealing how successfully *Blast* had freed itself from stereotypes of 'artistic' and 'serious' magazines. Without those stereotypes for guidelines, *Blast*'s readers hardly knew how to take its serious intentions mixed with gaucherie and bad taste.

Antagonism, misinterpretation, and incomprehension seemed to be the only possible responses for most critics and reviewers. Futurism, which had been a butt of their jokes, now became their standard for measuring *Blast* – in spite of *Blast*'s persistent attacks on Futurism – and in their comparisons *Blast* came out second. Excepting only Pound's poems and Ford's story, the *Pall Mall Gazette* (1 July 1914) declared, 'There is nothing in *Blast* but various kinds of silliness ... The descent from Futurism to Vorticism has obviously thinned the blood, and the writers have far less "snap" than their master.' The New York *Times* called *Blast* the 'reductio ad absurdum of mad modernity' and 'merely a rather dull imitation of Signor Marinetti and his Futurists.'[2] Stephen Phillip's *Poetry Review* found the Vorticists to be only 'desperate iconoclasts infected by Milan.'[3] The *Morning Post*'s reviewer could find nothing in *Blast* but 'irrepressible imbecility which is not easily distinguishable from the words and works of Marinetti's disciples.'[4] J.C. Squire, writing as 'Solomon Eagle' in the *New Statesman*, called the illustrations and typography 'Futurist,' and proceeded to reduce the whole movement to a delusion in the minds of a few misguided artists: 'We haven't a movement here, not even a mistaken one; all we have is a heterogeneous mob suffering from juvenile decay tottering along (accompanied by the absent-minded Mr. Hueffer

[Ford Madox Ford] in a tailcoat) in reach-me-down fancy-dress uniforms (some of them extremely old-fashioned), trying to discover as they go what their common destination is to be.'[5] Goaded by a chorus of such opinions, Ezra Pound responded,

OYEZ.    OYEZ.    OYEZ.

Throughout the length and breadth of England and through three continents BLAST has been REVILED by all save the intelligent.

WHY?

Because BLAST alone has dared to show modernity its face in an honest glass.[6]

He took spiteful solace in arguing that *Blast* had to be attacked because it challenged the public's general stupidity and resistance to new ideas. At the same time, he insisted that *Blast* had come to many people 'as cooling water, as a pleasant light.' He was right to suggest that not all the reactions to *Blast* were single-mindedly negative.

The problem for sympathetic critics, as for hostile ones, was what to do with the seemingly diverse intentions and conflicting modes and levels of meaning in *Blast*. To P.G. Konody, *Blast* seemed 'a strange mixture of seriousness and facetiousness, common sense and absurdity.' Much of *Blast*, said Konody, 'reads like the production of naughty boys who are impelled by love of mischief'[7] – as if 'seriousness' and 'common sense' could only be good, while 'facetiousness,' 'absurdity,' and 'mischief' must be bad. Eunice Tietjens, reviewing *Blast* for the *Little Review*, ran into the same problem. She called *Blast* 'a street urchin with his tongue in his cheek, crying in an infinitely wise treble that the world is an exciting place after all,' but she had doubts about 'how much of [*Blast*'s] singular make-up will prove to be juvenile spleen and how much genuine integrity.'[8] A shrewder insight into the Vorticists' intentions came from R.A. Scott-James in the *New Weekly*. 'What is really new about the Vorticists,' he wrote, 'is that whilst they expect you to take them seriously, they engage in propagandism with the combined earnestness and lightheartedness of sportsmen.'[9] Although the Vorticist manifesto used the more aggressive analogy of mercenaries rather than sportsmen, the basic idea was the same. Mercenaries, like sportsmen, can be in dead earnest for the fun of it. Approached in that spirit, as Scott-James recognized, nothing in *Blast* should be dismissed simply because it seemed like 'juvenile spleen' or the 'mischief' of 'small boys.'

Even Pound and Lewis were not ready to defend unequivocally the flashy, vulgar, and bombastic qualities of *Blast*. 'The large type and the flaring cover are merely bright plumage. They are the gay petals which allure,' said Pound.[10] Lewis admitted that *Blast*'s 'portentuous dimensions and violent tint did more

194

than would a score of exhibitions to make the public feel some-
thing was happening,'[11] but he could not grant those qualities
equal status with what he considered to be the serious intellec-
tual content of the magazine. 'When you have removed all that
is necessarily *strident*,' he said later, 'much sound art-doctrine is
to be found in this puce monster.'[12]

Pound and Lewis, like Konody and Eunice Tietjens, seemed
determined to separate form and content, instead of recognizing
that gawdy 'plumage,' 'portentuous dimensions and violent tint'
could no more be separated from 'sound art doctrine' than
destructive clearing-away could be separated from constructive
rebuilding. They went together, just as *Blast*'s stridency went
with the stridency of the times. The movement *Blast* represented
could not be isolated from the means used to present it, however
much, in theory, its proponents would have liked to distinguish
the publicity from the art, the means from the ends.

Without worrying too much about form and content, means
and ends, Ford Madox Ford suggested another useful approach
to *Blast*. '*Blast* is an adventure, an exploration,' he wrote in
1915, 'and to refuse to consider where it may possibly get to is
to say: "What fine fellows those yachtsmen, lounging on the
pier, are in comparison with the dirty-looking chaps whose ship
is visible on the horizon, bound for the North-West Passage." '
Few people could share Ford's admiration for an adventure
without knowing where it would lead and an exploration with-
out knowing what it might discover. Nor could many people
understand, as Ford seemed to, that much of *Blast*'s stridency
and aggressiveness came from the Vorticists' efforts to come to
terms with the modern machine world. 'Nowadays,' Ford con-
tinued, 'ten times a day we are whirled at incredible speeds
through gloom, amidst clamours. And the business of the young
artist of to-day is to render those glooms, those clamours, those
iron boxes, those explosions, those voices from the metal horns
of talking-machines and hooters. Upon this task the Vorticists
have set out, quite tentatively.'[13]

By pointing out *Blast*'s tentative and exploratory quality and
its mixture of 'earnestness and lightheartedness,' Ford and Scott-
James demonstrated the proper spirit in which to approach
*Blast*. But by their openmindedness, they avoided the problem
of interpreting *Blast* and saying what it meant. Richard Alding-
ton was the only reviewer who combined sympathy for the
avant-garde cause with enough understanding of the Vorticists'
intentions to venture an interpretation of *Blast*'s message.

Reviewing *Blast* for the *Egoist*, Aldington gave full approval
to the manifesto, in which, as he put it, 'the distressing and cow-
like qualities of this nation are successfully blasted, and the

admirable, unique and dominating characteristics piously bles-
sed,' and he welcomed *Blast*'s attempt to make a place for
English art among the ranks of American and Continental
avant-garde artists. Although he found Pound's poems 'un-
worthy of the author,' he praised 'Enemy of the Stars.' 'This
hard, telegraphic sort of writing expresses pretty well one side
of our modern life,' he wrote of Lewis' prose style, and while
admitting that he did not understand the piece, he insisted, 'I do
perceive a strong, unique personality in Mr. Lewis' "Enemy of
the Stars"; I do receive all manner of peculiar and intense emo-
tions from it.' Aldington also understood and admired Gaudier's
'Vortex.' He called Gaudier 'perhaps the most promising artist
we have,' and of the painters represented in *Blast* he wrote,
'These Vorticist painters have created something like a new
form of art.' Vorticism, he believed, put an end to imitating art
of the past. With a touch of *Blast*'s own rhetoric, he concluded,
'Vorticism is the death of necrology in art.'[14]

196

In an earlier essay entitled 'Anti-Helenism,' Aldington had
catalogued the chief tendencies of the English avant-garde:

The art of this age is tired, like that of the Byzantines, who invented
conventions to excuse themselves for not attempting to emulate the art
of their ancestors; or it is wild and savage, like the art of the South Sea
Islanders and of the makers of totem poles; or it is agitated and nervous,
as no other age has been, and the result is the work of M. Picasso or Mr.
Wadsworth, which may intrigue our eyesight but does not illuminate our
intelligence. And against all this I have no word to say. I believe it to be
all admirable and right and very fine.

Yet, he admitted to preferring a different view of art and life,
what he called the 'Hellenic ideal,' and he was not happy with
what he felt to be the modern artist's love of 'angular sternness
and power.'[15] Without saying so explicitly, Aldington seemed
to be replying to Hulme's 'Modern Art and Its Philosophy' and
to Gaudier's contemptuous dismissal of the classical-Renais-
sance tradition.

He recognized the Hulmean view in Vorticism, and returned
to it when he reviewed *Blast*. 'It seems to me,' he wrote, 'that the
profound intellectuality, the love of abstract design, of abstract
colour, the serious revolt against the Renaissance and all
sensuousness – all of which I agree is perfectly and truthfully
English – give to this movement something I can only call
religious.' Looking back on the period from the vantage point
of the 1930s, Edgar Jepson put Aldington's point more suc-
cinctly: 'I take it,' he wrote in *Memories of an Edwardian*, 'that
*Blast* was the affirmation of the revolt against humanism.'[16]

Few people at the time took *Blast* so seriously. To most people
who cared about such things, *Blast* was the 'height of sophistica-

tion,' a 'dashing advertising poster.'[17] Society found *Blast* amusing. Not only was 'its immense puce cover ... the standing joke in the fashionable drawingroom from Waterloo Place to the border-line in Belgravia,' as Lewis claimed,[18] but Aldington testified, 'On two occasions I have seen copies of *Blast* brought into crowded rooms – full of ordinary sort of people – and from that moment *Blast* has been the sole topic of conversation.'[19] Celebrating their success, the Vorticists held *Blast* dinners at the Dieudonné and the Eiffel Tower. Ford and Violet Hunt gave a party for the Vorticists at South Lodge, where guests bought copies of *Blast* at half-price. Vorticism seemed to be, as Violet Hunt said, 'all the rage in 1914,' and *Blast* rode high on the cresting wave of London's bohemian life and avant-garde art.

If *Blast* had appeared a few months earlier, it might have set off a full-scale avant-garde movement. But the coming of war in August broke the Vorticists' momentum. Like any popular success, *Blast* was at the mercy of sudden shifts in public interest. When the war came, *Blast* and Vorticism, like much else in English life, quickly faded from the public mind. In fact, as early as October, *Poetry* sensed in *Blast* 'something of the wan excitement of Fourth of July fireworks on the day after the Fourth.' In the same month, the poet Gordon Bottomley, who had just seen a copy of *Blast*, found it 'amazingly stale and old-fashioned already now.'[20] Such is the fate of fads and 'rages.' Vorticism, after the appearance of *Blast* in July 1914, turned out to be a series of more or less isolated events that echoed the same message, but with ever-diminishing volume.

The second issue of *Blast* should have come out in October. Re-scheduled for December, it finally appeared 20 July 1915 – much thinner than *Blast* No. 1, with a semi-abstract drawing by Lewis on its grey cover, with block-prints instead of glossy reproductions, with a much-reduced list of blasts and blesses, and with no manifesto. Nor was there anything comparable to 'Enemy of the Stars.' It was a toned-down, more serious *Blast*, labelled, at Wadsworth's suggestion, 'War Number.'

The sobering effect of the war only partially explained the diminished size and inventiveness of *Blast* No. 2. Lewis' interests and energies had shifted directions after the brief flurry of parties and dinners in July 1914. He fell ill and left London to rest and recuperate at the Berkshire estate of the writer Mary Borden Turner, who was at that time a warm admirer of Lewis and his work. He returned to London expecting to continue publishing *Blast*, but his more immediate interests centred on painting more pictures, so that, as he told Pound, 'If I get my head blown off when I'm pottering about Flanders, I shall have

left something.'[21] He also wanted to finish and publish his novel, *Tarr*.

To further diminish his enthusiasm for *Blast*, Lewis found himself entangled in its financial problems. Sales of the first number did not come to enough to pay Leveridge's bill (the actual costs of printing turned out to be double the original estimate, according to Lewis), so there was nothing with which to repay Kate Lechmere's loan, or to provide Lewis with any income. The harassed Miss Lechmere found that Jessie Dismorr and Helen Saunders had taken a number of copies of *Blast* from the Rebel Art Centre, where they were supposed to be available for sale; then she discovered that she could not find buyers for the copies she had ordered and expected to sell privately. These copies she sold back to John Lane at cost, much to the displeasure of Lewis who apparently regarded the transaction as a kind of admission of *Blast*'s failure. His complaints to her were so angry and insulting that he destroyed any possibility of working out a personal, friendly settlement of his debt to her. To force Lewis to repay the £100 she had lent him, Kate Lechmere sought the services of a solicitor who wrote Lewis that Miss Lechmere would return his paintings given her as collateral, and Lewis would have to repay the £100 from the proceeds of the next two or three issues of *Blast*. Lewis, in turn, insisted that one or two issues would have to be sold just to pay Leveridge. Admitting 'vagueness in business matters,' he claimed not even to know how much he had borrowed – though he thought it was only £40 or £50. In any case, he foresaw no possibility of selling his pictures to repay the loan. 'For you know that the War has stopped Art dead,' he wrote her. 'I have no money at all. I am shortly going to the Front, and am meantime desperately struggling to get my immediate affairs in order.'[22] The loan was never repaid, and Lewis' and Kate Lechmere's friendship came to an end.

By early 1915, Lewis had finished *Tarr*, his novel based on the life of the bohemians he had observed in Paris before his return to London in 1909. Although Pound later described the book in terms applicable to *Blast* – 'a highly energized mind performing a huge act of scavenging; cleaning up a great lot of rubbish, cultural, Bohemian romantico-Tennysonish arty, societish, gutterish'[23] – and Hugh Kenner, in his book on Lewis, said the first fifty pages of *Tarr* 'simply transfers portions of *Blast* into a more general idiom,'[24] the novel did not, in fact, approach the experimental daring of 'Enemy of the Stars' or the manifesto. A characteristic passage from the first version of *Tarr*, as it appeared in the *Egoist*, reads as follows, 'Tarr felt the street was a pleasant current, setting from some immense and tropic gulf,

198

neighboured by Floridas of remote invasion. He ambled down it puissantly, shoulders shaped like these waves; a heavy-sided drunken fish.'[25] Compared to the prose of 'Enemy of the Stars,' that does not seem to be 'a piece of writing worthy of the hand of the abstract innovator,' as Lewis put it many years later.[26]

Although Lewis had started the novel as early as 1910 or 1911, he finished it after *Blast* came out, and, if he had chosen to do so, he could have made it a vehicle for further experiments along the lines opened up by 'Enemy of the Stars.' He chose not to, however, and later admitted that he retreated from the challenge thrown down by the revolution in the visual arts. 'Words and syntax,' he decided, 'were not susceptible of transformation into abstract terms, to which the visual arts lent themselves quite readily.'[27] That was the first step in Lewis' withdrawal from Vorticism. His second would come when he decided that 'abstract terms' no longer seemed worth exploring in the visual arts either.

While Lewis devoted his time to his own work, Pound spent another winter in Sussex with Yeats, gathered material for his *Catholic Anthology*, edited *The Poetical Works of Lionel Johnson*, prepared his own poems for *Cathay*, and eked out a small living writing articles for *Poetry*, the *New Age*, the *Egoist*, *Fortnightly Review*, *Quarterly Review*, and *Reedy's Mirror*.

Gaudier-Brzeska, meanwhile, left England to join the French army, and by September 1914 was at the Front. He wrote back a number of letters, including a short note reaffirming his allegiance to abstract art and 'THE VORTEX OF WILL, OF DECISION.' That note appeared in *Blast* No. 2 as 'VORTEX GAUDIER-BRZESKA (Written From the Trenches),' and immediately preceded the black-bordered announcement, 'MORT POUR LA PATRIE. Henri Gaudier-Brzeska: after months of fighting and two promotions for gallantry Henri Gaudier-Brzeska was killed in a charge at Neuville St. Vaast, on June 5th, 1915.'

As Gaudier left London, T.S. Eliot arrived, and soon met Pound and Lewis. Simply because Pound and Lewis were Vorticists, Eliot found himself potentially a Vorticist too. In January 1915, Lewis wrote Pound, 'Eliot has sent me Bullshit and the Ballad for Big Louise. They are excellent bits of scholarly ribaldry. I am trying to print them in *Blast*; but stick to my naif determination to have no "words ending in -Uck, -Unt, and -Ugger." '[28] Instead of 'Bullshit and the Ballad for Big Louise,' Lewis included in *Blast* No. 2 Eliot's Laforgue-like 'Preludes' and 'Rhapsody of a Windy Night,' which proved, if proof were necessary, that Eliot was not after all a Vorticist.

By the time *Blast* No. 2 appeared, the Vorticist artists had shown their work in the London group exhibition in March

1915 and their own Vorticist exhibition in June and July. At the London group show, Lewis, Wadsworth, Roberts, and Gaudier-Brzeska, along with Nevinson and Epstein, provoked the label 'Junkerism in Art' from the *Times* (10 March 1915). The Cubist-Futurist-Vorticist artists, said the *Times*, 'seem to execute a kind of goosestep' to produce 'pictures [that] are not so much pictures as theories illustrated in paint.' The *Saturday Review*'s critic, C.H. Collins Baker, found 'the Vorticists, or whatever they used to call themselves,' a 'bore.' 'Generally speaking,' Baker continued, 'the trouble with the Vortex school is that its members are either dull or dishonest. Some are both.'[29] Frank Denver, somewhat more generously, wrote in the *Egoist*, 'The Vorticist group are not numerically strong, though individually engaging. Mr. Roberts is honest but undistinguished; Mr. Etchells is unrepresented. Mr. Wadsworth's *Blackpool* is too pretty ... Mr. Wyndham Lewis is original, enigmatic and apparently imaginative.'[30] If most critics seemed willing to grant the Vorticists a group identity, they neither appreciated Vorticist work nor pretended to understand the doctrine lying behind it.

Lewis replied to some of the critics in *Blast* No. 2 (pp78-9). Since most reviewers are 'converted reporters, who enjoy a good dinner far more than a good picture,' said Lewis, it is not surprising 'that Vorticists and Cubists should, like Chinamen "look the same," ' but a more educated taste, Lewis believed, would be able to see differences between the different modern movements. As for 'Junkerism in Art,' Lewis pointed out that the Junker, 'if he painted, would do florid and disreputable canvasses of nymphs and dryads, or very sentimental "portraits of the Junker's mother." ' People seemed to feel, Lewis continued, that if 'paintings are rather strange at first sight,' they must be 'ferocious and unfriendly.' 'They are neither,' Lewis insisted,

although they have no pretence to an excessive gentleness or especial love of the general public. We are not cannibals. Our rigid head-dresses and disciplined movements, which cause misgivings in the unobservant as to our intentions, are aesthetic phenomena ... As to goose-steps (the critic compares "rigidity" to "goose-step") as an antidote to the slop of Cambridge Post Aestheticism ... or the Gypsy Botticellis of Mill Street, may not such "rigidity" be welcomed?

So much for the Fry-Bell group (Hulme had also charged them with 'aesthetic archaism' and a 'Cambridge sort of atmosphere') and for Augustus John and his gypsies. As for 'rigidity' and 'discipline,' there was plenty of that to be seen when the Vorticists presented their own group exhibition three months after the London group show.

On 10 June 1915, the Vorticists appeared in full force for the 'First Vorticist Exhibition' at the Doré Gallery. Large posters advertising the exhibition and tickets to the opening identified the Vorticists as 'Etchells, Brzeska, Roberts, Wadsworth, Wyndham Lewis, Dismorr, Saunders.' Bernard Adeney, Lawrence Atkinson, David Bomberg, Duncan Grant, Jacob Kramer, and C.R.W. Nevinson were included as artists 'invited to show' with the Vorticists. An orange-covered catalogue printed by Leveridge in a type-face much like that used in *Blast*, included a note on the exhibition by Lewis. Somewhat extravagantly, Lewis claimed, 'The show includes specimens of the work of every notable painter working at all in one or other of the new directions.' Except for Hamilton's unexplained absence, the show did, for the first and only time, bring together in one place the work of every Vorticist. It proved that the propaganda and theory in *Blast* were not just talk.

Almost all the Vorticist work shown at the Doré in June 1915 has since disappeared, but every indication is that the characteristic, clean-cut, geometrical abstractions developed during 1913 and 1914 predominated. Since Lewis had been one of the earliest to move in that direction, his influence seemed to have, as one critic put it, 'overwhelmed five of the true-blue Vorticists.'[31] The *Athenaeum*'s critic, who withheld praise for the Vorticists in general, wrote of Lewis and Wadsworth, 'They certainly fill their canvases with systems of interacting movement, the co-ordinations and antagonisms of which are admirably stressed by a use of colour very similar to that of any other capable designer. Their designs are now virtually rectilinear, the small sharp curve occasionally introduced as a kind of knot being used not for purposes of transition, but rather to envenom the clash of opposing forces.'[32] That description nicely captured the mood and look of Vorticist work, but, if wholly accurate, it also showed that no new tendencies had developed among the Vorticists since the spring of 1914, when, it now seemed clear, Vorticism reached the limit of its explorations into geometric abstractionism. While reiterations and personal variations could be valuable, they offered nothing new.

The same was true of Vorticist propaganda and doctrine. In his note for the catalogue, Lewis only repeated the intentions and theories already propounded in *Blast*. 'A point to insist on,' said Lewis, 'is that the latest movement in the arts is, as well as a great attempt to find the necessary formulas for our time, directed to reverting to ancient standards of taste, and by rigid propagandas, scavenging away the refuse that has accumulated for the last century or so' – which was a mild condensation of

the Vorticist manifesto. For a definition of Vorticism, Lewis listed criteria much more general than those *Blast* had provided a year before:

By Vorticism we mean (a) ACTIVITY as opposed to the tasteful PASSIVITY of Picasso; (b) SIGNIFICANCE as opposed to the dull or anecdotal character to which the Naturalist is condemned; (c) ESSENTIAL MOVEMENT and ACTIVITY (such as the energy of a mind) as opposed to the imitative cinematography, the fuss and hysterics of the Futurists.

A more complete explanation of Vorticism, Lewis promised, would appear in the forthcoming issue of *Blast*.

The 'War Number' did not, however, explain Vorticism more clearly. If anything, it explained it less – certainly less than *Blast* No. 1 had done, and its contents seemed even less unified by the common concerns of a group movement. Ford was again included, this time with a non-Vorticist poem, 'The Old Houses of Flanders.' Poems contributed by Pound, Eliot, Jessie Dismorr, and Helen Saunders were too diverse in intentions to illustrate Vorticist theory or technique. Lewis' notes and essays (which took up nearly half of the magazine) hardly mentioned Vorticism. Except for the war, no significant new subject of discussion appeared in *Blast* No. 2, and the war fit neatly into the violence-savagery-machinery-modern life constellation that had been fully charted in the first *Blast*.

Summing up the impact of war on English society, Lewis wrote in 'The Crowd Master,' 'The only possibility of renewal for the individual is into this temporary Death and Resurrection of the Crowd!' (p98) For Gaudier, 'This war is a great remedy. In the Individual it kills arrogance, self-esteem, pride.' (p33) Lest the Vorticists begin to sound like Marinetti ('We wish to glorify War – the only health giver of the world ... etc.') Lewis smugly reported a rumour that Nevinson, upon returning from the Front, had written to Marinetti that, 'He no longer shares, that he REPUDIATES, all [Marinetti's] utterances on the subject of War ...' (p25) From Lewis' point of view, the war *per se* made no difference for art. 'All art that matters is already so far ahead that it is beyond the sphere of these disturbances,' Lewis said. (p12)

Nevertheless, Lewis and Gaudier discovered in the machinery of war deeply moving imagery and inspiration for artists. 'The huge German siege guns, for instance, are a stimulus to visions of power,' Lewis wrote, and added, 'In any event, [the artist's] spirit is bound to reflect these turmoils, even if only by sudden golden placidity.' (p23) Gaudier, writing from the trenches, described a German Mauser: 'Its heavy unwieldy shape surrounded me with a powerful IMAGE of brutality,' but it moved him to carve the handle into a 'gentler expression of order.'

(p34) In that way, the artist made the war serve him, as he had made machinery and other images of modern energy and violence serve his art.

Since 'murder and destruction is man's fundamental occupation,' Lewis argued (p15), war only brought into the open society's covert urges to violence. Men have retained a taste for blood since their primitive days, said Lewis, and now they express it in the 'iron Jungle [of] the great modern city.' (p9) What the gun is to war, the machine is to the 'iron Jungle,' and so it is through machine forms that the modern artist comes to terms with the basic, violent, nature of man. Therefore, Vorticist art, with its effort to be, in Lewis' words, 'hard, clean and plastic' (43), sets the standard for all modern art: 'In any heroic, that is energetic representation of men to-day the immense power of machines will be reflected,' Lewis wrote in his 'Review of Contemporary Art.' (p44) Modern artists, he said in the same context, must strive to express 'something of the fatality, grandeur and efficiency of a machine.' (p43)

In 'The God of Sport and War,' 'A Super-Krupp or War's End?' 'The Exploitation of Blood,' 'The Six Hundred, Verestchagin and Uccello,' and other essays that, along with the semi-fictional 'Crowd Master,' nearly drowned out the other voices in *Blast* No. 2, Lewis had much more to say about the war, modern life, and contemporary art. Interesting in their own right and as evidence of Lewis' increasing strength as critic and writer, his essays clearly spoke for an individual, not for the group. Like *Tarr*, they were only distantly related to the attempt at creating 'a battering ram all of one metal,' which, however flawed it may have been, gave *Blast* No. 1 its sense of mutual effort.

In a few places the original Vorticist spirit did persist in *Blast* No. 2. Companion lists of people and things blasted and blessed appeared near the end of the 'War Number.' (See appendix B) Among its fifteen blasts and nineteen blesses, were blasts – for the second time – at the Reverend Mr Pennefeather and Frank Brangwyn, and a blast at W.L. George, who had been blessed a year before. Brangwyn's contemporary, Sir William Orpen, ARA, was blasted, and so was the Slavic sculptor, Ivan Meštrović, whose heroic sculpture was on display at the Victoria and Albert in the summer of 1915. Although Sir Joseph Lyons had been blessed in *Blast* No. 1, his 'Lyons Shops (without exception)' were blasted in No. 2; whereas 'All A.B.C. Tea-Shops (without exception)' were blessed. Lewis had remarked in *Blast* No. 1 that the 'trivial ornamentation, mirrors, cheap marble tables, silly spacing, etc.' of the ABC's offered 'a thousand great possibilities for the painter.'

The war figured in several blessings; specifically, in blessing Adolphe Max, Burgomaster of Brussels, who led a strong resistance against the Germans when they invaded Belgium in 1914; Airman Reginald A.J. Warneford, winner of the VC and Cross of the Légion d'honneur for heroic air battles with German Zepplins; the War Loan, which, in widely propagandized campaigns (one in November 1914 and another in June 1915), sold government bonds to raise money for the war effort; A.G. Hales, a widely read war correspondent; 'War Babies,' a topic in the headlines in June 1915, because a 'Committee on Illegitimate Births during the War,' chaired by the Archbishop of York, had announced that there would be no increase of 'war babies' in England during the war; and 'The scaffolding around the Albert Memorial,' which had been erected to protect that epitome of Victorian public sculpture from German bombs. Remarking on the 'cloak of scaffolding' around the Albert Memorial, the art magazine *Colour* said, 'The memorial never looked better than at present.'[33] Blessings on the music hall entertainer, Basil Hallam, the French comedian, Max Linder, and the heavyweight boxing champion of the British Empire, Bombardier Billy Wells, were about all that remained of the pre-war spirit of the first issue's blesses.

As in *Blast* No. 1, Pound contributed prose and poetry. His prose 'chronicles' were devoted to a lengthy complaint against the bell-ringing at St Mary Abbotts, an attack on *Blast*'s hostile critics, and an attempt to bring Lawrence Binyon's *Flight of the Dragon* into the 'ancestry' of Vorticism. With one exception, his poems were like the satiric and Imagist pieces in the first *Blast*. The exception was 'Dogmatic statement on the Game and Play of Chess (Theme for a Series of Pictures).' The poem, like a Vorticist picture, presented an abstract composition based on line, colour, and pattern. It also suggested a Vortex of violent energy held under control by the rigid regularity of the chess board. The chessmen hit the board 'in strong "L's" of colour':

Reaching and striking in angles,
holding lines in one colour.
The board is alive with light ...

The moves of the chessmen 'break and reform the pattern, working toward a climax:

Whirl, centripetal, mate, King down in the vortex:
Clash, leaping bands, straight strips of hard colour,
Blocked lights working in, escapes, renewing of
contest. (p19)

The abstract patterns of line and colour, the interstices of light and space, the in-turning, self-perpetuating energy at the end

(the contest is renewed), made 'Dogmatic Statement' Pound's
one truly Vorticist poem.*

The only other writing in *Blast* No. 2 to approach the Vorticist goals of intense, compressed energy and sharp, hard-edged imagery appeared in Jessie Dismorr's *vers libre* and prose poems. In 'Monologue' she writes,

I admire my arrogant spiked tresses, the disposition of my
   perpetually foreshortened limbs,
Also the new machinery that wields the chains of muscles
   fitted beneath my close coat of skin.

In the same poem, eyes 'dismember live anatomies innocently' and the appetites 'yell war.' 'Obsessions rear their heads. I hammer their faces into discs.' (p65) In 'London Notes,' familiar London scenes turn into abstract designs. 'Ranks of black columns of immense weight and immobility are threaded by a stream of angular volatile shapes,' she writes of the British Museum, and of the museum's Egyptian gallery: 'In a rectangular channel of space light drops in oblique layers upon rows of polished cubes sustaining gods and fragments.' (p66)

Only in scattered spots did the writing in *Blast* No. 2 come up to the Vorticist standards of *Blast* No. 1. The illustrations, on the other hand, showed no backsliding. With three exceptions – a crude, 'naïve' cartoon called *Types of the Russian Army* by Jacob Kramer, a Futurist drawing by Nevinson, and a *Design for Programme Cover – Kermesse* done by Lewis in his expressionist style of 1912 – the fifteen illustrations in the 'War Number' stuck closely to the Vorticist ideal of hard, geometric clarity. Lewis' cover illustration, *Before Antwerp*, set the tone, with a nearly abstract geometrical maze of lines and blocks of black and white that, on close inspection, revealed the stiff forms of four gun-carrying soldiers in front of buildings, trenches, and artillery pieces. (See plate 24) Lewis also contributed a totally abstract *Design for 'Red Duet'* which used some of the motifs of his large Vorticist oil, *Revolution (The Crowd)*. Other abstract drawings came from Jessie Dismorr, Helen Saunders, Etchells, Wadsworth, and Dorothy Shakespear (who had become Mrs Ezra Pound the previous year).

* Pound told Donald Hall ('Ezra Pound: An Interview' 30) that this poem 'shows the effect of modern abstract painting,' but he was more specific in a letter to Harriet Monroe (10 April 1915) in which he said the 'pictures proposed in the verse are pure vorticism ... Admitted there is a shade of dynamism in the proposition, to treat the pieces as light potentialities, still the concept arrangement is vorticist.' (Quoted in K.K. Ruthven *A Guide to Ezra Pound's* Personae (1926) [Berkeley and Los Angeles 1969] p75)

All of the illustrations gained from being done as block prints. Their stark black and white simplicity emphasized the draughtsmanship and the interplay of geometric shapes and masses, which were the touchstones of Vorticist art. But the impression conveyed by the illustrations in *Blast* No. 2 – that Vorticism still flourished as a visual style – soon faded. When the London group held its second show of the year, in December 1915, the *Times* announced in the sub-headline of its review, 'CUBISTS, BUT NO VORTICISTS.'

With the collapse of the Rebel Art Centre, the removal of Marinetti and the Futurists, the financial failure of *Blast*, and the shift in Lewis' interests from group movements to personal projects, much of the impetus and cohesiveness of the Vorticist movement disappeared. And the war took its toll: Gaudier dead at the Front in 1915; Hulme dead at the Front in 1917; Lewis, Wadsworth, Ford, Nevinson, and others in uniform; the art market at a standstill; the pre-war mood and the avant-garde spirit, out of which Vorticism had grown, shattered. Lewis promised in the editorial notes to *Blast* No. 2 that two more issues would appear before January 1916, and that *Blast* would accompany the arts into the post-war world of 'a more ardent gaiety.' But he promised in vain.

Only Ezra Pound worked to keep Vorticism alive. Hardly had the first *Blast* appeared when he began publishing articles designed to promote Vorticism: an appreciation of Edward Wadsworth in the *Egoist* (15 August 1914); an elaboration of a talk on Vorticism given at the Rebel Art Centre published in the *Fortnightly Review* (1 September 1914); an explanation of Vorticism for the *New Age* (14 January 1915); and a discussion of Gaudier-Brzeska for the same journal (4 February 1915). His major effort in behalf of Vorticism came in the form of a memoir of Gaudier-Brzeska published in 1916 by John Lane. There Pound brought together photographs of Gaudier's work, reprints of his published writings, along with some of his letters written from the Front, and added his own somewhat rambling text composed of previously published essays and some new comments on Gaudier, Vorticism, and art in general. After finishing the Gaudier book, Pound wrote John Quinn, 'I have certainly GOT to do a Lewis book to match the Brzeska. Or perhaps a "Vorticists" (being nine-tenths Lewis ...).'[34] In the same year, he wrote Joyce that he hoped to do a book called *This Generation* about 'contemporary events in the woild-uv-letters, with a passing reference of about 3600 words on Vorticism.'[35] In January 1917, Pound was still writing to Quinn about the projected book on Lewis, but it never appeared.

Pound became an agent-without-pay for Vorticist artists. Upon Gaudier's death, he fell heir to a number of Gaudier's sculptures, drawings, and pastels. Before leaving for the Front, Lewis entrusted Pound with forty-five of his drawings (with prices indicated) and a large body of manuscript material. Pound sold several of Lewis' and Gaudier's works to John Quinn, and, in fact, tried to force on Quinn more Vorticist work than Quinn wanted.

However, with Pound doing the necessary work in London, Quinn provided money to get together some seventy-five Vorticist works (including forty-five by Lewis) and ship them to New York, where they appeared in the winter of 1916-17 at the Penguin, an artists' club with rooms on East 15th Street. The show included Lewis, Wadsworth, Etchells, Roberts, Dismorr, and Saunders, and it won a few sales for the artists. Its impact on American viewers can be guessed from a tongue-in-cheek explanation of Vorticism written by the humorist Don Marquis. 'Vorticism,' he wrote in *Art World*, 'is the result when Cubism and Futurism rush into a vacuum from opposite sides, meeting in the center. They collide and whirl, producing something like a maelstrom in a turpentine bottle.' The viewer of Vorticist art, said Marquis, must look at the work from 'inside,' which means he must think about the spinning universe, until he is so dizzy that all the ideas are sucked out of his head. This creates a vacuum – 'the central, pivotal vacuum of the universe.' 'Thus,' Marquis concluded, 'we come to another great law showing the superiority of Art over Nature: Nature abhors a vacuum; but Art often builds itself upon one.'[36]

While Vorticist painting and drawing appeared in New York, a new form of Vorticism, Vortography, made its appearance at the Camera Club in London – again with assistance from Pound. In 1916, the American photographer Alvin Langdon Coburn developed a method of making abstract photographs – which Pound dubbed 'Vortographs' – by fastening three mirrors together to form a triangle. Like a kaleidoscope, the mirrors split reflected images into segments, and transformed simple objects (Coburn usually used bits of wood and crystals) into abstract designs. Coburn then photographed the designs. (see plates 2 and 25)

In an anonymously written introduction to the catalogue of the exhibition, Pound pointed out the similarities between Coburn's and the Vorticists' interest in abstract form. As a Vortograph, 'the dull bit of window-frame produces "a fine Picasso," or if not a "Picasso" a "Coburn," ' said Pound. 'It is an excellent arrangement of shapes, and more interesting than most of the works of Picabia or of the bad imitators of Lewis.'[37] Writing

about Vortographs to John Quinn, Pound was equally re-strained in his praise ('The vortographs are perhaps as interest-ing as Wadsworth's woodcuts, perhaps not quite as interesting'), but their chief value, Pound concluded, was to 'upset the muckers who are already crowing about the death of vorti-cism.'[38]

'The Death of Vorticism' became the title of an article Pound contributed to the *Little Review* in the spring of 1919. He had become a regular contributor to Margaret Anderson's magazine as a covert means of promoting Vorticism. 'My corner of the paper is *Blast*,' he wrote Edgar Jepson, 'but *Blast* covered with ice ...'[39] In his article on Vorticism, Pound argued that the movement was not dead, and for proof he pointed to a memorial exhibition of Gaudier's work, which had been held at the Leicester Gallery in May-June 1918; to the war paintings of Lewis and Roberts (Roberts was made an Official War Artist in 1917, and Lewis in the same year became Official War Artist to the Canadian Corps Headquarters); and to the assignment of a 'vorticist lieutenant' (Edward Wadsworth) 'to be in charge of naval camouflage.'[40] But Gaudier was dead; Lewis and Roberts did not adhere to strict Vorticist principles in their war paintings; and naval camouflage hardly promised to sustain a flourishing art movement.

Pound's *Little Review* article was his last attempt to resuscitate Vorticism. In 1919 he went to Paris and reported in the summer issue of Frank Rutter's *Art and Letters*, 'I am out of the whirl-pool, and have had a few weeks' rest from all sort of aesthetic percussions ...'[41] The following year, taking permanent leave from the 'whirlpool' of London's Vortex and the 'aesthetic per-cussions' of *Blast*, Pound returned to Venice, whence he had come to London in 1908. Symbolically, he started over. This time he rejected London for Paris and Rapallo, and group movements for individual development.

He readily acknowledged, however, the contribution Vorticism had made to his own work. 'Roughly: what have they done for me these vorticist artists?' he asked rhetorically in his memoir of Gaudier, and answered, 'They have awakened my sense of form, or they "have given me a new sense of form," or what you will ... These new men have made me see form, have made me more conscious of the appearance of the sky where it juts down between houses, of the bright pattern of sunlight which the bath water throws up on the ceiling, of the great "V's" of light that dart through the chinks over the curtain rings, all these are new chords, new keys of design.'[42]

Pound summed up this 'new sense of form' in the phrase 'planes

in relation,' and as an illustration of the formal significance of
'planes in relation,' he wrote,

The pine-tree in mist upon the far hill looks like a
fragment of Japanese armour.

The beauty of this pine-tree in the mist is not caused
by its resemblance to the plates of the armour.

The armour, if it be beautiful at all, is not beautiful *because*
of its resemblance to the pine in the mist.

In either case the beauty, in so far as it is beauty of form,
is the result of 'planes in relation.'

The tree and the armour are beautiful because their diverse
planes overlie in a certain manner.[43]

This vivid sense of abstract visual form helped Pound cross over
from Imagism to Vorticism, declaring, as he made the crossing,
that a poem is Imagist in so far as it 'falls in with the new
pictures and the new sculpture.' (See pp130-1 above) It also
prepared him to deal with the Chinese written character. His
beginning to work on Ernest Fenollosa's manuscripts coincided
with his transition from Imagism to Vorticism, and both in-
volved understanding things in a new, visual way.

Following Fenollosa's lead, Pound responded to the 'pictorial
elements' of Chinese characters, which he saw as formally com-
posed and extremely simplified abstract pictures of natural
forms. A series of such characters, said Fenollosa, is like 'a
continuous moving picture,' and poetry composed in characters
'speaks at once with the vividness of painting, and with the
mobility of sounds.'[44] Vorticism helped Pound appreciate that
visual-verbal relationship, and it may have influenced the form
of Pound's *Cantos*, where the innumerable disparate elements
of the poem can be thought of as 'planes in relation' or 'diverse
planes' that, like fragments of Japanese armour, 'overlie in a
certain manner.' To have picked up a 'new sense of form' at that
stage in his development probably helped Pound re-examine
and expand upon the techniques of Imagism.

For Lewis, on the other hand, the chief value of Vorticism lay
in the working out of the movement itself. His painting, draw-
ing, and writing would have been little different, had there been
no Vorticist movement. But *Blast* forced him to think out and
put into words what, otherwise, might have remained only
implicit and unarticulated in his work of that time. Once he had
gotten everything said (as he did in *Blast* No. 1), he had no
reason to keep the movement going – except for its publicity
value.

When he returned to London early in 1919, Lewis hoped to
bring out another issue of *Blast*. During the war Pound had tried

to get help for *Blast* from John Quinn, and at one point he wrote Lewis, 'I'm not very keen on spending Q[uinn]'s money on the *Egoist*. Shall I try to get it shifted to bring out another number of *Blast* – possibly an American number – with Q's assistance [?]'[45] That opportunity to get financial assistance – if it really existed at all – passed, though Lewis still talked of bringing out a third *Blast* in November 1919. That issue would have included designs by Roberts, Etchells, Wadsworth, Turnbull, Dismorr, and Lewis. Pound was not to be included. Instead of a third *Blast*, however, Lewis published a pamphlet called *The Caliph's Design: Architects! Where is Your Vortex?* in which he argued that modern cities should be remade according to Vorticist concepts of 'the great line; the fine exultant mass; the gaiety that snaps and clacks like a fine gut string; the sweep of great tragedy; the immense, the simple satisfaction of the surest, the completest art ...'[46] Much of the pamphlet was devoted to short notes on modern art, and proved, as had *Blast* No. 2, that Lewis wanted to present his own ideas, not the collective attitudes of a group. As late as 1920, Lewis still talked about bringing out another *Blast*, but the magazine which finally appeared in 1921 was not *Blast* but *The Tyro: A Review of the Arts of Painting, Sculpture and Design*, and it signalled a new, purely individualistic phase in Lewis' career.

In February 1919, Lewis exhibited his war paintings and drawings, and, in spite of the show's *Blast*-like title, 'Guns,' no Vorticist work appeared. For his war scenes, Lewis developed a rough, stiff, stylized realism. In 1915 he had said that good artists would not revert to naturalism to depict the war, but now, in his foreword to the 'Guns' catalogue, Lewis defended his nonabstract technique by insisting that it was appropriate to his subject matter. He later wrote, 'The geometrics which had interested me so exclusively before, I now felt were bleak and empty. They wanted *filling*.'[47] Like his rejection of abstractionism in literature at the time of composing *Tarr*, this rejection of 'geometrics' in painting marked a definite turn away from Vorticism. A month after the 'Guns' exhibition, Lewis wrote in the *English Review*, 'The revolution in painting of the few years preceding the war has thoroughly succeeded.'[48]

Whether through success or failure, the geometric-abstract style of the pre-war Vorticists no longer attracted enough interest to motivate a group movement. In the spring of 1920, Lewis, Dismorr, Etchells, Hamilton, Roberts, and Wadsworth regrouped with some other artists (Frank Dobson, Charles Ginner, E. McKnight Kauffer, and John Turnbull) to exhibit under the name 'Group x.' The x, said Lewis at the time, 'signifies nothing more didactic' that that it 'pleases the members of

this group.' As to common concerns of the group, Lewis could point to nothing more specific that the fact that, 'All the members of Group x belong to the general European movement in painting that has disturbed art more during the last ten years than has happened since the storm of Impressionism.'[49] In the Group x show at the Mansard Gallery (26 March-24 April 1920), Lewis exhibited six drawings and one painting, all entitled *Self-Portrait* and, judging from illustrations in the catalogue, only Hamilton – and to a lesser degree Dismorr, Roberts, and Turnbull – worked in the pre-war Vorticist manner. Vorticism had dwindled to an x – the eviscerated remains of an exhausted Vortex.

'In the early stages of this movement,' Lewis wrote of Vorticism in 1934, 'we undoubtedly did sacrifice ourselves as painters to [the] necessity to reform *de fond en comble* the world in which a picture must exist ... In the heat of this pioneer action we were even inclined to forget the picture altogether in favour of *the frame* ...'[50] Later, in *Rude Assignment*, Lewis returned to this point: 'It was, after all, a new civilization that I – and a few other people – was making the blueprint for ... It was more than just picture-making: one was manufacturing fresh eyes for the people, and fresh souls to go with the eyes.'[51] With *Blast* and Vorticism, in other words, the Post-Impressionist revolution became a cultural – even a political and ethical – crusade.

Pound saw it in much the same light. When he wanted to instruct readers on how to determine the merit of a work of literature, he wrote (in *ABC of Reading*), 'In all cases one test will be, "could this material have been made more efficient in some other medium?" This statement is simply an extension of the 1914 Vorticist manifesto.'[52] On a broader plane, Pound wrote in *Culture*, 'If I am introducing anybody to Kulchur, let 'em take the two phases, the nineteen teens, Gaudier, Wyndham L. and I as we were in *Blast*, and the next phase, the 1920's.'[53] The Vorticist manifesto, Pound said in one of his wartime talks over Italian radio, 'was the best we could then do toward assertin what has now become known to the world, or at least to the European continent as the crisis OF the system.' *Blast*, he insisted, was the 'harbinger' of 'the end of the materialist Era, the end of that particularly dirty Anschauung.'[54]

Lewis and Pound seemed to claim, in retrospect, more significance for their movement than it deserved, especially when Vorticism is compared with larger and more broadly influential movements on the Continent. But considering the time and place of their movement, their remarks are reasonable enough. Besides capturing London's bohemian high spirits and a parti-

cular coterie's attitudes and visual style, *Blast* and Vorticism brought into a single, fairly coherent movement several developing tendencies in twentieth century art and literature: rebellion against the nineteenth century; fascination with machinery, the city, energy, and violence; commitment to anti-romanticism and pro-classicism (albeit a tough, anti-humanistic 'classicism' most often associated with T.E. Hulme); experiments with pure form in art, with particular emphasis on geometrical abstraction and the interplay of 'planes in relation'; attempts to create spatial forms in literature and discover common aesthetic ground for all the arts.

To do all that may not have produced a 'new civilization' or even fully prefigured the collapse of the old 'materialist Era,' but it was a great deal for a few artists to accomplish in two or three years amid the political and artistic turmoil of post-Edwardian England.

# Appendix A
# Title Pages and Contents
# of 'Blast' No. 1 and No. 2

Most items included here are discussed in chapter ten or eleven. The listings below follow the order of the table of contents in *Blast* No. 1 and No. 2, but give a fuller record of individual titles of short pieces, such as Pound's poems and Lewis' 'Vortices and Notes.'

TITLE PAGE OF *Blast* NO. 1

No. 1 June 20th 1914| BLAST| Edited by Wyndham Lewis| Review of the Great English Vortex| 2/6 Published Quarterly| 10/6 Yearly Subscription| London:| John Lane| The Bodley Head| New York: John Lane Company| Toronto: Bell & Cockburn.

CONTENTS OF *Blast* NO. 1

ART REPRODUCTIONS IN *Blast* NO. 1

Edward Wadsworth, *Newcastle-on-Tyne, Cape of Good Hope, A Short Flight, March, Radiations*
Wyndham Lewis, *Plan of War, Timon of Athens, Slow Attack, Decoration for the Countess of Drogheda's House, Portrait of an English Woman, Enemy of the Stars*
Frederick Etchells, *Head, Head, Patchopolis, Dieppe*
William Roberts, *Dancers, Religion*
Jacob Epstein, *Drawing, Drawing*
Gaudier-Brzeska, *Stags*
Cuthbert Hamilton, *Group*
Spencer Gore, *Brighton Pier, Richmond House*

214    TITLE PAGE OF *Blast* NO. 2

No. 2 July, 1915| BLAST| Edited by Wyndham Lewis| Review of the Great English Vortex| Price 2/6. Post free 2/10| Yearly Subscription 11/4 post free| London:| John Lane| The Bodley Head| New York: John Lane Company| Toronto: Bell & Cockburn.

CONTENTS OF *Blast* NO. 2

ART REPRODUCTIONS IN *Blast* NO. 2

# Appendix B
# The Blasted
# and the Blessed

Many of the people and institutions listed below are discussed in chapter ten, but only a complete, annotated list can convey the scope and peculiar tone of *Blast*'s selection of candidates for blasting and blessing. In the case of names such as Bergson, Croce, and James Joyce, when identification, per se, seems unnecessary, only some indication of possible reasons for their inclusion in the lists appears here. Except for a few guesses (which are always identified as such), the identifications seem certain.

All names from both issues are included, whether or not they have been identified, and they have been separated under the two headings used in *Blast*, 'Blast' and 'Bless.' While retaining original misspellings, and listing the items exactly as they appeared in *Blast*, I have placed them in alphabetical order without regard to titles, articles, or first names. When needed, corrected spelling and full names begin the identification. Unless marked '(No. 2),' all items appeared in *Blast* No. 1.

## BLAST

*Norman Angel* – The author of *The Great Illusion* (1910) was an outspoken agitator for peace, and perhaps for that reason was blasted.

*William Archer* – Drama critic for the *Nation*, and a strong supporter of Ibsen.

*The Architect of the Regent Palace Hotel* – (No. 2) Situated on Sherwood Street off Piccadilly Circus, the hotel was the newest (opened 29 May 1915) and largest in London; its architecture was tastelessly conventional.

*Abdul Bahai* – Sir Abdul Baha Bahai, leader of the universalist religion Bahaism founded by his father, Baha Ullah.

*Mr. Backbeitfeld* – (No. 2) Grouped with Messrs Hiccupstein and Stormberg to suggest, perhaps, the sort of people Pound rejects in 'Salutation the Third' ('Let us be done with Jews and Jobbery,' etc.); one of the very few examples of anti-semitism in *Blast*.

*Beecham (Pills, Opera, Thomas)* – Beecham's Pills, a popular 'digestive tonic' widely advertised as a cure for 'all Bilious and nervous disorders'; 'Opera' probably refers to Sir Joseph Beecham, who presented the Russian Opera, the English Opera, and the Russian Ballet at the Drury Lane Theatre in 1914; Thomas Beecham (son of Sir Joseph) was already famous as 'conductor, composer, and operatic impresario.' (*Who's Who*, 1914)

*A.C. Benson* – Arthur Christopher Benson, president, fellow, and lecturer, Magdalene college, Cambridge; prolific writer; books on Rossetti (1904), Edward Fitzgerald (1905), and Pater (1906) for the English Men of Letters Series; his *Collected Poems* appeared in 1909; with Viscount Esher he edited Queen Victoria's letters.

*R.H. Benson* – Catholic priest and popular writer who died in October 1914. Excerpts from the *Times Literary Supplement*'s review of his last book, *Initiation*, show why the Vorticists would blast him: 'at once a sermon and an interesting study of men and women,' the book's moral is that 'suffering [is] inevitable in human life ... It must be accepted as part of the order of the world – an order which for Monsignor Benson means, of course, the will of a beneficent Providence.' (12 February 1915, p77)

*Bergson* – Bergson's emphasis on the 'flux,' intuition, and the *élan vital* seemed romantic, Futurist, and opposite to the Vorticists' ideals of rigidity, outlines, and distinct demarcations.

*Annie Besant* – Both her socialism and spiritualism would represent nineteenth century 'romanticism' to the Vorticists; in May-June 1914, she lectured on mysticism at Queen's Hall, London.

*Bevan, and his dry rot* – (No. 2)

*Birth-Control* – (No. 2) Perhaps in a political context, birth control seemed too closely tied to 'meddling,' scientific liberalism. In any case, the blast at birth control must be taken in conjunction with the blessing of 'war babies' (qv).

*Frank Brangwyn* – Blasted in both issues, Brangwyn was a member of the Royal Academy and a very popular Edwardian painter.

*British Academy* – Incorporated in 1902 for the study of history, philosophy, and philology; headquarters in Burlington House. Of the British Academy, the *New Freewoman* (15 December 1913) wrote, 'I suppose one could find a duller set of old buffers if one set out with that intention.'

*R.J. Campbell* – Reginald John Campbell, a well-known nonconformist minister who preached the 'new theology' at City Temple, London.

*Messrs. Chapell* – Possibly Chappell and Co., music publishers and piano makers. The company was involved in a law suit in May 1914.

*Chenil* – Chenil gallery, Chelsea; associated with Augustus John and the 'John generation,' but also the location of David Bomberg's one-man show in June 1914.

*Codliver Oil* – Perhaps, like birth control (qv), codliver oil represented meddling with things that should be left alone.

*Captain Cook* – If this is Captain James Cook, the famous eighteenth century English explorer, the blast is perhaps at Cook's opening the way for 'civilization' to corrupt South Seas 'primitive cultures.' Publicity about the forthcoming unveiling of a statue of Captain Cook in the Mall (7 July 1914), may have brought Cook's name to mind as the Vorticists prepared their list of blasts.

*Marie Corelli* – Although constantly attacked by the critics, her 'religious' novels and romances were consistently bestsellers; her sentimentality would be particularly disagreeable to the Vorticists.

*Croce* – Probably his organic and time-conscious philosophy seemed to the Vorticists to lack the proper emphasis on space and separateness.

*Lionel Cust* – Director of the National Portrait Gallery (1895-1909) and then joint editor of *Burlington Magazine*; in both positions he represented conservative, academic standards in art.

*Mr. and Mrs. Dearmer* – The Reverend Percy Dearmer, Vicar of St Mary the Virgin, Primrose Hill, Hampstead; published many articles on social questions; his wife, Mabel Dearmer, was a playwright, book illustrator, and president of the Poetic Drama Centre (in 1914).

*George Edwards* – George Edwardes, chairman and managing director of Daly's Theatre and Gaiety Theatre; the latter especially famous for its Gaiety Girls.

*Edward Elgar* – One of England's most famous composers of grand marches, symphonies, and oratorios; awarded the Order of Merit in 1911; wrote the coronation march for George v in 1911; a masque, 'The Crown of India,' celebrating the King's visit to India, was performed on the stage of the London Coliseum on 11 March 1912.

*Ella* – According to Douglas Goldring, this was Ella Wheeler Wilcox, popular poetess whose poems were published in the Hearst chain of newspapers.[1]

219

*Willie Ferraro* – Willy Ferraro, a child genius who began conducting orchestras at the age of four; gave a private performance with the New Symphony Orchestra at the Albert Hall, 28 April 1914, and had an audience with Queen Alexandra, 2 May; at the time he was less than eight years old.

*C.B. Fry* – Charles Burgess Fry, famous cricketer who was making a comeback in 1914 after a season's absence; author of a book on cricket; founder of *Fry's Magazine*, an 'outdoor' and sporting magazine.

*Galsworthy* – Like Shaw, Bennett, and Wells, representative of the successful Edwardian writer, social commentator, 'liberal'; at the opposite extreme from the Vorticists, aesthetically and politically.

*Geddes* – Probably Sir Patrick Geddes, a professor of biology at St Andrews, a contributor to the *New Age*, and co-author (with J. Arthur Thompson) of a widely read pamphlet, *Problems of Sex*, written for the National Council of Public Morals and published by Cassell in 1912. The pamphlet took a strong, moralistic stand against what its authors saw as the 'dirt and deviltry' arising from a relaxation of strict moral standards in contemporary society. (A complete discussion of the pamphlet appears in Samuel Hynes, *The Edwardian Turn of Mind* [Princeton 1969] pp170 ff.)

*Lord Glencommer of Glen* – Edward Priaulx Tennant, Lord Glenconner, Lord High Commissioner to the General Assembly of the Church of Scotland; made a lord in 1911.

*George Grossmith* – Actor, author, songwriter; appeared in a number of his own plays and reviews at the Gaiety Theatre; like C.B. Fry (qv), capitalized on his fame to sell his own writing – his autobiography, *Diary of a Nobody*, first appeared in *Punch*. For this reason, perhaps, he was blasted, whereas other popular performers, such as Gertie Millar and George Mozart, were blessed.

*Martin Harvey* – John Martin Harvey, actor (with Angelita Helena de Silva, his wife, made up a popular male-female team); theatre manager and minor painter.

*Hawtrey* – Charles Hawtrey, another actor-manager; a major comedy star of the legitimate theatre; possibly blasted because he revived the innuendo-laden bedroom farce, *Dear Old Charlie*, by Charles Brookfield, while Brookfield was examiner of plays (1911-13) (Brookfield passed his own plays while prohibiting performances of *Mrs Warren's Profession*, *Waste*, and other contemporary works with controversial themes).

*Mr. Hiccupstein* – (No. 2) see Mr. Backbeitfeld, above

*Seymour Hicks* – Edward Seymour Hicks, author, actor, and singer in musical comedy and light opera.

*Joseph Holbrooke* – Joseph Charles Holbrooke, composer and conductor; presented an annual series of Modern English Chamber Concerts.

*Dean Inge* – William Ralph Inge, Dean of St Paul's (1911-34); used by Wilensky in *The Meaning of Modern Sculpture* (Boston, Beacon Press Paperback 1961) p9, as an example of the artistic philistine.

*Galloway Kyle* (Cluster of Grapes)

*Bishop of London and All His Posterity* – Winnington Ingram, who was unmarried; made an 'unofficial wager' that with new churches built in London, he could make London a 'better, purer, nobler' city than New York.[2]

*Lyceum Club* – The Lyceum Club for Women, 138 Piccadilly, where Marinetti gave a lecture in 1910.

220 *Lyon's Shops (without exception)* – (No. 2) White and gold tea shops started by Sir Joseph Lyons in 1904; comparable to ABC tea shops (qv) which the Vorticists bless. In March 1915, Lyons and Co. was fined for sending bad meat for troops quartered at the White City.

*Ad. Mahon* – Possibly Admiral Mahan, whose writings on the English navy were well-known. Richard Aldington writes in *Life for Life's Sake* (p120), that, when he joined the Garton Peace Foundation, he was set to work 'criticising Admiral Mahan's views of naval strategy.'

*Matthews*

*Colonel Maude* – (No. 2) Colonel Frederick Stanley Maude, a general staff officer at the War Office and author of newspaper and magazine articles on military tactics (later a highly successful commander of British forces in Mesopotamia).

*Mestrovic, Etcetera* – (No. 2) Ivan Meštrović, Yugoslavian sculptor, whose simple, stylized forms showed a strong influence from Byzantine and archaic Greek sculpture. The formality and rigidity of his lines should have attracted the Vorticists' admiration. But Pound writes in the Gaudier memoir, 'We are, I think, getting sick of the glorification of energetic stupidity. Vienna, Mestrovic, etc., etc. (there are worse forms.)'[3] His fame in England was considerably extended by a large one-man exhibition at the Victoria and Albert Museum in June and July 1915. The 'Etcetera' probably includes Thomas Rodandić and Dujan Pentić, fellow Yugoslavians and sculptors.

*Rev. Meyer* – The Reverend Frederick Brotherton Meyer, minister of Regent's Park Chapel, joint secretary of the National Council of Evangelical Free Churches, publisher of religious books; took a strongly conservative stand on most public issues; preached against Sunday public amusements and the loose life of London's 'smart set.'

*Clan Meynell* – Alice Meynell, poetess (*Collected Poems* 1913) and her husband, Wilfrid Meynell, journalist and editor, were the core of a group of Catholic writers of the 1880s-90s. Others in the 'clan': Everard Meynell, who ran the Serendipity Shop and wrote *The Life of Francis Thompson* (1913); Gerrard Meynell, editor of *Illustration*, a trade paper published by the Sun Engraving Company; Viola Meynell, author of *Alice Meynell: A Memoir* (1929).

*Robertson Nicol* – Sir William Robertson Nicoll, editor of *The Bookman*, a 'despicable paper' according to Pound,[4] and a strong conservative voice in the world of letters.

*Orpen, Etcetera* – (No. 2) Sir William Orpen, portrait and genre painter,

member of the Royal Academy; like Brangwyn (qv), a successful and widely imitated traditionalist.

*Rev. Pennyfeather (Bells)* – The Reverend Prebendary Sommerset Edward Pennefeather, Vicar of Kensington; blasted again in *Blast* No. 2; responsible for the ringing of St Mary Abbots' bells, which so irritated Pound that it led to his questioning the whole basis of Christianity: 'Questionings aroused by the truly filthy racket imposed on denizens of Kensington, W. 8, by a particular parson. It appeared to me impossible that any clean form of teaching cd. lead a man, or group, to cause that damnable and hideous noise and inflict it on helpless humanity in the vicinage.'[5]

*The Post Office* – Perhaps blasted because of problems in distributing *Blast*.

*Mrs. E.A. Rhodes* (No. 2)

*The Roman Empire* – (No. 2) Perhaps blasted for spreading Greco-Roman art and culture at the expense of more 'barbaric' forms.

*Sardlea*

*Mr. Stormberg* – (No. 2) See Mr. Backbeitfeld, above.

*Clan Strachey* – Lady Jane Strachey, essayist, mother of Lytton Strachey, the biographer; along with John St. Loe Strachey (qv), representatives of the 'Bloomsbury' coterie.

*St. Loe Strachey* – John St. Loe Strachey, journalist and editor of the *Spectator*; Pound regarded him as 'the type of male prude, somewhere between Tony Comstock and Henry Van Dyke.'[6]

*Rhabindraneth Tagore* – Rhabindranath Tagore, 'from whose recitations ad infinitum we all suffered from a good deal about that time [1913-14],' said Violet Hunt;[7] and Pound: 'Tagore got the Nobel Prize [in 1913] because, after the cleverest boom of our day, after the fiat of the omnipotent literati of distinction, he lapsed into religion and optimism and was boomed by the pious non-conformists.'[8]

*Clan Thesiger* – The family name of Baron Chelmsford, the Honourable Frederic Ivor Thesiger; others in the family: Captain Bertram Sackville Thesiger, the Honourable Sid Edward Pierson Thesiger, Captain the Honourable Wilfred Gilbert Thesiger, and Ernest Thesiger, a Slade student who became a well-known actor.

*Father Vaughn* – The Reverend Bernard Vaughan, SJ, mission worker in the London slums; writer and popular preacher against the sins of modern society. 'The lovely ladies thronged his church in order to shiver delightedly in their "ill-gotted furs and silks" ... People said it was "as good as a play" ...' wrote Shaw Desmond in *The Edwardian Story* (London 1949) p54. Father Vaughan's reaction to Epstein's Strand statues was reported in the *Evening Standard*: 'As a Christian citizen in a Christian city, I claim the right to say that I object most emphatically to such indecent and inartistic statuary.'[9]

*Countess of Warwick* – Frances Evelyn Greville, wife of the fifth Earl of Warwick; society leader and founder of a college to train the daughters of professional men in horticulture, and a science and technical school in Warwick; called the 'Socialist Countess' for her support of the socialist cause among English nobility.

*Sidney Webb* – Reformer, socialist, writer on social problems; the Vorticists probably shared Georges Sorel's opinion of Webb: 'All that can be put to [Webb's] credit is that he has waded through uninteresting blue-books, and has had the patience to compose an extremely un-

digestible compilation on the history of trade unionism; he has a mind of the narrowest description, which could only impress people unaccustomed to reflection.'[10]

*Weininger* – Otto Weininger, young Austrian genius who published *Geschlecht und Charakter* (*Sex and Character*) in 1903, and in the fall of the same year committed suicide. He tried to distinguish between the essential male and female characteristics, and found that women are unconscious, the object, matter, and that men are conscious, the subject, God. Woman's capacity is for sexual intercourse and childbearing; man's is for thought, self-control, domination. Further, he argued that there is a sexual law of attraction which is inborn and draws 'matching' pairs of males and females together. August Strindberg wrote to Weininger, 'To be able, at last, to see the solution of the problem of woman is a great relief to me. Therefore accept my reverence and my thanks.'[11] Frank Swinnerton writes, 'In those days [reign of George v], the perfect limit of comprehensive psychological knowledge was contained in an extraordinary book by a young German suicide named Otto Weininger.'[12] Weininger was often invoked in support of anti-suffragette sentiments.

222

*Filson Young* – Author of many books, including *Letters from Solitude* (1912), *Opera Stories* (1912), *New Leaves* (1914).

## BLESS

*All A.B.C. Tea-Shops* (Without Exception) – (No. 2) The blessing on Aerated Bread Corporation teashops balances the blasting of Lyons' shops. In *Blast* No. 1, p146, Lewis writes of the ABC: 'With its trivial ornamentation, mirrors, cheap marble tables, silly spacing, etc., it nevertheless suggests a thousand great possibilities for the painter.'

*Lady Aberconway* – An outspoken supporter of liberal causes, including women's suffrage; presided at a meeting of the Liberal Women's Suffrage Union on 9 March 1914.

*Young Ahearn* – A welterweight boxer from Brooklyn; knocked out Private Braddock in the eighth round at the London National Sporting Club, 29 May 1914.

*Alfree* – Probably Geoffrey Allfree, a young painter who exhibited with the Allied Artists in 1914; later became an official war artist with the Navy and was lost at sea in 1918.

*Applegarth* – Probably Robert Applegarth, the grand old man of trade unionism, who celebrated his eightieth birthday in January 1914.

*Barker (John and Granville)* – Like Selfridge (qv), John Barker was synonymous with the modern department store; its founder and president died in 1914. Harley Granville-Barker was sufficiently rebellious and unconventional in his drama, apparently, to please the Vorticists.

*Sir James Matthew Barry* – J.M. Barrie, made a baronet in 1913. The unlikely appearance of the author of *Peter Pan* among the blessed is perhaps explained by the fact that he is immediately preceded in the list by Gilbert Cannan, who was Barrie's wife's lover. Cannan had been Barrie's secretary and was corespondent when Barrie divorced his wife upon whom he settled £300 a year; she continued living with Cannan. According to Sir Compton MacKenzie (*My Life and Times* IV [London 1965] p221), it was widely believed at the time that Barrie had never consummated the marriage, and that the £300 was paid out of Barrie's sense of failure as a husband. For that magnanimity, perhaps, he is blessed by the Vorticists.

*Bearline* – Henry Phillip Bernard Baerlein, according to Violet Hunt, who also says the misspelling was intentional;[13] Baerlein's books include *On the Forgotten Road* (1909), *The Singing Caravan: Some Echoes of Arabian Poetry* (1910), and, probably his best known work, *Mariposa* (1924). In 1914 he published *Abu'l Ala, the Syrian* in the Wisdom of the East Series, to which Cranmer Byng (qv) had contributed *The Lute of Jade* in 1909.

*Colin Bell* – Heavyweight boxer defeated by Bombardier Wells (qv)

*Berrwolf*

*Bottomley* – (No. 2) Probably Horatio Bottomley, well-known journalist, gambler, and MP, who in 1914 was brought to trial on charges of 'contravening the Lotteries Act' through an article in his magazine *John Bull*. Possibly Gordon Bottomley, the Georgian poet and verse dramatist.

*Bridget* – Brigit Patmore, according to Douglas Goldring;[14] she is called 'Maleine' by Violet Hunt in *I Have This to Say*; Pound dedicated *Lustra* (London, 1915) to her under her *nom de plume*, Vail de Lencour.

*Dick Burge* – former light-heavyweight champion; also prizefight promoter; promoted the bout between Gunboat Smith and Charpentier, 16 June 1914.

*Cranmer Byng* – L. Cranmer Byng, 'Closely identified with the literary movement of the early nineties, he published Paul Verlaine's last poems ...' (*Who's Who* 1914) After the nineties, concentrated on Oriental literature; instrumental in introducing Chinese poetry into England; published the *Odes of Confucius*.

*Gilbert Canaan* – Gilbert Cannan, dramatist and drama critic; in 1910, 'Gilbert Cannan, in particular, was demolishing all the older writers ...' said Frank Swinnerton in *The Georgian Literary Scene* (p11). Cannan's novel about Mark Gertler, *Mendel, A Story of Youth* (1917), indicates his close association with London's rebel artists. (See also J.M. Barrie)

*Preb. Carlyle* – The Reverend Wilson Carlile, Prebendary of St Paul's Cathedral; founder and strong supporter of the Church Army.

*Carson* – Sir Edward Carson, leader of the Ulster Volunteers, who, in 1914, were preparing to set up a separate government in Belfast if the Irish Home Rule Bill passed; openly defied parliament, Prime Minister Asquith, and King George by supporting Ulster Unionism.

*Castor Oil* – Blessed, suggests Geoffrey Wagner, because it curbs nature.[15]

*Chaliapine* – Feodor Ivanovich Chaliapin, great star of the Russian Opera; appeared in London in May and June 1914, in *Boris Godounov*, *Ivan the Terrible*, and *Prince Igor*.

*Commercial Process Co.*

*Charlotte Corday* – The assassin of Marat, for which crime she was guillotined 17 July 1793; perhaps a heroine to the Vorticists because she acted out of revolutionary idealism, and with the fervour of the most militant suffragettes of 1914.

*Capt. Craig* – Captain James Craig, lieutenant to Sir Edward Carson (qv); with Carson, represented Ulster in conferences with England and Ireland; became the first prime minister of Northern Ireland, 1921.

*Cromwell* – Perhaps reflects the Vorticist admiration of Strong Men.

*Petty Officer Curran* – An English heavyweight boxer; defeated by Sam Langford in January 1914, and by Jim Savage in May 1914.

*Mrs. Duval*

*Mrs. Wil Finnimore*

*Miss Fowler* – Kate Lechmere suggests this may be a friend who stayed with Miss Lechmere in 1914 and was often the object of teasing by Lewis and his friends.[16]

*Mon. Le Compte de Gabulis*

*Gaby* – Probably Gaby Deslys, popular music hall entertainer.

*W.L. George* – Blessed in No. 1 and blasted in No. 2; highbrow journalist and supporter of new writers in articles for the New York *Bookman*. However, Aldington remarked in a review of George's *The Making of an Englishman*, 'Alas, George, that you are not one of us, who do marvellous things for no remuneration ...'[17]

*Frieder Graham* – Freda Graham, a militant suffragette, whose exploits were often covered by the press; damaged five pictures at the National Gallery, 23 May 1914, and was sentenced to six months imprisonment.

*R.B. Cuningham Grahame (Not His Brother)* – R.B. Cunninghame Graham, writer, aristocrat, and socialist; probably blessed because of the clarity and control of his writing, which so impressed Hudson, Ford, Garnett, and the rest of the Edwardian writers. His brother was Commander Charles Elphinstone Fleeming Cunninghame Graham, groom-in-waiting to the king.

*Graham White* – Claude Grahame-White, an aviator; with Hamel (qv), a leading exponent of aviation in England; specialized in taking important people for flights; appointed temporary flight commander in the Royal Navy, 2 September 1914.

*A.G. Hales* – (No. 2) Writer of poetry, fiction, and non-fiction; journalist and war correspondent.

*Basil Hallam* – Music hall performer; killed in France.

*Hamel* – Gustav Hamel, Swedish aviator 'whose skill and daring have made him Great Britain's leading exponent of aviation,' said the New York *Times* (21 May 1914); gave a 'command performance' of loop-the-loops before King George at Windsor, 2 February 1914; disappeared during a Channel flight, 23 May 1914; his body found by French fishermen, 6 July 1914.

*Frank Harris* – Although closely associated with the 1890s and the Edwardian era, Harris's bombastic personality and his ability to outrage people probably appealed to the Vorticists; also an admirer of Gaudier-Brzeska (see his essay on Gaudier in *Contemporary Portraits*, third series).

*Mrs. Hepburn* – Australian poet living in London; published under her maiden name, Anna Wickham; kept open house for artists and writers; her *The Man With a Hammer* was published in 1916 by Grant Richards.

*Lewis Hind* – Editor of the *Academy* (1896-1903), art critic, author of books on art, including *The Post-Impressionists* (1911) and *Consolations of a Critic* (1911); since he had little sympathy with the more advanced art movements, the Vorticists' blessing may have been intended to pique rather than flatter him.

*George Hirst* – Cricket star famous for his 'swingers.'

*Huber* – Probably a man by that name who owned a row of houses in Charlotte Street, which he let to artists needing studios.

*Hucks* – B.C. Hucks, a noted aviator engaged in races, long distance, and stunt flying; won an airplane race around London, 22 September 1913.

*Jenkins* – Possibly Arthur Jenkins, a painter.

*Jenny*

*James Joyce* – Through Ezra Pound, London's rebel artists learned about

Joyce who was then in Trieste. *A Portrait of the Artist as a Young Man*
began appearing serially in the *Egoist* in February 1914.

*Shirley Kellog* – American music hall artist, appearing at the Hippo-
drome in May 1914; helped popularize American songs, idiom, and
attitudes in popular entertainment.

*Captain Kemp* – Captain Thomas Webster Kemp of the Royal Navy;
made commander of HMS *London* in 1913; in May 1914, brought a libel
suit against the *Fleet*, a nautical magazine, for publishing an article
defaming his character and abilities as a commander; after a widely
publicized trial, Kemp was awarded £3000 damages by the court.

*Captain Kendell* – Probably Captain H.G. Kendall, captain of the
*Empress of Ireland* of the Canadian Pacific steamship line, which was
rammed by a Danish collier and sunk in the St Lawrence River, 29 May
1914. Captain Kendall remained on the bridge as his ship sank, but was
saved; a major figure in the public inquiry into the disaster, but was
apparently not to blame for the collision.

*Konody* – P.G. Konody, art critic for the *Observer* and *Daily Mail*; one
of the few critics sympathetic to the rebel artists and their aims.

*Korin* – (No. 2) Japanese painter of the seventeenth century; his work
determined the style of the 'Korin School' of Japanese art. 'Korin carries
the [national style of Japan] to a climax and extreme, so that in him we
see the distinctive essence of the Japanese genius in final flower.'[18]

*Koyetzu* – (No. 2) A forerunner of Korin (qv) in Japanese art; died
in 1643; his greatest fame came for his work as a lacquerer and calli-
grapher; Fenollosa was the first westerner to recognize his importance
in Japanese art.

*Kate Lechmere* – An obvious subject for blessing because of her support
of the Rebel Art Centre and backing of *Blast*.

*Lefranc* – A picture dealer and frame maker who also sold colours, oils,
and other artists' supplies.

*Lillie Lenton* – Lillian Lenton, militant suffragette; committed several
protest arsons, including the burning of the tea pavillion in Kew
Gardens, 20 February 1913; often jailed and always went on hunger
strikes while in jail; she was on a hunger strike in May 1914.

*Leveridge* – The printer of *Blast*.

*Max Linder* – (No. 2) See 'Max' below.

*Mrs. Belloc Lowdnes* – Mrs Belloc Lowndes, well-known writer of
mystery stories, plays, and novels; published *Told in Gallant Deeds* and
*The End of Her Honeymoon* in 1914; Hilaire Belloc's sister.

*Sir Joseph Lyons* – Chairman of Lyons & Co., extremely wealthy,
created the Lyons shops (qv), which are blasted; was an artist in his
younger years.

*Mrs. MacGaskill* – (No. 2)

*Mr. MacGaskill* – (No. 2)

*Max (Norton, Burgomaster, Linder)* – (No. 2) Max Norton remains
unidentified. Adolphe Max, Burgomaster of Brussels in 1914, became a
popular hero for leading a strong resistance against the Germans at the
beginning of the war. Max Linder was a French comedian and early
film star.

*Gertie Millar* – One of the most famous of the Gaiety Girls, the chorus
girls of the Gaiety Theatre; especially famous for her beautiful eyes.

*George Mozart* – London music hall entertainer.

*Munroe* – Possibly Harold Munro, the proprietor of the Poetry Book-
shop, editor of the *Georgian Poetry* anthologies, *Poetry Review*, and

*Poetry and Drama*; possibly Harriet Monroe, editor of *Poetry* (Chicago).

*Henry Newbolt* – Poet and critic; on Council of the Royal Society of Literature.

*The Poet's Bride (June 28th)* – possibly Vivienne Haigh-Wood, married to T.S. Eliot 26 June 1915.

*The Pope* – Pius X was then pope; on 20 August 1914, he issued a statement denouncing the war.

*Rayner* – According to Kate Lechmere, the solicitor consulted by Lewis and Miss Lechmere when they set up the Rebel Art Centre as a limited company.

*Bandsman Rice* – Heavyweight boxer; defeated by Bombardier Wells (qv) in May 1914 in a fight for the championship of Great Britain.

*Mary Robertson*

*George Robey* – A favourite music hall comedian, with a round, simpering face; created the stage character of the 'impudent-eyed decollete curate.'[19]

226

*Rotatzu* – (No. 2) Probably Sotatzu, a seventeenth-century Japanese painter closely associated with Koyetzu (qv); the two artists often worked together. Sotatzu was also an important innovator in technique and design.

*Frank Rutter* – Curator of the Leeds Art Club, editor of *Art and Letters*, commentator on art in the *New Weekly*, secretary of the Allied Artists' Association, and, like P.G. Konody (qv), a consistent defender of the new and experimental in the arts.

*Salmet* – Chief pilot of Bleriot Flying School at Hendon Airport; during 1914 he gave flying exhibitions for the *Daily Mail* along the Devon and Cornwall coasts.

*Salvation Army* – Along with General Booth, an integral part of Edwardian and Georgian society; held its annual congress in London, June 1914.

*The Scaffolding Around the Albert Memorial* – (No. 2) The scaffolding, erected to protect the Albert Memorial from German bombs, effectively hid from sight that epitome of Victorian public sculpture. The scaffolding is blessed for hiding, not for protecting, the memorial.

*Selfridge* – The first modern department store in London; celebrated its fifth anniversary in March 1914.

*Sievier* – Possibly Robert Standish Siever, sportsman, owner of prize race horses, publisher of the racing paper, the *Winning Post*; his gambling exploits were well known to the public through several widely publicized trials, one of which involved Horatio Bottomley (qv); he also wrote novels and plays.

*Smithers* – Possibly Sir Waldron Smithers, a strong conservative from Kent who called himself the 'last of the real Tories'; or Leonard Smithers, publisher of the *Savoy* and other exotic and erotic works.

*Madame Strindberg* – Frida Uhl Strindberg, August Strindberg's second wife; as the well-known proprietress of the Cave of the Golden Calf and the Cabaret Theatre Club, she was an obvious subject for blessing.

*33 Church Street*

*Marie de Tomaso*

*Tommy*

*Lord Howard De Walden* – Wealthy patron of Gordon Craig and his school for art of the theatre in Florence; also patron of the Poetic Drama Centre, and president of the Contemporary Arts Society; published *The Children of Don* with Joseph Holbrooke (qv).

*Norman Wallis*

*Wilfred Walter* – A Slade student who later became an actor.

*War Babies* – (No. 2) A logical subject for blessing, since birth control is blasted. The London *Times* (18 June 1915) reports that the 'Committee on Illegitimate Births During the War,' chaired by the Archbishop of York, announced that it had found no evidence to indicate that there would be a substantial increase in the number of 'war babies' in England during the war.

*The War Loan* – (No. 2) Based on subscriptions from private individuals and businesses; all economic levels participated and the war loan campaigns were widely propagandized in the press and through government leaflets. The first war loan, November 1914, raised £350,000,000 at 3½%; the second war loan, June 1915, raised £600,000,000 at 4½%.

*Warneford* – (No. 2) Reginald A.J. Warneford, sub-lieutenant and aviator in the Royal Navy; first man to destroy an enemy Zepplin in an air battle (7 June 1915), for which he was awarded the Victoria Cross and the Cross of the Légion d'honneur; killed 17 June 1915, in a plane crash at Buc, France; the day of his burial was a day of national mourning in England.

*Watt*

*Harry Weldon* – One of the earliest players (along with Charlie Chaplin) in Fred Karno's 'Karno's Komics'; a favorite music hall comedian, who specialized in playing anti-heroes and satirizing romantic types.

*Bombardier Wells* – (No. 2) Heavyweight boxing champion of Great Britain; Shaw Desmond remembered 'Bombardier Billy Wells of steel heart and tin jaw fighting 'em off with his pickaxe left ...'[20] Blond, blue-eyed favorite with the public, he defeated Bandsman Rice (qv) in March, Albert Lauric, the French champion, in May, and Colin Bell (qv) in June 1914.

*Martin Wolff* – Minor painter well known in avant-garde circles around 1914.

*Lydia Yavorska* – Madame Lydia Yavorska (Princess Bariatinsky) played Nora in *A Doll's House* in September 1913; took over the Ambassador Theatre for the season of 1913-14 to produce major continental plays in which she played leading roles.

# NOTES

## INTRODUCTION

1 'Introduction' *Wyndham Lewis and Vorticism* p3
2 Roberts 'The Resurrection of Vorticism and the Apotheosis of Wyndham Lewis at the Tate' *Vortex Pamphlets, 1956-1958* np
3 Letter to Gladys Hynes (13 November 1956). The full passage on Vorticism appears in Wees 'Pound's Vorticism: Some New Evidence and Further Comments,' 211-2
4 Letter to the author (1 September 1962)
5 New York *Times* (9 August 1914) section 5, p10
6 Roberts *Abstract and Cubist Paintings and Drawings* p8
7 *The Letters of Wyndham Lewis* p567
8 Tate Gallery *Official Guide* p29
9 Ford *Thus to Revisit* p64
10 Pound 'Status Rerum' 126
11 Pound 'Small Magazines' 692
12 Pound *Gaudier-Brzeska: A Memoir* p81
13 Pound 'Vorticism' [1] 466
14 Lewis 'The Vorticists' 216
15 Ford *Thus To Revisit* p174

## CHAPTER ONE

1 Rutter *Revolution in Art* p1
2 Lewis, Lecture Notes ('About Myself'), Wednesday Club (18 February 1944), Wyndham Lewis Collection, Cornell
3 Lewis 'The Vorticists' 221
4 Read *The Philosophy of Modern Art* p174
5 Pound 'Gaudier-Brzeska' 280
6 Baisch 'London Literary Circles, 1910 to 1920' p66
7 Jepson *Memories of an Edwardian* p131
8 Abercrombie 'Literature' *Edwardian England, A.D. 1901-1910* (London 1933) p187
9 *The Letters of Ezra Pound, 1907-1941* p296
10 Quoted in Cooper *The Courtauld Collection; A Catalogue and Introduction* p36
11 Quoted in Woolf *Roger Fry* p108
12 Bomberg 'The Bomberg Papers' 185
13 Quoted in Mary Woodall, 'Introduction' *The Early Years of the New*

*English Art Club, 1886-1918* 9

14  Read *Philosophy of Modern Art* p174
15  Swinnerton *Background with Chorus* p170
16  New York *Times* (25 May 1919) 13
17  Sitwell *Great Morning!* p235
18  Quoted in Ross *Georgian Revolt, 1910-1922* p3
19  Pound *Affermations VI* 411
20  Bell *Old Friends* p80
21  Quoted in Ross *Georgian Revolt* p16
22  Lewis *Blasting and Bombardiering* pp255-6
23  Ford *Thus to Revisit* p137
24  Sinclair *Tree of Heaven* p240
25  Pound 'The New Sculpture' 68
26  Lewis 'Man of the Week: Marinetti' 329

230  27  Nevinson 'Art and War' p17
28  'The Exhibitors to the Public' (5 February 1912), reprinted in
    Taylor *Futurism* p127
29  'Manifesto dei Pittori Futuristi' (11 February 1910), *Archivi del
    Futurismo* I p64
30  'Futurist Painting; Technical Manifesto' (11 April 1910) Taylor
    *Futurism* p126
31  Dangerfield *Strange Death of Liberal England* pp107-8
32  *Letters of Ezra Pound* p28
33  Sinclair *Tree of Heaven* pp158, 161-2, 233, 163
34  Rose and Isaacs *Contemporary Movements in European Literature*
    p3
35  Dangerfield *Strange Death of Liberal England* p4
36  Woolf *Mr. Bennett and Mrs. Brown* p4
37  Ibid p5
38  Rutter *Revolution in Art* p1
39  Cruse *After the Victorians* p238
40  Petrie *The Edwardians* p231
41  Read *Contemporary British Art* p20
42  Dangerfield *Strange Death of Liberal England* p67
43  Petrie *The Edwardians* p231
44  Fisher *History of Europe* II p1201
45  New York *Times Magazine* (25 May 1919) 13
46  Taylor *Futurism* pp124-5
47  Sinclair *Tree of Heaven* p242
48  Cournos *Autobiography* p274
49  Goldring *Odd Man Out* p127
50  Ford *The Marsden Case* p13
51  'Manifesto' *Blast* (20 June 1914) 33

CHAPTER TWO

1  Quoted in Dangerfield *Strange Death of Liberal England* p84
2  Petrie *The Edwardians* p231
3  Rothenstein *British Art since 1900* p4. Douglas Cooper makes the
   same point and documents it fully in his introduction to *The
   Courtauld Collection*.
4  Quoted in Cooper *Courtauld Collection* p51
5  Ibid p53

6   Quoted in *Art News* II (16 January 1911) 1
7   Letter to C.J. Holmes, quoted in Holmes *Self and Partners* p280
8   MacColl 'A Year of Post-Impressionism' *Confessions of a Keeper* 202 (reprinted from an article in *19th Century* January 1912)
9   'French Post-Impressionists at the Grafton Gallery' 316
10  Ross 'Post-Impressionists at the Grafton' 3
11  Blunt *My Diaries* II pp343-4
12  Bennett 'Post-Impression' 443
13  *Morning Post* (16 November 1910) 5
14  MacCarthy 'The Post-Impressionist Exhibition of 1910' 124
15  Fry 'Retrospect' *Vision and Design* p235
16  Hind *The Post-Impressionists* pp4-5
17  Quoted in Cooper *Courtauld Collection* p53, and Woolf *Roger Fry* pp154-5
18  Burne-Jones 'Post-Impressionism' *Morning Post* (18 November 1910) 10
19  Ricketts 'Post-Impressionism at the Grafton Gallery' *Pages on Art* p151
20  Fry 'Retrospect' *Vision and Design* pp234-5
21  Bell 'How England Met Modern Art' 26-7
22  Rutter *Revolution in Art* pp46-7
23  Nash *Outline* p89
24  Forge *The Slade, 1871-1960* part 2, p20
25  Nash *Outline* p89
26  Cannan *Mendel* p366
27  Rutter *Revolution in Art* pp10-11
28  Holmes *Notes* p11
29  Fry 'Post-Impressionism' 862-3
30  Quoted in Lipke *David Bomberg* p38
31  Hone *The Life of Henry Tonks* p103. George Moore reports the comment in *Conversations in Ebury Street* p171.
32  Forge *The Slade* part 2, p20
33  *Blast* No. 1 (20 June 1914) 11
34  Sadler *Nation* 3 December 1910 406
35  *Art Journal* January 1911 29
36  Richmond *Morning Post* 16 November 1910 5
37  Hind *Morning Post* 17 November 1910 3
38  Woolf *Roger Fry* p189
39  McColl 'A Year of Post-Impressionism' p202
40  Bell 'The English Group' 21
41  Bell *Pot-Boilers* p185
42  Nevinson *Paint and Prejudice* p60
43  Roberts *Abstract and Cubist Paintings and Drawings* p6
44  Rutter 'Extremes of Modern Painting' 313
45  Woolf *Roger Fry* p180
46  Cournos 'The Battle of the Cubes' 214

231

CHAPTER THREE

1   Service *Ballads of a Bohemian* (London 1921) p64
2   Aldington *Life for Life's Sake* pp109-10
3   Ford *Thus to Revisit* p64
4   Roberts 'Wyndham Lewis, the Vorticist' 470

5  'Shocking Art' London *Star* (1914)
6  Ford *No Enemy* p207
7  *Daily Graphic* (23 May 1914)
8  Hamnet *Laughing Torso* p36
9  Nevinson *Paint and Prejudice* p37
10  Ford *Return to Yesterday* pp356-7
11  Ede *Savage Messiah* p247
12  Hall 'Ezra Pound: An Interview' 32
13  Rodker 'The New Movement in Art' 184
14  Lewis *Blasting and Bombardiering* p40
15  Sitwell *Great Morning!* p231
16  Bell *Pot-Boilers* pp249, 251
17  Nevinson *Paint and Prejudice* p58
18  Lewis *Blasting and Bombardiering* p51

232  19  For information about the Omega's 'Art Circles,' I am indebted to
        Miss Winifred Gill, whose vivid memories of the Omega have
        supplied many details presented in this and the following chapter.
    20  Copies of the invitation and press release are in the Wyndham Lewis
        Collection, Cornell.
    21  Pound 'The Curse' *The Apple* I (first quarter 1920) 24
    22  Lewis *Blasting and Bombardiering* p40
    23  Roberts 'Wyndham Lewis, The Vorticist' 470
    24  Letter to Jessie Dismorr (*c*1915) Wyndham Lewis Collection,
        Cornell
    25  Goldring *South Lodge* pp67-8, *Odd Man Out* p120
    26  MacShane *The Life and Work of Ford Madox Ford* p124
    27  Quoted in Rose 'Ezra Pound and Wyndham Lewis, The Crucial
        Years' 77-8
    28  Nevinson *Paint and Prejudice* p85
    29  *Letters of Ezra Pound, 1907-1941* p97
    30  Roberts 'Wyndham Lewis, The Vorticist' 470
    31  Ford *No Enemy* p206
    32  Cournos *Autobiography* p271
    33  Pound *Gaudier-Brzeska: A Memoir* p52
    34  Forrest Read *Pound/Joyce* p31
    35  Jones *The Life and Opinions of T.E. Hulme* p28
    36  Lewis *Blasting and Bombardiering* p281
    37  Interview with Mrs Helen Rowe, who accompanied Lewis
    38  Woddis 'The Café Royal in War Time' 218
    39  Goldring *Reputations: Essays in Criticism* pp138-9
    40  For impressions of Mme Strindberg, as well as information con-
        cerning the Cave of the Golden Calf and Cabaret Club, I am
        indebted to Mrs Spencer Gore, whose husband was directly involved
        in the management of the Cave. The minutes of the meetings of the
        Cave's directors, of whom Gore was one, are in Mrs Gore's
        possession and provide some of the information for the discussion of
        the Cave and Cabaret which follows.
    41  Hunt *I Have This to Say* p114
    42  Lewis *Rude Assignment* p124
    43  John *Chiaroscuro: Fragments of Autobiography* p116
    44  Interview with Mrs Spencer Gore; Lewis reportedly told Kate
        Lechmere about the incident (Lipke 'A History and Analysis of
        Vorticism' p88).
    45  The contract for lending 'Kermesse' to Mme Strindberg is in the

Wyndham Lewis Collection, Cornell. It provides for a three month
rental of £10, and the option to purchase upon payment of another
£20.

46 Woddis 'The Café Royal in War Time' 220
47 *Letters of Wyndham Lewis* p54
48 Letter quoted in Eustace Mullins *This Difficult Individual, Ezra
   Pound* p98
49 Selver *Orage and the New Age Circle* p49
50 Mullins *This Difficult Individual, Ezra Pound* p98
51 *Letters of Wyndham Lewis* p46
52 Interview with Mrs Spencer Gore.
53 Jepson *Memories of an Edwardian* p155
54 Sitwell *Great Morning!* p229
55 Selver *Orage and the New Age Circle* p49
56 Cournos *Autobiography* p276
57 Goldring *Odd Man Out* p127
58 Dangerfield *Strange Death of Liberal England, 1910-1914* p67

## CHAPTER FOUR

1 Baisch 'London Literary Circles, 1910-1920' pp335-6
2 Eddy *Cubists and Post-Impressionists* pp47-8
3 Woddis, 'The Café Royal in War Time' 219-20
4 John *Chiaroscuro: Fragments of Autobiography* p83
5 'Books in General' (4 July 1914)
6 *Exhibition by the Camden Town Group and Others* 'Introduction' p7
7 Wyndham Lewis Collection, Cornell
8 Letter to Lewis (24 October 1913), Wyndham Lewis Collection,
   Cornell
9 'Modern Art and Its Philosophy,' Hulme *Speculations* p94
10 'The Grafton Group,' Hulme *Further Speculations* pp114-15
11 'The London Group,' Hulme *Further Speculations* p129
12 The source of this anecdote and many other details concerning the
   Omega, is Miss Winifred Gill, who was regularly employed at
   the Omega from its inception until the second or third year of the
   war. Supplementing the author's interview with Miss Gill (winter
   1968) are carbon copies of letters written by her to Duncan Grant,
   in which she recounts her experiences at the Omega. The originals
   are now deposited at the Victoria and Albert Museum. Also at the
   V&A is the typescript of a tape recorded interview with Miss Gill,
   which Mr Carol Hogben at the V&A kindly allowed me to read.
13 Letter to Roger Fry (22 May 1914), photocopy in possession of Mr
   Carol Hogben, V&A
14 'Decoration at the Ideal Home Show' 1062
15 Quoted in Holmes *Self and Partners (Mostly Self)* p281
16 Nevinson *Paint and Prejudice* p42
17 *Epstein: An Autobiography* p43
18 Hulme *Further Speculations* p129, *Speculations* p105
19 Hassall *Edward Marsh: Patron of the Arts* p258
20 Bell *Old Friends* pp68, 89
21 Woolf *Beginning Again* p95
22 Letter to Fry (nd), Wyndham Lewis Collection, Cornell
23 Lewis *The Letters of Wyndham Lewis* p53

24 Those clashing opinions continued to reverberate through Virginia Woolf's biography of Fry, *Roger Fry* pp191-4, and Sir John Rothenstein's essay on Lewis, *Modern English Painters* I pp292-3. The arguments were stirred up again by Quentin Bell and Stephen Chaplin, 'The Ideal Home Rumpus' 284-91. See also *Letters of Wyndham Lewis* pp46-53, and Walter Michel 'Tyros and Portraits' 128-33. Michel supports Lewis' contention that Fry continually obstructed Lewis' career. The argument continued in correspondence in *Apollo* (January 1966, p75) from Bell and Chaplin and from Michel.

25 See Lewis' letters to P.G. Konody and Clive Bell, *Letters of Wyndham Lewis* pp52-3, and Fry's letters to Gore printed in Bell and Chaplin 'The Ideal Home Rumpus' 289

26 Letters from Fry to Lewis (31 July 1913) and from Clive Bell to Lewis (nd), both in Wyndham Lewis Collection, Cornell

27 Letter from Lewis to Fry (nd), Wyndham Lewis Collection, Cornell

28 Rose dates this letter August-September 1913, *Letters of Wyndham Lewis* p47

29 Bell and Chaplin 'The Ideal Home Rumpus' 289

30 Letter from Fry to Lewis (10 October 1913), Wyndham Lewis Collection, Cornell

31 Drafts and a final copy of the letter are in the Wyndham Lewis Collection, Cornell. The letter appears in its entirety in Bell and Chaplin 'The Ideal Home Rumpus' 284-5, and *Letters of Wyndham Lewis* pp47-50

32 Rothenstein *Modern English Painters* II p27

33 Bell and Chaplin 'The Ideal Home Rumpus' 290

34 (20 October 1913), Wyndham Lewis Collection, Cornell

35 Quentin Bell and Stephen Chaplin 'Rumpus Revived' *Apollo* LXXXIII (January 1966) 75

36 (13 November 1913), Wyndham Lewis Collection, Cornell

37 (nd), Wyndham Lewis Collection, Cornell. A misleading, pro-Fry interpretation is put on John's views by Bell and Chaplin 'Ideal Home Rumpus' 291

38 (nd), Wyndham Lewis Collection, Cornell

39 Nevinson *Paint and Prejudice* p76

40 Letter from Haldane McFall to Horace Brodzky; Brodzky *Henri Gaudier-Brzeska* p172

41 Hassall *Edward Marsh: Patron of the Arts* p256

42 (22 December 1913), Wyndham Lewis Collection, Cornell

43 (4 February 1914), Lipke 'A History and Analysis of Vorticism' p84

44 Woolf *Roger Fry* p194

45 'Cubist' rather than 'Rebel' appears in a legal document of 25 March 1914 in which Lewis assigned his dividends in the company to Kate Lechmere (Wyndham Lewis Collection, Cornell). Many details concerning the operation and decoration of the Rebel Art Centre are from two interviews with Kate Lechmere (summer 1965).

46 Interview with Kate Lechmere

47 'Rebel Art in Modern Life' 14

48 Hunt *I Have This to Say* pp213-14

49 'Centre For Revolutionary Art: Cubist Pictures and Cubist Curtains' 7

50 'Home of the Cubist Artists at 38, Great Ormond Street' 726

51 Roberts *Abstract and Cubist Paintings and Drawings* p7

52 (nd), Wyndham Lewis Collection, Cornell
53 Two undated prospectuses issued by the Rebel Art Centre, Wyndham
    Lewis Collection, Cornell
54 Rothenstein *Modern English Painters* II p29
55 'The Vorticists' 216, 221
56 Letter to the author (1 September 1962)
57 'Allied Artists Association, Ltd' 228, reprinted in Pound *Gaudier-
    Brzeska: A Memoir* p34
58 Letter to Lewis (19 May 1914), Wyndham Lewis Collection, Cornell
59 Letter to Lewis (24 May 1914), Wyndham Lewis Collection, Cornell
60 Letter from Kate Lechmere to Lewis (nd), Wyndham Lewis
    Collection, Cornell
61 BBC transcript of taperecorded interview with Kate Lechmere (11
    February 1965)
62 Lewis *Blasting and Bombardiering* p35

CHAPTER FIVE

1 *The Letters of Ezra Pound, 1907-1941* p296
2 Hall 'Ezra Pound: An Interview' 34
3 Lewis *Rude Assignment* p122
4 Goldring *South Lodge* p39
5 Ford 'The Poet's Eye' 108
6 Pound 'Mr. Hueffer and the Prose Tradition in English Verse'
    *Poetry* IV (June 1914), reprinted in *Pavannes and Divisions* p137
7 Pound 'This Hulme Business' 15
8 Ford *Thus to Revisit* p58
9 Goldring *South Lodge* p25
10 Ford *Return to Yesterday* pp389-90
11 Jepson *Memories of an Edwardian* p149
12 Ford *No Enemy* p205
13 Goldring *South Lodge* p65
14 Hunt *I Have This to Say* p212
15 Ford *Return to Yesterday* p401
16 Ford *Mightier Than the Sword* p281
17 Ibid p282; see also Ford *Return to Yesterday* p400
18 Ford 'On a Notice of "Blast" ' 143-4
19 Ford *Thus to Revisit* p140
20 Hulme *Further Speculations* p109
21 *Epstein: An Autobiography* p60
22 Hutchins *Ezra Pound's Kensington* p125
23 D.L. Murray, quoted in Jones *The Life and Opinions of T.E. Hulme*
    p93
24 *The Letters of Wyndham Lewis* p63
25 Pound 'This Hulme Business' 15
26 Worringer *Abstraction and Empathy* ppvii-viii
27 Ibid p12
28 Ibid p42
29 Ibid p121
30 Jones *The Life and Opinions of T.E. Hulme* p94; Hulme *Speculations*
    'Foreword' p. viii.
31 Hulme *Speculations* p81
32 Lewis *Blasting and Bombardiering* p106

33 Jones *The Life and Opinions of T.E. Hulme* p116
34 Roberts 'A Reply to My Biographer' *Vortex Pamphlets 1956-1958* (London 1958) p9
35 Hulme *Further Speculations* p113
36 Published under that title in *Speculations* pp75-109
37 Gaudier-Brzeska 'Vortex' *Blast* (20 June 1914) 156
38 'How England met Modern Art' 27
39 Hulme *Speculations* p96
40 Ibid p97
41 Ibid p104
42 Ibid p105
43 Ibid p106
44 Hulme *Further Speculations* p131
45 Hulme *Speculations* p105
46 Ibid p109
47 Jones *The Life and Opinions of T.E. Hulme* p14, quoted from *Criterion* II (7 April 1924) 232
48 Hulme *Further Speculations* p107, editor's note
49 This nearly legendary incident is reported as fact by Jones *The Life and Opinions of T.E. Hulme* p123

236

CHAPTER SIX

1 Pound 'Vorticism' 461
2 *Blast* (20 June 1914) 143
3 *The Letters of Ezra Pound, 1907-1941* p57
4 Unless otherwise indicated, quotations from Futurist manifestos are from Taylor *Futurism* pp124-34. Taylor reprints English translations provided by the Futurists for their exhibitions in England.
5 *Lacerba* (1 August 1914) 236
6 Taylor *Futurism* p100; he reproduces Carrà's collage on p111
7 Ibid p125
8 Ibid p126
9 Ibid p128
10 Ibid p129
11 Severini *The Futurist Painter Severini Exhibits his Latest Works* p3
12 Goldring *South Lodge* p64
13 Marinetti *Marinetti e il Futurismo* p55
14 Marinetti *Le Futurisme* pp22-3, translated by James Joll *Intellectuals in Politics* (London 1960) pp151-2
15 Marinetti *Le Futurisme* p31; my translation
16 Marinetti *Marinetti e il Futurismo* p56; my translation
17 Sickert 'The Futurist "Devil-Among-the-Tailors" ' 147
18 See letters from Max Rothschild to *Pall Mall Gazette* (4 and 6 March 1912), and from Sir Edward Burne-Jones (5 March 1912)
19 Sickert 'The Futurist "Devil-Among-the-Tailors" ' 148-9
20 *Observer* (3 March 1912) 6
21 Letter to Vico Baer, *Archivi del Futurismo* II p41
22 *Daily Chronicle* (4 March 1912) 6
23 *Archivi del Futurismo* I p235
24 Letter to F.B. Pratella, *Archivi del Futurismo* I pp237-8
25 *Archivi del Futurismo* II p42
26 McCullagh *Italy's War for a Desert* pp xii-xiii. Boccioni briefly

mentioned the incident in letter of 15 March 1912, *Archivi del Futurismo* II p42

27 Taylor *Futurism* p134
28 'Marinetti' *Poetry and Drama* I (September 1913) 263
29 Letter to A.H. Walden, *Archivi del Futurismo* I p266
30 Both translations are by Harold Monro, *Poetry Review* I (September 1913) 292, 296
31 *The Letters of Wyndham Lewis* p53
32 Letter to Severini, *Archivi del Futurismo* I p294
33 Newark *Evening News* (17 January 1914)
34 'The New Movement in Art' 186
35 Quoted in Ross *The Georgian Revolt, 1910-1922* p37
36 Monro 'The Origins of Futurism' 389
37 Aldington 'M. Marinetti's Lectures' 226
38 Letter from C.R.W. Nevinson to Lewis (14 November [1913]), Wyndham Lewis Collection, Cornell. A copy of the letter of invitation is in the Wyndham Lewis Collection, Cornell
39 Nevinson *Paint and Prejudice* p77
40 Lewis 'A Man of the Week: Marinetti' 329
41 *Letters of Wyndham Lewis* pp310, 368
42 (19 November [1913]), Wyndham Lewis Collection, Cornell
43 Lewis 'A Man of the Week: Marinetti' 329

CHAPTER SEVEN

1 *Daily Mirror* (6 May 1914)
2 A note from Nevinson to Lewis (nd) says a cheque is enclosed for £1 19s 4d, as Lewis' share of the sum made by Marinetti's lecture at the Doré organized by the ' "Blast" group.' Wyndham Lewis Collection, Cornell.
3 Ross *The Georgian Revolt, 1910-1922* p37
4 Aldington *Life for Life's Sake* p108. The fragment Aldington quotes is from 'A Mon Pégase,' *Le Ville charnelle* (Paris 1908), p169, and appears there in the following form: 'Dieu véhément d'une race d'acier/ Automobile ivre d'espace,/ qui piétine d'angoisse, les mors aux dents stridents!'
5 A copy of the manifesto is in the Wyndham Lewis Collection, Cornell.
6 'Futurist Clothes'
7 The *Sketch* LXXXVI (13 May 1914) 162. Nevinson's brief account of the evening appears in *Paint and Prejudice* p61.
8 'Futurism and Vaudville' 1173
9 Photographs of noise-tuners appear in the *Sketch* (17 June 1914) 324.
10 'The Variety Stage' *Times* (14 June 1914) 20
11 *Times* (16 June 1914) 5
12 Nevinson *Paint and Prejudice* p61
13 'About the Halls' *Sketch* (24 June 1914) 382
14 *Archivi del Futurismo* I p340
15 Rodker *Future of Futurism* p10
16 Nevinson *Modern War: Paintings by C.R.W. Nevinson* p17
17 Nevinson *Paint and Prejudice* p64
18 'Futurist Music' *Pall Mall Gazette* 7

237

19 'Musical Gossip' *Athenaeum* 4510 (4 April 1914) 503
20 'Futurist Music' *Observer* (29 March 1914) 6
21 'Letters from a Town to a Country Woman' (April 1914) 43
22 Hassall *Edward Marsh: Patron of the Arts* p258
23 *English Review* XVI (February 1914) 22; XVI (March 1914) 25
24 *Lacerba* II (15 July 1914) 209-11, printed the manifesto in English
   and Italian; Nevinson reprints it in *Paint and Prejudice* pp58-60;
   Marinetti reprints it in French in I *Manifesti del Futurismo* III
   pp154-61. However, all three sources omit the final paragraph.
25 Wyndham Lewis Collection, Cornell
26 Lewis *Blasting and Bombardiering* p36
27 Interview with author (August 1965)
28 Nevinson *Paint and Prejudice* p61
29 Charles Brookfarmer [pseud. for Carl Bechhöfer], *New Age* (18
   June 1914) 154. Other reports of the evening appear in Lewis
   *Blasting and Bombardiering* p36; Nevinson *Paint and Prejudice* p61;
   Glasgow *Herald* (13 June 1914); Newark *Evening News* (8 August
   1914); Yorkshire *Observer* (15 June 1915); Manchester *Courier*
   (13 June 1914).
30 Lewis *Blasting and Bombardiering* p36
31 The letter, headed 'Futurism' and dated 8 June 1914, appears on
   Rebel Art Centre Stationery in the Wyndham Lewis Collection,
   Cornell. The salutation is 'Dear Sir,' and there is a blank space at
   the end for signatures. The letter as it appeared in the *Observer*,
   with signatures included, is in *The Letters of Wyndham Lewis*
   pp62-3.
32 Lewis *Blasting and Bombardiering* p38
33 Reprinted in the *Egoist* I (1 January 1914) 9
34 'Technical Manifesto of Futurist Sculpture' Taylor *Futurism* p124;
   Read *Speculations* p97
35 *New Weekly* II (20 June 1914) 13
36 Lewis 'Futurism and the Flesh' 49
37 (13 July [1914]), Wyndham Lewis Collection, Cornell
38 Draft of letter of 13 July in Nevinson scrapbooks, Tate Gallery
39 'Futurism,' letter to the editor, *New Weekly* 18
40 [13 June 1914], Wyndham Lewis Collection, Cornell
41 *Archivi del Futurismo* I p340
42 'I Vorticisti sorpassano in audacia I Futuristi,' quoted with accom-
   panying article by Ezra Pound, *Gaudier-Brzeska: A Memoir* pp51-2
43 Newcastle-on-Tyne *Illustrated Chronicle* (22 January 1919)

CHAPTER EIGHT

1 Pound *Gaudier-Brzeska: A Memoir* p44. Unless otherwise indicated,
   information about Pound and Gaudier in the next four paragraphs
   is from this source, pp44-50.
2 Ede *Savage Messiah* p243
3 *The Letters of Ezra Pound, 1907-1941* p27
4 Lewis *Blasting and Bombardiering* pp280-1
5 *The Cantos of Ezra Pound* p85
6 *Letters of Ezra Pound* p74
7 Ibid p52
8 Pound 'Wyndham Lewis' 234

9  *Letters of Ezra Pound* p74
10  Lewis *Blasting and Bombardiering* p277
11  Gaudier-Brzeska 'Allied Artists' Association, Ltd.' 227
12  *The Letters of Wyndham Lewis* pp491-2
13  Lewis *Blasting and Bombardiering* pp114-15
14  Lewis *Rude Assignment* p129
15  *Letters of Wyndham Lewis* p492
16  Reprinted in Pound *Pavannes and Divisions* pp245-6
17  Letter to Gladys Hynes (13 November 1956), published in Wees 'Pound's Vorticism: Some New Evidence and Further Comments' 211
18  Pound 'Vorticism' [1] 471
19  *Letters of Ezra Pound* p27
20  Lewis *Time and Western Man* p41
21  Pound *Pavannes and Divisions* p245
22  *Letters of Ezra Pound* p7
23  Quoted in Guy Deghy and Keith Waterhouse *Café Royal: Ninety Years of Bohemia* (London 1956) p121
24  [T.S. Eliot] *Ezra Pound: His Metric and Poetry* p 19
25  *London Opinion* 22 April 1916
26  Letter to Eustace Mullins, quoted in Mullins *This Difficult Individual, Ezra Pound* p98
27  Jepson *Memories of an Edwardian* p152
28  Russell (ed.) *Ezra Pound: A Collection of Essays* p258
29  Patmore 'Ezra Pound in England' 69
30  Coburn *More Men of Mark* p10
31  Patmore 'Ezra Pound in England' 70
32  Interview with Mrs Helen Rowe (August 1965)
33  Lewis *Time and Western Man* p38
34  Lewis *Blasting and Bombardiering* p278
35  Selver *Orage and the New Age Circle* p36
36  Pound 'Vorticism' [1] 462
37  Cecil Gray *Musical Chairs* (London 1948) p276
38  Goldring *South Lodge* p47
39  Bottome *From the Life* p71
40  Aldington *Life for Life's Sake* p105
41  Hall 'Ezra Pound: An Interview' 36
42  Pound *Ripostes* p58
43  *Letters of Ezra Pound* p6
44  Quoted in Hughes *Imagism and the Imagists* p38
45  *Letters of Ezra Pound* p38
46  Letter to Gladys Hynes (see note 17 above)
47  Pound 'The New Sculpture' 68, 'Wyndham Lewis' 234, 233
48  Pound 'The New Sculpture' 68
49  Quoted in Aldington 'Presentation to Mr. W.S. Blunt' 57
50  *Letters of Ezra Pound* pp23-4
51  Letter to Lewis quoted in Rose 'Ezra Pound and Wyndham Lewis: The Crucial Years' 81
52  *Letters of Ezra Pound* pp23-4
53  Read *Pound/Joyce* p46
54  Pound *Personae* p145
55  Aldington 'Blast' 273
56  *Florence Ayscough and Amy Lowell* ed. Harley Farnsworth MacNair (Chicago 1945) p255

57 Quoted in Coffman *Imagism: A Chapter for the History of Modern Poetry* p21

58 Middleton 'Documents on Imagism from the Papers of F.S. Flint' 42-3

59 Ibid 39

60 Hulme *Further Speculations* 'A Lecture on Modern Poetry' p75

61 Pound 'Vorticism' [1] 462, 464

62 Murray *Between Two Worlds* p225

63 Ede *Savage Messiah* pp233-4

64 Ford *No Enemy* p213

65 BBC 'Vortex Gaudier-Brzeska' p20

66 Harris *Contemporary Portraits* p153; Murray *Between Two Worlds* p224; Pound *Gaudier-Brzeska* p44

67 Quoted in letter to Duncan Grant

68 BBC transcript of tape recorded interview with Horace Brodzky (4 September 1964)

69 Ede *Savage Messiah* pp24, 68, 77-8

70 Quoted in Canaday *Mainstreams of Modern Art* p209

71 Ford *Thus to Revisit* p181

72 Wilenski *The Meaning of Modern Sculpture* p147

73 Ibid p147

74 Pound *Gaudier-Brzeska* p79

75 Wilenski *The Meaning of Modern Sculpture* p91

76 Pound *Gaudier-Brzeska* p80

77 Brodzky *Henri Gaudier-Brzeska, 1891-1915* pp91, 93

78 Quoted by Pound *Gaudier-Brzeska* p18

79 BBC 'Vortex Gaudier-Brzeska' p29

80 Pound *Gaudier-Brzeska* p42

81 Reprinted in ibid p37

82 *Letters of Wyndham Lewis* p44

83 Lewis 'The Vorticists' 216

84 *Letters of Wyndham Lewis* p45; in a footnote on the same page Rose conjectures that the novel was *Tarr*.

85 Ramiro de Maetzu 'Expressionism' *New Age* XIV (27 November 1913) 122, quoted in Lipke, 'A History and Analysis of Vorticism' p243

86 Bell 'The London Salon at the Albert Hall' *Athenaeum* no. 4422 (27 July 1912) 98-9, quoted in Lipke 'A History and Analysis of Vorticism' p243

87 Rutter *Art in My Time* p143

88 (16 October 1913) 12

89 Cournos 'The Battle of the Cubes' 214

90 Bell *Pot-Boilers* p82, from the *Nation* (25 October 1913)

91 Letter to Lewis (*c* November 1913), Wyndham Lewis Collection, Cornell

92 Letter to Pound (12 April 1916), *Letters of Wyndham Lewis* p79

93 Konody 'Art and Artists: The London Group' 7

94 Bell *Pot-Boilers* p229, from *Burlington Magazine* (July 1917)

95 Press cutting of 1914, no day or month given; the same quotation is attributed to the *Daily News and Leader* (6 March 1914) by Malcolm Easton, *Art in Britain, 1890-1940* exhibition catalogue (University of Hull, 27 February-20 March 1967)

96 Pound 'The New Sculpture' 67

97 Hunt *I Have This to Say* p212

98  Lewis *Rude Assignment* p145
99  Ford *Return to Yesterday* pp389-90
100  Felton 'Contemporary Caricatures' 297
101  Lewis *Blasting and Bombardiering* p35
102  Roberts *Abstract and Cubist Paintings and Drawings* p4
103  *Letters of Wyndham Lewis* pp72-3
104  Hassall *Edward Marsh* p258
105  Interview with Mrs Helen Rowe (August 1965). During two interviews, Mrs Rowe provided a number of details about Lewis and his activities of 1914-15. The discussion of Lewis in the following pages draws heavily upon Mrs Rowe's information and insights.
106  Letter to Duncan Grant (29 August 1966)
107  Letter to the author (9 February 1963)
108  Aldington 'Books, Drawings and Papers' 11
109  Interview with Miss Kate Lechmere (August 1965)
110  *Letters of Ezra Pound* p52
111  Lipke *David Bomberg* p36
112  Interview with Mrs Helen Rowe (August 1965)
113  Interview with Mrs Spencer Gore (August 1965)
114  Interview with Miss Kate Lechmere (August 1965)
115  Interview with Mrs Helen Rowe (August 1965)
116  Interview with Mrs Spencer Gore (August 1965)
117  (c1904?), in possession of Mrs Spencer Gore
118  John *Chiaroscuro* p73
119  Roberts 'A Press View at the Tate Gallery' *Vortex Pamphlets, 1956-1958* np
120  Lewis 'The Vorticists' *Vogue* 221
121  Ibid 221
122  Roberts 'Portrait of the Artist' *Art News and Review* 1
123  Letter to Gladys Hynes (see note 17 above)
124  'The Cubist Room' *Exhibition by the Camden Town Group and Others*, reprinted in the *Egoist* I (1 January 1914) 9
125  Hulme 'Mr. Epstein and the Critics' *New Age* XIV (25 December 1913), reprinted in *Further Speculations* p106
126  Ford *Thus to Revisit* p181
127  Epstein *Epstein: An Autobiography* p56
128  Ibid pp59, 43, 199-201
129  Ibid p190
130  Roberts 'Cometism and Vorticism' *Vortex Pamphlets* np
131  Rutter *Revolution in Art* p46
132  Aldington 'Blast' 272
133  Denver 'The London Group' 61
134  Bell 'Contemporary Art in England' (see note 94 above) p230
135  Hulme 'The Grafton Group' *New Age* XIV (15 January 1914), reprinted in *Further Speculations* p115
136  Michel 'Vorticism and the Early Wyndham Lewis' 6
137  Lewis *The Art of Wyndham Lewis* p53
138  Reprinted in Pound *Gaudier-Brzeska* p86n
139  Ede *Savage Messiah* pp163-4

CHAPTER NINE

1  Information in this paragraph is from letters from Nevinson to Lewis

(5 November 1913 to 4 December 1913), Wyndham Lewis Collection, Cornell; and from C.R.W. Nevinson *Paint and Prejudice* p81

2  Wood 'Art Notes' *Colour* I (August 1914) 8
3  Letter of introduction written by H.W. Nevinson for Lewis and Nevinson (nd), Wyndham Lewis Collection, Cornell; letter from T.E. Hulme to Lewis (nd), Wyndham Lewis Collection, Cornell; Goldring *South Lodge* p67
4  Sir John Squire *The Honeysuckle and the Bee* (London 1937) p203
5  Letter from Lewis to Kate Lechmere (1915?), Wyndham Lewis Collection, Cornell; Rothenstein *Modern English Painters* II pp32-3
6  Letter from Edward Wadsworth to Lewis (25 February 1914), Wyndham Lewis Collection, Cornell
7  Nevinson *Paint and Prejudice* p137
8  Letter from Wadsworth to Lewis (17 November 1913), Wyndham Lewis Collection, Cornell

9  'Rebel Art in Modern Life' (7 April 1914) 14
10  Letter from Wadsworth to Lewis (17 November 1913), Wyndham Lewis Collection, Cornell
11  Interview with Mrs Ezra Pound (August 1961)
12  Information on Wadsworth's part in preparing *Blast* comes from letters from Wadsworth to Lewis (4 February 1914, and *c* spring 1914), Wyndham Lewis Collection, Cornell
13  (*c* spring 1914), Wyndham Lewis Collection, Cornell
14  Letter from Dame Rebbecca West to the author (9 February 1963)
15  Goldring *Odd Man Out* p120
16  Dated 29 June 1913, the manifesto was translated into Italian for publication in *Lacerba* (15 September 1913). The French version appears in *Archivi del Futurismo* I pp27-9; the Italian version is in Taylor *Futurism* p141.
17  Read *Pound/Joyce* p26
18  Letter to John Quinn, *Letters of Ezra Pound* p74
19  Hunt *I Have This to Say* p211
20  Advertisement in the *Spectator* 4485 (13 June 1914) 1015
21  Letter from Guido Waldman of The Bodley Head, Ltd, to the author (1 June 1961). No other information concerning *Blast* seems to have survived among the Bodley Head's records.
22  *Letters of Wyndham Lewis* p61

CHAPTER TEN

1  The last two, more imaginative, descriptions are from, respectively, *Poetry* v (October 1914) 44; *Little Review* I (September 1914) 33
2  *The Will to Power* II, quoted in W.T. Jones *A History of Western Philosophy* (New York 1952) p930
3  'Rabindranath Tagore' *New Freewoman* I (1 November 1913) 187
4  Interview with Miss Kate Lechmere (August 1965)
5  Letter from Wadsworth to Lewis (25 February 1914), Wyndham Lewis Collection, Cornell
6  Pound *Culture* pp300-1
7  Announcement in *Second Post-Impressionist Exhibition*
8  Letter from Helen Saunders to the author (1 September 1962)
9  Roberts 'Cometism and Vorticism' *The Vortex Pamphlets, 1956-1958* np

CHAPTER ELEVEN

1 Lewis *Rude Assignment* pp128-9
2 Ibid p129
3 Bennett 'Neo-Impressionism and Literature' (8 December 1910), reprinted in *Books and Persons* p284
4 Although Joseph Frank, in his excellent essay 'Spatial Form in Modern Literature,' discusses Worringer, Hulme, and Pound, he does not consider the place of Lewis in the twentieth century's shift from time-logic to space-logic in literature.
5 Stirner *The Ego and His Own* p312
6 Ibid pp151, 160
7 Ibid p64
8 Ibid p30
9 Pound 'Status Rerum – The Second' 39
10 Pater *The Renaissance* pp129, 132
11 Pound *Gaudier-Brzeska: A Memoir* p144
12 Lewis *Wyndham Lewis the Artist* p78
13 Ibid p80

CHAPTER TWELVE

1 'Blast' *Pall Mall Gazette* (1 July 1914)
2 'Vorticism the Latest Cult of Rebel Artists,' New York *Times* (9 August 1914) section 5, p10
3 Phillips 'Views and Reviews' 48
4 Quoted in *Blast* No. 2 (July 1915) 104
5 Eagle 'Books in General' *New Statesman* 406
6 'Chronicles' *Blast* No. 2, 85
7 Konody 'Art and Artists: "Blast" '
8 Tietjens 'Blast' 33-4
9 Scott-James 'Blast' 88
10 Pound *Gaudier-Brzeska: A Memoir* p107
11 Lewis *Rude Assignment* p125
12 Letter to Lord Carlow, quoted in Norman *Ezra Pound* p150
13 Ford 'On a Notice of "Blast" ' 143-4
14 Aldington 'Blast' 272-3
15 Ibid 35
16 Jepson *Memoirs* p172
17 *Poetry* v (October 1914) 44; Hunt *I Have This to Say* p115
18 *Blasting and Bombardiering* p51
19 Aldington 'Blast' 272
20 Letter from Gordon Bottomley to Paul Nash (2 October 1914), Bottomley *Poet and Painter* p75
21 Lewis *Letters of Wyndham Lewis* p67
22 Ibid p69. Other sources of information for this paragraph are Sir John Rothenstein *Modern English Painters* II pp32-3; letters from Kate Lechmere to Wyndham Lewis, 23 and 26 July 1914 (Wyndham Lewis Collection, Cornell); interview with Kate Lechmere, August 1965
23 Pound *Instigations* p221
24 Kenner *Wyndham Lewis* p32
25 Lewis 'Tarr' 72
26 Lewis *Letters of Wyndham Lewis* p552

27 Lewis *Rude Assignment* p129
28 Lewis *Letters of Wyndham Lewis* pp66-7
29 Baker 'Dry Bones'
30 Denver 'The London Group' 60
31 'Vorticists and Others'
32 'Vorticist Exhibition at the Doré Galleries'
33 *Colour* II (April 1915) 80
34 *Letters of Ezra Pound, 1907-1941* p74
35 Read *Pound/Joyce* p5
36 Marquis 'The First Intelligent Answer' 166
37 Pound *Vortographs and Paintings*
38 *Letters of Ezra Pound* pp104-5
39 Ibid p112
40 Pound 'Death of Vorticism' 45-51 passim
41 Pound 'Durability and De Bosschère's Presentation' 125
42 Pound *Gaudier-Brzeska* p126
43 Ibid pp120-1
44 Fenollosa *The Chinese Written Character as a Medium for Poetry* pp33, 12
45 Letter from Pound to Lewis (nd), Wyndham Lewis Collection, Cornell
46 Lewis *The Caliph's Design* p14
47 Lewis *Rude Assignment* p129, Lewis' italics
48 Lewis 'What Art Now?' 338
49 Lewis 'Group x' 4
50 Lewis 'Plain Home-builder: Where is your Vorticist?' 156
51 Lewis *Rude Assignment* p125
52 Pound *ABC of Reading* p76
53 Pound *Culture* p95
54 Pound *If This Be Treason* pp29, 31

## APPENDIX B

1 Goldring *South Lodge* p68
2 Reported in the *New Weekly* I (16 May 1914) 264
3 Pound *Gaudier-Brzeska: A Memoir* p124
4 Pound *Instigations* p222
5 Pound *Culture* p300
6 *Letters of Ezra Pound, 1907-1941* p21
7 Hunt *I Have This to Say* p115
8 *Letters of Ezra Pound* p106
9 Quoted in Jones *The Life and Opinions of T.E. Hulme* p144
10 Sorel *Reflections on Violence* p132
11 Quoted in David Abrahamsen *The Mind and Death of a Genius* (New York 1946) p122
12 Swinnerton *The Georgian Literary Scene* p283
13 Hunt *I Have This to Say* p215
14 Goldring *South Lodge* p68
15 Wagner *Wyndham Lewis* p146
16 Interview with Kate Lechmere, August 1965
17 Aldington *Egoist* I (2 February 1914) 49
18 Laurence Binyon *Painting in the Far East* (New York 1959) p218
19 M. Wilson Disher *Music Hall Parade* (New York 1938) p122
20 Desmond *The Edwardian Story* p54

# BIBLIOGRAPHY

Books, Pamphlets, Exhibition Catalogues, Brochures, Films

*Abstract Art in England 1913-1915* [exhibition catalogue] introduction
Anthony d'Offay. London, d'Offay Couper Gallery 1969
ALDINGTON, RICHARD *Life for Life's Sake* New York 1941
ANDERSON, MARGARET *My Thirty Years' War* New York 1930
APOLLINAIRE, GUILLAUME *The Cubist Painters: Aesthetic Meditations,
1913* translation Lionel Abel. New York 1944
– *Calligrammes: Poèmes de la paix et de la guerre, 1913-1916* Paris nd
*Archivi del Futurismo* raccolti e ordinati de Maria Drudi Gambillo e
Teresa Fiori. 2 vols. Rome 1958-62
*Art in Britain, 1890-1940* [exhibition catalogue] appendix Malcolm
Easton. University of Hull 1967

BELL, CLIVE *Pot-Boilers* London 1918
– *Old Friends* London 1956
BENNETT, ARNOLD *Books and Persons* London 1917
BINYON, LAURENCE *The Flight of the Dragon* New York 1961
BLUNT, WILFRID SCAWEN *My Diaries* I-II London 1919-20
BOCCIONI, UMBERTO *Pittura Scultura Futuriste (Dinamismo Plastico)*
Milano 1914
BOMBERG, DAVID *Works by David Bomberg* [exhibition catalogue]
London, Chenil Gallery 1914
– *David Bomberg* [exhibition catalogue] introduction Andrew Forge.
Arts Council of Great Britain 1958
– *David Bomberg 1890-1957* [exhibition catalogue] introduction
David Sylvester. London, Marlborough Gallery 1964
BOSSCHÈRE, JEAN DE *The Closed Door* translation F.S. Flint. London
1917
BOTTOME, PHYLLIS *From the Life* London nd
BOTTOMLEY, GORDON *Poet and Painter: Being the Correspondence
between Gordon Bottomley and Paul Nash, 1910-1946* editors Claude
Colleer Abbot and Anthony Bertram. London 1955
BOWEN, STELLA *Drawn from Life* London nd
BRODZKY, HORACE *Henri Gaudier-Brzeska 1891-1915* London 1933
BROWSE, LILLIAN (ed.) *Sickert* London 1943
BUCKLE, RICHARD *Jacob Epstein, Sculptor* London 1963

CANADAY, JOHN *Mainstreams of Modern Art* New York 1959
CANNAN, GILBERT *Mendel: A Story of Youth* New York 1917

CANTRILL, ARTHUR *Henri Gaudier-Brzeska* London, Firebird Films 1968 [16 mm colour/sound film, 30 min, Produced by Corinne Cantrill; written, directed, photographed, edited by Arthur Cantrill]

CASSON, STANLEY *Some Modern Sculptors* London 1928

CAVE OF THE GOLDEN CALF *Preliminary Prospectus (Cabaret Theatre Club)* London, April 1912

– *Cabaret Theatre Club* [illus. pamphlet] London, May 1912

CLOUGH, ROSA TRILLO *Futurism: The Story of a Modern Movement* New York 1961

COBURN, ALVIN LANGDON *Vortographs and Paintings* [exhibition catalogue] introduction Ezra Pound. London, Camera Club 1917

– *More Men of Mark* London 1922

– *Alvin Langdon Coburn, Photographer: An Autobiography* London 1966

COFFMAN, STANLEY K., JR *Imagism: A Chapter for the History of Modern Poetry* Norman 1951

COOKE, E. WAKE *Anarchism in Art and Chaos in Criticism* London 1904

– *Retrogression in Art* London 1924

COOPER, DOUGLAS *The Courtauld Collection: A Catalogue and Introduction* London 1954

COURNOS, JOHN *Autobiography* New York 1935

CRUSE, AMY *After the Victorians* London 1938

DANGERFIELD, GEORGE *The Strange Death of Liberal England 1910-1914* New York, Capricorn Books 1961

DAVIOT, GORDON *The Laughing Woman* London 1934

*Decade 1910-1920* [exhibition catalogue] introduction and notes Alan Bowness. Arts Council of Great Britain 1965

DESMOND, SHAW *The Edwardian Story* London 1949

*The Early Years of the New English Art Club, 1886-1918* [exhibition catalogue] introduction Mary Woodall. Birmingham Museum and Art Gallery 1952

EDDY, ARTHUR JEROME *Cubists and Post-Impressionists* Chicago 1914

EDE, H.S. *Savage Messiah, Gaudier-Brzeska* New York 1931

ELIOT, T.S. *Ezra Pound: His Metric and Poetry* New York 1917

ELLMANN, RICHARD (ed.) *Edwardians and Late-Victorians* New York 1960

EMMONS, ROBERT *The Life and Opinions of Walter Richard Sickert* London 1941

EPSTEIN, JACOB *The Sculptor Speaks* New York 1932

– *Epstein: An Autobiography* New York 1955

– *Epstein Drawings* New York 1962

*Exhibition by the Camden Town Group and Others* [exhibition catalogue] Brighton Public Art Galleries 1913-14

*Exhibition of Furniture, Textiles and Pottery Made at the Omega Workshops 1913-1918* [exhibition catalogue] Arts Council of Great Britain 1946

*Exhibition of Works by Members of the Cumberland Market Group* [exhibition catalogue] London, Goupil Gallery 1915

*Exhibition of Works by the Italian Futurist Painters* [exhibition catalogue] London, Sackville Gallery 1912

*Exhibition of the Works of the Italian Futurist Painters and Sculptors* [exhibition catalogue] London, Doré Gallery 1914

FENOLLOSA, ERNEST *The Chinese Written Character as a Medium for
  Poetry* New York 1936
*The First Exhibition of the Camden Town Group* [exhibition catalogue]
  London, Carfax Gallery 1911
FISHER, H.A.L. *A History of Europe* 2 vols, London 1960
FLETCHER, JOHN GOULD *Life Is My Song* New York 1937
FORD, FORD MADOX *Thus to Revisit* London 1921
– *The Marsden Case* London 1923
– *No Enemy* New York 1929
– *Return to Yesterday* New York 1932
– *It Was the Nightingale* London 1934
– *Mightier Than the Sword* London 1938
– *The Letters of Ford Madox Ford* ed. Richard M. Ludwig. Princeton
  1965
FORGE, ANDREW *The Slade, 1871-1960* London nd
FRASER, G.S. *Ezra Pound* New York 1961
FRY, ROGER *Vision and Design* New York 1947
– *Transformations* New York 1956

GAUDIER-BRZESKA, HENRI *Twenty Drawings from the Note-books of
  H. Gaudier-Brzeska* London 1919
– *Gaudier-Brzeska Drawings* introduction Horace Brodzky. London
  1946
– *Gaudier-Brzeska* introduction Mervyn Levy. London 1965
GIEDION, SIEGFRIED *Space, Time and Architecture* Cambridge, Mass.
  1947
GOLDRING, DOUGLAS *Reputations: Essays in Criticism* New York 1920
– *Odd Man Out: The Autobiography of a 'Propaganda Novelist'*
  London 1936
– *South Lodge: Reminiscences of Violet Hunt, Ford Madox Ford and
  the English Review Circle* London 1943
GOLDWATER, ROBERT, and MARCO TREVERS (eds.) *Artists on Art* New
  York 1947
*The Grafton Group: Vanessa Bell, Roger Fry, Duncan Grant, Second
  Exhibition* [exhibition catalogue] London, Alpine Club Gallery 1914
GRAY, CHRISTOPHER *Cubist Aesthetic Theories* Baltimore 1953
*Group X* [exhibition catalogue] London, Mansard Gallery 1920

HAMNET, NINA *Laughing Torso* New York 1932
HARRIS, FRANK *Contemporary Portraits* third series New York nd
HASSALL, CHRISTOPHER *Edward Marsh, Patron of the Arts* London 1959
HASTINGS, BEATRICE *The Old 'New Age,' Orage – and Others* London
  1936
HEARNSHAW, F.S.C. (ed.) *Edwardian England, A.D. 1901-1910* London
  1933
HIND, C. LEWIS *The Post-Impressionists* London 1911
HOFFMAN, FREDERICK J., CHARLES ALLEN, and CAROLYN F. ULRICH
  *The Little Magazine: A History and Bibliography* Princeton 1946
HOLLOWAY, JOHN *The Charted Mirror* London 1960
HOLMES, C.J. *Notes on the Post-Impressionist Painters* London 1910
– *Self and Partners (Mostly Self)* London 1936
HONE, JOSEPH *The Life of Henry Tonks* London 1939
HOUGH, GRAHAM *Reflections on a Literary Revolution* Washington 1960
HUGHES, GLENN *Imagism and the Imagists* New York 1960

HULME, T.E. *Speculations: Essays on Humanism and the Philosophy of Art* edited Herbert Read. London 1936
– *Further Speculations* edited Sam Hynes. Minneapolis 1955
HUNT, VIOLET *I Have This to Say: The Story of My Flurried Years* New York 1926
HUTCHINS, PATRICIA *Ezra Pound's Kensington: An Exploration, 1885-1913* London 1965
HYNES, SAMUEL *The Edwardian Turn of Mind* Princeton 1968

ISAACS, J. 'England' *Contemporary Movements in European History* New York 1929
– *An Assessment of Twentieth-Century Literature* London 1951

JEPSON, EDGAR *Memories of an Edwardian* London 1938
JOHN, AUGUSTUS *Chiaroscuro: Fragments of Autobiography* London 1952
JOHNSON, PHILIP *Machine Art* New York 1934
JONES, ALUN R. *The Life and Opinions of T.E. Hulme* London 1960

KANDINSKY, WASSILY *On the Spiritual in Art* edited Hilla Rebay. New York 1946
KENNER, HUGH *The Poetry of Ezra Pound* London 1951
– *Wyndham Lewis* London 1954
KERMODE, FRANK *Romantic Image* London 1961

LAVER, JAMES *Portraits in Oil and Vinegar* London 1925
LESLIE, SHANE *The End of a Chapter* New York 1916
LEWIS, WYNDHAM *The Caliph's Design: Architects! Where is Your Vortex?* London 1919
– *Time and Western Man* New York 1928
– *The Enemy of the Stars* London 1932
– *Blasting and Bombardiering* London 1937
– *Wyndham Lewis the Artist: From 'Blast' to Burlington House* London 1939
– *Wyndham Lewis* [exhibition catalogue] foreword Michael Ayrton. London, Redfern Gallery 1949
– *The Art of Wyndham Lewis* edited Charles Handley-Read. London 1951
– *Rude Assignment* London 1951
– *The Letters of Wyndham Lewis* edited W.K. Rose. London 1963
– *Wyndham Lewis on Art: Collected Essays, 1913-1956* edited Walter Michel and C.J. Fox. New York 1969
– and LOUIS F. FERGUSSON *Harold Gilman: An Appreciation* London 1919
LIPKE, WILLIAM *David Bomberg: A Critical Study of His Life and Work* London 1967
*The London Group* [exhibition catalogues] London, Goupil Gallery 1914, 1915
*London Group* [exhibition catalogue] note Dennis Farr and Alan Bowness. London, Tate Gallery 1969

MACCOLL, D.S. *Confessions of a Keeper* London 1931
MCCULLAGH, FRANCIS *Italy's War for a Desert* London 1912
MACFALL, HALDANE *The 'Nut' in War* London 1914

MCLUHAN, MARSHALL *Counterblast* Toronto 1969
MacSHANE, FRANK *The Life and Work of Ford Madox Ford* London 1965
*Manet and the Post-Impressionists* [exhibition catalogue] London, Grafton Galleries 1910
MARINETTI, F.T. *Le Futurisme* Paris 1911
− *I Manifesti del Futurismo* Firenze 1914
− *Zang Tumb Tuum Adrianopoli Ottobre 1912* Milano 1914
− *I Nuovi Poeti Futuristi* Rome 1925
− *Marinetti e il Futurismo* Rome/Milan 1929
MARSH, EDWARD *A Number of People* London 1939
MARTIN, WALLACE *The New Age Under Orage* Manchester 1967
MAUROIS, ANDRÉ *The Edwardian Era* New York 1933
MEINER, JOHN A. *Ford Madox Ford's Novels: A Critical Study* Minneapolis 1962
MICHEL, WALTER *Wyndham Lewis: Paintings and Drawings* London 1971
MONROE, HARRIET *A Poet's Life: Seventy Years in a Changing World* New York 1938
MOORE, GEORGE *Conversations in Ebury Street* London 1924
MORPHET, RICHARD *British Painting 1910-1945* London 1967
MULLINS, EUSTACE *This Difficult Individual, Ezra Pound* New York 1961
MURRY, JOHN MIDDLETON *Between Two Worlds: An Autobiography* London 1935

NASH, PAUL *Outline: An Autobiography and Other Writings* London 1944
NEVINSON, C.R.W. *Modern War: Paintings by C.R.W. Nevinson* London 1917
− *British Artists at the Front* part 1, introduction C. Dodgson and C.E. Montague. London 1918
− *The Great War: Fourth Year* introduction J.E.C. Flitch. London 1918
− *Paint and Prejudice* New York 1938
− *Memorial Exhibition of pictures by C.R.W. Nevinson* [exhibition catalogue] introduction Osbert Sitwell. London, Leicester Galleries 1947
NORMAN, CHARLES *Ezra Pound* New York 1960

*Omega Workshops, Ltd* [pamphlet] London c1914
ORAGE, A.R. *Readers and Writers, 1917-1921.* London 1922

PATER, WALTER *The Renaissance* London 1914
PETRIE, SIR CHARLES *The Edwardians* New York 1965
PORTEUS, HUGH GORDON *Wyndham Lewis: A Discursive Exposition* London 1932
*Post-Impressionist and Futurist Exhibition* [exhibition catalogue] foreword Frank Rutter London, Doré Galleries 1913
POUND, EZRA *Ripostes* London 1912
− *Pavannes and Divisions* New York 1918
− *Instigations* New York 1920
− *Personae* London 1926
− *Profile: An Anthology Collected in MCMXXXI* Milan 1932
− *Culture* Norfolk, Conn. 1938
− *If This Be Treason* Chicago 1948

– *The Letters of Ezra Pound, 1907-1941* edited D.D. Paige. New York 1950
– *Gaudier-Brzeska: A Memoir* New York 1960
– *Impact: Essays on Ignorance and the Decline of American Civilization* Chicago 1960
– *The Cantos (1-95)* New York 1965

READ, FORREST *Pound/Joyce* New York 1966
READ, HERBERT *The Philosophy of Modern Art* New York 1953
– *Contemporary British Art* London 1964
REBEL ART CENTRE *Prospectus* London 1914
– *Prospectus: The Art School* London 1914
RICKETTS, CHARLES *Pages on Art* London 1913
ROBERTS, MICHAEL *T.E. Hulme* London 1938
ROBERTS, WILLIAM *Abstract and Cubist Paintings and Drawings* London nd
– *The Vortex Pamphlets, 1956-1958* London 1958
– *Paintings, 1917-1958* London 1960
– *William Roberts, ARA: Retrospective Exhibition* [exhibition catalogue] introduction Ronald Alley. Arts Council of Great Britain 1965
– *Drawings and Watercolours, 1915-1968* [exhibition catalogue] London, d'Offay Couper Gallery 1969
RODKER, JOHN *The Future of Futurism* London nd
ROSE, WILLIAM and J. ISAACS (eds.) *Contemporary Movements in European Literature* London 1928
ROSS, ROBERT *The Georgian Revolt, 1910-1922* Carbondale and Edwardsville 1965
ROTHENSTEIN, JOHN *Modern English Painters* 2 vols London 1952-6
– *British Art since 1900* Greenwich, Conn. 1962
RUSSELL, PETER (ed.) *Ezra Pound: A Collection of Essays ...* London 1950
RUTTER, FRANK *Revolution in Art* London 1910
– *Some Contemporary Painters* London 1922
– *Evolution in Modern Art: A Study in Modern Painting, 1870-1925* London 1926
– *Art in My Time* London 1933

SADLER, MICHAEL ERNEST *Modern Art and Revolution* Day to Day Pamphlets, 13. London 1932
SADLIER, M. *Michael Ernest Sadler* London 1949
*The Second Exhibition of the Camden Town Group* [exhibition catalogue] London, Carfax Gallery 1911
*Second Post-Impressionist Exhibition* [exhibition catalogue] London, Grafton Galleries 1912
SELVER, PAUL *Orage and the New Age Circle* London 1959
SEVERINI, GINO *The Futurist Painter Severini Exhibits His Latest Work* [exhibition catalogue] London, Marlborough Gallery 1913
SHATTUCK, ROGER *The Banquet Years: The Arts in France, 1885-1918* New York 1958
SHIPP, HORACE *The New Art* London 1922
SINCLAIR, MAY *The Tree of Heaven* New York 1917
SITWELL, OSBERT *C.R.W. Nevinson* London 1925
– *Great Morning!* Boston 1947

SOBY, JAMES THRALL and ALFRED H. BARR, JR *Twentieth-Century Italian Art* New York 1949

SOREL, GEORGE *Reflections on Violence* translation T.E. Hulme and J. Roth, introduction Edward A. Shils. Glencoe, Ill. 1950

STIRNER, MAX [Johann Kasper Schmidt] *The Ego and His Own* translation S.T. Byington. New York nd

STOCK, NOEL *Poet in Exile: Ezra Pound* Manchester 1964

SWINNERTON, FRANK *The Georgian Literary Scene* London 1938

– *Background with Chorus* New York 1956

TATE GALLERY *Official Guide to the Tate Gallery* London 1967

TAYLOR, JOSHUA C. *Futurism* New York, Museum of Modern Art 1961

THORNTON, ALFRED *Fifty Years of the New English Art Club, 1886- 1935* London 1935

*Twentieth Century Art, A Review of Modern Movements* [exhibition catalogue] London, Whitechapel Gallery 1914

VAN DIEREN, BERNARD *Epstein* London/New York 1920

*Vorticist Exhibition* [exhibition catalogue] London, Doré Galleries 1915

WAGNER, GEOFFREY *Wyndham Lewis: A Portrait of the Artist as the Enemy* New Haven 1957

WHITTEMORE, REED *Little Magazines* University of Minnesota Pamphlets on American Writers, 32. Minneapolis 1963

WILENSKI, R.H. *The Meaning of Modern Sculpture* Boston 1961

WILEY, PAUL L. *Novelist of Three Worlds: Ford Madox Ford* Syracuse 1962

WILLIAMS, WILLIAM CARLOS *The Autobiography of William Carlos Williams* New York 1951

WOOLF, LEONARD *Beginning Again* New York 1964

WOOLF, VIRGINIA *Mr. Bennett and Mrs. Brown* London 1924

– *Roger Fry* London 1940

WORRINGER, WILHELM *Abstraction and Empathy: A Contribution to the Psychology of Style* translation Michael Bullock New York 1955

*Wyndham Lewis and Vorticism* [exhibition catalogue] London, Tate Gallery 1956

## Essays in Books; Articles, Photographs, and Drawings in Newspapers and Magazines

The absence of a page number indicates an article that was read as a press cutting for which no page number was given. When articles on Roger Fry's first Post-Impressionist exhibition (abbreviated P-I), and on Futurism, Vorticism, and *Blast* do not reveal their subjects in their titles, the subject is indicated in brackets. Unless otherwise identified, newspapers are published in London. Contributions to *Blast* may be found in Appendix A. A complete list of Ezra Pound's books and contributions to periodicals appears in Donald Gallup, *A Bibliography of Ezra Pound* (London 1963).

A.O. 'Wyndham Lewis and the Vorticists' *Art Review* I (July 1922) 13, 29

E.S.G. 'The Newest Art' [P-I] *Daily Graphic* (9 Nov. 1910) 12
– 'The Art of M. Flandrin' [P-I] *Daily Graphic* (12 Nov. 1910) 4
– 'Art Old and New' [P-I] *Daily Graphic* (10 Dec. 1910) 10
– 'Is It Art? – The Foibles of Futurism' *Daily Graphic* (9 March 1912)
    339
G.R.H. 'The Revolt in Painting' [P-I] *Pall Mall Gazette* (7 Nov. 1910) 1
– 'Gallery and Studio: Mr. Bomberg's Futurist Bombshell' *Pall Mall
    Gazette* (25 June 1914)

ALDINGTON, RICHARD 'M. Marinetti's Lectures' *New Freewoman* I
    (1 Dec. 1913) 226
– 'Books, Drawings, and Papers' *Egoist* I (1 Jan. 1914) 11-12
– 'Anti-Helenism' *Egoist* I (15 Jan. 1914) 35-6
– 'Presentation to Mr. W.S. Blunt' *Egoist* I (2 Feb. 1914) 56-7
– 'Blast' *Egoist* I (15 July 1914) 272-3
– 'Free Verse in England' *Egoist* I (15 Sept. 1914) 351-2
– 'The Poetry of Ezra Pound' *Egoist* II (1 May 1915) 72
– 'Periodical Not Received' [*Blast* no. 2] *Egoist* II (2 August 1915) 132
ALLEN, WALTER 'Lonely Old Volcano ...' *Encounter* XXI (Sept. 1963)
    63-70
'Allied Artists' Association at Holland Park Hall' *Athenaeum* 4521
    (20 June 1914) 859-60
ALLOWAY, LAWRENCE 'Revolutionary Front' *Art News* LV 4 (1956) 64-5
'Are Futurists Mad?' Newcastle-on-Tyne *Illustrated Chronicle* (22 Jan.
    1914)
'Art and Artists' *Observer* (21 June 1914)
'Art and Practice' *Edinburgh Review* (April 1910) 365-88
*Art Journal* (Feb. 1911) 60
'The Art of Group X' *Daily Graphic* (25 March 1920)
'Art of Yester-Year' [*Blast* no. 2] *Daily Graphic* (31 July 1915)
'Art That Alarms' [Futurism]*Daily Mirror* (4 March 1912) 5
'Art Which Makes for Emotion' *Literary Digest* LIII (1916) 1406
'Artists of the Future: Weird Paintings Exhibited in Paris' *Daily Mirror*
    (7 Feb. 1912) 11
'At the Varieties' [Futurism] *Daily Graphic* (17 June 1914) 16
AYRTON, MICHAEL 'The Stone Guest' *New Statesman and Nation* LII
    (21 July 1956) 68

BAKER, C.H. COLLINS 'Dry Bones' [Vorticism] *Saturday Review* (20
    March 1915)
BELL, CLIVE 'The English Group' *Second Post-Impressionist Exhibition*
    [exhibition catalogue] London, Grafton Galleries 1912
– 'How England Met Modern Art' *Art News* XLIX (Oct. 1950) 24-7, 61
BELL, QUENTIN and STEPHEN CHAPLIN 'The Ideal Home Rumpus'
    *Apollo* LXXX (Oct. 1964) 284-91
BENNETT, ARNOLD 'Post-Impressionism' [letter] *Nation* VIII (10 Dec.
    1910) 443
*Blast*, no. 1 and 2 (1914, 1915)
'Blast!' *Pall Mall Gazette* (1 July 1914) 7
'Blast' *Sunday Times Magazine* (8 Jan. 1967) 20-1
BOCCIONI, UMBERTO 'La Sculpture Futuriste' *Tripod* 5 (Nov. 1912)
    20-30
'Bombelewis, Marionetti' 'New Art Movement' [letter] *Observer* (5 July
    1914)

BOMBERG, DAVID 'The Bomberg Papers' *X: A Quarterly Review* I (June
    1960) 183-90

BRIDSON, D.G. 'An Interview with Ezra Pound' *New Directions* 17
    (1961) 159-84

BROCK, A. CLUTTON 'The Post-Impressionists' *Burlington Magazine*
    XVIII (Jan. 1911) 216-19

BRODZKY, HORACE 'Gossip from New York' *Colour* VI (Feb., March,
    July 1917) 25, 57-8, 169

BROOKFARMER, CHARLES [Bechhoffer Roberts] 'Futile-ism' *New Age*
    (18 June 1914) 154

BUCCIOLLINI, GIULIO 'Primavera Italica: I Futuristi Si Fanno Onore'
    *La Nazione* (16 Marzo 1912) 3

BURNE-JONES, PHILIP 'Post-Impressionism' [letters] *Morning Post* (17,
    18, 19 Nov. 1910) 3, 10, 4

– 'Sir Philip Burne-Jones and the Futurists' [letters] *Pall Mall Gazette*    253
    5 and 7 March 1912) 4, 4

BURR, JAMES 'The Neglected British Léger' *Apollo* LXXXII (Dec. 1965)
    510, 511

CARTER, HUNTLEY 'Blaspheming Creation' *New Freewoman* I (1 Dec.
    1913) 238-9

CARY, JOSEPH 'Futurism and the French Théâtre d'avant-garde' *Modern
    Philology* LVII (Nov. 1959) 113-21

'Centre for Revolutionary Art' *Daily Mirror* (30 March 1914) 7

CHESTERTON, G.K. 'The Asceticism of the Futurists' *T.P.'s Weekly* XXIV
    (4 July 1914) 5-6

– 'English Tests of Futurism' *Literary Digest* XLIX (1914) 192-3

COBURN, ALVIN LANGDON 'Modern Photography' *Colour* I (Nov. 1914)
    158

COOK, E. WAKE 'Post-Impressionism' [letter] *Pall Mall Gazette* (10 Nov.
    1910) 7

– 'Post-Impressionism' [letter] *Morning Post* (19 Nov. 1910) 4

'Countess and Futurist' *Sketch* (4 March 1914) 26

COURNOS, JOHN 'The Battle of the Cubes' *New Freewoman* I (15 Nov.
    1913) 214-15

– 'Henri Gaudier-Brzeska' *Egoist* II (2 Aug. 1915) 121

– 'Henri Gaudier-Brzeska's Art' *Egoist* II (1 Sept. 1915) 137-8

– 'The Death of Futurism' *Egoist* IV (Jan. 1917) 6-7

– 'New Tendencies in English Painting and Sculpture' *Seven Arts* I
    (Oct. 1917) 762-78

– 'The Death of Vorticism' *Little Review* VI (June 1919) 47-8

– 'An Environment for Writers' *Saturday Review* XLIII (29 Oct. 1960)
    13-15

'A Cubist Room' *Times* (28 Feb. 1914) 8

'The Cubist's Error' *Times* (7 March 1914) 6

CUNNINGHAME-GRAHAM, R.E. 'Post-Impressionism' [letter] *Morning Post*
    (18 Nov. 1910) 10

DARRACOTT, JOSEPH 'Wyndham Lewis' *Connoisseur* CLII (March 1963)
    178-82

'Decoration at the Ideal Home Show' *Journal of the Royal Society of
    Arts* (24 Oct. 1913) 1062

DENVER, FRANK 'The London Group' *Egoist* II (1 April 1915) 60-1

DEUTSCH, BABETTE 'Ezra Pound, Vorticist' *Reedy's Mirror* XXVI (21 Dec.

1917) 860-1

DREY, O. RAYMOND 'Gino Severini' *Blue Review* I (July 1913) 213-14

EAGLE, SOLOMON [J.C. Squire] 'Books in General' [*Blast*] *New Statesman*
  III (4 July 1914) 406
– 'Post-Impressionist Poetry' *New Statesman* IX (22 Sept. 1917) 594
'Echoes' *Art World* II (16 Jan. 1911) 1
ELIOT, T.S. 'Tarr' *Egoist* VIII (Sept. 1918) 105-6
– 'Ezra Pound' *Poetry* (Chicago) LXVIII (Sept. 1946) 326-38
ELLMAN, RICHARD 'Ez and Old Billyum' *Kenyon Review* XXVII (Sept.
  1966) 470-95
'Examples of Work of the Italian Futurist Painters' *Daily Graphic*
  (20 March 1912) 10
'Exhibitions' *Athenaeum* 4506 (7 March 1914) 348-9

254

FARR, DENNIS 'Wyndham Lewis and the Vorticists' *Burlington Magazine*
  XCVIII (Aug. 1956) 279-80
FELTON, JOHN 'Contemporary Caricatures' *Egoist* I (14 Aug. 1914)
  296-7
FENABY, H.C. 'Artists as House-Painters' *Daily Express* (28 March 1913)
'Fine Art Gossip' [*Blast*] *Athenaeum* 4523 (4 July 1914) 26
FLINT, F.S. 'Imagisme' *Poetry* (Chicago) I (March 1913) 198-200
FORD, FORD MADOX 'The Poet's Eye' *New Freewoman* I (1 Sept. 1913)
  107-10
– 'On a Notice of "Blast" ' *Outlook* XXXVI (31 July 1915) 143-4
FRANK, JOSEPH 'Spatial Form in Modern Literature' *Sewanee Review*
  LIII (1945) 221-40, 433-56, 643-53
'French Post-Impressionists at the Grafton Gallery' *Connoisseur* XXVIII
  (Dec. 1910) 315-16
FRY, ROGER 'The Grafton Gallery, I' *Nation* VIII (19 Nov. 1910) 331-2
– 'The Post-Impressionists' *Nation* VIII (3 Dec. 1910) 402-3
– 'A Postscript on Post-Impressionism' *Nation* VIII (24 Dec. 1910) 536-7
– 'Post-Impressionism' *Fortnightly Review* DXXXIII, n.s. (1 May 1911)
  856-67
– 'Introduction' *Second Post-Impressionist Exhibition* [exhibition cata-
  logue] London, Grafton Galleries 1912
– 'The Artist as Decorator' *Colour* VI (April 1917) 92-3
'Futurism' *Manchester Guardian* (23 March 1912) 8
'Futurism' *Tramp* I (Aug. 1910) 487-8
'Futurism and English Art' *Observer* (7 June 1914)
'Futurism and Vaudville *Literary Digest* XLVII (1913) 1173-4
'Futurism and Women' *Vote* (31 Dec. 1910) 112
'Futurism in London' *Morning Leader* (21 March 1912) 7
'Futurism in the Dance' *Nash's and Pall Mall* LV (May 1915) 330-1
'Futurist Art and Life' *Graphic* (23 May 1914) 950
'Futurist Clothes' *Pall Mall Gazette* (28 May 1914) 2
'A Futurist Dinner Menu' *Daily Mirror* (16 March 1914) 5
'A Futurist Grumble' *Daily Mirror* (6 May 1914) 5
'Futurist Leader in London' *Daily Chronicle* (20 March 1912) 1
'Futurist London' *Evening News* (4 March 1912) 3
'Futurist Music' *Observer* (29 March 1914) 6
'Futurist Music' *Pall Mall Gazette* (8 April 1914) 7
'Futurist Music at the Coliseum' *Graphic* (20 June 1914) 1144

'Futurist Music: "Noisy Tuners" at a Rehearsal' *Pall Mall Gazette*
(12 June 1914) 1
'Futurist Sculpture' *Daily Graphic* (8 May 1914) 7
'The Futurist Split' Yorkshire *Observer* (15 June 1914)
'Futurist Squabbles' *Daily Express* (11 June 1914)
'A Futurist Vision' *Pall Mall Gazette* (8 June 1914)
'The Futurists Again' Manchester *Courier* (13 June 1914)
'Futurists Invade Buckingham Palace' *London Life* (4 April 1914) 3

GAUDIER-BRZESKA, HENRI 'Mr. Gaudier-Brzeska on "The New
Sculpture" ' *Egoist* I (16 March 1914) 117-18
– 'Allied Artists' Association, Ltd.' *Egoist* I (15 June 1914) 227-8
GIBBS, PHILIP 'Futurist Sculpture' *Daily Chronicle* (3 Oct. 1912) 6
GINNER, CHARLES 'Modern Painting and Teaching' *Art and Letters* I
(July 1917) 19-24
GORDON-STABLES, MRS I. 'On Painting and Decorative Painting' *Colour*
VI (June 1916) 187-8
'The Grafton Group at the Alpine Gallery' *Athenaeum* 4498 (10 Jan.
1914) 70
GWENNET, GUNN 'Vorticism and Mysticism' *Drawing* (July 1915) 56

HADOW, W.H. 'Aspects of Modern Music' *Musical Quarterly* I (Jan.
1915) 57-68
HALL, DONALD 'Ezra Pound: An Interview' *Paris Review* 28 (summer-
fall 1962) 22-51
HARDIE, MARTIN 'Post-Impressionism' [letter] *Morning Post* (18 Nov.
1910) 10
HENRY, LEIGH 'Liberations: Studies of Individuality in Contemporary
Music' *Egoist* I (15 April 1914) 147-9
HERON, PATRICK 'Wyndham Lewis the Artist' *New Statesman and
Nation* XLIII (12 Jan. 1952) 43-4
HIND, C. LEWIS 'Maniacs or Pioneers?' [P-I] *Daily Chronicle* (7 Nov.
1910) 8
– 'Post-Impressionism' [letter] *Morning Post* (17 Nov. 1910) 3
– 'Futurist Painters' *Daily Chronicle* (4 March 1912) 6
'The Home of the Cubist Artists at 38, Great Ormond Street' *Graphic*
(25 April 1914) 726
HONIG, EDWIN 'The Mutation of Pound's' *Kenyon Review* XVII (1955)
349-56
'How Mr. Fry is Trying to Bring a "Spirit of Fun" Into Our Sedate
Homes' *Daily News and Leader* (7 August 1913)
HUTCHINS, PATRICIA 'E.P. as a Journalist' *Twentieth Century* (Jan.
1960) 39-48

'Impressionism at Its Latest' *Daily Graphic* (7 Nov. 1910) 14

'Jews and Cubism' *Jewish World* (c June 1914)
JOHN, AUGUSTUS 'Elephants with Beards' *Sunday Times Magazine* (5
Oct. 1958) 19
JOLL, JAMES 'F.T. Marinetti: Futurism and Fascism' *Intellectuals in
Politics* (London 1960) pp133-84
JONES, ALUN R. 'Notes Toward a History of Imagism' *South Atlantic
Quarterly*, LX (1961) 262-85

'Junkerism in Art: The London Group at the Goupil Gallery' *Times* (10 March 1915) 8

KAPP, E.X. 'Impression of Wyndham Lewis' [caricature] *New Weekly* I (30 May 1914) 331

KEENAN, PETER 'Memories of Vorticism' *New Hope* II (Oct. 1934) 5-6, 18-19

KIRK, RUSSELL 'Wyndham Lewis' First Principles' *Yale Review* XLIV (1955) 520-34

KONODY, P.G. 'Futurism – The Latest Art Sensation' *Illustrated London News* CXL (17 Feb. 1912) 225

– 'The Italian Futurists' *Pall Mall Gazette* (1 March 1912) 5

– 'Art and Artists: Futurist Pictures in London' *Observer* (3 March 1912) 6

– 'Art and Artists: The London Group' *Observer* (8 March 1914) 7

– 'Art and Artists: "Blast" ' *Observer* (5 July 1914)

– 'Art and Artists' [*Blast* no. 2] *Observer* (2 Aug. 1915)

– 'Modern War' *Modern War: Paintings by C.R.W. Nevinson* (London 1917) 7-30

*Lacerba* I-III (1913-1915)

'Lady Drogheda's Futurist Dining-Room: Decorations' *Sketch* (4 March 1914) 265

LANDINI, RICHARD G. 'Vorticism and *The Cantos* of Ezra Pound' *Western Humanities Review* XVI (1960) 172-81

LEWIS, ANNE WYNDHAM [letter] *Arts Review* (27 Nov. 1965) 22

LEWIS, WYNDHAM 'The Cubist Room' *Egoist* I (1 Jan. 1914) 8-9

– 'A Man of the Week: Marinetti' *New Weekly* I (30 May 1914) 328-9

– 'Automobilism' *New Weekly* II (20 June 1914) 13

– 'Futurism and the Flesh' *T.P.'s Weekly* XXIV (11 July 1914) 49

– 'Tarr' [instalments] *Egoist* III-IV (April 1916-Nov. 1917)

– 'Foreword' *Guns* [exhibition catalogue] London, Goupil Gallery 1919

– 'What Art Now?' *English Review* XXVII (April 1919) 334-8

– 'Group x' *Evening News* (20 March 1920) 4

– 'Foreword' *Group X* [exhibition catalogue] London, Mansard Gallery 1920

– 'Plain Home-builder: Where is your Vorticist?' *Architectural Review* LXXVI (Nov. 1934) 155-8

– 'Early London Environment' *T.S. Eliot* edited Richard March and Tambimuttu. London 1948 pp24-32

– 'Edward Wadsworth: 1889-1949' *Listener* (30 June 1949) 1107

– 'Ezra Pound' *Ezra Pound: A Collection of Essays ...* edited Peter Russell. London 1950 pp257-66

– 'The Rock Drill' *New Statesman and Nation* XLI (7 April 1951) 398

– 'The Vorticists' *Vogue* (Sept. 1956) 216, 221-2

'Letters from a Town to a Country Woman' *English Review* XVI-XVII (Feb.-Oct. 1914)

LIPKE, WILLIAM C. [letter] *Arts Review* (27 Nov. 1965) 22

– 'Futurism and the Development of Vorticism' *Studio* CLXXIII (April 1967) 173-8

– and BERNARD ROZRAN 'Ezra Pound and Vorticism: A Polite Blast' *Wisconsin Studies in Contemporary Literature* VII (Summer 1966) 201-10

'The London Group' *Athenaeum* 4507 (14 March 1914) 387

'The London Group' *Times* (2 Dec. 1915)

'Londoner,' 'Tonight's Gossip' [Futurism] *Evening News* (2 March 1912) 1

LUDOVICI, ANTHONY 'The Italian Futurists and their Traditionalism' *Oxford and Cambridge Review* 21 (July 1912) 94-122

LUDWIG, RICHARD M. 'Ezra Pound's London Years' *Aspects of American Poetry* Ohio State University, 1962, pp99-119

MacCARTHY, DESMOND 'Post-Impressionist Frescoes' *Eye-Witness* (9 Nov. 1911) 661-2

– 'The Post-Impressionist Exhibition of 1910' *Listener* XXXIII (1 Feb. 1945) 123-4, 129

MCFALL, HALDANE 'Art of the So-Called Futurists' *London Academy* 2080 (16 March 1912) 325-7

MCLUHAN, MARSHALL 'Wyndham Lewis: His Theory and Art of Communication' *Shenandoah* IV (1953) 77-88

MCNAUGHTON, WILLIAM 'Ezra Pound's Meter and Rhythms' *PMLA* LXXVIII (1963) 136-46

'Manet and the Post-Impressionists' *Atheneum* 4333 (12 Nov. 1910) 598-9

MARINETTI, F.T. 'Le Futurisme Pictural' *Tripod* 1 (April 1912) 25-8

– 'Geometric and Mechanical Splendour in Words at Liberty' *New Age* XV (7 May 1914) 16-17

– 'Abstract Onomatopoeia and Numeric Sensibility' *New Age* XV (16 July 1914) 255

– 'War, The Only Hygiene of the World' *Little Review* I (Nov. 1914) 30-1

MARKINDO, YOSHIO 'The Post-Impressionists and Others' *Nineteenth Century* LXXIII (Feb. 1913) 317-27

MARQUIS, DON 'The First Intelligent Answer' *Art World* II (May 1917) 166

MICHEL, WALTER 'Vorticism and the Early Wyndham Lewis' *Apollo* LXXVII (Jan. 1963) 5-9

– 'Tyros and Portraits' *Apollo* LXXXII (Aug. 1965) 128-33

MIDDLETON, CHRISTOPHER 'Documents on Imagism from the Papers of F.S. Flint' *The Review* 15 (April 1965) 31-51

MONROE, HARRIET 'Miss Monroe *Re* Ezra Pound' *English Journal* XX (January 1931) 86-7

MORELY, ROBERT 'Post-Impressionism' [letter] *Nation* VIII (3 Dec. 1910) 406

MORGAN, LOUISE 'Wyndham Lewis' *Writers at Work* London 1931 pp43-52

*Morning Post* [letters from Arthur Severn, E.F. Benson, R.B. Cunninghame-Graham on Post-Impressionism] (22 Nov. 1910) 5

MUDRICK, MARVIN 'The Double-Artist and the Injured Party' *Shenandoah* IV 2-3 (1953) 54-64

MURDOCK, W.G. BLAIKIE 'Henri Gaudier-Brzeska' *Bruno's Weekly* III (29 July 1916) 880-1

NEVINSON, C.R.W. 'Post-Impressionism and Cubism' [letter] *Pall Mall Gazette* (7 March 1914)

– 'Tum-Tiddly-Um-Tum-Pom-Pom: A Futurist Masterpiece' Cardiff *Western Mail* (15 May 1914)

– 'Futurism' *New Weekly* II (20 June 1914) 18

– 'The Vorticists and the Futurists' *Observer* (12 July 1914) 15
– 'Art and War' [letter] *Daily Graphic* (11 March 1915)
– 'Modern Art' *World* (4 Oct. 1919)
– 'Studio Reminiscences' *Studio* CXXIV (1942) 195
NEVINSON, HENRY W. 'The Impulse to Futurism' *Atlantic* CXIV (Nov. 1914) 626-33
'The New Art Gospel' Glasgow *Herald* (13 June 1914)
'New Pictures; Principles of the X Group' *Times* (1 April 1920)
'A New Venture in Art' *Times* (9 July 1914) 4
NEWBOLT, HENRY 'Futurism and Form in Poetry' *Fortnightly Review* DLXIX (May 1914) 806-18
NICOLSON, BENEDICT 'Post-Impressionism and Roger Fry' *Burlington Magazine* XCIII (Jan. 1951) 11-15
'Note' *Athenaeum* 4506 (7 March 1914) 348-9

'The Omega Workshops' *Times* (10 Dec. 1913) 13

PACK, ROBERT 'The Georgians, Imagism and Ezra Pound: A Study in Revolution' *Arizona Quarterly* XII (1956) 250-6
'Painter of Smells at the Front' *Daily Express* (25 Feb. 1915)
'Painting War as a Soldier Sees It' New York *Times* (25 May 1919) 13
PATMORE, BRIGIT 'Ezra Pound in England' *Texas Quarterly* VIII (autumn 1964) 69-81
PEVSNER, NIKOLAS 'Ω' *Architectural Review* XC (Aug. 1941) 45-8
PHILIPS, CLAUDE 'Sackville Gallery' [Futurism] *Daily Telegraph* (2 March 1912) 9
– 'Goupil Gallery: The London Group' *Daily Telegraph* (10 March 1914)
PHILLIPS, STEPHEN 'Views and Reviews' [*Blast*] *Poetry Review* V (July 1914) 48
*Poetry and Drama* I (Sept. 1913) [Futurist issue]
'A Post-Impressionist Exhibition' *Connoisseur* XXXIX (June 1914) 142
'Post-Impressionist Flat: What Would the Landlord Think?' *Daily Mirror* (8 Nov. 1913) 3
'Post-Impressionist and Futurist Exhibition' *Athenaeum* 4487 (25 Oct. 1913) 462
'Post-Impressionist Pictures' *Times* (16 Oct. 1913) 2
'Post-Impressionists' *Daily News* (7 Nov. 1910) 3
'Post-Impressionists' *Athenaeum* 4367 (8 July 1911) 51
POUND, EZRA 'Prologomena' *Poetry Review* I (Feb. 1912) 72-6
– 'Status Rerum' *Poetry* (Chicago) I (Jan. 1913) 126
– 'A Few Don'ts By an Imagiste' *Poetry* (Chicago) I (March 1913) 200-6
– 'The Serious Artist' *New Freewoman* I (15 Oct., 1 Nov., 15 Nov. 1913) 161-3, 194-5, 213-14
– 'The New Sculpture' *Egoist* I (16 Feb. 1914) 67-8
– 'Exhibition at the Goupil Gallery' *Egoist* I (16 March 1914) 109
– [letter] *Daily News and Leader* (8 April 1914) 4
– 'Wyndham Lewis' *Egoist* I (15 June 1914) 233-4
– 'Edward Wadsworth, Vorticist' *Egoist* I (15 Aug. 1914) 306-7
– 'Vorticism' [1] *Fortnightly Review* DLXXIII (1 Sept. 1914) 461-71
– 'Preliminary Announcement of the College of Arts' *Egoist* I (2 Nov. 1914) 413-14
– 'A Blast from London' *Dial* LVIII (1 Jan. 1915) 40-1

– 'Affirmations I: Arnold Dolmetsch' *New Age* XVI (7 Jan. 1915) 246-7
– 'Vorticism' [2] *New Age* XVI (14 Jan. 1915) 277-8
– 'Jacob Epstein' *New Age* XVI (21 Jan. 1915) 311-12
– 'As For Imagisme' *New Age* XVI (28 Jan. 1915) 349-50
– 'Gaudier-Brzeska' *New Age* XVI (4 Feb. 1915) 380-2
– 'Affirmations VI' *New Age* XVI (11 Feb. 1915) 411
– 'Status Rerum – The Second' *Poetry* VIII (April 1916) 39
– 'The Death of Vorticism' *Little Review* V (Feb.-March 1919) 45-51
– 'Durability and De Bosschère's Presentation' *Art and Letters* II
    (Summer 1919) 125-6
– 'Thoughts and Opinions' *Colour* XI (August 1919) 21
– 'That Audience, or the Bugaboo of the Public' *Colour* XI (Sept. 1919)
    42
– 'The Curse' *Apple* I (first quarter 1920) 22-4
– 'Obstructivity' *Apple* I (third quarter 1920) 168-72
– 'Data' *Exile* 4 (1928) 104-17
– 'Small Magazines' *English Journal* XIX (May 1930) 684-704
– 'Past History' *English Journal* XXII (May 1933) 349-58
– 'This Hulme Business' *Townsman* II (Jan. 1939) 15
– 'On Wyndham Lewis' *Shenandoah* IV (1953) 17
– 'Verse is a Sword: Unpublished Letters of Ezra Pound' *X, A Quarterly
    Review* I (Oct. 1960) 258-65
PRATELLA, BALILLA 'Le Futurisme Musical' *Tripod* 2 (May 1912) 31-8

'Rebel Art in Modern Life' *Daily News and Leader* (7 April 1914) 14
'Rebels in Art' *Times* (16 June 1914) 11
REDMOND-HOWARD, L.G. 'The Futurist Note in Interior Decoration'
    *Vanity Fair* (25 June 1914) 32, 74
'Restaurant Art' *Colour* IV (April 1916) xiv
RICHMOND, W.B. 'Post-Impressionists' [letter] *Morning Post* (16 Nov.
    1910) 5
RICKETTS, CHARLES 'Post-Impressionism' [letter] *Morning Post* (9 Nov.
    1910) 6
ROBERTS, WILLIAM 'Portrait of the Artist' *Art News and Review* I
    (5 Nov. 1949) 1
– 'Wyndham Lewis, the Vorticist' *Listener* LVII (1957) 470
RODKER, JOHN 'The New Movement in Art' *Dial Monthly* II (May
    1914) 184-8
ROSE, W.K. 'Ezra Pound and Wyndham Lewis, the Crucial Years'
    *Southern Review* IV (Jan. 1968) 72-89
ROSS, ROBERT 'The Post-Impressionists at the Grafton' *Morning Post*
    (7 Nov. 1910) 3
ROTHERY, GUY CADOGAN 'Futurism in Furnishing' *Colour* IV (May 1916)
    155-6, xiv
ROTHSCHILD, MAX 'Sir Philip Burne-Jones and the Futurists' [letters]
    *Pall Mall Gazette* (4 and 6 March 1912) 4, 8
ROZRAN, BERNARD 'A Vorticist Poetry With Visual Implications: The
    "Forgotten" Experiment of Ezra Pound' *Studio* CLXXIII (April 1967)
    170-2
RUSSOLO, LUIGI 'Gl'Intonarumori Futuristi' *Lacerba* I (1 July 1913)
    140-1
RUTTER, FRANK 'The Mural Paintings at the Borough Polytechnic' *Art
    News* III (15 Nov. 1911) 9
– 'Art and Artists' *New Weekly* I (4 April 1914) 85

– 'A School for Cubists' *Sunday Times* (5 April 1914) 7
– 'Extremes of Modern Painting: 1870-1920' *Edinburgh Review*
CCXXXIII (April 1921) 298-315

SADLER, MICHAEL 'Post-Impressionism' [letter] *Nation* VIII (3 Dec. 1910)
405-6

SAINT-POINT, VALENTINE DE 'La Femme Futuriste: Réponse à F.T.
Marinetti' *Tripod* 4 (Oct. 1912) 15-21

SAMUEL, HORACE B. 'The Future of Futurism' *Fortnightly Review* DLVI
(1 April 1913) 725-40

SANDBURG, CARL 'The Work of Ezra Pound' *Poetry* (Chicago) VII (Oct.
1915) 249-57

SCHNEIDAU, HERBERT N. 'Vorticism and the Career of Ezra Pound'
*Modern Philology* LXV (Feb. 1968) 214-27

SCOTT-JAMES, R.A. 'Blast' *New Weekly* II (4 July 1914) 88

'A Sculptor in War's Vortex' *Literary Digest* LI (1915) 349-50

SEVERINI, GINO 'Get Inside the Picture' *Daily Express* (11 April 1913)

SICKERT, WALTER 'The Post-Impressionists' *Fortnightly Review* LXXXIX
(Jan. 1911) 79-89

– 'The Futurist "Devil-among-the-Tailors" ' *English Review* X (April
1912) 147-54

SIMON, ANNE 'F.T. Marinetti and Some Principles of Futurism'
*Poet-Lore* XXVI (Winter 1915) 738-43

SINCLAIR, MAY 'The Reputation of Ezra Pound' *North American Review*
CCXI (May 1920) 658-68

*Sketch* [articles on Futurism] (14 Feb. 1912) 116-17, (6 March 1912)
45-6, (20 March 1912) 999, (16 April 1913) 41, (29 April 1914)
101, (13 May 1914) 161-2, (20 May 1914) 199, 209, (17 June
1914) 324, (24 June 1914) 382

'Some of the Manifestos of Futurism ...' Newark *Evening News* (17 Jan.
1914)

STONE, GEOFFREY 'The Ideas of Wyndham Lewis' *American Review* I-II
(Oct.-Nov. 1933) 578-99, 82-96

STORER, EDWARD 'The London Group' *New-Witness* (11 March 1915)

STOWELL, F. MCLEAN 'Post-Impressionism' [letter] *Nation* VIII (17 Dec.
1910) 503

'The Strange Manifesto of the Futurists' Nottingham *Guardian*
(10 June 1914)

TARRATT, MAGARET ' "Puce Monster" ' *Studio* CLXXIII (April 1967)
168-70

T[IETJENS], E[UNICE] 'Blast' *Little Review* I (Sept. 1914) 33-4

*Times* [articles on Futurism] (1 March 1912) 11, (18 Nov. 1913) 5,
(1 May 1914) 10, (5 May 1914) 6, (6 May 1914) 8, (8 May 1914)
4, (9 May 1914) 6, (14 June 1914) 20, (21 June 1914) 8

'Tis,' 'The Younger Generation: C.R.W. Nevinson' *Colour* V (Feb.
1917) 10-12

– 'About Wyndham Lewis' *Colour* X (March 1919) 24-7

'A Trio of Futurist Flower Robes' *Daily Graphic* (19 May 1914) 17

'Troubles of the Futurists' Newark *Evening News* (8 August 1914)

'Tuppence, Hosea,' 'Paregoric' *London Opinion* (22 April 1916)

'Two Futurist Manifestos' *Academy* 2117 (30 Nov. 1912) 693

'Two Views of One Man' *Evening News* (20 March 1920) 5

260

'Views and Reviews' *Poetry Review* v (July 1914) 47-51
'Vorticism' Manchester *Guardian* (13 June 1914)
'Vorticism and the Politics of Art' *Times' Literary Supplement* (22 Nov. 1957) 700
'Vorticism, the Latest Cult of Rebel Artists' New York *Times* (9 Aug. 1914) sec. 5, p10
'Vorticist Art' *Times* (13 June 1914) 5
'Vorticist Exhibition' *Colour* II (July 1915) 198
'Vorticist Exhibition at the Doré Galleries' *Athenaeum* (19 June 1915)
'The Vorticists' Glasgow *Herald* (11 June 1915)
'Vorticists and Others' *Westminster Gazette* (18 June 1915)

WAGNER, GEOFFREY 'Wyndham Lewis and the Vorticist Aesthetic' *Journal of Aesthetics and Art Criticism* XIII (1954) 1-17
'War as the Futurist Sees It' *Daily Graphic* (5 March 1915)
WATSON, SHEILA 'The Great War, Wyndham Lewis, and the Underground Press' *Arts Canada* 114 (Nov. 1967) 3-17
WEES, WILLIAM C. 'Ezra Pound as a Vorticist' *Wisconsin Studies in Contemporary Literature* VI (1965) 56-72
– 'Pound's Vorticism: Some New Evidence and Further Comments' *Wisconsin Studies in Contemporary Literature* VII (1966) 211-16
– 'England's *Avant-Garde*: The Futurist-Vorticist Phase' *Western Humanities Review* XXI (Spring 1967) 117-28
WEISSTEIN, ULRICH 'Vorticism: Expressionism English Style' *Yearbook of Comparative and General Literature* 13 (1964) 28-40
'Which is Blackpool? How a Vorticist Sees It' *Daily Mirror* (11 June 1915) 12
'Will These Pictures Help the Germans? (Uncensored)' *Daily Express* (25 Feb. 1915)
WINAS, WALTER 'The Ugly Side of the Cubist-Futurist-Vorticist Craze' *Quest* IX (Oct. 1917) 144-9
WODDIS, M.J. 'The Café Royal in War Time' *Colour* II (July 1915) 218-20

## Unpublished Material

In the acknowledgements at the beginning of this book will be found a list of persons who provided information in correspondence or interviews with the author. Below are listed other unpublished sources of information.

BAISCH, DOROTHY RUTH 'London Literary Circles, 1910-1920,' unpublished dissertation. Cornell University 1950
BRITISH BROADCASTING CORPORATION Typescripts of tape recorded interviews with Enid Bagnold, R.P. Bevan, Horace Brodzky, Oliver Brown, O. Raymond Drey, Kate Lechmere, Anthony Lousada, and Kitty Smith (1964-5) for use in 'Vortex Gaudier-Brzeska'
– 'Vortex Gaudier-Brzeska' transcript for BBC Third Programme broadcast 5 June 1965, compiled by Mervyn Levy and Douglas Cleverdon
DAVIE, DONALD 'The Analogy with Sculpture,' typescript of lecture delivered 8 April 1963 at the University of Cincinnati
EDMAN, JOHN HENRY 'Shamanism and Champagne: A Critical Intro-

duction to the Vorticist Theory of Wyndham Lewis,' unpublished dissertation. Syracuse University 1960

GILL, WINIFRED Typescript of interview on file at the Victoria and Albert Museum, London

– Letters to Duncan Grant on file at the Victoria and Albert Museum, London

LEWIS, WYNDHAM Letter to Spencer Gore (c1904) in possession of Mrs Spencer Gore

LIPKE, WILLIAM C. 'A History and Analysis of Vorticism,' unpublished dissertation. University of Wisconsin 1966

POUND, EZRA Letters to Gladys Hynes, Ezra Pound Collection, Yale University

TRITSCHLER, DONALD 'Faulkner and Vorticism,' Appendix A: 'Whorls of Form in Faulkner's Fiction,' unpublished dissertation. Northwestern University 1957, pp274-81

WYNDHAM LEWIS COLLECTION Manuscripts, letters, memorabilia, etc., Cornell University

# INDEX

The following abbreviations will be used, except where the name or term appears as a heading:

v Vorticism      WL Wyndham Lewis
F Futurism      EP Ezra Pound
PI Post-Impressionism    HGB Henri Gaudier-Brzeska

Works of art and literature will be listed under their author's name.

Designed by
ALLAN FLEMING
and
WILLIAM RUETER
University of
Toronto
Press